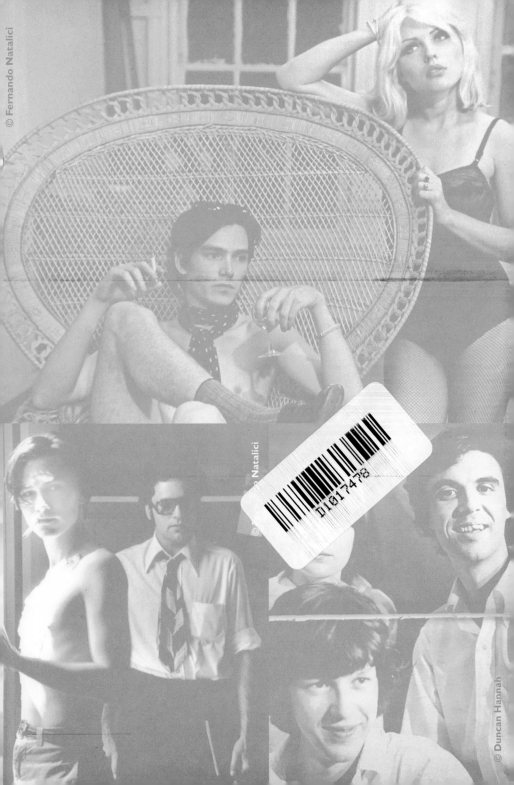

20th CENTURY BOY

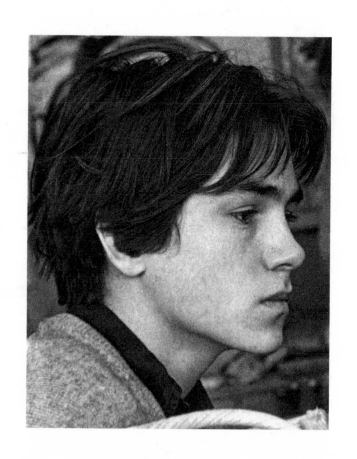

20th CENTURY BOY

Notebooks of the Seventies

Duncan Hannah

ALFRED A. KNOPF
New York
2018

THIS IS A BORZOI BOOK
PUBLISHED BY ALFRED A. KNOPF

Library of Congress Cataloging-in-Publication Data
Names: Hannah, Duncan, author.
Title: Twentieth-century boy : notebooks of the seventies / Duncan Hannah.
Other titles: 20th-century boy : notebooks of the seventies
Description: New York : Knopf, 2018.
Identifiers: LCCN 2017018607 | ISBN 9781524733391 (hardback) ISBN 9781524733407 (eBook)
Subjects: LCSH: Hannah, Duncan—Diaries. | Painters—
 United States—Diaries. | Art and society—New York (State)—
 New York—History—20th century. | New York (N.Y.)—Biography. |
 BISAC: BIOGRAPHY & AUTOBIOGRAPHY / Artists, Architects,
 Photographers. | BIOGRAPHY & AUTOBIOGRAPHY /
 Personal Memoirs. | ART / History / Contemporary (1945–).
Classification: LCC ND237.H2925 A2 2018 | DDC 759.13—dc23
 LC record available at https://lccn.loc.gov/2017018607

Cover photograph by Regis Redon Scott
Cover design by Megan Wilson

Manufactured in the United States of America
First Edition

For Megan,
and to all those friends gone
and friends still here

Blazing our nights with arguments uproarious,
What care we for a dull old world censorious,
When each is sure he'll fashion something glorious?

—JOHN REED, "42 Washington Square"

Contents

Preface

This is not a memoir. These are journals, begun in 1970, at the age of seventeen, written as it happened, filled with youthful indiscretions. They have occupied a couple of shelves in my library for the past forty years. I think I initially kept a journal because I didn't like the feeling of time slipping through my fingers, and this was a way of arresting it. Writing was a way of self-mythologizing, so I could get a grasp on who I, and my friends, might be. I read a lot and wanted to emulate what I was reading. I was under the spell of Kerouac. The early journals were filled with a lot of stream–of-consciousness writing (which I have edited out—terrible mumbo-jumbo), exacerbated by the drugs I was taking. I'm fortunate I jotted down a lot of dialogue and bits of detail, because these would have left my memory. Anyhow, it's all as I saw it.

The books themselves are black-bound, unlined, sized eight and a half by eleven inches, purchased at art supply stores. I named each one (there are twenty) and did a proper DIY title page. They acted as scrapbooks as well, which was a family tradition. Even my grandparents were avid scrapbook keepers. My Rapidograph script is wedged in between pasted clippings of my current favorite rock stars, movie stars, nudes, candy wrappers, tickets, and general flotsam my magpie nature retrieved from the dustbin. I wasn't yet a collagist, but had

an eye for paper ephemera. I started pasting with Elmer's glue, then switched to rubber cement, which smelled nice, but discolored the clippings and lost its adhesive qualities after a few years. I eventually settled on spray fixatives, which are highly toxic yet were perfect for my needs. There were black-and-white photos of me and my friends sprinkled throughout.

These journals start when I was a junior in a public high school. I'd been expelled from the private boys' school (Blake) I'd attended for five years for selling LSD (under duress) to a tubby student who used to play keyboards in the Atlantic Queen, a garage band that we both once were in. He freaked out and ratted on me. As it turned out, it was a good thing I got thrown out, as I was flunking French, Latin, history, science, and geometry (we were doing $E = mc^2$—in tenth grade, for chrissakes!). I excelled only at English and art. Hated the compulsory sports.

My dad had been valedictorian of that same school, skipping a couple of grades before entering Harvard at sixteen. I wasn't exactly following in his footsteps. He was a dapper corporate lawyer (think James Mason) and had been on mood stabilizers since the year I was born, to combat depression. He always wished he'd stayed in the Navy. He had a good war, skippering a sub chaser in the Solomon Islands, rescuing Australian coastwatchers from Japanese-occupied islands, doing clean-up after Guadalcanal . . . plus, he was on a destroyer moored next to the *Missouri* during the Japanese surrender in Tokyo Bay.

Now there were his evening martinis, wine with dinner, sometimes a Scotch-and-soda after dinner. Pills to wake up, pills to go to sleep. He said the secret to happiness was distraction. He belonged to an old men's club in downtown Minneapolis, covered in ivy, where he played squash. I liked to read Sherlock Holmes in their big burgundy-leather armchairs. We belonged to a beautiful country club just outside the city, where he played tennis with his lawyer

buddies. I liked the giant kidney-shaped swimming pool overlooking Lake Calhoun, listening to my transistor radio, eating Fudgsicles.

My mother was a great beauty in her youth. Still was. A bit like Maureen O'Sullivan (Tarzan's Jane). She was always stylishly dressed and loved parties. She worked as an interior decorator. My parents used her income to travel to Europe several times a year. They would pore over travel magazines and timetables, plotting trips. When I began to go wrong, my mother seemed to take it personally and would unleash her anger. She could never hold her liquor, whereas my dad could. Dad usually took the long view that my generation was being profoundly affected by the ongoing turmoil in the USA. He took the high road.

My sister was five and a half years older. She was a great achiever, voted "Peppiest" by her high school. She left to go to Mount Holyoke. Marched with Martin Luther King. My parents had been strict with

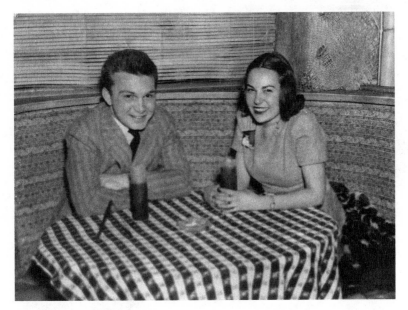

Jim and Bunny Hannah

her, but they gave up when it got around to me. I didn't have a virginity to protect.

The end of the sixties hit me dead-on. I started smoking cigarettes at fourteen, pot at fifteen; then came the rest—LSD, psilocybin, mescaline, hashish, opium, Dexedrine, crystal meth, booze. I lost *my* virginity while still in boys' school, to an apple-cheeked suburban cheerleader with whom I had nothing in common other than raging hormones. The ritual took place in the back of a small speedboat docked in a marina on Lake Minnetonka, smelling of canvas, vinyl, and gasoline. She had me pull out periodically when she thought I was getting too excited, terrified of getting pregnant. She wouldn't let me use a rubber, said they were "dirty."

What I was interested in was rock 'n' roll music, pop art, girlie magazines and dirty books (I learned the facts of life from two paperbacks, *Strumpets' Jungle* and *Pay-for-Play Girl*), drugs, my weirdo friends, movies, and books, mostly coming-of-age stuff like Salinger and the Beats, also the pulp reissues of Doc Savage and Fu Manchu. I was a drummer in various bands and an artist. I did impatient, jittery drawings that combined all my interests. I was always the "class artist," for which I was given special attention. I had a fresh face which I inherited from my mom. I assumed I was headed for great things. And indeed, I had a lot of lucky breaks over the years. I was eager to move to New York and join in the fray.

The title *Twentieth-Century Boy* (taken from the T. Rex song of that name) seemed fitting. I am truly a product of the second half of the twentieth century. For all its faults, the seventies in NYC were a great time to come of age. There was no money, so that wasn't a concern. Living in Manhattan was cheap, and one could lead an interesting existence on four hundred dollars a month. There was no Internet, so one did one's research in a more hands-on way. I suspect the results meant more to us, because they were hard won. The seventies had a

rearview undercurrent of interest in the thirties, forties, and fifties, which jibed with my sensibility. Our quest for authenticity and experience led us in colorful directions. We had faith in the journey, even if we were unsure of the destination.

I had never read these journals before transcribing them. In preparing them for publication, I removed a lot of extraneous detritus. I didn't do a lot of navel gazing, as many diarists do, so I didn't have that to contend with. I noticed, at the time, that mostly it was girls who kept journals, and they generally wrote only when they were upset. I was determined not to do this. I tended to write from jubilation. I wrote these at night, in bed (if I was in any kind of shape to write), or in the morning, over coffee. I didn't write every day, and as life accelerated I would miss notating chunks of experience. Indeed, 1979 hardly gets a look in at all. I don't know why. I've changed some of the names to protect the innocent, and also the not-so-innocent. The grammar and spelling have also been corrected, as my slipshod grasp of English composition leaves something to be desired.

It struck me, as I waded through these journals, that this was a very long time ago—totally different from today's climate. Strange to view this rake's progress through a contemporary lens. The sexual landscape was different then—wide open. It seemed a new frontier. It was a weird feeling to reconnect with my youthful self, whom I was often amused by and often ashamed of, but such is the nature of youth. I felt a sympathy for my parents and my sister Holly that I selfishly didn't have at the time. I felt sympathy for me as well, in the throes of nascent alcoholism that I didn't then understand. I saw the arc of addiction going from bad to worse. I saw myself trying to keep up with it all, from becoming the artist I wanted to be to becoming the man I wanted to be. I was scrabbling for a foothold in the contemporary culture on my own terms. Miraculously, most of what I'd yearned for on page one had come true on the last page, when I was

twenty-eight. I think only then did I begin to grow up. Of course a lot of it was fun, and funny, but a lot of it was harrowing too. It could have ended up very differently had I not had a guardian angel watching over me. What would I change? A futile question. It is what it is. No regrets.

New York City, February 2017

MYSTIC EYES

Winter of 1970

I think back on the private boys' school I went to. They tried to break me. Those bastards. They whacked me with oak boards and gave me noogies. My homosexual Latin teacher twisted my ear around because my conjugation lacked something. I had lead ashtrays pitched at my head. I was shoved into a gym locker and hammered upon. I came onto mescaline in French class. I wrote hundreds of sentences beginning with "I will not . . ." I wheezed during soccer practice. It was crushing me. Now I'm free. Adrift in a huge public high school where very little is demanded of me.

I just got done jamming with my band, the Hurricane Boys. We did "Boris the Spider," "Run Run Run," "Communication Breakdown," "I'm So Glad," "I'm a Man," "Stormy Weather." I felt invincible behind my set of silver-sparkle Ludwigs. Cutting through dense layers of Gibson guitars, leading, following, patterns lock in, my head spins, and a rush swoops up from my toes to my crossed eyes. Sounds great, and it's coming from *us*!

Driving back home past nighttime-neon suburbia, Tom Thumb, the Little General, Nate's Food Market, Snuffy's Drive-In, Smack's Hamburgers, Quik Mart, Dairy Queen, Pee Wee's Big Fish, the A&W, the 7-Hi, Hart's Cafe, listening to Clapton on the radio, the car full of crazy longhairs, a working unit, one feeding off of the other, observing, pretending, babbling, goofing. We're on the way to somewhere, picking up, dropping off.

I think of fifteen-year-old Honey Sullivan. Last December she got

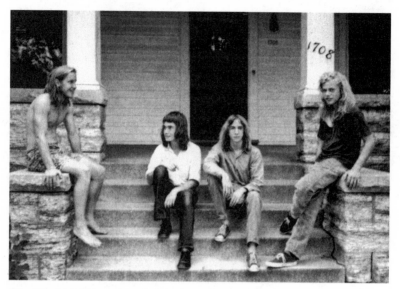

The Hurricane Boys: Steve Brooks, DH, Jimmy Clifford, Steve Kramer

shipped back to her mother's house in Dixie County, Missouri. She was only here for a few months after some trouble back home. Honey had been one of those precocious kids who would be the only girl in an all-boy club and do a striptease for them in a treehouse. Never had a dad. She was hot to trot. She'd been shown the ropes by some pool shark/drug dealer ten years her senior for one entire summer. Our first kiss was in Loring Park. After smoking a joint and watching the ducks, we rolled around by the flower beds. All tongues and suction. We break for air, and she says in her southern accent, "I knew you'd kiss like that." I thought to myself, "I never kissed like that in my life!" We made out till midnight. She said, "Next week I want to make love to you."

I remember her big eyes looking up at me in the school hallways as she grinned and said, "Hello, boy," hungry for the nights of passion to come. She is two years younger than me but much more sexually advanced. I remember her back as she undid her white brassiere

and then turned to me where I lay. An indelible sight I replay over and over in my head. Perfect breasts jutting out, downy soft and pink-tipped. Fawn-colored fluffy pubis. Arching up her limbs to me like a sensuous cat who wants to be petted and stroked . . . her creamy flat stomach . . . her hair smelled honey-sweet. For real.

Once in my parents' house (they were in Europe), listening to the Beatles' "I Want You," and she was getting all worked up. "She's so *heavy*," sang John. "C'mon, Dunc," pleaded Honey. I was nervous that my aunt was going to drop in to water the plants or something, even though it was eight o'clock on a school night. So we climb the wooden stairs to the small loft over the living room, where there is a divan to fool around on. Off come my pants and boxer shorts, off come her brown tights. On goes the Sheik prophylactic I stole from my dad's bathroom drawer. She presents her beautiful ass to me as she grips the banister; I position myself down between her buttocks, rake the silky slope of her thighs, enter the maiden hair. I am nervous, thinking we don't have much time, so I'm going at it pretty fast. Honey looks back over her shoulder at me and says in that southern drawl of hers, "Hey, where's the fire?" We laughed, and I slowed down and savored just what it was we were doing. She's open to me, thrusting back, skin to skin. Riding the dark waves, coming nearer and nearer, and then in a soft, shuddering convulsion she was gone, and so was I, melting in exquisite delight.

She once passed me a note in the library, written in her kid's loopy block letters, reading, "I want a butt fuck!," and I blushed and laughed, thinking, "Who does that, anyway?!?" But of course she was serious, probably having tried most things with her ex-boyfriend, who was now serving time in prison for dealing drugs. I remember another time in a college kid's apartment, a bunch of older freaks were getting high listening to *Abbey Road* solemnly. She knelt next to me, smoking, gently rearranging her limbs under her miniskirt every so often, playing with the cat. We crawled out of sight onto the

kitchen floor, where we writhed about together and French-kissed, getting thoroughly excited, sexual stimulation being her favored emotional state. "I want you," she whispered. "Here? Now? What about all these people?" "We can go in the bathroom . . . C'mon . . . I need you inside me." And I didn't do it! Idiot! I stood on propriety! What a dolt! I dropped off a very unsatisfied girl at her sister's house and drove home with blue balls. She was a nympho-schoolgirl from ear to sweet southern ear.

. . .

I'm haunted by her now. I dreamt she was in a production of *Peter Pan*. I have another recurring dream where I ride an orange school bus to a lake. And she's there. The shimmering lake is surrounded by irregular cliffs, making it dark, romantic, and spooky. She's incredibly sexy, sitting upright, an insistent little girl, waiting to be kissed and fondled. She says, "Little teapots take time." We embrace. I never, ever, have sex in my dreams, sadly, so that was the end. After her the rest don't seem right. So that's why I'm haunted.

. . .

Jefferson Airplane at the Minneapolis Auditorium. Kurt and I dropped mescaline and smoked a lot of boo for the show. Ten thousand freaks were there, tons of hippie babes that were beautiful and I fell in love with them all, grinning like mad. The place was buzzing and so was I. Everyone out of their heads for the occasion. Anticipation for San Francisco's finest! Lights go down, joints are passed. First they show a movie of the Airplane at various be-ins, love-ins, and we forget what we're seeing, "Is this the Airplane?" we laugh. Then the screen rolls up, blue Fender amp glow, and it's the chugging intro to "Volunteers." *This* is the Airplane. Transfixed by the light show, lysergic tunnels opening up. I stood on my chair with everyone else. A sea of rocking heads. They had us, were directing

our trip with buzz-saw currents, guitars slashing, thrashing, sling-
ing lightning bolts, improvising space music, drifting off and fading
together, "Feed your head!" Grace wails. Total professionals guiding
us through the people's music.

Afterwards, when the band left, and the houselights came on, we
all looked at each other, minds blown, new knowledge on people's
faces. We all saw the same thing, heard the same thing, felt the same
thing. Unified. Strengthening our resolve to let our freak flags fly.
There *is* a revolution!

In the cold parking lot, I find my mother's blue Buick station
wagon, and the gang climbs in. I reach to turn on the radio, and Kurt
says, "Wait, Dunc . . . what if it's *not* the Jefferson Airplane?!?"

I pause. "You're right."

Silence. Then he says, "Go ahead, it will be."

So I switch it on, and of course it *is* the Jefferson Airplane. What
else could it be?

I drive everyone home, we're all drained from the experience, the
black sky of Minneapolis winter whipping past at 60 mph. Someone
in the backseat says, "Yay, Dunc, for staying on the road!" Instanta-
neous applause from all the stoned teenagers.

May 26, 1970

Saw Roland Kirk at the ExtraOrdinaire on Lake Street. We were the
only white kids in there. He was blind and played two horns at the
same time.

More Concerts

Rod Stewart and the Faces (the Labor Temple)
Tony Williams Lifetime with Jack Bruce, John McLaughlin,
 Larry Young (same)
Traffic (Mpls. Auditorium)

The Who (ditto)
The Mothers of Invention, with Aynsley Dunbar and
 Jeff Simmons (Guthrie)
Blodwyn Pig (The Depot)

Likes
Robin Hood and his Merry Men
Count Felix von Luckner, the Sea Devil
Ghost stories
Tarzan
Procul Harum
Nipples
Dracula
King Crimson
The Nice
Richard Halliburton
Flash Gordon
The Shadow
Paul Butterfield Band
Zap Comix
Larry Coryell
Laura Nyro
Fu Manchu
Terry Reid
Free
Susannah York
LeRoi Jones
Soft Machine

Summer Vacation

Riding on Tommy Haskells's dad's cabin cruiser on Lake Minnetonka. I lie on the prow, stoned on the good grass he got from those hoods at Excelsior Amusement Park. Endless shoreline projection, green and gray. Stereo booms Hendrix on the lake. *Axis: Bold as Love.* The boathouse is our HQ. Sometimes we sit in there and watch the rain. Listen to thunder. Someone brought a cute girl with wire-rims and a gray velvet bikini. I loved her! She swam under my legs. It's all in a dream.

In the past three days, my mother has discovered . . . my roach clip . . . my pack of Pall Malls . . . a paperback entitled *Drive-In Nympho.* I told her I smoke dope. We really haven't talked much lately. I always have something to hide. Forced into a double life. Mom said she found my sleepover pal, Tommy, "in a condition that couldn't have been *more* zonked out!" True enough, we smoke marijuana three or four times a weekday.

· · ·

I'm going to summer school at the Minneapolis College of Art and Design. My past knowledge doesn't count for much. I'm in a new pool with a bunch of strange kids, all the best in their class. My teacher had a band in San Francisco called Fifty Foot Hose. He wired the Merry Pranksters' bus! He says I look like Stevie Winwood (one of my favorite English rock stars). He urges me to talk in stream of consciousness. That comes rather naturally. They are trying to teach us to express our personality in line and paint. But some of these yokels have no personality to translate. You gotta *live* your art. Go to where the extremes lead you. That's my credo.

After school we sometimes meet at a little secluded park in Kenwood called 7 Pools. Me and the boys sometimes call it "the Palace of

Piss" because it's the first thing we do on arrival, unzip and perform
"circulars" or "swordfights." We can hear the symphony of a distant
train coming to a halt. Screech.

I'm ushering at the Guthrie Theater. The Mothers play. There's a
party for them after at Sue Weill's modernist house. Flo and Eddie
(backup singers, used to be in the Turtles) ask if I've got any weed. I
do, so we retire to the garage to toke up. Zappa disapproves of drugs,
so they gotta be careful. Back inside, harpist Tony Glover looks men-
acing. Spider John Koerner comes in looking dazed, bony shoulders
up high. Aynsley Dunbar asks me why there is tape on my fingers.
"'Cause I'm a drummer, like you!" We talk drums.

A fellow usher tells me he flunked his draft physical by putting
peanut butter up his ass, and snacking on it as he stood in the line.
Offered some to the man in charge. 4-F baby!

. . .

Been hanging around with an art-school girl with the poetic name
of Robin. A Pre-Raphaelite from St. Paul. Kind of Greek goddessy.
Almond eyes, hooded eyelids. A long, tangled mass of Medusa-like
brown hair. She wears minuscule wide-wale beige shorts and tight
T-shirt tops. We went skinny-dipping off the boathouse, both very
shy. We peeked at each other. Her upper lip curls, her eyes flash all
over my face. She's coy and naturally loony. She says she's afraid to
get too attached to me because I might leave. We go to Lake of the
Isles one summer night, lie under the trees and finally start to ini-
tiate the heavy-petting part of the deal. Five-finger shuffle. Eager,
hungry, moaning, sighing, hot breath in my ear. I was messing with
her peach T-shirt and the tits inside. Sliding my hand into her cut-
offs, where there is a multitude of hair. Now I can smell her natural
fragrance on my fingers. But she keeps freaking out, saying, "What
are you doing!?!" and bursting into screams and sobs. I try to soothe
her, but she's kind of nuts.

New York City Trip

I flew to NYC to visit my sister, who lives above Uncle Hugo's bar on Columbus Avenue. She's working for Houghton Mifflin. Tommy is in NYC too, staying with his beautiful blond older sister, Ellie, who I first got high with, who always knew what was cool before we did. She reads my horoscope. She says I'm a perfectionist at lovemaking, friendly at it. I look for cleanliness and modesty in a woman (she says). Only a natural woman will do. She's into cocaine and Tantric sex now with some mysterious older guru guy.

Tommy and I go see Charles Mingus at Top of the Gate on Bleecker Street. Take the subway back uptown. Smoke pot in the nighttime park we have been warned against. A gang of Puerto Ricans stop in the gully below us. Danger! I put the joint out with spit. We are quiet. They are listening, looking for intruders in their domain. They sense us, smell the lingering pot, but cannot find us in the darkness.

Our hearts pound. To be discovered would mean sudden death, we'd been told. They finally moved on, and we scrambled over the wall to the relative safety of Central Park West.

Holly and I took the bus to Newport to visit her husband, Barrs. We passed right through Harlem, and I spied Smalls Paradise from the window. I love New York.

Meanwhile, Tommy got robbed. I went to the Museum of Modern Art, and liked Pavel Tchelitchew's *Hide-and-Seek*. Plus Kirchner's *Street, Dresden*. I met a fashion model named Penny who asked where I was from. "Minnesota," I replied shyly. "Is that in the United States?" She also asked if I was a leg or breast man. She asked if I was a writer and I thought for a while and said yes, and she said, "If you had said no I wouldn't have believed you."

Also an impeccably dressed forty-year-old Frenchman took me under his wing and bought me a coffee at Zum Zum. He told me about coming here with an older woman who looked up at the sau-

sages hanging from the ceiling and said, "I wish my husband had one of those." He gave me his card. They sure carry on in this city.

I had a college interview at Bard today. Was picked up at the Rhinecliff train station by a hippie on a motorcycle, who told me he wasn't really a freak. I told the Bard interviewer that I tied buildings up with string (a lie). He seemed impressed. Bard was all very green and ivy covered. Perched on a cliff over the mighty Hudson.

August 6th. Went to an all-day rock show at Shea Stadium. Paul Butterfield, Al Kooper, the Rascals, Janis Joplin, Johnny Winter, etc.

I also went to the Fillmore East, that hallowed hall where history has been made. Loved the long-haired ushers in their green baseball jerseys. Saw Brian Auger with Julie Driscoll and the headliners, Steppenwolf. The bass player, Nick St. Nicholas, wore bunny ears and a jock strap. Period. I was most impressed.

My last night, Holly let me venture to Seventieth and Amsterdam Avenue, to a basement rock club called Ungano's, whose ads I had perused in the alternative press, like *Cheetah, Eye, Creem, Crawdaddy,* and *Ramparts.* I knew the Stooges had played there. Inside it was covered with industrial gray carpet, and the clientele was indeed fabulous. The openers, Chicken Shack, were a first-rate British blues ensemble, led by the charismatic and self-effacing Stan Webb, he of the fast fingers and foghorn voice. The headliners were the Tony Williams Lifetime, with Jack Bruce, John McLaughlin, and Larry Young. Tony sat behind his set of yellow drums and produced polyrhythms that seemed truly impossible. Each of his limbs had a mind of its own, and he sang plaintively over the top, as if it wasn't him that was creating the percussive thunder underneath. I remember reading a *Downbeat* interview with him where he was asked why Miles Davis hired him when he was only seventeen. "Because I was that good," he replied. When asked why he left that famous quintet to form his own group when he was twenty-four, he replied again, "Because I am that good." He is the epitome of cool.

Back in Minneapolis. Just heard Honey Sullivan is pregnant from her jailbird boyfriend, who's behind bars again. Only sixteen, just a baby herself. She wanted us to stay together, to run away on a Greyhound bus, but I knew I had a bright future in front of me, and she didn't. I dreamt of her at a train station in a green dress, green tights, and little black waitress shoes. I was amazed at her beauty, her innocent strength, her uplifted chin. I was trying to get her to look into my eyes, trying to embrace her, to keep her forever. But she was crying.

August 21. I turned eighteen.

Mom left an article on my desk, about how "pot makes people reckless and your child will come home injured." When I saw it I had a fresh fat lip from some pot-induced shenanigans.

. . .

My biggest (and last) LSD trip ever.

I bought a tab from an usher I work with. He told me it was special, to take it alone, in the country, and to focus on positive thinking and mind over matter. I assured him I was a "head," no stranger to psychedelics, having tripped over fifty times. He said *this* acid was made by monks on a mountaintop, and would give me the third eye of awareness. "Don't underestimate the power of this pill!" he cautioned.

So, Sunday I drive my mom's navy blue Opel wagon out to Hidden Valley, park the car, walk through the concrete tunnel to the magical bowl within. The drug was coming on real strong. Maybe that freak was right. On the crest of the cliff I could see King Arthur and his knights galloping along, followed by two brontosauruses. I bowed my head and slipped into the depths of time/no time. All the sounds around seemed to have a new meaning. My mind unwound itself, filters *off*! I could dream an elaborate dream in seconds flat,

multidimensional brain films that seemed to take hours but only took minutes. I kept looking at my watch to try to gauge what the hell was going on. Walking through purple reeds and green shoots. I crouch, background becomes foreground, fractured Kathmandu. Sky hauling. Wave after wave of overheated scenarios wash over me. The answer to it all is everything is invading! Petula Clark flashes before my spiral eyes. Crickets talk about septic envelopments. Carol Lynley smiles down from a cloud. Everything is everything. Time doesn't exist. The back of my mind has shifted to the front. The duality of things. Whiz bang!

I decided I'd better cool it down, so sat down in a creek bed. Then I felt the heartbeat of the earth, slowly at first, then gaining. Mother Earth! She is a woman! Our beats were in sync. I started to get turned on. The sun shining down, the planet undulating beneath me. I had a full-on erection. Nothing would do but to unzip my jeans, roll over on my front, dig a little womb in the mud, and slip it in. This I did. I began to fuck the earth, and lo and behold, the earth began to fuck back, rockin' this way and that. I'm taking cues from the swelling ground beneath me, enveloping me with her goodness. Why had I never tried this before? I ground down into her welcoming core one last time, and had a shuddering ejaculation.

I rested in the pulsing afterglow . . . then, realizing what I had done, pulled out, and looked at my little mud cunt, with the sad deposit of my pearly seed within. Looked at my scraped, dirty cock. "You've gone mad!" I thought. "Get it together, Dunc."

Then I tried to scale a cliff. Using positive thinking: "I can I can I can." Bad idea. I couldn't. Almost killed myself. I drifted from the bottom of the sea, to the bottom of time, to the bottom of pleasure. Sound turned into color, perceptions intermingling. I could taste shapes. Synesthesia.

I walked up the valley slopes till the whole greenness was in front of

me. There was a moving speck in the distance. It was headed toward me. It was human. It was a grubby sixteen-year-old pimpled farm boy with no chin and buck teeth. He wore an aquamarine T-shirt with white trim. As he ascended the hill, he eyed me with some trepidation. Here I was, badly sunburned, in a filthy white shirt, eyes as big as saucers, all by myself in the middle of nowhere. He said, "Hey, man, whatcha doin'?"

"You don't wanna know, son," I thought to myself.

He sat by me and gave me some cheap sweet wine from a jug he carried. I lit up a joint and passed it to him, and we began to talk. He was depressed because of women, he explained. He had a shaky hand (he showed me) and when girls asked him what's with his hand, he says it's cuz he's horny for them. That wasn't going over too well with the ladies. I gave him some sage advice. I was beginning to feel a little more my old self, thanks to this cretin. We smoked another, drank some more of the putrid wine. Then I realized I had to work tonight, for a Leon Russell concert at the Guthrie! I had to be there in an hour! The whole day had whizzed by! We bid our farewells, and I descended down the valley, past the creek bed I fucked (pregnant now with a small planet?), and into the tunnel that would lead me to my car.

Could I drive? I had no depth perception and kept getting mesmerized by the least little thing. Mind over matter, that's what the man said. I began my journey from Eden into the big, bad city. I had to avoid getting transfixed by the beauty of taillights. Red stop lights . . . green go lights, top lights, back lights, night lights. Had to remind myself that I was moving at 60 mph in a current of steel and aluminum and that it was occasionally important to slow down or even stop. Sometimes a car horn would alert me to the fact that I wasn't really obeying the traffic laws to a T.

Miraculously enough, I made it to the theater, but when my co-

workers caught a look at me, their jaws dropped. Was it my third eye? Had it appeared in the middle of my forehead? No, it wasn't that. It was the fact that I looked completely off my head, dirty, sweaty, red-faced, generally insane. My boss shook his head and just muttered the word "Hannah . . ." Unfortunately I got aisle 3 that night, the biggest aisle, which meant I had to seat 150 people. They would approach me and hold out their tickets, small bits of cardboard, colored either rose or sea-foam green. These tickets had black numbers on them (which crawled like ants when you looked at them long enough) having some relation to what I was meant to do with them. I couldn't always comprehend what, exactly. But then (mind over matter, positive thinking) I'd snap to, and say "Follow me, please" and lope (or maybe stumble) down the aisle to the correct row. I could hear the people behind me say: "What's the matter with him?" "I don't know, but it's scary . . . he's like a ghost." I thought, "It's only me, it's only dumb ol' Duncan." This drug was almost impossible to "maintain" on. It had been nine hours already, and I was still peaking, I'd had enough.

The music was another surprise. I couldn't handle the sound of an electric guitar. It sounded like the vicious whine of a table saw in shop class, slicing right through my poor overtaxed brain. After the show I went by myself up to a vacant lot in Kenwood, where I smoked joint after joint of cheap weed, hoping to change the nature of my high from chemical to organic. I didn't get much sleep that night, and the next day in school I noticed the persistent feeling that someone was scratching the inside of my (hollow) eyeball with their fingernail. I could even hear a *scritch scritch scritch*. This unpleasant sensation lasted about six weeks. That was my last acid trip.

· · ·

So . . . clear my head.

Five years ago "Satisfaction" was the number-one song on the AM dial, blaring from every transistor radio across the country. I remem-

ber hearing its sinister tones wafting over the Minnekahda Club pool. Today I'm going apeshit over Iggy and the Stooges' new album, *Fun House.* "Down on the street . . . I'm lost in love. . . ."

. . .

I can't get into the teen spirit of the Hopkins High pep rally. Purple Power! Youth Fever! Sieg heil! School is intended to prepare us for a life of submission. Dead wasted energy in high school. Makes me sick.

I put out a comic book with some other freaks that is sold in the hallways for a dime. *The Daily Planet.* My mom gets a call from a concerned parent who'd said she'd already had enough trouble with her son without this pornography inciting him to take drugs. She said countless other parents were up in arms. They were going to see that it stopped. The lady asks my mom if she knew what I was putting out. "Yes, but my son is a very, very nice boy and has a great deal of artistic talent." Lady on the phone said I had to be on drugs to do the awful things to her son that I did. (*In a comic book!?!?*) Mom's scared and shaking. Poor dear. She weakens and tells me I'm missing out on the best years of my life.

But meanwhile, my art teacher, Vern, says I've got it, just do it harder, that I'm on the verge of greatness. So . . . I've been making a six-foot-tall papier-mâché sculpture of a sax player with a diving helmet on his head. Vern says I *must* devote myself to art, carry a sketchbook everywhere.

September 20. Jimi Hendrix od'd in a London hotel room two days ago. He is dead. I remember soaring through the stratosphere with him in the headphones one night in a friend's basement on some pretty strong acid . . . realized the music was made for this. Space music. Whipping through the galaxies at warp speed. "You got me

floatin'." Saw him a couple times at the Auditorium, found him a bit clownish but he sure could play that guitar.

More Concerts
Savoy Brown
Poco
Johnny Winter And (with Rick Derringer)
Youngbloods
Grateful Dead
Elton John
Eddie Harris
Flying Burrito Brothers
Faces (with Rod Stewart)
John Sebastian
Leo Kottke
Neil Young
Al Kooper
Taj Mahal
Elvin Jones

I check in in homeroom each morning before walking across the golf course back home again. The joys of "modular scheduling," which basically means I don't have to spend much time in school. I usually have the house to myself as Dad is downtown being a corporate lawyer and Mom is off being an interior decorator. Anyhow, at nine a.m., I sit behind Laurie Gold, who is a heavy-lidded, slim Jewish girl with velvet pants and no bra. A spoiled and sultry rock chick whose dad owns a chain of food stores. She drives a Camaro and always has good hash. She's continually looking down to see if her tits are arranged right, then moistening her lips. We have sex together once in a while, but I don't see her as girlfriend material. She's got a phony way about her. She's a real snob and looks down on

all these high-school jocks and squares. Except me. I'm the chosen
one . . . She says she cares about me but I'm impossible to communi-
cate with. She says I have highly developed intuitive skills, including
ESP!

"Why don't you come over and treat me like a whore," she whis-
pers over my desk, then giggles. "My parents are in Florida, and I've
got some good weed." She's on the Pill. Wants to get some use out
of it. It's very tempting, but I have a hard time objectifying girls that
I basically don't like very much. And afterwards I'm stuck with her.
I'm often telling her that she and I don't mix, we're too different. She
doesn't argue the fact, but never gives up. Says she is "a silly little
girl." So after spending a sleepless Friday night thinking about how
there is a real, live, naked teenage girl not five minutes away, I suc-
cumb to my base desires, get up early, drive over there, and ring the
doorbell. She answers in a white robe that's open all the way down,
heavy with sleep. Slutty and pleased that her honey trap has worked.
We headed straight for the living room couch, where she straddled
me. Mixed emotions.

Janis Joplin was found dead this morning. I got high with her and
Big Brother when they played the Guthrie. Brought a couple buck-
ets of Kentucky Fried Chicken to their dressing room. They were so
skanky. The boys said, "Look, Janis, your chicken is here!," all laugh-
ing at the sweet young fellow in his blue blazer and gray flannel uni-
form. Janis's eyes were dancing all over me, smackin' her lips at the
meal before her—*me*! She was playin' the horny chicken hawk, swig-
ging from a bottle of Jack Daniel's, making rude remarks. Nobody
touched the chicken, but we stood in a circle in the cramped quarters
and passed a joint around. I was trying to act cool, but the dope was
so strong that I came out of some kind of time warp to see that they
were all laughing at me as if I were a choirboy they had just cor-
rupted. She came over and comforted me, smelling of patchouli oil,
her feather boa tickling my nose. I blushed. I felt like a real hayseed.

Fifteen minutes later she was on stage, stamping her foot, sweating, screaming. I thought she was tragic even then. Saw her over a year later without Big Brother, liked her even less. Too much angst. Gone now.

Girls: Where is my loony rock 'n' roll queen? I scour the yellow-tiled school hallways filled with zombie vibes looking for my soulmate. I need some more carnal knowledge. It's November, time for indoor games. I saw *Performance*, so I want someone like Anita Pallenberg, or Genevieve Waite or Susannah York or Monica Vitti. There's a girl in my theater class named Rachel who's cool, but she's got a boyfriend already. Although once she did pull me into the dark maroon velvet folds of the stage curtain and we made out for a minute or two. She's got a dark mane of hair and interesting eyebrows, braless tight T-shirts and hip-huggers, high-heel leather boots. A vixen for sure. Haughty attitude. Our teacher is a wire-rimmed liberal who plays with his beard constantly. Always yakking about Ionesco and the experimental theater. Us kids write a nonsense play called *Cincinnati World's Fair 1936* that came out of improv. Totally stupid, but our teacher twiddles his beard and stares at us intently like it's genius. He has a great investment in being "with it." He's a creep.

· · ·

Albert Ayler drowned this week.

College entrance forms hanging over my head. Hampshire, Boston University, and Bard. I write an essay for the applications on the good and the bad in me. I write a book review of *Slaughterhouse-Five*.

I'm writing these journals to capture my youth. When I'm fifty in an easy chair in Scotland I can pull them out and relive my teendom. It'll be in an archaic lingo.

I'd like to fulfill a dream and become a pop star, but I can't sing!

. . .

Met a girl called Angie Miller who goes to Minnetonka. She's little. Ninety-eight pounds. Flirty. Ran into her at some countercultural festival and she took my hand and said, "Where do we go now, Funny?" Cute. Still a virgin. Looks like Minnie Mouse. Clucks her tongue a lot. Eats "sammies." We go to *2001*. Even better, we go to *Borsalino*. Marseilles, 1930. Pin-striped gangsters. Belmondo and Delon. Great soundtrack.

The *I-Ching* says I will go through a lot of changes and will eventually be very successful, with riches both spiritual and otherwise. It warned me to not let that go to my head, to keep it simple. Says I always have a thing with identity.

Astrologically speaking, I'm on the cusp between Leo and Virgo, with Pisces rising. My numerology number is 7, and my color is green. I don't know what any of that means.

Meanwhile, my new girlfriend's passivity and virginity is wearing me down. We're at a party at Archie Cosgrove's parents' mansion (his dad is governor or something, which is weird because Archie is like a werewolf, always *so* stoned and wanting nothing more than a bowl of Rice Krispies). Angie is there, in white majorette boots, a little girl's blouse with tiny flowers all over it, a red Eisenhower jacket with a fur collar, and black corduroy pants. My imagination plays around in her pants. Angie leads me away to the bowels of the mansion, sits me down on a bay window seat, moonlight on her face. Pulls me to her, all swoony-like, eager for that thing I do with her musky black patch. It's fun, but it's a one-way street.

Another time, at Archie's parents' horse farm, we were drinking Bacardi rum in the fancy sunken living room, and someone had an archaic stag movie that he projected onto the wall. No women! Just nude men and their dicks, jouncing on bongo boards . . . all sorts of

dicks, circumcised, uncircumcised, Negroid, Caucasian, skin-tight erections, culminating in a super close-up of a fly walking across the purple head of a penis (taking his time, too). A drop of semen appears. Totally gross and confusing to this group of entitled youth on the brink of manhood. We all spent the night, smoking and drinking and listening to Tim Buckley. In the morning we were still fucked up, so we talked to the horses.

· · ·

Listening to the new Velvet Underground LP, *Loaded*. "Then one fine mornin' she hears a New York station / She don't *believe* what she heard at all . . . hey, not at all." Also, the Zombies' *Odessey and Oracle* is fantastic. Such a rich wealth of music coming out. It's where we get our messages, our subversive directions. It's the soundtrack to our lives. The centerpiece to all this action. Ties us all together.

· · ·

My parents left for eleven days. Steady stream of visitors: Angie; hilarious Steve Kramer, pianist, artist, and general absurdist with dangerous tendencies (mostly to himself, crazy feats of derring-do, like climbing up a wall and hanging from the rafters upside down); and Kurt Thometz, a shaggy beatnik informed by the *Evergreen Review* and Grove Press paperbacks. Miracles came to pass, staying up for days with ganja weed, opium, champagne, angel dust, and super-hash. A big New Year's Eve bash at my parents' shingled Cape Cod–style house attracts loads of freaks who needed a place to go and derange their senses. Ice-cream orgy in the kitchen somehow leaves the Formica countertop burnt. Green cake frosting on ceiling. Some group dancing makes it look like the floor just might cave in. I was in the basement as it started to rain sawdust. Uh-oh. Angie and I go outside in the freezing moonlight to see if the earth is tremoring. I had to talk some guy down from a bad LSD trip with my cosmic homilies.

Kids were storing their cheap hippie wine in the snowbanks out-side to chill for later consumption. "Can this happen, is it all right?" my cousin Swanny asks me. "This is *us!*" yells Kramer, having some kind of revelation. "Let the giant out!" he bellows. Someone gives me a gas mask and a white lace hat. Gershwin's "Funny Face" is boom-ing from the big KLH speakers. At midnight everyone congregates in the living room to see what's next, they nosedive into a hog pile of writhing flesh screaming "I LOVE YOU!" A mangy collection of electrified, reeling, bug-eyed loons filled with holy smoke. The house has blasted off! Steve Brooks looking like Martha Washington in a surgeon's drawstring pants with one rain boot and one after-ski boot, in love with cute Mary Kennedy. Jimmy Clifford has got his hand down Monica Muller's pants. There's a guy unconscious on the pool table. At five in the morning we dress up like old ladies and go to Perkins Pancake House for breakfast, hollow-eyed and covered in kisses.

January 1971. I heard the voice of Mrs. Lovingfoss over my home-room intercom say that I have been nominated to be a Sno-Daze can-didate. *What a hoot!*

Oh no, now it's really happened . . . I *have* been elected Sno-Daze king! My moptop got crowned onstage in the gym. Huge roar of laughter, disbelief, and applause from the student body. Flashbulbs go off—*flash, flash, flash!* Much cheering from the "heads," who have one of their own elected as the wintertime equivalent of homecom-ing king, traditionally given to the captain of the wrestling team. A purple-velvet and faux-ermine cape is put over my tattered Salvation Army shoulders. The queen (a very pretty straight girl I have never noticed before) and I march through the noisy throng, she holding a large bouquet of roses. It was fun, actually, but weird. My parents flipped out, having assumed I was an outcast from society. My cousin

Eisenhower General News

Vol. 1, No. 16 Hopkins Eisenhower February 5, 1971

Congratulations to Our 1971 Sno-Daze King

Prince Mark Jeffries King Duncan Hannah Prince Rob Mason

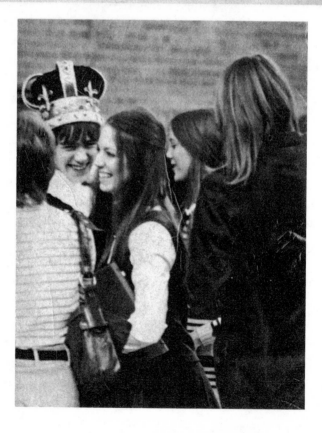

Cynthia said, "No, everyone loves Duncan." There was a photo of me in the school paper looking appropriately wasted in art class, next to the two runners-up, a couple of burly jocks who looked like they could eat me for breakfast . . . and still be hungry. Headlines said, "Congratulations to Our 1971 Sno-Daze King, Duncan Hannah." What a goof! The times, they are a changin'.

Things are heating up with Rachel, the raven-haired temptress from theater class. I sneak cigs with her under the stage. She tells me about an erotic dream she had with me. "When either of us get blue we should comfort each other, don't you think?" she said in the foyer one day, looking very alive with lust. We made out at the cast party for *Cincinnati World's Fair* and she wanted to find an empty bedroom then and there, but like a fool I told her to wait until the others went home and the next thing I knew she was gone. Seize the moment! She's got pale gray eyes like a Siamese cat and hard, wide breasts with permanently erect nipples. She came over after school one day and we had Scotch-and-sodas and grass, listening to a stack of rock records, then made out on my single bed, dry-humping like crazy, but she wouldn't go all the way out of deference to her boyfriend. Our time will come; we're like magnets drawn together.

March 3, 1971. I'm stayin' at Kurt's this week. My parents are in Austria, and I'm not allowed to stay alone anymore after the New Year's Eve party debacle. Use chopsticks for Kurt's brown rice, onions, carrot, and mushroom diet. He wakes me up to give me a mug of honey and cinnamon in warm milk. He says, "Here, this will help you sleep." Quit smokin' butts. Don't brush my teeth, read, draw, write, cut and paste, drive. Listening to Nico a lot. Meet Rachel for secret sexy rendezvous. I smell my fingers. She says, "You sure have a lot of energy, you're always right there."

More Concerts
Captain Beefheart
Ry Cooder
The Grease Band
Savoy Brown
The Faces
Ian and Sylvia
Miles Davis
Allen Ginsberg
Laura Nyro
The Allman Brothers
The Stooges
Mott the Hoople
Emerson, Lake and Palmer
J. Geils Band
Johnny Winter And
John Mayall

Magazines say the seventies are gonna be about nostalgia. There's still a war we're waging in Vietnam. I'm not proud to be an American.

. . .

I've been accepted to Bard College, Annandale on Hudson, so it's the East Coast for me next fall. I'll put myself in odd situations. I won't avoid challenges, I will uncover my true grit. I'll exhaust my resources and keep pushing through. I will embrace imperfection (something I find myself thinking about a lot). Fantasies about who I am and what I want may not be true. What is innately "me" will come naturally.

I've been reading D. H. Lawrence lately. Saw *Women in Love* for the second time. I like the end where Alan Bates is living in a small stone cottage by a river with his blond lover, catching fish for their supper. Aspirational.

An Evening with Allen Ginsberg

Driving down Highway 12 on my way to the Guthrie Theater I have a premonition that something big is going to happen tonight. Allen Ginsberg himself! Kerouac's best friend and international ambassador for the Beat Generation (which is currently meaning more to me than this bogus Aquarian Age I find myself in). There he is, doing a sound check, dressed in faded blue slip-on boat shoes, new baggy Levi's, a blue work shirt, a cheap early flower-power wide pink-and-marigold tie, and a red lumberjack jacket. A beatnik!

I'm working the show, so I seat the people, the beret crowd, college kids, plus a lot of English teachers and poet types. I crouch near the foot of the stage, below his podium. Ginsberg's playing his harmonium, it's wheezing away. He uses a different voice for each poem. Pushes his black-framed glasses up his nose. Shakes his big yoga belly. Swings his curly black ringlets to the ceiling. His Blakean songs, his CIA conspiracies, his ganja-weed references. Then he recites the Whitmanesque "Please Master," his childlike ode to homosexual love. He looks down at me and chants it into my wide eyes, like a hypnotist. It's all about teenage bellies and innocent man-boy love, softly spoken in his faint New Jersey accent. "Please master, make me say Please master fuck me now . . ." And then it's over and he's beaming at me, and I was quite turned on by his sweet brazenness. There is a silence, a tittering of applause, then resounding applause.

Intermission. Some of the straights left.

Part two: More William Blake songs. Ginsberg is fantastic, mesmerizing. Then the show is over. I climb up on the octagonal stage where the Great Man is talking with radicals and poets and people who are going to modern schools in Switzerland. He looks up at me and puts his arm around my waist and says, "Hello, what's your name?"

"Duncan."

"I saw you in the shadows and thought you were too good to be true." He is hustled away by some serious people, leaving me grinning at the fairy-tale aspect of the magical night. Kurt (my closest beatnik buddy) and I go backstage and I tell him about Allen's attentions. Kurt says, "He's trying to pick you up!" Then we run into Allen, who's trying to escape his fans. He asks us how to get to the greenroom.

"C'mon, we"ll show ya," and he follows us up a gray stairwell, carrying a worn leather attaché case full of poems. He says, "What are you two guys up to, anyhow?"

"We're just a couple of high-school kids," I say.

"How do you know where the greenroom is?"

"Cuz we work here," I say, looking back at him on the stairs.

He's staring at me in an intense way and says, "You're *too* beautiful, you know that? I suppose everyone tells you that."

I smile and shake my head no.

"Really, you're *too* beautiful."

"You're the beautiful one," I say, and poke him in the stomach.

In the greenroom he asks if I want to go to a party. "I don't think I can," I said, it being a school night and all.

"Well, come if you can," he says, sitting down into a full lotus position, about to give a press conference.

Kurt and I adjourn into a corner by the vending machines. "Kurt, what do I do now?!?" I'm in his love spell. He *is* the king of the beats and I am his designated crush. I watch his press conference in rapture. I was meant to give a bunch of guys rides home, but I couldn't tear myself away from those beautiful vibes. He's telling a story about Bill Burroughs, now in England, who is making funny anti-marijuana advertisements. A mad scientist with a huge hypo injects pure cannabis into a buckled-down pregnant rat. The needle is so big that it pops the rat's stomach, blood everywhere. "See, that's what happens," Burroughs says in his expressionless voice.

Allen is trying to drag himself away from the questioning people. He's still talking to someone as he pauses at a table and writes something on an eight-by-five index card. When he finally extricates himself, he comes over and puts his arm around me, gives me the card, says, "Here's where I'll be, then afterwards at the Gay Liberation Front . . . if you can make it."

I say, "It sure was nice to see you."

Allen says, "It was *divine* to see you, Duncan."

Now we're at the exit. I give a little Hindu bow and say, "Goodbye."

He bows double-deep and says, "Shalom."

That was it. I didn't go. Even though I wanted to. I wanted more Allen, but not the kind that I was sure would be on offer. I could've told him about the animated short I was drawing based on "Howl." I could have given him a copy of my newest comic, *Lip Balm Comix*. I could have asked him questions about *Desolation Angels*. But that's not what he would have been interested in. I recognized in his gaze the same look of infatuation that I too get, when faced with someone whose beauty speaks to me in a personal way . . . as if you're witnessing some kind of miracle. Even tonight, in the audience, I saw Lisa Friedman, who I've met once, and fell instantly head over heels for. Too tongue-tied to even talk to her, dazzled by her looks. So I knew what Allen was feeling, although he was much more forward than me. I bet his seduction success rate is pretty high. I'm sure our paths will cross again.

· · ·

Angie, the Virgin Girlfriend, continued:

She's pushing her body against me in a dark bathroom at a friend's house. We move to a bedroom, also dark. "Let's get naked," I whisper, unbuttoning her blouse.

"Well . . . what if someone comes in and finds us flopping around like a couple of fishes?" "Then it will be funny," I reply. "Besides,

we should be able to do anything together, and this stands between us. We could have done it all winter. If we do it, you won't feel so nervous about it anymore. And it'll be so much fun! We'll be like Indians!"

"Well, you'd have to stay with me . . . all night. I couldn't go home alone. You'd have to be there."

Her back is arched over my lap, pulling me so hard against her mouth that it clicks. She shudders as I stroke my fingers over her dark triangle. No deflowering tonight.

. . .

Back at the Guthrie for a Sunday-night concert, Emerson, Lake and Palmer. Getting there early, I can hear them doing their sound check. Running down the back stairway listening to the fantastic, majestic Emersonian organ. There he is in black, with his Prince Valiant haircut, with a colossal array of keyboards, piano, two organs, an electric harpsichord, a Moog, a theremin. They're laughing, jamming. To an audience of one . . . me. It's like being in a baroque rock cathedral. What a rush. At the show Keith plays pirate, sticks daggers in his organ. He's like a sexy Phantom of the Opera. When it was all over, I was leaving, passed by the stage. Keith Emerson was alone, playing the piano. I said, "Good night." He looked up and said, "Yeah, man," and grinned.

. . .

My dad says, generously, "Holly did everything by the book—good grades, married a Harvard man, and all the rest—and you know, it's kind of boring. You, on the other hand, give me some vicarious excitement. I wanted you to be Ivy League and go to law school and become president of United Airlines. But you had these special talents that I don't understand. You shouldn't waste them. Either you're going to be a great success or a miserable failure."

. . .

I read "Jabberwocky" by Lewis Carroll, inspiring nonsense prose. I was writing tons of stream of consciousness in the winter, squeezing my brain out like a sponge. Now I have *Breathless* to show for it, my self-published comic book. Conceived with hashish, scrambled memories, and a Rapidograph pen.

. . .

I remember my adolescent boys' school friend Henry See. His parents were rich (advertising). His glamorous mom had been on the cover of *Life*. Henry had braces. We were boxing partners (compulsory). He lived in a big house on Lake Minnetonka, and we used to swim there with his two younger sisters. We learned all the capitals of South America at the lunch table (cherry tomatoes). They were all Catholics. I often slept over on Saturday nights, huddled in sleeping bags in the basement telling ghost stories. They'd leave me alone on Sunday morning when they went to Mass. I'd go through the junk drawers, watch their color TV (the first I'd seen, distorted Day-Glo), play Henry's records (the Animals, the Lovin' Spoonful, Herman's Hermits, Beatles, Stones, Dylan). We played spy, Henry was 008 and I was 006. Henry had watched his cousin make out on the couch and had checked for pubic hairs the following morning. Henry was brilliant, but a crybaby. He had freckles like Alfalfa and a pudding-bowl haircut. Wore glasses. Was much smarter than me. I just got a letter from him from Montreal (where he now lives). He says people are androids and he doesn't associate with androids.

Henry and I had gone to Miss Mayhew's dancing school together. I wore Royal Lyme cologne. Danced a slow dance with prematurely busty Alice Kaplan to the Box Tops' "Neon Rainbow" and got a boner that I tried to hide from her. She was well aware of my condition and seemed to nestle right into it. Erotic bliss!

. . .

There's a fancy party at the new Walker Art Center which I've been hired to work at. Leo Kottke is the entertainment. After some gorgeous acoustic guitar instrumentals, he is blabbing to the guests about a diagram of a sperm cell he studied. Then says, "Excuse me, but I'm gonna take a break for about half an hour to get something to eat, cuz if I don't, I'm gonna be drunk for the rest of my life."

. . .

The Minnetonka Prom. All our girlfriends are graduating. Pre-prom party at my house. Cold Duck, grass, wine, Scotch, and Colt 45 malt liquor. We're listening to Ruben and the Jets to get in the mood. As for corsages, Tommy's got a lilac branch for Mary. I've got some wild-flowers in a rubber band for Angie. Kramer's got a log for Lainie. We set off in my mom's station wagon. Lainie's already ripped her dress, Kramer's already stained his white tuxedo. He's puking out the back window as we're speeding down Highway 7 on our way to the country club. Then he's gone. Where'd he go? He's on the roof of the car! Tommy climbs out to get him down. Lainie is crying because her boyfriend is crazy. So is she. Then she goes out the window to get him. All this at 50 mph. They get him back in but he's out again, this time dragging behind, ripping his knees out. I stop. We piss. Kramer casually says he's got suicidal thoughts. Finally we get to the Lafayette Club and park. Kramer immediately disappears.

Angie and I go into the lobby, trying to walk in a straight line. An official stops me. "Okay, let's see your breath," he says.

"Huh?"

"Let's see your breath."

I've got peppermint Certs in my mouth, so I blow at him.

"Okay, you better come in the office."

The high-school principal, Mr. Brominschinkel, says, "What have we got here?"

"Drinking."

"What did you have?"

Looking him in the eye I say, "I had a beer about two hours ago. I feel fine."

"Well, the rules are *blah blah blah*," says the principal. The police are called in, they call my father to pick me up. When he arrives, he greets me by saying, "Hello, criminal." A very solemn ride home. We have to return the next day to pick up the car. All for a stupid prom that was supposed to be a goof in the first place. Brother!

I break up with Angie. Big drama.

· · ·

Back at school after another wild weekend. Keg party with a hundred crazies. Busted by a helicopter. Pushin' too hard. Feeling schizo. Snort some speed. Burn out my nose. My cock shrinks to the size of a peanut. Talk to my new pal Crosby about everything under the sun, about sex drives and nudism and Terence Stamp and gold-slipper suburbia and Black Jack chewing gum and psychotic theater and Fleetwood Mac. My fantasies sometimes don't click with my true self, which causes opposition. But I'm about to leave to spend the summer with my sister in Naples. Her husband is in the Navy, stationed on the USS *Cascade*. Should be an eye opener.

CAT FOOD

June 1971. Frankfurt, Germany. Got a layover, staying in a brand-new germ-proof high-rise hotel. Outside, body odor and bratwurst. Sex supermarkets with brightly colored rubber ticklers in the window. Photo of a girl in bed with a pig. She's holding the pig's long, pencil-thin pink thing. Germans! I spent the afternoon at the zoo, mostly at the baby-chimp cage. So human. Fingers in their mouth like they're thinkin'. Giving me that "Why are you lookin' at me?" look. There's a masturbating chimp. A street-fighting chimp. I buy some postcards of chimps. Drink big glasses of beer and eat a sausage sandwich.

Naples. Italy is everything I ever thought about Italy, except magnified a hundred times. Very like the Mastroianni-Loren movies I'd seen. Little changed since World War II. My sister's elegant, marble-floored, high-ceiling apartment overlooks the Bay of Naples. Three balconies. Rent is cheap because locals say it's haunted. It's not. The view is of the orange cubist roofs, palm trees, the blue Mediterranean. The top surface of Naples bristles with TV antennas. Tiny Fiats beep their shrill beeps. A lit-up gondola climbs Vesuvius in the distance. I love it. I feel exalted, elated, intoxicated. I am, in fact. Whiskey, wine, and beer are cheaper than Coca-Cola at the PX. Streets smell of French cigarettes. The men wear tight pants and open shirts and ogle my sister's bust and derriere. Fat ol' toothless mamas yell at kamikaze Fiats, lots of hand gestures. Stop lights don't mean anything. Honking is for honking's sake. Sandaled children off to church. I bought five pairs of continental-style shoes for ten bucks

down at the market. A ragamuffin kid rattles clear plates to show how unbreakable they are. Roosters rush past on the cobblestones. I love the girls with their fleecy armpit hair. There are fish markets on the sidewalk full of huge sideswiped swordfish, dry and gray on the outside (flies buzzing around) and peachy pink and moist on the inside. Buckets of squid and octopus. A tripe stand. A medieval cart with an enormous hippopotamus head sticking up. For real. Whiskered nostrils, little gray ears. Stolen from the zoo? Sold to make soup? Surreal. The tobacco shops carry tobacco, salt, shoelaces, and auto parts. On New Year's Eve, at the stroke of midnight, Neapolitans throw their garbage out the window.

There's a walk I often take from the top of the hill we live on down to the port. A long, narrow alley that is populated by large rats, large enough to challenge me, but it's cool because I know the password. We have christened this "Rat Alley." Past open doorways of afternoon dinners and siestas. Clotheslines hanging overhead with colored cotton garments. Past impromptu kickball games. At the bottom are beggar kids asking for chocolate or cigarettes, their flies held together with safety pins. Old Neapolitans left over from the war, humpbacked, sucked-out, pinch-cheeked, arms in slings, belts cinched tight, limping along cockeyed, cigarettes dangling from their drawn-in mouths. What we like to call "gimpy." Then too there are the breezy, tree-lined avenues, like Paris, with expansive outlooks of the city. Vestiges of a once powerful city. The colors are the best thing of all. Sun-bleached Indian reds, old roses, mustards, terracottas, ivories, and chrome yellows, chipped and worn and scraped.

We go to the NATO beach where international babes are changing in the blinding sun, a trickle of soft black down reaching from their belly buttons to their mottes. We suck on rainbow popsicles called *arcobaleno.* Red is cherry (top), yellow is lemon, orange is orange, etc. Nothing better. Tanned mothers with their crying naked infants. Someone's mom's screaming "Babette! Babette!" It sounds like a

war hospital except for the whooshing of the ocean. The thick-crust coal-oven pizza is delicious. The lifeguard calls me "Signor Ha Ha." Locals call this the Three Swim Beach: the sweaty swim on the drive out here, the swim you take when you're here, and the swim back in your car on the return.

Summer of '71 Reading List
The Hobbit, Tolkien
The Sun Also Rises, Hemingway
A Farewell to Arms, Hemingway
This Side of Paradise, Fitzgerald
The Great Gatsby, Fitzgerald
The Benson Murder Case (S. S. Van Dine's Philo Vance mysteries)
The Gracie Allen Murder Case, S. S. Van Dine
The Ginger Man, Donleavy
The Beastly Beatitudes of Balthazar B., Donleavy
Ada, Nabokov
The Narrative of Arthur Gordon Pym, Poe
Zelda, Milford

• • •

Barrs is on the ship most of the time. It's just me and Holly. She's worried that I'm an alcoholic, because I drink alone, when there's no one to join me. We both smoke Winstons.

Holly and Barrs befriended a family called the Cristianos, headed by Salvatore, a taxi driver. He has twin pigtailed daughters in the third grade, Nunzia and Rosaria. They look like little Italian mice and are total lunatics. They call me "Danke" or "Ta." We go out at night for *arcobalenos,* hand in hand, not being able to talk, but they just laugh at me because they pointed me out in an animal book: a skinny gorilla eating a banana. They find this hysterical. Nunzia says she and I are to be married. I say "*Sì.*" She pulls at my long hair and

says, *"Bellissimo."* She looks at a picture of an orangutan and says *"Mamma mia,* what a brute!" Rosaria has schemes, shakes her finger at me and says *"Attenzione, attenzione!"* I play T. Rex's "Woodland Bop" for them and they dance around the living room, declaring it to be the best thing ever. They try on my hats and shriek with laughter. Nunzia is a natural actress, having studied old movie queens on TV, and repeats their body language as best she can. We dance (me on my knees) and I say, "My love, you dance divinely," and she sighs *"Amore"* and falls back over my arms in true thirties romance fashion. She sings sad love songs at the top of her lungs with open arms. Real anguish!

The huge extended Cristiano family sits around the dinner table at night, everyone screaming and laughing. Dinner is usually eight to midnight. Mamma says, "Long hair—you like Beatles."

"Sì . . . mucho," I reply.

• • •

I sit in the Galleria. Several stories tall, with a vaulted glass roof. An indoor/outdoor atmosphere. Gargoyles are perched up high. Shops line the courtyard, wings shoot off in all directions. Everyone gathers here. I sit at a café with a beer. Happy to watch all the Europeans doing what they do, many doing what I do: watch, look, listen. A schoolboy in a blue uniform leans against a tobacco shop, playing with that wooden ball on a string that makes that infernal clacking noise. A female impersonator, or sex change, tries to pick me up. I keep saying, *"No capeesto, no capeesto,"* as I look up at his badly concealed beard. He went away angry, fake tits 'n' all. I read the *International Herald Tribune.*

June 26. Naples. Returned from Positano. Aquamarine beach with two beautiful bikinis next to me. Navy-blue nipples fresh from the

salty sea. Roman-nosed teenage girls with their arms linked through the crook of their mother's. They have to be in at eight every night. They have nowhere to go, except if a fella's got a car; then they park and steam up the Fiat windows. Virginity is well protected here. The mother-and-the-whore bit. Highly sexed Catholic country. An Italian man always marries a girl ten years his junior. Italy has the worst reputation in Europe. Naples has the worst reputation in Italy. "Florence is the lady of Italy, Rome is the woman, and Naples is the idiot bastard daughter."

July 4. Jim Morrison just died in Paris of a heart attack. Only twenty-seven. I saw him twice at the Minneapolis Auditorium. The first time was fantastic, the Doors transcendent, took me to another world. The second time Morrison was drunk, surly, bearded, bloated, a disappointment.

Barrs's Harvard roommate Mike shows up from teaching English in Japan; he's cool, he's riding his motorcycle across Europe. We bunk together. He says I smile in my sleep. We stay up late drinking liters of local wine and smoking some hash he got at a gas station in Morocco. Watching Vesuvius steam, listening to Soft Machine, *Third.* Perfect.

Mike and I walk up to a scrubby park with clay soil and cropped palms. We're sitting in the shade talking about the cherry bombs of our youth and two girls approach us. They want to take our picture because we look like the Rolling Stones. A crowd gathers to listen to this exchange. The more forward of the two girls is called Tina; she had a ratty shag, dirty feet, and a cold sore on her lip. On the plus side, she had a nice exposed stomach and round tits in a halter that looked fun. She said, "London is very beautiful and so are you." Then she tugged on my hair to see if it's real. She takes off my new tortoiseshell sunglasses and says something about "night, *sì?*" and

"drugga." There are some guys standing around smiling, winking at me, giving me the thumbs up. I pass out cigarettes. One guy told Mike that she was propositioning me, and that she'd already been tried and tested. Wink, wink. She gave me her address, 23 Geronimo something. With some sort of rendezvous I didn't understand. Why did she have to be so grungy? I've got two female admirers, one the neighborhood slut and the other is nine years old.

. . .

Led Zeppelin played in Milan last week and the building caved in.

. . .

I smell garlic and olive oil. Barrs is reading Archibald MacLeish aloud.

. . .

I woke up with the sound of a dogfight in the courtyard below. I had a terrible pain in my chest. I get up and pad barefoot (*flap flap flap*) across the cold marble floor, where I piss and drink some tap water. Went back to my Sunday-morning bed and tried to get back to sleep. No dice. My left lung was popping, gurgling, sputtering, and bubbling. I vowed to never smoke again. I've been lucky so far. When I drew a breath I got a sharp pain.

Next day I played tennis with Mike and it hurt like hell. I'm in bad shape. Holly says we come from a long line of rheumatoid arthritis and muscular dystrophy. I breathed shallowly as I contemplated my early demise. TB? Cancer? My poor seedy lung!

I was meant to go to Capri today with Mike. Mountain climbing and café drinking. Instead I was put on a Navy launch, which brought me out to the USS *Cascade.* Barrs was waiting on deck for me, looking embarrassed. He gave me a little wave and hustled me

to the sick bay, where a doctor x-rayed me and tapped on my chest. Doctor was stumped. No spots detected. Pleurisy, maybe? He gave me pain pills and sent me back to my worried sister.

. . .

Someone asked JFK how he got to be a war hero. He answered, "They sank my boat."

July 26, 1971. My chaste summer continues. I fall back on memories. Girls I've known and girls I wish I'd known. I think back to a day after school in suburbia, the jeweler's daughter letting her expensive sheepskin coat slide to the kitchen floor, landing with a thunk, in a fiction of seduction she picked up in the movies. Kissed her pasty lips. Unzipped her pink turtleneck. She led me to her "little girl / slut" bedroom (her words) with the single bed and white wicker furniture, where she wrapped her flexible and elongated limbs around me as I buried myself in her nonfiction cunt.

. . .

So I devote my time to watercolors and reading. I go outside to prowl the neighborhood. Two luscious girls approaching, swinging their butts, and one alerts the other to my approach, we're getting nearer. What do I do? Ask them to show me around or something? Submit to their open Italian stares? Now we are next to each other and this dazzling creature unexpectedly breaks into a full-faced, lascivious smile that reduces me to a blithering idiot. That was it . . . that was my twenty-second intense romance, struck by Cupid's arrow. And now it's over. I limp into Piazza del Maggia Dore and plop into a chair, order a Pernod, wiping the sweat from my brow. Why am I so devastated by beauty and desire?! The despair of desire. Sigh.

August 1, 1971. Only two weeks left of my Italian summer. I've gained fourteen pounds. I weigh 129. Big fat Naples hit me to my midwestern American soul. The rotten bay smell, the high-rise hairdos, the young magazine vendors, the cappuccinos, the marble statues, the mad beggars, the ratty palm trees. The squares are like stage sets. Families fanning themselves in their plaster sitting rooms lit by the blue glow of their televisions. The parking-lot attendant looks up from his comic book and says, "Hey, English! You wanna buy a watch? I can get you anything."

"I don't want anything. I'm content with what I've got, thanks," and wave. The sound of Ringo Starr's "It Don't Come Easy" wafts from the café jukebox. Squealing tires.

The commodore of the Sixth Fleet lent my brother-in-law his private launch. We were joined by a couple of bearded sailors and two English girls from Brighton they'd met at the USO. I couldn't help but notice that one of the lovelies' pubic hair was bursting from the side of her paisley bikini bottoms. We had a picnic of fried chicken, potato chips, and beer. Lots of beer. Because of the intense heat, you see. The girls were on the foredeck while we men ogled and my sister scowled.

We anchored in a pirate cove off Capri. Very reminiscent of Skull Island in *Peter Pan*. I couldn't believe how perfect this location was. I dove in and swam to some carved sandstone steps on the cliffside and scuttled to the top. Took in the blazing blues of the Mediterranean. Climbed down and put mask and flippers back on. Moseyed about in the clear aquamarine water with little fish, followed them into a tunnel, leading to a round grotto with a small sand beach at the end. Illuminated by the outside sunlight refracted through the water, creating an otherworldly glow. I fantasized about coming to the rescue of pouty-lipped Hayley Mills. A lock of her golden hair falling over one eye. I stayed in my private cave in a state of excitement. When

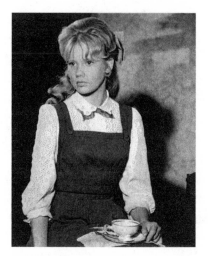

Hayley Mills in Summer Magic

I swam out at last, the sun had begun to drop from the sky, leaving orange streaks. Naples was a washed-out pastel on the horizon.

I read *Candide* in one sitting. I enjoyed the adventure very much. The implied raciness leaves much to the imagination. How does one treat sex? Each in one's own way, I suppose. As the sun and the moon in a celestial master plan? With honor? With lewdness? With grubby-fingered junior-high delight? With wide-eyed never-get-used-to-it wonder?

Then I moved on to Nabokov's *Ada,* which I loved. I remember staying at the Montreux Palace with my parents in the spring of 1967. It was foggy and quiet (off season). There was an older man in the enormous formal breakfast room every morning reading the paper by himself. Was it Nabokov? That's where he lived. I'd like to think it was. That trip I was recovering from a broken leg (ski accident at Vail) and walked with a cane. I wore a brown beret. I was in love with Europe and Jane Fonda and had recently discovered masturbation, of which I had become a great devotee. I remember swimming in the

pool alone, gusts of mist wafting over the chlorinated water. Very moody indeed. I remember thinking that I would never forget this, and I never did.

Bought an excellent LP on pink vinyl, called *Never Never Land* by the Pink Fairies. Their drummer is called Twink. Great anthem called "Do It." Not only are they telling us to do it, they are *doing it*! "Don't think about it / All you gotta do is . . . *do it*! Don't talk about it /All you do is . . . *do it*!" Great riff, great message.

Some old Pope's blood is kept in a phial and is supposed to boil three times a year, and if it doesn't the superstitious Neapolitans get uptight, businesses fail, candle makers don't have the heart to work with tallow anymore, etc. So the new conqueror goes to the local priest and says, "You better make that blood boil, man!" So the priest makes the blood boil and the people say, "Ah, good! The blood boiled!" and go back to their jobs.

Bye bye, Naples!

. . .

Three days in Rome with Holly. Still hot as hell! We sit around various sidewalk cafés drinking cappuccinos (*freddo e caldo*), Pernod, anisette, Chartreuse, Guinness stout, dark German ales, etc. Rome is noisy. Rome is chic. Rome is where Leda and her relationship with a swan is captured in oil and marble over and over. I ran into naughty Pauline Bonaparte reclining on an Egyptian couch in a lovely villa. At night they turn out the lights and view her cold marble sheen by candlelight. When asked how she could have posed for the scandalous statue in the nude, Pauline replied, "Oh, the studio was heated." I was here in 1963, reading *The Agony and the Ecstasy*, madly excited by the Colosseum, where I found a bone. I was convinced it had belonged to a gladiator and wanted to bring it home, but my mother wouldn't let me.

August 14. Back at Steigenberger Hotel in Frankfurt, continental breakfast next to airline executives, marmalade and *The Greene Murder Case.*

Returned to Minneapolis just in time to see the Who playing *Tommy* at the twelve-hundred-seat Guthrie. Searchlights roaming over the audience, Townshend banging his cherry-red Gibson over his knee; he does a little two-step, then charges his Hiwatt amps like an enraged animal, Moon doing an antic pantomime, Daltrey center-stage bathed in a silvery halo, singing his "See me, feel me, touch me, heal me . . ." as Pete rips it up from the wings. They debuted songs from *Who's Next.* FANTASTIC!

Moonlight, 10 p.m. skinny-dipping at Cedar Lake, which supposedly has a sea monster in it. Lainie, Angie, and I silently glide in the cold, inky water, pools of love and seaweed, beautiful, naked teenage-nymph euphoria. Dripping sirens emerge from ankle-deep shallows against shadowy shoreline. Timeless.

Two a.m. A trio of freaks (two boys and a girl) drove up in a Valiant and tapped at my bedroom screen. Wanting to say hello to me after my return from Italy. I slipped out and talked to them in the backyard. Mom magically appeared in her nightgown, shooed them away, and then let me have it.

"I have never been so disappointed in anyone in my entire life! What a stupe!"

I told her she was crazy and petty.

"I don't even want to know what you were *doing* out there!"

"I had an unnatural act with a dog!" I say, pissed off.

"No, and I don't care if you do! Or with boys! In fact, I don't care how much you get—just make sure she's on the Pill! And don't get syphilis!"

Speaking of which, Angie's virginity has finally been breached. She's got an apartment on Chicago Avenue with a couple of other

hippie girls. A nice room. Bed level with the window, moonlight streaming in. She's nervous and passive, but she *is* nude. That's a good start. I realize I have to take charge. I put two pillows under her. I put her small fingers on my smooth cock. Her legs go back. I work around the ground gained, a little bit of rhythm, she's back, I'm forward, and by accident we hit it just right, with an intake of breath and a gasp, the taut membrane snaps aside and takes me in. She fades away just like a heroine in a Victorian novel, eyes closed. I marvel at her pretty face, colored with passion. Ardent tongues and biscuit odors. She kneaded me and rocked me ever so subtly, and then swooned off. Ecstasy! We slept encased in one another.

In the morning, soft light, haystack breath, gypsy hair, rumpled sheets. Angie whispers, "Do you wanna make love?" Once the genie is out of the bottle . . .

I had to go to court for a speeding charge, and my dad had the judge changed to a family friend. Dad asked me to cut my hair for the occasion. I said I couldn't. "Why?" he asked. "I can't put it into words—you just have to be nineteen to understand." Something to do with outrage and cool. The judge had the charges dropped, told me to keep my nose clean, as I was on probation now. Whew!

Honey called from Dixie this morning, saying, "I'm ready to be your girl forever." Her baby is due in January! I tell her words she doesn't want to hear, that I can't, I'm still a child myself, must go to college, must travel the globe and meet everyone in the world. "But can't you do that with me next to you?" she pleads. Poor Honey, all this misplaced love, she never had a chance.

Three weeks home from Naples. Did I dream it?

Bard

Freshman Year, 1971

I'm rooming with a curly-haired kid from Englewood Cliffs, New Jersey, Lloyd Bosca, in a modern white cinder-block coed dorm called Tewksbury. Resembles a Holiday Inn. This must be the male-ponytail capital of the world. The fashion is work shirts, blue jeans, and sneakers. Same for girls, except for the addition of nipple-showing T-shirts and art deco dresses. Women's liberation is in full force. There isn't a brassiere in sight. Seven hundred students total. The East Coast kids can't believe I came all the way from Minnesota. "What's out there, anyhow?" they ask. The hallways smell of dope. A guy that looks like Charlie Manson, actually *named* Charlie, says, "Well, you can major in sex, or drugs, or religion, etc." Bard's sister schools are Goddard (where the drugs come from), Hampshire, Bennington, Antioch. Expensive radicalized colleges for creative types.

Lloyd is a bit of a character, loves Pinocchio and his bad friend Lampwick. He's got a Volkswagen Beetle, so we drive down to the city to see Dan Hicks and His Hot Licks at the Cafe au Go Go. Laconic Dan says, "We're gonna do a series of tunes, know what I mean?" Sid Page on violin during "I Scare Myself" was sublime.

I'm reading:

Lolita. Such writing! Such feeling!
Memoirs of a Beatnik by Diane di Prima.
The Tin Drum by Günter Grass.
The Painted Bird by Jerzy Kosinski

Bard girls
1. Quiet, sad, dark-haired girl on a stair landing has on a
 skintight white T-shirt molding her perfectly shaped tits,

complete with very visible ebony nipples. Eyes front! She has a German shepherd, and someone told me they saw her in the woods giving her dog a hand job.

2. Jean Hammond from Boston in her oxford-cloth shirt and pale-blue sweater, horn-rimmed glasses and barrette. Very pretty. She's in my Art and Aesthetics class. We walk into the woods and linger under a hoary stone bridge. She knocks on my door at night to share a bedtime joint with me in her nightgown and bathrobe. She says I don't have a heart for anyone. I act silly instead. I should just kiss her and let nature take its course. She said, "You must have really nice parents, because I never met anyone like you before, you're so free." Most of the kids here have divorced parents. They've seen shrinks. They have antidepressants.

3. Suzanne from Woodmere, Long Island. On a diet of Fresca, lipstick, and Kools.

 She bends over and I see her pale-pink untouched nipples (another virgin). She lost relatives in the Holocaust. She loves the Kinks.

On the KLH
White Light / White Heat, Velvet Underground
Desertshore, Nico
Rough and Ready, Jeff Beck Group
Rory Gallagher
Looking On, The Move
Electric Warrior, T. Rex

Letter from best Minneapolis pal Kurt says he got drunk with Angie and they had sex, because "they missed me." Then he described it in detail, in faux Kerouacian prose, like I'd enjoy that! True, I am

far away. What's she supposed to do, wait for me? I'm jealous just the same and feel left out. Possessive me. Double-standard me.

But it's autumn, and the leaves are exploding with New England color. I walk to the waterfalls rapt in my fantasy world. I always go to my classes, I only have five or six a week, I try to outwit my teachers.

My next-door neighbor John Browner comes in my room and says, "Hey, Shakespeare, what ya say we go down the road?"

"No money. Plus I gotta study my anthropology."

"I'm treating," he says, and we're off.

Eight beers later and he's singing his pornographic version of "The Twelve Days of Christmas" for the third time. My drawing teacher is at the next table trying to make a tough little chick. We stagger back to campus, stopping often to piss, crying for a joint to solidify our sloshy beer high. There's a sign in our hallway that says, "Whoever ate my guinea pig, thanks a lot! Paul." Someone has written underneath, "It was delicious." There's a sign on my door (214) that says, "Sorry, NO visitors, Duncan has contracted a rare ape-like disease which is highly contagious." We check on my roommate, who's talking in his sleep. We go to John's room and smoke some weed, and dissolve to the Soft Machine. "Moon in June." Never tire of that song.

November 10. The sky has ribcage-shaped clouds. Read *The Picture of Dorian Gray*, gave me some good ideas. Also *The Song of Roland* and *Flowers of Evil*.

My drawing teacher, Jake Grossberg, is angry at me for handing in lazy homework. He says that I'm not expressing myself with art, I'm expressing myself with drugs and sex. He says to break through, to attempt what you cannot do. Push! "You're better than most super-star high-school hotshot artists—sometimes you're mind-blowing!

But then you're masturbatory and hand in this San Francisco comic-book bullshit. Break through it!" He says I'm compulsive. Tells me to look up Egon Schiele. Jake doesn't like him but knows I will. He's right. Blows my mind. I am also in the throes of de Kooning worship.

· · ·

Lloyd and I got drunk and went to the Rainbow Room to hear Jerry Vale. Lloyd's twisted idea of surreal fun. Jerry had blue skin. Sang "Norwegian Wood." Creepy. Captain Beefheart is more my speed.

Back at Bard the sky was so gray and foggy and misty that I realized I was *alive!* Walking down dirty black Annandale Road, breathing air, smelling the wet earth. *"ALIVE!"* I scream it at the fir trees . . . Alive! I wonder at the world. I am here. *Now!* I'm alive. One of the living things!

· · ·

Pretty friend Suzanne got us tickets to the Kinks at Carnegie Hall. First dinner at the dark Russian Tea Room (her father's treat; he slipped me a fifty-dollar bill), cherry duck and Mateus. Then into the Carnegie bar, where all the NYC British rock fans are sitting out the first band. Some I recognize from the recent Faces concert. There's Rick Derringer! Suzanne buys me a couple of Pernods. Quite an array of peacocks, resplendent in velvet, feather boas, high heels, and those are just the boys! These creatures only come out at night. Inside the hall, it's all about to happen, "Ladies and gentlemen, after a long absence . . . *the Kinks!*"

Ray Davies in a Dickensian stovepipe hat, tails, gap-toothed drunken grin, Telecaster with the price tag still on it. He bows like the music-hall showman he is. We go Kinks krazy. "Waterloo Sunset"!!! "Apeman"! "Dead End Street"! "Wonderboy"! "Berkeley Mews"! "Big Black Smoke"! "King Kong"! "Dedicated Follower of Fashion"! And of course, their new AM radio hit, "Lola," where Ray really camps it

up. The next thing we know it's the third encore ("Louie Louie") and Ray is bidding us a good night.

Back in snowy Minneapolis for Thanksgiving. Go to a party in someone's house. Angie's on the Pill now, tits grew, busting out of her Ruby Keeler dress. We drink too much Pernod, which has such an intense high. I rub her monkey. Girl and boy, little joys. Ankles away.

I go see family doctor, who says I have arrhythmia or something, and I better quit smoking, drinking, and taking drugs. My dad says I'm "pathetic" and that if I flunk out of college, I'm out of the family as well.

PUNK

𝓙anuary 1972. Nineteen years old

. . .

Draft Physical, or How I Became 4-F

The war rages on. Student deferments abolished. There is a lot-
tery. Thinking about my good luck thus far, I assumed I would get
number 365 and they'd never get to me. Not so; there was my birth-
day in *The New York Times*, number 30! Uncle Sam wants me! I met
with the local draft-resistance organization to plot my disqualifica-
tion, otherwise I'd have to hightail it to Montreal. They were very
helpful, but warned me that the military had become very jaded, and
the days of getting out by wearing pink lace underpants were long
gone.

For my height (5'9"), I needed to weigh at least 120 to pass the
physical. I weighed 123. I stopped eating. Kept drinking, smoking.
With no food (except for an occasional hard-boiled egg) I lost twenty
pounds in two weeks. I got a note from the family doctor which
explained that I had Wolff-Parkinson-White syndrome, with a short
PR interval that gave me an irregular heartbeat. Said that military
service would be hazardous to my health.

So one ominous gray morning my dad drops me off at the hoary
downtown building where the physicals take place. I stand in line in
my boxer shorts in a dim, drafty corridor with all the farmboys from
rural Minnesota . My ribs stick through my white skin. I'd put a little
rouge on my cheeks in the bathroom to accentuate my pallor. When

I get up to the scale, it says 103. The guy writes down 120. "Look, it says 103!" I blurt out. The jerk chuckles and says, "Maybe I need glasses. . . . Move along kid."

"But wait!" I cry. "It's not fair!"

"Tough luck, kid—now move along!"

Uh-oh. My ace in the hole was just removed. We put our clothes back on and sat on benches filling out forms on clipboards. I was frightened and lightheaded. I checked all the boxes—alcoholic, drug addict, homosexual. After a long wait I was sent to an office where a burly man with a crew cut read my chart. I gave him the doctor's letter. He read it and said, "Well, this is pretty vague. I don't think we need to concern ourselves with this," and threw it in the wastebasket. One more line of defense gone. He asked me what I drank. "A quart of Scotch a day, and a six-pack or two."

"Mmm-hmm," he said. "What about the drugs?"

"Anything I can get. Lots of LSD. I suffer from acid flashbacks a lot . . . I'm never sure when the acid will come on again. It's pretty weird."

"Mmm-hmm . . . Well, you won't be able to get your hands on any of that where you're going."

Fuck. This is going all wrong.

"You checked the 'homosexual' box . . . What about that?"

"What about it?" I replied flatly.

"I mean, er, are you . . . *actively* homosexual?" he said with some distaste.

I said, just as cool as could be, "Yeah, sure, I've always been queer." And shrugged.

"Mmm-hmm. Well, I don't know about that. I'm going to send you to our psychiatrist so he can evaluate you. He'll sort this out." He stamped some papers and handed them to me with a look of disgust on his face. "Go to room 211 and wait outside until you're called."

I left his office and wandered down the hall, past the farmboys

who had already been classified 1-A and would be in boot camp in March. They'd be in Saigon by summer! Soldiers! Trying to kill North Vietnamese teenagers! Trying not to step on land mines! Fuck!

I sat on my bench waiting, shivering, actually hallucinating from starvation. What now? I had not prepared for this. The Army was taking some homosexuals. Which kind didn't they like? I didn't even know. They'd seen it all. They needed numbers. Everyone was gone. I couldn't fabricate a plan. I was gonna have to wing it. Eventually I was called into the psychiatrist's office. Sitting at a big wooden desk was a mousy little man. "Have a seat, Mr. Hannah."

I walked over to his desk and hiked myself up on it, crossed my legs, and looked him dead-on through my long bangs.

"In the chair, Mr. Hannah!" he said, unnerved.

I said, "I'm fine here . . . Why, am I making you nervous?" and laughed.

"In the chair!" he said in a panicky voice.

I leaned over and picked up a framed photo of a dowdy female and studied it. "Who's this? Your . . . wife?" and threw it to the floor with a leer.

"Mr. Hannah, I must insist you remove yourself from my desk and sit down in that chair!" I slowly got up and positioned myself in the chair, all the while smiling at him with contempt.

"Now, about your sexuality . . . What . . . what exactly do you mean by this? I mean . . . uh, what is the nature of these homosexual leanings?"

"What is the *nature* of my leanings?" I answered, laughing sarcastically. And so began my perverse soliloquy on the nature of my fictitious sex life. It was like an out-of-body experience. I could hear my voice describing sodomy and cocksucking, but I wasn't aware of composing any of it in my mind. It was like speaking in tongues; it just flowed out unfiltered, describing things I'd never even heard of. As if I was actually enjoying myself in front of this funny little man.

He was very agitated, looking down at my file, fiddling with his pen. "I see . . . and . . . uh . . . does this predilection of yours ever lead to any kind of trouble?"

"All the time, Doc. You see, I feel that everyone has a little bit of queer in them. Some more than others. My favorites are straight—" I cleared my throat—"men. If they don't like it, it often leads to violence, which is fine by me . . . It turns me on. Gets me hard. It's like I'm on a mission. I don't take no for an answer. I'm gonna have *fun* in boot camp. Those bunk beds, all those boys in their BVDs—that's like a dream come true for me. I'm gonna . . ." and I continued with my graphic description of the lewd mayhem I was going to wreak at Fort Bragg or wherever the fuck they planned on sending me.

"That's enough, Mr. Hannah," he said, waving me to stop. He reached for a stamp. "I'm afraid, under the circumstances, I find you unfit for military duty." And with that his stamp came down on my form, leaving a bold red 4-F behind it. I kept up my chatter, as if I was now pissed off at this outcome. Railing at the poor little schmuck, clearly out of his depth here. He held out the paper and said, "Please leave my office *now*, Mr. Hannah!"

I made a dramatic exit, slammed the door behind me—then the spell was over. My spirit floated up to the dingy ceiling, looked down on my frail 103-pound self standing on the old green linoleum, wondering what had just happened. Was it some kind of divine intervention? Who said those words? Where had they come from? It was the performance of my lifetime.

My dad picked me up in his orange Fiat Spider and said, "Well, how did it go?"

"4-F," I beamed.

"Was it the doctor's note?"

"Nope."

"Was it your weight?"

"Nope."

"Well, then, what was it?"

"Oh, uh, I guess they just realized that I wouldn't be much good over there."

"And how did they realize that?" he asked, now suspicious, ever the lawyer.

"Um, they just sent me to talk to a couple of doctors, you know . . ."

Long silence. "I hope you haven't done anything that you'll regret later. These things are on your record forever."

"Yah, but it's not like I'm going to run for president or anything . . . I'm going to be an artist!"

"What did you do?" he asked ominously.

"Nothing! I just saved myself from getting shipped over to Vietnam and committing suicide!" (I'm sure that's what I would have done in the face of all that horror: turn the gun on myself.) Great relief in having *literally* dodged a bullet. The sword of Damocles no longer hovers over my head.

Now that that's over it's something called Field Period—one month off from Bard where I'm supposed to work independently. Parents went to Europe. Have the house to myself. Living on Bloody Marys, screwdrivers, Pernod. Enjoying being a spoiled kid on a tear. I just gotta flip. Gone. Real gone. Solid gone.

January 8, 1972. I was reading the morning paper and saw an obituary for the poet John Berryman, fifty-eight. I'd never heard of him. He was teaching at the U of M, was depressed, and jumped off the Washington Avenue Bridge on the West Bank side. He missed the water and smothered in the mud. A semi-botched suicide. There was a picture of him in his black glasses and long beard. The thing is, I recognized him. Us druggy brothers used to see him around the

West Bank, after we'd scored our acid and hit the Electric Fetus for albums, rolling papers, and *Zap Comix*. Once when we were all tripping we walked over to him at the foot of the Washington Avenue Bridge. Same place where he leapt. It was snowing, and he had his arms wrapped around him because of the cold, like he was waiting for somebody. We didn't know who he was, but he seemed to be a cool old guy. Very drawn, like he had really "lived." So we just started yakking in our disconnected stoned way, and he listened, without saying much. We asked him what he was doing, standing by a bridge in the bitter winter wind. He was noncommittal. We thought maybe he was a lunatic, or a holy bum. Some kind of seer. We had many theories on who this lonely stranger might be. It never occurred to us he was a professor, or a celebrated poet. Although we did think he was touched in equal parts with madness and genius. Just because of the way he absorbed our nonsense and looked into us without judgment. I only knew him as "John." Poor guy. Now he's dead.

· · ·

Drunk. Empty Kenwood house. I knocked over an Xmas tree. I cracked my head open on a radiator. Blood. Woke up and ate an omelette, then drank some more while I smoked a cigar in the tub with Kramer, listening to *The Wizard of Oz*. Later all of us naked boys in a living room listening to a parakeet-training record. "Hello, baby, want a kiss? . . . Hello, baby, want a kiss?" Later it kept skipping on the word "Henry." "Henry, Henry, Henry," over and over.

Later, at yet another party, in another basement, I pulled Lucy Hood over to my place on the couch, sat her on my lap, and started kissing her Susannah York look-alike face. I slid my fingers up into her snatch and whispered that we should find a quiet spot and make love. "I want to so bad you can't even know, but I just can't," she replied, adding that I had the most beautiful smile in the world. I

got her up in the attic anyhow, got her undies off, but she wouldn't go all the way. Still very exciting. Pretty blond prep-school girl. Very passionate on the plank floor.

Angie comes over to read as I paint Marlon Brando. One thing leads to another. Bubble-gum breasts. Now she's just got on green tights, very attractive and coquettish. "Take those off." Then we get down to it, she's spiraling around my joint with her inner contractions. She calls me a playful little shit. Loves me by the hour.

Kramer, Haskell, and I spending an afternoon in their slum apartment drinking muscatel. The tenants are mostly Native American winos. This neighborhood is loosely called "Indiantown." The boys call up a hippie floozy they know, name of Nancy, with a slack look on her face, and we cajole her into a bedroom and take turns on her supine body. At least sort of. I couldn't do it. I don't think they could, either. Too weird. Not sexy. Ruthless youth. Is this all part of a Rake's Progress? Or maybe we're just obnoxious creeps.

Grades from Bard arrived. Here's what my advisor, Jake Grossberg (Larry Rivers's cousin), writes. "You have facility but settle for devices rather than pushing towards a personal means of arriving at drawing. The only clue as to how one does this I can give you is to examine where the devices you use come from. You've a wonderful facility, but a self-indulgent, silly attitude toward your work. When you start to make demands of yourself, you will do fine work—that I believe—but you settle for banality, frivolity and easy affect. It's a real loss." Honors.

· · ·

Back at Bard, Lloyd and I kicked off the new semester with a bottle of Pernod. We hit the Ping-Pong room and I shot Lloyd with the fire extinguisher. Campus security tracked me down, I was summoned to the dean's office the following Monday, and now I'm on probation.

I run into Doc Bray in the hallway. "You look different," I say.

"Oh, yeah, I had my eyeballs removed," he says casually. Interesting guy.

Reading *Tropic of Cancer*. Miller is cunt crazy. "I want to fuck you so you'll *stay* fucked."

"Last week I thought I was an artist, today I *am!*" Miller writes.

The Blithewood Ghost, Part I

Patty was in my painting class. Loved Virginia Woolf. Lived in a girls' dorm at the end of a road. Blithewood Manor, an enormous 1900 white mansion sitting on a bluff high above the Hudson. The blue Catskills across the river. The jewel in the crown of Bard's various buildings. Lots of big white pillars, statuary, formal Italianate gardens, gazebos, a fountain, real Henry James grandeur.

Patty and I were painting late in the empty art building, and she invited me over to spend the night (platonically; she was going through a Sapphic phase). I did, and we lay on her mattress in her room on the top floor, talking and smoking the night away. I heard a *ooooooo*, and said, "Cool, you can hear the train from your room!"

"That's not the train. That's the woman upstairs."

"Some student lives in the attic?"

"Not a student," Patty said calmly. "It's the spirit who lives here."

"What?"

Patty smiled at me. "Okay, this is the story. At the end of the nineteenth century, two families arranged a marriage between their kids. A power marriage between two aristocratic families. Their wedding present was to be a Hudson River mansion to be passed down through the generations. They picked a stylish architect of the time, Francis Hoppin, from McKim, Mead and White, and it was suggested that Frances, the bride-to-be, oversee some of the construction so it would be tailor-made for the couple. While doing so, she fell in love

with the architect, and they embarked on a secret affair. Frances and Francis. They used to make love in the attic. We know this because she kept a diary. The wedding date was approaching, and the architect pleaded with her to call it off and run off with him. Maybe California. She said she couldn't go against her father's wishes. So, heavy hearted, she married her intended, and off they went to Europe on their grand-tour honeymoon. She sank into a deep depression, and on their return, when they moved into the now completed Blithewood, her depression became critical. She knew she'd made the mistake of her life. She finally couldn't stand it anymore, and hanged herself from a beam in the attic, dressed only in her nightgown. She lives here still, and we often see her walking in the garden at night."

"You all see her? Everyone here knows?"

"Yes." Patty laughed. "It's quite fitting, don't you think? For a girls' dorm? She's one of us. She's our sister."

"Wow. So that was HER we heard?"

"Yes . . . She's still sad. I hear her most nights," Patty said solemnly.

Then a train *did* pass by under the cliff, on its way north, and we heard its *woooo-wooooo*, clearly *not* from upstairs. As if on cue, we heard again a mournful moan from above. Then another. Chilling. A cry from a broken-hearted young woman who's been dead for seventy years.

I went up to the attic the next morning. A large, mostly empty, rough-hewn space, with an old ladder leading up to the roof. There were large dormer windows looking out over the lawns and gardens. A stack of *L'Illustration* magazines from the twenties and thirties. I looked at the beams, and wondered which one took her weight.

Baudelaire says, "Talent is nothing more nor less than childhood rediscovered at will—a childhood now equipped for self-expression, with manhood's capabilities and a power of analysis which enables it to order the mass of raw material which it has involuntarily accumulated."

I've been getting some pretty heavy letters from my parents, telling me to grow up and stop being such a bizarre version of Peter Pan. They seem to think I'm a transvestite. My mom got a letter from the cops saying she was gonna get arrested in five days if she didn't pay my traffic ticket. Well, there aren't any parents here. "Call me irresponsible, call me unreliable, call me undeniably . . . blue."

Robert Wyatt sings, "Time wasted / Time that could be spent completely nude, and naked."

. . .

"Bang a Gong (Get It On)" is number one on WABC-AM radio. T. Rex, baby! Just in time for Bolan's British Invasion of America. *Melody Maker* (I'm a subscriber) has featured him on the cover for weeks as T. Rex mania sweeps England. Exciting. Going to see them on Sunday.

Weekend in New York: A black limousine picks up Suzanne and me (courtesy of her grandfather). Black driver named Julius drives us from Annandale-on-Hudson to Woodmere, Long Island. Dinner with her eccentric parents. We stay up watching *Village of the Damned* while I work my way through a bottle of Napoleon brandy. To Manhattan in the morning, incredible pop art of Times Square, the juxtaposition of billboards and neon and the steaming cup of Salada tea and blinking Coca-Cola and marquees and the Camel smoke-ring sign, it's one big collage! Then St. Mark's Place, still wearing the vestiges of the Aquarian age—super-graphics on the sides of brick buildings, faded rainbows, tattered hipsters on the drizzly street, an old lady pleads for cha-cha records. We take pictures of each other posing like we see on album covers. Buy a couple of shirts in Limbo. Dinner at Wo Ping in Chinatown with Lloyd.

Fifty-seventh Street. Spotlights outside Carnegie Hall shoot silvery beams of light over the deco cityscape. Getting primed for the much-awaited rock show in the ornate red-and-gold bar beforehand.

All the cool cats have come out of their coffins for the T. Rex debut in NYC. They are a sight to behold. I like the flash ugly ones with their hooked noses and souped-up hair. Gaunt scarecrows wearing patchworks of silks and satins and velvets, lotsa gold bracelets and rings. Hunched over, teetering on their high heels. Fops to the left of me, dandies to the right. Jammed with the crème de la crème of rock aristocracy. Even Candy Darling! It looks like the court of Louis XVI in here.

Showtime: Marc struts out wearing a Bolan T-shirt under his white lamé suit. Only five foot four inches tall, mincing and preening. Playing his sunburst Les Paul. Playing "Hot Love" and "Jeepster." Crowd goes wild, girls screaming, crying, fainting, and getting carried out by security. Pissing in their seats? He's laughing and doing his Chuck Berry thing. It's a short, sloppy set, but the teen-idol mayhem makes it thrilling.

BOMBARDIER

I run into handsome guitarist Rob DuPrey in the showers. He says, "Hey, are you the guy who plays that punk music?"

"I dunno—what's punk music?"

"You know, the Stooges. I can hear it through the door. It's okay— I love the Stooges."

Now he is trying to teach me to sing so we can form a band. Our set list:

"Schoolgirl," Argent

"Little Doll," "Real Cool Time," Stooges

"Curly," "Tonight," "Omnibus," Move

"Nellie Takes Her Bow," "Whisper in the Night," ELO

"Call Me Animal," MC5

. . .

After a week of dedicated alcohol consumption, I'm run down. I have ravished myself out of my senses. I can't remember Friday, Saturday, Sunday, Tuesday, Wednesday, Thursday nights at all. I got the feeling of impending doom. My fingernails are ragged. My drowned heart feels funny, like it's got a knife in it. I'm not right. I is sick. Depraved. Deranged. Paranoid. I can't sleep cuz I'll die. I got restless tension. Bad circulation. No oxygen in my brain. Never-ending shakes. I'm weak. Hallucinations. Can this be DTs? Aren't I too young for DTs? I'm so goddam young! There's a shadow looming over me. I lie on

my single bed and look up at the creepy portrait of Fu Manchu that I finished, (acrylic on canvas) dressed in the height of aristocratic Chinese crime-boss fashion. A plume of opium smoke drifts up to his cat's eyes. Why am I obsessed by Fu Manchu? Thinking about Dr. Jekyll and Mr. Hyde. There's been a lot of Mr. Hyde lately. I grit my teeth and tough it out.

· · ·

I had a dream of living in a Chinese junk in the foghorn darkness . . . a bunk bed lit by a Chinese lamp. Smell of opium. A coppery quilt. A boyish girl. Oval mouth. Wide, dark, heavy-lidded eyes. Long-fingered. My freckled feline imp arches, coaxes, slips, churns, seethes, nuzzles, boils, beats, softly crashes into me over and over. Whew. My subconscious is starved for eros. It's been a while. I've almost forgotten that there's a little creature that lives between every pair of female legs. I wanna get on my camel and ride.

· · ·

I learn painting is about painting. We paint for ourselves and other painters. It's not just what you put in but also what you leave out. I dig Marca-Relli lately. He's got a great feel for shapes.

April 21, 1972. Woke up this morning with a bird's nest in my head. Those Seconals weren't too good for me, cardiac-wise. Went to the bar last night with Paul Morrissey, who had just shown *Chelsea Girls* at the campus screening room. We told jokes for four hours. Another barroom drama was when I found poet Fielding Dawson (great name) on a stool nursing a hangover at around noon. I heard him read the night before. We split a pitcher of beer and he told me about his pals the abstract expressionists. Pretty funny stories about the

Cedar Tavern, involving belligerent beatniks and especially Franz Kline, who I like a lot. I got up to pee, and suddenly he was in the can too, mauling me. "Knock it off, man!" I yelled, pushing him off. He was persistent, so I kneed him in the ghoulies, and took off out of the joint, very disappointed that our dipsomaniac communion should've had to end this way.

Saw *Satyricon*. Loved Ascilto (Hiram Keller), the brawling, lusty demigod, grinning with self-assurance. Many pretty boys abound. Stupendous sets used only for a minute or so.

I get a letter from Angie. She writes "I am making two new dresses especially for you. One is *hubba-hubba* and the other is *whisper me sweet nothins*. They are the kind that when you see me in them, you'll want to see me out of them, you old rooster."

Bard is like a country club with no golf course. Baghdad-on-the-Hudson. Sunbathing on the Blithewood roof, slathered in Coppertone, the comforting smell that takes me back to Miami Beach in the 1950s. I can hear the hushed drone of the waterfall through the trees, I can hear the birds singing, hear my pen scritching. Somewhere, someone is playing "Opportunity" by Eddie Cochran.

Boys'-night-out dept: Rob DuPrey, the libertine, and I fulfilled our orgy fantasies last night, scrambling round on naked classmates. Social climber Mallory and her pal, a girl called Andy, drove us home from the bar in her Alfa Romeo and we went in Rob's empty room, threw on some Soft Machine, lit a joint, and we got down to it. Sex for sex's sake and the sheer *whee* of women. Mallory's taller than me, short hair and hard brown nubbin nipples, pubic hair trimmed like a small hedge. Huge vagina. She seemed no stranger to this kind of scene, Rob and Andy next to us, copulating away. I catch Rob's eye; a twinkle of amusement passes between us. I think the girls found us a little too nutty. They were trying to be sophisticated. But it was hard to take seriously. Hard to be cool.

May 5, 1972. DuPrey and I hit NYC to see the Jeff Beck Group at Carnegie Hall, featuring his fabulous drummer Cozy Powell. First we load up on Pernod till we got a nice buzz going. Beck is ripping it up in his bad-boy way, one of the best guitarists ever, a real connoisseur of sounds, from dirty to lyrical. He's got that great shag haircut (that I made my mother try to replicate when she cut my hair), dark eye sockets, played Stratocaster over his head, sounding like the dragsters he loves, laughing at the mayhem he conjures up. Some hippies bounce a balloon up to the stage, and he stomps it flat immediately with his Cuban heels. No Summer of Love here, son, this is a crack team of professionals. "Going Down." "Ice Cream Cakes," and the gorgeous "Raynes Park Blues." It is *loud* and it feels *good*! What a fucking band!

After the show DuPrey and I run down Fifth Avenue in drunken high spirits, a myriad of lights and fountains and yellow cabs, with a clear black New York City sky above us. We accost a couple of girls we never saw before and one says, "Wait, is your name Duncan Hannah?" and I say, "Yah!" and we run off because it was too perfect. Who's she? Streets, you better get outta the way! Howling at the moon! We got the devil in us.

The next day, however, I got the DTs again, while standing in the Met. I started to fade away. My vision was going. I thought, "This is too melodramatic, I can't die in the Met, right in front of Sargent's *Madame X!*" I sat down on a bench. I didn't think I'd make it and almost didn't.

· · ·

My dad's been writing me man-to-man letters in his open, loopy handwriting. We were so close up until age fourteen or so. I was the child of his dreams back then. I remember eating scrambled eggs in the sunroom of the Plaza, dressed in my little Brooks Brothers getup,

complete with a gray leather Eton cap. He brimmed over with pride. Now he wonders what hath God wrought. But I'm a logical extension of that other Duncan. I'm not sure he sees it that way.

Jake Grossberg (my drawing teacher) is exasperated with us students. We don't work hard enough. He blew up. He ripped up Elliot Caplan's homework drawing into small pieces and threw it in his face. Said he wasn't here to babysit us. "In my day the kids were exciting and the teachers were dull. Now it's the other way around!" He storms out of the studio, slamming the door behind him. Elliot is in tears. We look around at each other . . . now what? We are guilty as charged. Bard is an odd reality.

Zabo Stanislav is a beautiful blond theater major, the acknowleged stunner of the campus. One night in the coffee shop, someone runs in and says,"Quick, get down to the arts building, Zabo is modeling for life class!" Who could have hoped for anything more glorious? I grab my pad and charcoals and sprint down there, into the hush of the studio. There she stands in her altogether, frozen in a dance position, like an Ingres odalisque or a *Playboy* Playmate. Perfect. I hurriedly set up at an easel, and let my eyes feast over her supple dancer's body. She watched me out of her mysterious gray eyes, the hint of a smile at her lip. How her maize-colored hair frames her gorgeous face, the long neck settles into the chest, the swell of the upturned breasts with nipples at attention, the ribcage, the navel, the southern slope down to the furred sex, the hip meeting the thigh, faster now south to the long legs and feet! How could one do justice to this vision of beauty? It's all made of creams and blushes, the poetry of her dips and hollows. She's not made out of lines. Lines don't exist here. At the break, she stretches, slowly puts on her kimono, and comes over to look at my lousy drawing. I apologize for not rising to the level of her loveliness. She's amused at the power she has, not just over me but over the entire room. She's casually flirtatious. Toys with

me. Somehow the fact that she's naked under her silk wrapper flusters me even more. Says she enjoys modeling. Makes a little pocket money. The teacher says it's time to resume, and she leaves me to go back to her altar, to be our goddess again. She adopts a reclining pose, with her legs slightly parted. Her quim is aimed right at me. Winks at me. I'm staring hard, trying to memorize every detail for future reference. At the end of the session I have not captured the apparition before me at all. My drawings lack grace. I watched as she climbed back into her baggy blue jeans, worn cowboy boots, flannel shirt, and brown leather airman's jacket. She gave me a lift in her old Volvo down to Adolph's, where a night of heavy drinking took place.

I got up with no memory of pissing off the landing onto the stairs, so alcoholized that my teeth were chattering. Trudge over to my painting class. Jim Sullivan says, "In the beginning you tried to paint compelling paintings that forced us to look at them, but held our attention for a minimal time, because you used so many gimmicks. Now they're toned down, and much *more* compelling." I play nursemaid to my paintings, trying to give them what they need rather than what I want.

The school year is drawing to a close. I stock up on Pernod in the liquor shop in nearby Red Hook for the parties to come. A big confusing blur of bad behavior. Freshman year is over.

Summer of 1972, Minneapolis

My dad is shocked at my appearance. He says I am a disgrace to Fred Astaire. Says to Mom, "He's really flipped this time." They're worried about drunk driving (rightly so). No more car keys. "We want to be proud of you but we can't. When you were a little boy we had such high hopes for you, but each year we lower our expectations." Talking about alcohol with Dad over three Scotch-and-waters in the backyard, abuzz with mosquitoes. "We're trying to put the brakes on you

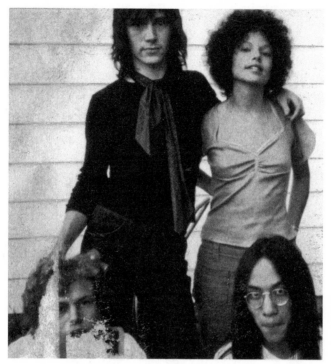

Clockwise: DH, Mary Kay (Steve's girlfriend), Eric Li,
Steve Kramer

because you are too fun-loving, it's abnormal." He hires me to paint
the house, which is covered in cedar shakes, but lots of trim, and
screen and storm windows. Then I can go to London in August to
infiltrate the underground. Make the club circuit in my flash fineries.

June sky is dark and threatening, now raining on the lush woods.
I'm alone in my room, listening to Tyrannosaurus Rex (1967–68),
One Year by Colin Blunstone (exquisitely romantic), and "Rawlin-
son End" by the Bonzo Dog Band. I feel like I haven't been alone
in ages. I leaf through picture books and paint a little. Calm for the
first time in a long time. Here I am in a backwater of Hopkins, once
the juvenile-delinquent capital of Minnesota. The hoods still bomb

down the main drag in hopped-up pink Camaros. On the local scene, Kramer and I ride a bicycle built for two and crash gleefully into trees, small children, and walls. No one is hospitalized.

Calm disrupted by David Bowie's new album, *Ziggy Stardust and the Spiders from Mars*. He outdoes T. Rex. *This is the next big step.* Can't stop listening to it. Makes me freak out in a moonage daydream!

June 17. The nice thing about having a lover is that it makes you think about everything anew; the rest of your life becomes a kind of movie, flat and rather funny. "Inspirations have I none / Just a touch of flaming love . . ." sings Bowie. My mom notices my shredded back, which came from Lainie Powell's fingernails. How I got my stripes goes like this. Lainie (Kramer's ex) called me in the afternoon and said, "Wait until you see my new haircut, you're going to love it, we'd make a perfect pair." Okay. She said she'd meet me later at a party in an empty house in Hopkins. There she is, busty Lainie in lederhosen, with her new Ziggy Stardust haircut. She looks like a super-sexy Swiss tomboy. We have instant chemistry after the ice-breaking flirtatious phone call this afternoon. It is on! Go into the dark basement away from the noise, and I slide my fingers up under her knit top and fondle the glory of her tits. Soul kissing. Look deep into her glittering eyes. She said, "Let's take a shower," which we did. Good idea. Which led to soaping, and drying, and then to bed, which was delicious, her long legs locked around mine, as we gently rocked. Lainie's a carnal girl, a sensualist, a favorite with the summer boys in Excelsior. It's what she's best at, and she knows it. Takes pride in her amorous physicality, which is nice. Exhilarating, in fact.

· · ·

My parents left for a party at six, so, since I'm grounded, my pals came to me, with lots of rum. Makeout party ensued, parents came

home early at ten, joint was hoppin'. Trouble. I started bowing and "om"-ing like the Mystic Magic Mullah Maji. Mom is pretty blotto herself, and holds her head in her hands. "Dunc's got a lot of problems, and you don't help him any. Please get out of this house, pronto!" They left.

In the morning I got up, little sergeant at salute, head pounding, heart doing fills and paradiddles, skin too tight, took a shower, made an omelette. Mom comes in, shit hitting the fan, and says, "I've lost faith in you. You're a worthless, no-good, homosexual choirboy." I laughed at that one, and countered with, "Well, I don't like you or your ding-a-ling friends either."

"You're driving me to an early grave!" she yelled. Just to wind her up a bit more, I told her how I *really* got out of the draft. She went wiggy over that one. She ridicules what she don't understand.

· · ·

Home alone on a gloomy summer's day. Lainie calls to say she's been thinking about that party. Could she come over to see me? Take the bus? Sure.

Bing-bong! She shows up at the doorstep looking a bit shy and sheepish. My heart fluttered. She looks fabulous in pleated pants and a little Fair Isle top. Very Bowie. My Puss-in-Boots. I make drinks and lead her into my room to listen to records. We kiss, more sober than last time, and we take off our clothes in stages. She's just seventeen years old. She's my height, flat stomach with a row of taut muscles that run down to where our pubic hairs meet. She tells me she's sterile so don't worry about birth control. We make love three times that afternoon. She's more comfortable in the throes of passion than she is making conversation. Lovely lying next to her, still messy with fairy dust. "I don't feel dirty or slutty going to bed with you," she says. "You're so pretty and appreciative. It's really nice."

I felt like a regular rogue running her home in Dad's low-slung

convertible sports car, dropping her off at the house of her fat mom, who's in the driveway wearing a flowered apron. She throws her pudgy arms around her daughter as I squeal off, saying, "Bye bye, ducks."

. . .

My dad looks at my attire and says, "Wouldn't you rather be Humphrey Bogart than Lauren Bacall?"

I'm talking to a Jehovah's Witness at the front door and "Sympathy for the Devil" comes on the living-room stereo. Nice timing.

Memorable night with the wild boys and girls of our extended pack. Wound up at cousin Swanny's house on Lake Minnetonka. Full house, so Lainie and I were given the sleeping porch, enclosed with screens, which has a large bed suspended by chains to the ceiling. That night there was a crazy thunderstorm, so we fucked our way through it with primitive passion. Sacred fucking in a second-story porch as the heavens exploded! Then we took a bath, facing each other, such cuteness to behold. Made it again in the bath, while a David Bowie record played from downstairs. Back to our swinging bed for a snuggle, which led to bout three. Lainie loves it, which is such a turn-on. Desire is the ultimate aphrodisiac. I like being wanted. I like being part of someone else's hunger.

. . .

Jimmy and I were summoned up to an island on Rainy Lake in Winnipeg by Gail Bennett (she's an heiress) and her friend Sybil, part of the girls' school clique. We were flown in the two-engine, five-seat company plane. Just the two of us and the pilot. We ran into an ultra-heavy storm a mile up. We were pitched upside-down, our Cokes on the ceiling, and the plane began twitching and clanking and dropped altitude like a loose elevator. The pilot was scared shitless, our knuckles were white, and Jimmy and I (friends since 1959) said our solemn

goodbyes to each other. Strangely enough, my heart was beating calmly for the first time since Easter. The plane that had lost its bearings suddenly righted itself, and we came out of the storm. We made it. When we touched down we kissed the tarmac. Alive!

We spent five days with the girls in this rustic compound, a main lodge and some cabins, sailing on a Sunfish, canoeing, drinking rye whiskey, skinny-dipping. We told ghost stories on the double-sided white sand beach one night, spooking the girls. Electrical storms broke out, lightning flashes zapping the aluminum lawn chairs at ten-second intervals. *Bzzzzt!* It was something to see. Our eyes were popping out at the extreme violence of nature.

That night Jimmy snuck out of our cabin to join Gail, and Sybil came a-knockin' at my door. I like Sybil, but I wasn't about to get into this. She had a mass of kinky hair, webbed toes, a forehead like the Rock of Gibraltar, saggy tits, and breath that smelled like buckskin scraps. I did not comply. But I was diplomatic about it.

· · ·

Back in suburbia, Lainie comes over to meet with my parents. She's sitting in the beamed living room, nursing a Scotch-and-soda and smoking a Parliament 100, dressed in pleated Busby Berkeley pants and no underwear. The dinner conversation is about the various merits of a high-school education, and the pointlessness of memorization. Meanwhile my dad is ogling her, his eyes all atwinkle. They tell me in the kitchen that this is the nicest girl I've ever brought home. If they knew the half of it!

I feel like a teenage werewolf. Free love abounds! This is a time of great urgency! We have no free will! We are controlled by our chemistry and electricity!

What a weird summer! Been through the ringer of all the emotions. This summer I rode a roller coaster, had a troublesome heart condition, went to Canada and almost died, painted the house, held

grudges, got in a car accident, played drums with the Hurricane Boys, made the scene at the country club, saw Todd Rundgren in concert, learned the funky penguin, saw an Egon Schiele show, drank a lot, screwed a pretty girl named Kit in the cabin of a sailboat, adored David Bowie, all in sixty days.

Night of Absinthe

Party at cousin Swanny's lakeshore house in Deephaven, and we have a bottle of *real* 1915 absinthe with the dreaded wormwood-root ingredient that drives you insane, which got it banned worldwide. Steve Brooks (who looks like Thor Heyerdahl) has an older brother, Conley Jr. He was safekeeping the contraband stuff for his uncle, who brought it back from World War I. Kramer stole it while rummaging around during a cacophonous party at the Brookses'. So we were taking hits off it. It was so strong, that when you forced a little sip down, it turned around halfway and tried to come back up. We were standing by the shore of the lake, taking it methodically, being connoisseurs of substance abuse. Waiting for the click. I take a piss. There's a thunderstorm brewing. Two pale figures are coming up out of the dark, cold and naked; it's Calvin Perry and Lainie. She starts to cry when she sees me, scared of what I must think. But I don't think anything. I'm just drinking absinthe and taking a piss. I help her with her clothes. Her mascara is running down her face. Kramer is playing Parisian street songs on his accordion. We work on the absinthe a bit more. Going down easier now. Calvin has entered the party house naked, bellowing some drivel about his godlike status. We decide this hippie scene is dead, time to move.

We pile into Kramer's mother's station wagon. We don't know it, but we're nuts! (absinthe doing what absinthe does best). Kramer peels out. Partygoers are screaming *"No!* Don't let those guys drive . . . they're crazy!" Kramer is going 50 mph through residential

Deephaven's windy, wooded roads. Kurt and I are grumbling about the complacent dullards at the party. We gotta *go*, man! There's a hellhound on our trail! Kramer's taking swipes at the steering wheel without actually touching it. We careen around a corner and slam into a tree. *Wham!* No brakes, nothin'. Just *wham!*

The tree broke. The car broke. Bent in two. Totaled. Car horn screaming. Smoke rising to obscure the moon. We are untouched. Blessed be the drunks. Only perturbed that now we have no means of transportation. Yelling at Kramer for being a crap driver.

The party sent a pursuit car after us, knowing we wouldn't make it far. Kurt and I pile in, take off to his house. Kramer decides he better stay with the car—but realizes he better be scarce when the cops show up, so he creeps down into the swamp, up to his neck, like he saw in war movies. Police search for owner of abandoned station wagon, to no avail. He's breathing through a reed underwater.

Meanwhile, Lainie is in the car that picked us up. She wants to explain her behavior. I don't care. I'm numb to jealousy tonight. She's feeling bawdy. Sexually compulsive. When we get to Kurt's we lock ourselves in the bathroom and fuck like nymphomaniacs on the floor. We had orgasms at the same time. What a rush! Absinthe did as advertised!

MUMBLES

Next stop: LONDON. With $770 in my sailor-pants pocket!

TWA to London, where I'm meeting Kramer for a glam-rock holi-
day. Check my bag in Victoria Station. It's London! Pale dolly birds
with red lips and high cheekbones swish by in plaid miniskirts, soft-
blue pleated hot pants, platform sandals, kohl-rimmed eyes, electric
heads of hair. Can't figure out the money, but a pound means five
pints of Courage. Jukebox plays summer chartbuster "All the Young
Dudes," an anthem for this time. We hit the shops on Kings Road,
Mister Freedom (where I pick up some black velvet overalls that I've
seen both Bolan and Bowie wearing in the rock magazines) and
Granny Takes a Trip. Maroon leather jacket and loon pants. Biba is
art-nouveau chic, mirrors, emaciated birds with brown lipstick tot-
tering about in automatic shoes. We make quite the Anglophilic pair:
eating fish and chips with plenty of vinegar, pint of Watneys, topped
off by an Embassy cigarette. We ride the red double-decker bus to
Hyde Park. Kramer's chasing the pigeons, saying, "Here, kitty kitty
kitty."

The first night we stayed with a Scot called Tommy whose accent
was so thick that we couldn't understand a word he said. Kramer met
him in a pub called the Cock, where he played "God Save the Queen"
on an upright piano. So, of course, Tommy turns out to be a bugger
boy, and threatens to climb in with us at the end of the night. He
produces an eight-inch razor, and says something like "Get in dere,

ya fookin' bastard." Kramer tells him that if he touches either of us he'll cut his balls off with that thing. Seems to calm Tommy down.

Everyone is very friendly, although it's the homosexual population that we seem to be attracting, which appears to be quite large. We are taken for a couple of bent boys everywhere we go, when it's only rock 'n' roll that we're after. Kramer's golden locks and Mick Jagger lips, my peekaboo shag and sailor suit seem to be sending out the wrong message. I looked in *Time Out* and lo and behold! Ziggy Stardust and the Spiders from Mars are playing two shows at the Rainbow. We get tickets immediately. But first it's the Reading Pop Festival in Berkshire.

Paddington Station. Stevie boards the train while I search for somewhere to buy film. The train begins to pull out, so I start running down the indoor/outdoor six-track station, porters and conductors screaming *"Stop!"* Steve's hanging out the window yelling, "C'mon, Dunc!" The train, gaining momentum just as I grab the rung of the speeding caboose, nearly jerks my arm off but I swing up, precariously balanced, and then . . . I'm on! I felt like Belmondo in *That Man from Rio*. Whew! Close call.

Fiddledeedee, we're cats on a holiday. We disembark at Reading and join the crowd of hippies marching off to the festival. Ah, country air!

August 11. The bands began to play. Pretty Things, Genesis, Curved Air, Mungo Jerry, who urge us all to "GET LAID!" We came unprepared for the cold nights, this being August, after all. The first night we sealed ourselves in a gigantic plastic bag, lying on the seams to capture our body heat, only to wake up an hour later to find our blue heads desperately gasping for oxygen. We got up with half our brains decayed and walked around the festival shivering, looking for an alternative plan. We were drawn like moths to a campfire where

hashish was being passed around. We sat up with these longhaired kids till dawn, sharing their heat. The nicest was a guy our age who looked like Robert Plant. He seemed smarter and better informed than his American counterparts.

August 12. We walk by the river into the village to get a right fry-up in the pub. Some bikers come in, eye the crowd. One particularly nasty one comes over to me, picks up my pint with a smile, and drinks it down in one go. "Hey," I cry. "That's mine!"

"Oh yah?" he says, then proceeds to pick up my fried egg with his fingers, pops it in his mouth, and swallows, looking me in the eye the whole time. Then he begins on my toast, sopping up the beans as he does. Everyone in the café is watching. Why is he picking on me? It gets very quiet.

"Oh . . . that's all right, I guess," I say meekly to the Cro-Magnon man standing over me. I reckon bikers get to have whatever they want.

Back at the festival, Focus are playing their annoying prog rock, so we wander around looking at the crowd. We spot a fabulously pretty girl in knee-high silver boots, a white cotton skirt, a white cotton top open to her bare (and beautiful) breasts, proudly sticking out, a circular shot of silver spray paint on each one. We kept leaping ahead of her to get more looks at this sexy moon maiden.

Our new friends drop acid, and Kramer and I start on a quart of vodka. Electric Light Orchestra does a good set. Then it's time for Rod Stewart and the Faces. They're as drunk as we are. Rod is strutting around in the distance, a thumbnail shimmer of silver going back and forth as if on a conveyor belt, having a good ol' time. I see two of everything, two Rod Stewarts boxing effeminately across the stage. It's impossible to get back to the portable toilets, so we piss into empty beer cans, which we set down carefully, only to knock them

over when we dance. Eventually Kramer is passed out on the ground, and I go into a blackout. We get separated. I wander in the hordes, completely disoriented, like a waking dream. I think I am in a large interior space in Paris. On an escalator, no less! I sleepwalk into a large tent, which turns out to be the Salvation Army medical center. A nurse observes my confusion and leads me over to a cot and hands me a cup of hot, sweet tea and a bacon sandwich. She assumes I'm having some kind of severe acid trip. I'm coming around, then look at my neighbor on the next cot. It's Kramer! What are the chances of that? In a sea of tens of thousands of people! We were lost and now we are found!

We make our way back to our friends' bonfire at the periphery of the mob. A teenage girl invites me to share her sleeping bag. In her pup tent. It sounds very cozy but Kramer won't let me. He's sick and tired of girls going for me and ignoring him. He's his own worst enemy, though. If he wouldn't act so crazy all the time . . .

August 13. Day 3. Robert Wyatt's new group, Matching Mole, play. I love them. Then it's Roy Wood's Wizzard, who look ridiculous but sound great. Headliners Ten Years After finish off the day with Alvin Lee's interminable hyper-fast amphetamine blues. Boring. Back to London for these two Minneapolis boys.

August 18. The fourth place we stay is near the Finchley Road. Mr. Stills, our landlord, brings us coffee and toast in the morning. We lie in our twin beds drawing and writing. Kramer laughs when he draws. We set off for the zoological gardens, where the animals are playing. Impressive penguins. Then to Piccadilly Circus and take in an adult double bill, *School for Virgins* and *Girl Stroke Boy*. Then Ronnie Scott's. Then the Speakeasy, where we hope to find rock royalty,

or at least their groupies. We sit at the dark basement bar and eyeball a couple of likely-looking English lasses, in their "frock coats and bipperty-bopperty hats." Very Kensington High Street. They return our gaze with interest. We sidle on over and ask if we could buy them a drink. Their faces dropped. The prettier one says, in a honking New York accent, "They're Americans! Look, guys, if we were interested in your sort we would have stayed in Long Island. Now fuck off!" Aha! Impostors, like us!

We refresh our weary stop-go-streetlight city eyes and take the boat down to Kew, past Mick Jagger's house on Cheyne Walk. In the big white Victorian greenhouse, we inhale deeply. A fragrant paradise. We walk through the bamboo and rhododendrons and take pictures of each other. The red-orange sun is slipping down into the horizon. On the boat trip back we watch a middle-aged couple. We decided they were on the boat because they wouldn't run into any of their friends. They were married to others. He was holding her hand and looking into her eyes all lovey-dovey, but she obviously had reservations about this adulterous affair. I suggested to Steve that I take their picture and blackmail them. We were acting it out, I being the outraged man "Why, you little punk, you can't do that to me . . . blah blah blah," and Steve started laughing so hard that he was crying and the couple forgot their melodrama to watch the strange kids on the bench facing them in a fit of hysterics.

Bowie at the Rainbow, Finsbury Park, August 19, 1972

Drinking Pernods in the pub across the way beforehand. Gawking at the beautiful girls that look like beautiful boys. Inside the crowd is insanely cool, milling about in the art deco lobby. The girls are dressed like twenties and thirties movie queens, lots of little Theda Baras and Jean Harlows. Roxy Music are the openers, who I've been reading about in the weeklies. Suave crooner Bryan Ferry in a tiger-

skin jacket and space alien Brian Eno (in a feathered outfit) rock out their fifties-futurist pop. Their single "Virginia Plain" has been blaring out of boutiques since we got here. They are noisy and energetic.

At intermission, we drank vodka and Tia Marias and wound up talking to a forward young girl named Mary, with her friend Sharon. Mary had an ostrich-feather thing around her neck. She announced that I was her gentleman escort, that I was pretty, and that she'd use me to forget about the "bastard" back home who slapped her. Mary said she liked effeminate boys and I nudged her over to the doorway of the ladies' room and kissed her and felt up her tits. She had a long tongue. It was that kind of night. But the lights blinked on and off, and that meant showtime.

In the concert hall the speakers played *Thus Spake Zarathustra*. Two-level scaffolding at the back of the stage. Smoke. Projected stars revolving around the theater. Excitement. The Spiders walk out in silhouette. And then . . . the space invader himself! Very assured he was, too. He had a loud, clear voice that could go wherever he wanted it to. The Lindsay Kemp dancers did some lame mime in the background. It was "theatrical." Bowie did many costume changes. The best part was the music itself, stripped down and dirty, playing those incredible songs. Bowie bare-legged and prancing about, mugging with Ronson in some kind of gay droogy thing. Up at the front Mick Jagger was dancing in the aisles. It was totally thrilling. Subversive. At the end he sang Jacques Brel's "My Death" alone with an acoustic guitar. Wow!

Back in the lobby Mary asks me to come home with her. "What about my friend?"

"Not him. Sharon doesn't like him. He asked her why she was so ugly. Just you, my gallant knight . . ."

Kramer gave me the fish eye. I declined the offer. I saw the sweet secretary who had invited me into her sleeping bag in Reading and gave her a little wave. She looked sad. So we went off into the London

night, the Katzenjammer Kids in search of more beverages. We are accosted by a band of black kids, who started picking at my camera, tugging at my clothes, asking for money, calling us fags. Kramer, never one to turn down a challenge, starts taunting them back, flying right into the eye of danger. It freaks them out and they scatter.

August 21, 1972. My twentieth birthday. Goodbye to my teenage years. Although I still get carded to see if I'm eighteen. And occasionally asked whether I'm a boy or a girl. I've slept with twelve girls. Lainie's slept with twelve boys. She and I have horniness in common.

We go to the infamous Prospect of Whitby (450 years old) in Wapping for a boozy birthday lunch of coq au vin, boiled potatoes, and peas, looking out over the dirty Thames. Home for a nap, then off to a drag bar we'd read about that's having a certain popularity with the glam set. The Black Cap. The performer is an old queen named Auntie Flo. She tells smutty jokes. We get picked up by a bunch of aging lechers led by drunken rock manager Kit Lambert (the Who, Hendrix), who says I'm delightful and a "superstar," and we simply *must* come with them to the after-hours Marquee Club because he has the key, so we pile in a van, and some geezer named Rocky kept trying to get me to squeeze his cock. "What are you doing to young David Cassidy back there, Rocky? Leave the child alone!" says Kit, who's got a posh accent. They're all extremely camp and very funny. We arrive and Kit opens the club up and we loll about soaking up the brandy. Then off to someone's apartment on Haverstock Hill. The evening got very blurred at the edges.

My Near-Rape Experience

We went to see the play *Sleuth*, and after were drinking gin and limes in a very crowded theater bar. I got to talking to a tall black

West Indian guy named David. It was last call (eleven p.m.), so we ordered doubles. David asked me about closing time in NYC (four a.m.), what a shame it was we couldn't keep drinking, etc. He said we could all go to his place, where he had a fresh bottle of Johnnie Walker—that is, if we wanted to. I said I'd ask my friend (who'd been talking to David's white friend), Kramer said sure, why not, another adventure. So we set off in two cars for the East End.

In David's car, a little MG, he was friendly and asking me about Kramer, was he my lover? "No, we're both straight," I said. "Me too," he said. We drove on through dark, rainy streets. "What an angel. You're really quite beautiful. Anyone ever told you that? And intelligent, too. I like you," he said, patting me on the knee. "I like you too," I said, beginning to get worried. Weird line of questioning.

In the other car, the friend asked Kramer if we were lovers. He answered in the negative. "But your friend is gay?" he asked. No, he's not, he just looks that way. "Then I think we might have a problem. David doesn't think he's gay, but he thinks Duncan is, and he just got out of prison for manslaughter. David can get violent when he's refused."

"What did he do?" asked Kramer.

"He killed a boy."

Meanwhile, we finally pull up at the curb of a dark, deserted street. David gets out and unlocks the door to a washing-machine showroom and directs me in. Weird room, no lights, just a dozen washing machines. He ushers me to the back and opens a door to a flight of stairs. "Up there," he says in a different tone of voice than before. Uh-oh. Now it's definitely creepy. He gives me a shove. I slowly ascend. The stairs open to a kitchen. David turns the light on, and I turn to look at his face. It's filled with hatred.

"I guess our friends will be here soon. Hey, where's that Scotch you mentioned?" I said, trying to be normal. I sat down at the kitchen

table. He just glared at me, then got a bottle and set a juice glass in front of me, unscrewed the cap, and started pouring. A few inches, then it started overflowing. "When!" I said, trying to make light of it. "You're spilling."

"Drink it!" he ordered.

"What about you, aren't you having one?" I asked timidly.

With that, things sped up, he picked me up roughly by my shirt collar and said, "Let me show you my flat. This is my kitchen, this is my bathroom, this is my sitting room, and this," he bellowed, "*is my bedroom!*"—and with that he hurled me across the room onto the bed. He flicked on the light and looked down at my cowering form. "You fucking little faggot cock tease! I hate little shits like you! Think you're so cute, don'tcha? Ha? Don'tcha?!?!"

"I'm sorry, you're right, I'll just go, I'm sorry I upset you," I said, getting up and making for the doorway. He swung at me and connected with my cheekbone. I saw stars. I began to scream. "Go ahead, you fucking little pansy, scream all you want! No one can hear you, and I like it! Save your breath, this joint is soundproof." With that he grabbed me and forced me face down on the bed, all the while chanting a litany of the things he was going to do, culminating with killing me. I believed him. I thought, So this is how it ends, all my hopes, all that promise, all my parents' love, just to be snuffed out by an angry maniac in some East End slum. He was very powerful, and was trying to pull my blue jeans down, but I wouldn't cooperate, so then he'd hit me again with his enormous fist. My face was jammed into the mattress. At one point he got out his cock, which was a Louisville Slugger, and said, "Look at that—is that what you wanted, huh?" and I screamed "NOOOOOO!" till he slugged me again. I could taste blood, and kept trying to writhe out of his grasp. But it was no good; I was in *his* nightmarish film, and he was going to have it his way no matter what. My ass cheeks were now bared, but I wouldn't open

my legs, and he was trying to wedge his cock up me with brute force. He's huffin' and puffin'. I felt it at my anus, and clenched shut as hard as I could, screaming and kicking all the while.

The other car pulled up outside. The guy said to Kramer, "This could be bad. Just run up the back stairs, grab your friend, and run back down here. I'll stay with the motor running . . . Now *go!*"

Just in the nick of time, Kramer burst into the bedroom acting like a drunken sailor, as if he was oblivious to the sexual assault taking place on the bed. He was singing "I Love Paris" at the top of his lungs, and doing a stumblebum dance, knocking over a lamp in the course of it. "Let's go, I gotta get up early tomorrow," says Kramer.

My assailant looked up, enraged, and tried to swat at him, but Kramer evaded his grasp. He kept up his inebriated song-and-dance routine, forcing David to get up to deal with him. I slid off the bed and scrambled out the bedroom door, Kramer right behind me, as David fumbled with his trousers, screaming at us. Down the stairs, past the washing machines, and out into the waiting sports car, with David in pursuit. The driver peeled out, David running behind the car, trying to catch up. He threw rocks at us. I was out of breath, and trembling from the terrifying experience. The driver dropped us off at a tube station, and we got on a train heading west.

I finally collected myself. "You saved my life. That guy was gonna kill me!"

Silence. Kramer eventually said, "You stupid idiot!"

"Me?! What was I supposed to do? They seemed all right. How was I supposed to know one of 'em was nuts?!"

Kramer told me the guy's story about manslaughter and prison. And then gave me the silent treatment for the next twelve hours. I tell him about the emotional distress I went through, and how since he's my best friend I could use a little compassion, but he *did* save my life, so I let it go. It was a very close call. It never occurred to me to report

the incident to the police. The next day I had a shiner and a split lip. We ate a solemn breakfast at Wimpy's.

Living with Kramer for three weeks in London has been a strange experience, since he's such a strange guy. Sometimes incredibly warm and friendly, sometimes remote and volatile. He's got some troubled waters roiling below the surface. When he was eight he was in a car crash in Colorado with his dad, who was killed, and Kramer was trapped in the car until the ambulance arrived. With his dead dad. I guess that'll do it. Did a number on his head.

Kramer flew back to Minneapolis, leaving me alone for the remaining week. I sat in the dim glow of pubs reading Chandler ("Smart-Aleck Kill," "Pick-up on Noon Street," "Spanish Blood," "Nevada Gas"). Went to a double feature (*Au Pair Girls* and *The Seduction of Inga*). Saw the Pretty Things again at the Roundhouse. Hung out in the super-modern Southbank complex, saw a terrible show at the Hayward Gallery (no paintings, just "information" that came out of computers, a bad sign). Ate in the cozy lounge/restaurant of the National Film Theatre, fresh greens and onions, pork sausages, coffee, numerous double brandy-and-gingers, vodka-and-limes, a Dubonnet on ice at midnight when a Peter Lorre festival began. Eight-hour marathon devoted to the pop-eyed freak, featuring *M*, *The Man Who Knew Too Much*, *Arsenic and Old Lace*, *The Beast with Five Fingers*, and *A Comedy of Terrors*. I staggered out at dawn thoroughly Lorre-ized.

Saw Bowie *again* at the Rainbow, even better second time around. Incredible genius. During "Starman" a glittering mirror ball cast stars over all of us. He played his new song "John, I'm Only Dancing," which was love at first hearing.

I end my days at my local pub in Finchley, the North Star. Strike up a conversation with an affable, middle-aged Londoner. Closing time. We're walking along chatting innocently when I observe an

interesting parking garage with bumper-car balconies. "It's kind of retro futurism," I say, and he says, "Yes, follow me, it's even better inside," and my warning bell goes off again. He walks into the darkness, and I follow at a safe distance. I see him in a shadowy recess, with his cock out, and he's saying "Please, please" in a whimpery voice. I back up and say, "You got it all wrong, pal," and set off to my sad bedsit, to ruminate on why this whole city seems to be bent.

I was walking down the old Kings Road when I noticed a couple of fourteen-year-old schoolgirls following me. They seemed to be all atitter. They caught up with me at the corner where I was waiting on the light. "Hello," I said with a smile. They burst into giggles; then one extended a copy of the new *Rolling Stone*, which featured David Cassidy on the cover, lying back on the grass, his chest exposed. "Would you sign this for me?" asked the breathless girl.

"Of course, darling, what's your name?"

"Sheila," she said with a fresh salvo of giggles.

I got out my trusty wide-tip Rapidograph and wrote, "To Sheila, all my love, David XXOO" right over his stomach and handed it back to her. She stared at it with awe, then looked up at me as if I was the second coming. "Thank you, we love you," she managed to get out. Then, unable to contain themselves, they ran off screaming. Oh, to be a pop star!

Time to go back to the USA.

September 5, 1972. Had to spend the night in the TWA terminal as my train to Bard don't leave until morning. Sopped up as many Black Russians as I could before the bar closed. Slept on a bench, cab to Grand Central, then dozed on the train up the Hudson. When I get there, I unpack my gear in my top-floor single room in ivy-covered Hobson. Felt like being in a treehouse. Nice windows with old leaded frames. Right across from the Greek Revival library. Then went down

to swill some of the free Pabst Blue Ribbon from a beer truck that's parked on Stone Row. Follow DuPrey down to his new room, and some guy is handing out free Scotch. I had a lot of it. I passed out, and was woken up to go down the road for some drinks. At this point I'm in kind of a waking dream. On the way, I became convinced that DuPrey was taking me off to "rub me out" (all that Raymond Chandler stuck in my subconscious). I took a swing at him and gave him a fat lip and a sore chin. But he was good-natured about it, took me to a dance where I sat passed out in a chair for three hours. DuPrey got me to my room, with some difficulty. He lives on the floor below me.

I woke up in the morning fully dressed, with no idea where I was, or even what country I was in. I looked in the corner of my room, and there was a naked boy crouched with his back to me. Oh, god, who is it? What have I done now? I said "Hello?" tentatively. He didn't move. I got up and walked over to him, and gently touched him on the shoulder. He slowly turned to face me and, looking up into my eyes with a forlorn expression . . . was *me*! Ahhhh! I raced out of the room wondering if I had somehow suffered a psychic split. A bad omen. I was shuddering with the shock of it all. My pores were secreting booze. I need a lobotomy. Welcome to a new term of higher education.

There's a cute freshman with frosted hair who I think is a rock chick. I was wrong; she's a fashion chick. I wonder what her name is. It's Hazel. She's from Philly. Sparkly eyes like Shirley MacLaine's. She raps on my door about midnight, I'm smokin' cigs with DuPrey and listening to Matching Mole ("O Caroline"). She's wearing a filmy two-piece number. She stays a couple hours, and gets me to promise to take a walk with her tomorrow.

Next evening she shows up looking like a Tootsie Pop in high-waisted yellow pants and a striped mambo wrapper. We go to haunted Blithewood, sit by the fountain listening to the burbling noises coming out of Eros's mouth. She asks if I have any romantic attachments.

Wander back holding hands, this concentrated progression of two would-be lovers. We go to her room, we're on the bed looking at a copy of *Vogue*, then she turns off the light and lies down, back to me. I reach around and fondle her excited nipples. Hearts beating left and right, we're both saying the sweetest things, all this buildup, and I roll her over and look down at her freckled face with her heavy Cleopatra-lidded eyes and glistening mouth ready to kiss. We do. Her pelvis starts going into an involuntary grind. Heat emanates from her. Next comes naked. Off goes her op-art undies. In goes me. Duncan and Hazel, all night long.

In the morning she says I fuck "like an enthusiastic little boy." She had an affair with a thirty-two-year-old man (she's eighteen). So I guess she should know.

Weekend in New York: Parents staying at the Waldorf. Dad hands me a double Scotch and says, "Here, maybe this will loosen your tongue." We went to the Rainbow Room and the Top of the Sixes. Dad's eyes twinkling at all the attractive girls. I held my mom's hand on Avenue of the Americas, told her she was beautiful, and kissed her on the nose.

My clique at the Bard dining commons consists of poet Doc Bray, who has a deeply indented chest and mad eyes, says he will be up there with James Joyce by the time he's thirty-five; then there's Jim Gardner, also a poet, full of insults, each one more disgusting than the last, losing friends fast, holds up a broken glass and says, "Here, want a drink? It tasted better before I sat on it."

Then there's John Browner from White Plains, into dance and yoga, talks in hippie jargon ("far out," "dig this," "bummer"), washes his ponytail with Phisohex. We drink gallons of coffee and smoke endless cigarettes. There's a musician from down the hall named Richard Edson, who looks like a squint-eyed Bowery Boy. Talks like one too.

Sometimes we are joined by Herb Ritts, who grew up in Beverly Hills next door to Steve McQueen. Once Herb gave me a doleful look and said he'd like to be my sugar daddy. He's got a boyfriend named Chuck who looks like Troy Donahue.

Then my best pal, handsome Rob DuPrey from DC, whose dad ran off with their French maid. He sent DuPrey off to Stockbridge boarding school with a hundred other drug addicts. He's as hilarious as Bugs Bunny. Some kid comes up to our dinner table and points at the salt shaker with his index finger and says, "Does anyone want to use this?" And DuPrey says, "Sure, thanks" and grabs the guy's finger and uses it to pick his nostril. The kid retreats in a state of shock. Another time DuPrey asks Peter Putnam (a tweedy, horn-rimmed philosophy major who tells us frequently that he's going to kill himself) if he would pass the salt. Putnam says, "I don't believe in salt." DuPrey says, "Well, whether or not you believe in salt, it *exists*! Now pass the fuckin' salt!"

Then there's my moll Hazel, who got a three-dollar Jean Seberg haircut at the barbershop in Red Hook. Very becoming to her lovely bone structure and Garbo eyes. Hazel says she doesn't know who she is—a common malady for a college freshman.

Down to Manhattan to see the New York debut of David Bowie. Carnegie Hall, no less. The joint is packed, decked out in full glam regalia. This situation calls for Pernod. Angela Bowie is swanning around with some Warholian riffraff. Eric Li is dressed as a droog, all white with black boots and suspenders. There's twenty-year-old Johnny Thunders, lead guitarist with the New York Dolls, swathed in multiple silk scarves, white leather jacket, and rooster cut. DuPrey goes over to Johnny, puts his arm around him, smiles threateningly into his hawklike face, and says, "Hi, pal." Johnny loses his cool composure.

It's all about to happen. DuPrey and I have our chins onstage, the

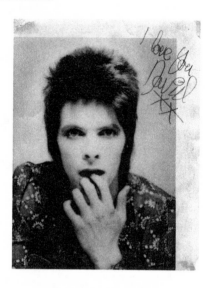

Clockwork Orange soundtrack is blaring, the strobe lights going, and out comes carrot-top Ziggy, spacesuit sleeves rolled casually to his elbows, "snow white tan," so pale he's luminous, holding a dozen roses. "I'm an alligator . . ." he sings, holding his fingers up to his different-colored eyes like goggles. "Do it again, do it again." He gives snarling Mick Ronson a passing caress, he blows his lines with laughter, it's sharp and menacing and cruel fun. "Look at those cavemen go . . ." A tear runs down his face and leaves a mascara trail. At the encore, autographed photos drop from the ceiling that say "I love you, David XXXXX." Oh, that this night would last forever!

Next day we wake up with pounding heads in the kindergarten playroom we crashed at on Thirty-third Street. Hungover but happy, we drink some V8 juice and aspirin, take the bus down to Paul McGregor's unisex hair salon, where big-busted Linda will give me a chop. She likes me, her tits accidentally-on-purpose grazing me repeatedly. Snipping away. Giving me a spiky lunar punk bull-dyke monkey cut. DuPrey went for a Jeff Beck shag. We get out, checking our reflections in the store windows. We talk in exaggerated homo-

sexual accents, lips pursed and pop-eyed at our peacock foppery. DuPrey says there were fifty murders in one day in NYC last week. There's a setting on my camera for apocalypse lighting.

Blithewood Ghost Story, Part 2

Jimmy Clifford is here from Lake Forest College visiting sexy tomboy Jenny Brown. I bump into them playing jacks in front of the dining commons. *"Jimmy!"* I cry. I tell him I'm looking forward to seeing more of him this weekend, but he whispers to me that it's unlikely

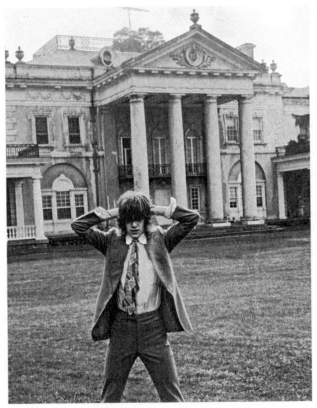

DH channeling Syd Barrett in front of Blithewood

because he's here on a mission of love. It's gonna be all Jenny, all the time. "Okay, I understand," I said with a wink. Jenny then told me she didn't like me and had no interest in getting to know me. "But we have the same bushy eyebrows," I joked. Jenny don't like herself, either. So anyone who loves her, like Jimmy, must be fucked up.

Anyway, I went to the film that night (*Dr. Strangelove*), which scared the shit out of me. I went back to my dorm thinking about Armageddon and found somber Jimmy sitting on my bed, dressed in a brown hooded sweatshirt listening to *Pavane for a Dead Princess* by Ravel. My only classical record. He'd lit a couple candles. I sat next to him. Just two Blake boys a long way from home.

"What's up, Jimmy? Where's Jenny?"

"Jenny's in love with some guy named George," he said glumly.

"I was afraid of that. I've seen 'em together. He's a big idiot." I suggested we go down the road to drink many, many pitchers of beer and drown his sorrows. He didn't respond. I'd never seen him like this, not in the thirteen years I'd known him (my oldest friend), not on any of the acid trips we'd taken together, staring up at the starry galaxies together. Why, Jimmy *laughed* at the cosmos! Jimmy could roll with the punches. Yet here he was, brokenhearted and funereal. His eyes were unfocussed; he was unresponsive. Suddenly he got up and left. "Jimmy!" I yelled. "Wait up!" I snuffed the candle out, turned off the KLH, and ran downstairs after him.

Now, Jimmy didn't know the layout of the sprawling campus, having limited himself to the center thus far. But he was behaving as if he knew it like the back of his hand, walking very fast over fields, taking shortcuts in the westerly direction of the river. I was not far behind, struggling to keep up, trying to grab his shoulder, yelling out, "Jimmy, you're going the wrong way, the bar is *that* way! Jimmy, STOP!" To no avail—he was like a man possessed, proceeding in a fixed course under the glowering autumnal sky.

"My god, he's going to Blithewood!" I thought. A place he's never been, and yet there was no hesitation in his single-minded route. Sure enough, he got to the long driveway and sped towards the entrance, under the white columns and through the front door. He'll be distracted by the students milling about and snap out of it, I thought. But no, he zoomed right past them and up the grand staircase to the second floor, down the hallway to the unmarked door to the attic, flung it open, and ascended. I couldn't believe what I was seeing. This was not the Jimmy I knew anymore. I followed him up into the attic, where the poor Mrs. Zabriskie hanged herself seventy years ago. The atmosphere up there was oppressive. It was dark, and very loud, with the kind of white noise you hear in a jet engine. The sound of whirring energy. Psychic static. *Shhhhhhh.* Jimmy had gone to the center of the room, where an old ladder led up to a trapdoor to the roof. He started to climb. I crossed to the base of it and yelled "JIMMY!!!!" over the din of the place. I looked up and saw him fling open the hatch, saw the stormy purple-and-gray sky scudding by overhead, saw him lift himself up, then heard him scream! Then he was up and out. To do what? Jump? I scrambled up after him, pulled my head through the trap, and looked around, fearing the worst. I felt a great relief when I saw him leaning over the railing, sobbing. I sensed he was himself again. I relaxed. Just as I did, I felt four very cold fingers pass over my neck! A kind of icy caress.

I leapt up with a rush of fear-induced adrenaline, and joined Jimmy at the railing. He was in a hysterical state, breathing heavily. "Dunc, I don't know where I am! Something just grabbed me by the neck!"

"I know, Jimmy, she grabbed me too. We gotta get out of here. Let's go back down."

"I can't go back in there—that's where it grabbed me!"

"I know . . . but it's the only way out. Let's get it over with. You

first." So down we went, pulling the trapdoor shut over us. The psychic roar of the attic was louder than ever, but we were gone in a matter of seconds. Down through the dorm, the girls giving us funny looks. Out the door and into the blustery night air.

Jimmy said, "The last thing I remember was being in your room after Jenny dumped me. I don't know how I got here."

"You were summoned. Somebody felt your pain." I told him the whole story as we walked down to Adolph's. It didn't fit into Jimmy's scheme of things. He had no room in his life for ghosts. And yet, he couldn't explain it. We got royally drunk.

. . .

Meanwhile, Hazel has given me my walking papers and taken up with a handsome bisexual artist who makes cool sculptures out of chrome car bumpers. He loves Motown. Loved me last year. Can't say I mind.

I paint in the studios at night, trying out the abstract expressionism I dig so much. De Kooning, Tworkov, early Alfred Leslie. Trying to get my painting to grow from the inside, fighting the inclination to design an abstract picture and fill it in. It's hard. I'm using acrylics, which after all are just plastic. They look shrill to me. I leave the dirty stain of my charcoal underdrawing visible to give it a little bite. Put a color down, study how its power is controlled by the colors next to it. All-over painting, turning it this way and that.

Afterwards I toddle off to Adolph's to meet DuPrey, who's got beautiful blond Alice Wilcox cooing by his side. We all get drunk, and Alice asks us to take her back for a ménage à trois. God bless her dirty mind. Through the haze of alcohol I can just barely remember DuPrey slowly undressing her like a doll, watching her plump pink lips fellating him. He looked like a wolf. She looked like Bardot. We all kissed each other a lot. I don't think I was good for much, bonerwise. Irish droop. Whiskey willy.

. . .

In Red Hook one night with the fellas. As we left the old movie theater and walked past the gas station, a townie stopped me and said, "Hey, why are you so queer?!"

"Because I like it," I shot back.

"You really do?" he asked incredulously. Then there was an explosion in my head as his unseen fist crashed into my nose. I toppled over, then slunk off, but he and his cronies followed me. My pals came to the rescue, Gardner, Boris, DuPrey, and Werner, my valiant knights. It was a real western showdown. After the face-off with the grease monkeys, we took off in Werner's old Pontiac with the illuminated orange Indian-head hood ornament.

. . .

It's Sunday morning and I'm sitting in DuPrey's room after a shower in the basement, where we used Wella Balsam on our hair. Nice smell. We're listening to a bit of Bach and talking about the film *If...*, which we dug so much. Like the part where McDowell kept putting on the Sanctus from *Missa Luba* over and over. I tell him about an Excelsior kid I knew who was hallucinating on belladonna all night, comes home and sees his mom hanging from a rafter, all blue in the face. He thinks, Wow, weird, and goes to bed. Next morning she was still there. Did herself in. My pal went off to the nuthouse, never to be seen again.

. . .

Trouble! A panicky long-distance phone call tells me that a complication has arisen in my charmed life. Lainie is nine weeks pregnant with *our* baby! On August 7 her parents dropped her off at my house about ten. She wanted to have a farewell fuck so I could remember what I was missing when I was in London. We went up into the loft

and turned the TV up so my parents couldn't hear us. Lainie told me her period was starting tomorrow so she was safe. My mother interrupted in her nightgown (she couldn't see us), saying, "Don't stay up too late." Anyhow, it *was* a special shag, unlike anything we had experienced before. We both came together, and both heard bells ringing. It felt momentous. Lainie said she remembered thinking, That one did it! Now our pleasures have caught up with us. Time to pay the piper.

Of course the poor girl is scared to death. Says she's "in hell and filled with bad thoughts." She was brought up Catholic. She's still in high school! She's depending on me to get her out of this mess. My responsibility. I need $250. I had $45, borrowed $60 from Browner, $25 from DuPrey. Jesus Christ! A human being! DuPrey said he'll take the baby and have him playing guitar in a couple of weeks. I think of Carol Lynley in *Blue Denim*. I think of Steve McQueen and Natalie Wood in *Love with the Proper Stranger*. I contact Planned Parenthood about abortion clinics (against the law in Minnesota). I eventually wire Lainie $150. She borrows the rest.

· · ·

Another wild night. Got drunk on Löwenbräu in the gym where a band was playing Todd Rundgren covers. Alice Wilcox drags me off to the bar for some stingers, telling me that I have the mind of Kierkegaard. What?! She's given to that kind of existential malarkey. But her mouth is like Brigitte Bardot's, so I concentrate on that. At two-thirty the lights go on, and Alice and I make that long walk back to campus. I'm suffering from alcoholic psychosis and bolt into the woods. She can't find me, so goes to DuPrey's room to enlist some help. Wakes him up. He says, "A dead Duncan is better than a tired Rob," and goes back to sleep. An hour later he hears her dragging me up the stairs, Beatle boots banging, me talking gibberish. I wake up at noon and find her naked in bed with me, smoking a cigarette.

"I found you in the mailroom," she says proudly. My heroic nurse. DuPrey said of her, "Well, she may not be smart, but she sure is stupid."

October 27, 1972

Lainie flies into NYC, takes the train up to Rhinecliff. I spy her gorgeous self sitting on a bench in the waiting room, under the yellow insect lights. Off to Adolph's, then back to my room for our last night of fornication. Finally a temporary room of our own, not a laundry room or a locked bathroom or a briefly borrowed bedroom. She's twelve pounds heavier, with swollen tits laced with delicate blue veins that weren't there before. Our lovemaking goes through three records on the turntable, Roxy Music, *Space Oddity,* and a Blue Note LP. We climaxed during an Art Blakey drum solo.

Abortion morning—raining, of course. Leave at dawn. Lloyd has agreed to drive us down to the Central Women's Center on Lafayette Street in Manhattan. I squeeze Lainie's hand on the two-hour ride in Lloyd's blue Beetle. When we delivered her, they herded her and the rest of the unwed mothers in like cattle. Lloyd and I walked the nine a.m. streets. Past the junkie scarecrows. Crazy hopheads. Panhandlers. Drunks with their hats on backwards. Some weirdies, some queeries, some filthies, some newies, some oldies. Vapor rising from manholes like hot breath. Eagles leaning over the parapets of the gleaming Chrysler Building. There's more challenge here in NYC. I'm overprotected at Bard. This is a normal day for most people. My child's short but brilliant career ends in one hour. "We were wrong, we were wrong, but sooo in love" flits through my mind. We picked Lainie up at two p.m. Her uterus completely vacuumed out. Much relief all around. After the fifty acid trips this girl had taken from eighth grade on, what would she have given birth to . . . a fish? Stan Laurel? Dear thing, I ouch for you.

. . .

Back on campus we sit through *Red Desert* by Antonioni, starring the ridiculously beautiful Monica Vitti. Lainie's bored out of her mind by it.

Halloween party in the gym. Lainie went as "the Kid," backwards newsboy cap and blacked-out front tooth. I went as Egon Schiele. We went back to my room and lay around talking. She wants to be an anesthesiologist or a *Vogue* model. Finally we have a room of our own with *no* parents. We can't have full-on sex, so we try out the moves adolescents do. We want to make the best out of this unfortunate situation. A two a.m. blow job, followed shortly thereafter by another, lots of thrillingly dirty acts. A whole week of heavy petting (as the high-school guidebook calls it).

. . .

Over there across the room, flopped on the single bed, Lainie's licking her salty lips, underneath a poster of a gorilla merrily carrying off a laughing brunette wearing nothing but silver dance shoes. I've never lived with her (or any girl) twenty-four hours a day. What is she thinking? She doesn't talk much. She's a mystery. She's butch like a bratty boy, childishly apes my "clever" sayings. But then she's back and lovey-dovey again. Doctors said she couldn't travel for a week. So here she is, frustrated at not being able to fuck. That's one thing that gives her confidence.

. . .

When asked what abstraction means to him, de Kooning tells a story about an old Armenian man who used to pick up free stale bread. De Kooning followed him to his house to see what he did with it all. Peered in his window. The guy crumbled it onto his floor to use as

a carpet. De Kooning said, "I remember he had a very abstract look on his face."

· · ·

Thanksgiving in Minneapolis. This house is the length of my dad's old sub chaser. Watched *The Counterfeit Traitor* and *Marriage Italian Style* on TV, a novelty since I don't have a TV at school.

Went to party at Angie's new apartment on Freemont Avenue, covered with posters of Bowie and Bolan, drank a bottle of rum, argued with Lainie, called Dad to say I wouldn't be home, and woke up with Angie. Strong sunlight streaming in. Hangovers always make me horny. Technically we are both sworn to others, but . . . she was looking slim and beautiful, and being very naughty, tugging on my sex hairs, so we made illicit love. Took a bath, then went back to bed for another bout in the perfumed garden. Something delicious about sex with your ex.

· · ·

Back to Bard. Listening to Messiaen's *Turangalîla Symphony* clicking its incisors. One of Jack Bruce's favorites. And Joni Mitchell sings, "It's the unknown child / So sweet and wild / It's youth / It's too good to waste." Youth is more aware of division than of continuity. Youth cult must be served.

Drawing is a way of learning to see. A way of reasoning on paper. I'm striving to do it with ease and simplicity. I've got a long way to go.

Androgynous Chinese pal Eric Li comes to visit me at Bard from Columbia, where he studies concert piano. We started drinking about noon, wandering around the snowy landscape in our rock 'n' roll clothes. Some girl asked me, "What is the sex of your friend?" "Male," I answer. Eventually he got picked up by a pretty girl named Emily. I woke up at four a.m. sleeping next to a trash barrel. Feeling

a little unwell now. Went down to the cellar shower room, lay on the cold floor, and let the hot water splash all over my skull.

December 15, 1972. Read *Strait Is the Gate* by Gide and *Nightwood* by Djuna Barnes. I have done eleven canvases in the last three months. None I'm satisfied with.

. . .

It's back to Minneapolis for Christmas. Dad and I go skiing. Sitting in the chairlift, Dad is worried because I don't know about economics or electricity or insurance or nuthin'. So I tell him that he don't know what I know, and if I'm gonna make it as an artist, I gotta be *really* good. And maybe the fun is in getting there. I'm not worried about money, I'll figure something out on the way. Then he gives me a lecture on Dale Carnegie's *How to Win Friends and Influence People,* a book he swears by. Ask strangers questions, win them over. Makes me ride the chairlift with strangers to practice the Dale Carnegie technique. Pretending to be fascinated by utter bores is my idea of hell.

Do you drink in the day?
Do you drink alone?
Do you drink to feel better?
Do you ever forget what you did when you were drunk?

Okay, all right, yes to all of these. My uncle tells me it's all right to drink, but it's never all right to get drunk. Where's the fun in that?, I'd like to know. I wonder what my liver looks like these days. My body is my laboratory. One of the things is, drinking facilitates adventures, especially of the erotic variety. It's like entering an alternate universe where anything goes. The night is up for grabs.

. . .

The Lainie and Angie Chronicles Continued. Lainie and Angie are best friends. We're in a triangle. A tug of war. Back and forth. Angie wears sexy schoolgirl clothes. Angie and I pretend we're Nick and Nora Charles, which leads to bed. Of course this makes Lainie mad and she threatens us with all kinds of punishment. She prides herself on her hot temper. Loves drama. When she sees something in my eyes that doesn't spell her name she goes nuts. Very narcissistic. I think of that song "How Could You Believe Me When I Said I Love You When You Know I've Been a Liar All My Life?" A dirty, stinkin' liar at that. Boys will be boys.

We're all keen on the new Lou Reed album, *Transformer*. He's jumped onto the glam bandwagon. "Satellite of Love" is pretty great. And "Gigolo Aunt" by Syd Barrett is sublime.

January 1, 1973. Washington, DC

My parents shipped me off to my sister's for the Bard field period, thinking it would be safer than letting me stay in Minneapolis with my gang and all. "Unforseen dangers," they called it. "Remember, we're working *for* you, not *against* you," said my dad. Mom says, "I hope you marry a rich girl, it's the only hope you've got. You're the most impossible human being I have ever known in my life."

It's good, a new inner city to explore. Holly and Barrs live in a nice hundred-year-old, three-story, red stone row house, 646 East Capitol Street, with a basement I can use as my studio. The nocturnal pink glow that comes in the bay window is from the crime lights. DC is a very black city. I'm listening to Grant Green's *Street of Dreams* to get myself in the right mood. Reading Sartre's "Intimacy," which is just like an angsty French movie. Riding the bus to Dupont Circle to buy

a sack of records. Thinking about all these brown-skinned people's lives.

· · ·

DuPrey's at his mom's in Rock Creek Park, so he picks me up and we hope to get into trouble just so we can get out of it again. We drive past Lafayette Park, the Capitol, the White House, the Lincoln Memorial, all spotlit at night and silent. We hang out at a rock club in Georgetown called Apple Pie, peopled with glamourpusses: flash guitar slingers in black mesh and python boots; hennaed gays in platform sandals; scarlet women with tits like hunting horns, rolling their eyes like planets, legs opening and closing at will. Six-foot-five vultures with colored beaks and bangles. We try another teen club, called Your Mother's Place, and learned that Roxy played a set there three nights ago. We were crushed. The greaser crowd didn't even like them! Another one, called Pier 9, multi-leveled, spacious, and mostly gay. Pretty wild in there. I met a beautiful girl called Genowefa, who has a high, breathy voice and big knockers that don't really go with the rest of her waiflike persona. She's twenty-six and is from Germany. Not only did she see Roxy three nights ago but she slept with Eno! She told me I was pretty, looked French, was just a kid, and gave me her phone number. And the dance floor is pounding "Crocodile Rock."

· · ·

Put in a ten-hour painting day in my makeshift basement studio, then went off bar hopping with DuPrey. Went to a sleazy strip bar filled with Marines. One dancer toyed with me, took off my clip bow tie, and attached it to her nipple. Danced to Led Zeppelin on her lighted platform for a while, then instructed me to remove it without using my hands. She ground her breast into my face while the Marines guffawed. I walked away with my polka-dotted tie hanging

from my mouth. Then back to Apple Pie, which has got a fab British jukebox. Filled with aggressively loose women, dressed in the slutty fifties getups so in vogue these days.

A group called the Cherry People is playing, with a phenomenal guitarist called Punky Meadows. There's lovely Genowefa, who said she had been looking for me. "Men promise you everything and give you less," she says. DuPrey and I drive her home, and we make out in the backseat. She's so exotic and nice. *Très feminine.*

I slept over at DuPrey's and we watched *A Night to Remember* and I started bawling when the father is reconciled with his son as the *Titanic* belches fire and the band plays "Rule, Britannia."

Holly's at work at the Board of Trade, Barrs at the Department of Transportation. Alice Wilcox came over on her lunch break. She's interning at a law firm. I take her down to my studio. The radio was on and "Reelin' in the Years" was playing, by previous Bard graduates Steely Dan. "You been tellin' me you're a genius / Since you were seventeen / In all the time I've known you / I still don't know what you mean," sings Donald Fagen. We looked at my new paintings (a big one of the Shadow that is pure pulp), drank a couple screwdrivers, and finally had sex on the floor. A matinee, I believe it's called. She kept her boots on. I have to say I can't really connect with that girl, as sexy as she is, we're like ships passing in the night. Her personality seems a put-on. There's no there there, as Gertrude Stein said. She went back to work. So did I.

DuPrey turns up at the front door, wants to know if I can come out and play. We hit the bookstores of Pennsylvania Avenue, looking at Ungerer, Gorey, remaindered erotic art tomes, etc. We entered a pet store that seemed lost in time. No proprietor visible. First room innocent enough—birds—but the shop continued down long corridors, getting darker and darker. We came upon a six-month-old chimp, name of Hannibal, very unhappy, bashing his head against the bars. The chimp extended his hand for me to shake (I swear), and I took

it in mine. His hand felt like pliable black plastic. He stared at me, sizing me up. I think he decided against me, because he started throwing a bunch of crap at me: wood chips, scrapings, smelly stuff. Was this Twilight Zone shop in fact run by funny animals? At any given turn I expected a huge black arm to hook me and drag me off.

Rendezvous with Genowefa at Pier 9. She looked ravishing in her deco clothes, brown crocodile shoes, her hair piled up over her long neck, her incongruously large breasts harnessed in a lace brassiere. (She wants to get a breast reduction, which is a good idea.) We danced amongst the high fashion types, the pretty boys, the snazzy girls, the lesbians, the gawkers. Slow dances were best. She's got funny mannerisms. Coquettish. Says she's addicted to happiness, but ultimately she seems sad. I should send her a dozen roses. (I don't.)

Meanwhile I watch a new documentary, *An American Family*, featuring Lance Loud, on PBS and it's really good.

Smoke some hash and have a solitary wander through Dumbarton Oaks to think my own thoughts, drifting down a path, see a giraffe's head peeking above the treetops. Good hash! But no, I've arrived at the zoo! Chimp picking up a peanut with his toes in the house of smelly monkeys. Great apes smoking cigars like gang lords, black lemurs in conversation with timid spider monkey. Two pandas sit politely next to each other eating carrots out of their dainty fists.

DuPrey takes me to one of his favorite haunts, the Admiral Benbow Inn. He says it reminds him of his favorite book, *Auto-da-Fé* by Canetti. Dark-red-lacquer gay dive with six-pointed silver stars on the midnight-blue ceiling. A florid old English queen sits next to me, buys us drinks, and says he gives the best blow jobs in town. Does a few funny Spike Milligan routines. DuPrey tells him to go sit on an egg. "Now don't you go puckering up your lips for another stinger!" he says, and orders another round.

Another night I get my sister and her husband high (for their first time ever) on hash. My pernicious influence. We go hear Les

McCann at the Cellar Door, and he plays his crossover hit, "Compared to What."

The Washington Monument isn't really a phallic symbol because it took them four years to get it up.

Farewell, Washington, DC.

SPUTNIK

Duncan Hannah

January 29, 1973

Back at Bard for my last semester before I transfer to Parsons School of Design in Greenwich Village. DuPrey flunked out! Now he's working in the kitchen and staying with his girlfriend, Sheryl.

Records
The Academy in Peril, John Cale
Filles de Kilimanjaro, Miles Davis
Nefertiti, Miles Davis
Earthspan, Incredible String Band
Aladdin Sane, David Bowie
For Your Pleasure, Roxy Music
Raw Power, Stooges
Urban Spaceman, Bonzo Dog Band
Led Zeppelin 5

I want to be a movie actor so I can get my screen life mixed up with my real life and can't even remember who Duncan Hannah is anymore.

Somebody's nuts. Is it me?

When I was about twelve I wrote J. Edgar Hoover a letter explaining that I wanted to be a G-man. He wrote a personal letter back, told me what a fine young lad I was, signed with a big flourish from his fountain pen. I've had a change of heart since then.

All the love letters I get sound like T. Rex songs.

UNITED STATES DEPARTMENT OF JUSTICE

FEDERAL BUREAU OF INVESTIGATION

In Reply, Please Refer to
File No.

WASHINGTON, D.C. 20535

November 2, 1965

Mr. Duncan Hannah
7 East Saint Albans Road
Hopkins, Minnesota 55343

Dear Duncan:

Your letter of October 27th has been received, and I certainly appreciate your kind comments regarding the work of our organization.

In response to your request, it is a pleasure to enclose some booklets about our activities which I hope will be of assistance in the preparation of your report. Perhaps you will also wish to read "The FBI Story" by Don Whitehead. This book describes in detail some of the cases investigated by this Bureau. You may be able to obtain a copy of it at your school or local library.

I would like to point out that material relating to fugitives currently sought by this Bureau is sent only to law enforcement agencies and areas in which the widest coverage can be obtained; however, I have included some cancelled Identification Orders on several individuals previously sought by the FBI.

With respect to your inquiries, I am also sending some literature describing the only positions which are available in the FBI. Your place of assignment would be contingent on your qualifications and our employment needs at the time you make application.

Sincerely yours,

John Edgar Hoover
Director

Enclosures (8)

∙ ∙ ∙

NYC with Eric Li, math wizard, the ching-chong-chinaman (his words). We get loaded and go see Free and Traffic at the Academy of Music. Walk through the lights of the city. Bought some English imports, Bowie tickets, corned beef sandwiches. We eat street hot dogs for thirty-five cents, they pop when you bite into them. They're made out of rat noses or something.

Down to the Mercer Arts Center for a Valentine's Day party featuring the New York Dolls. Also featured are Wayne County, Eric Emer-

son, and Suicide. It's like watching the birth of a wildly frantic and perverse new subculture, bordering on mass transvestitism. Where do all these kids come from, with their teased hair, their gold lamé, their plastic charm bracelets, their dyed rabbit's feet, and their cap pistols in studded holsters? "Trash, pick it up!" sings David Jo. At five-thirty a.m. we went to the after-party in Jungle Red Hair Salon, filled with painted ladies of both sexes, platinum blondes with black roots, and everybody preened in the endless mirrors.

Staying at Eric's dorm at Columbia. I salute Athena in her corroded brass throne on the steps of the library. Down into the graffitied subways (where a sad soul recently committed suicide) eating cashews on the way to the Whitney Biennial. My mind conducts a process of elimination, discriminating between what's good and bad. Then we pay five dollars for a ninety-minute hard-on induced by the much lauded *Deep Throat*.

Reading

Our Lady of the Flowers, Jean Genet
A Man and a Maid, Anon.
Maurice, E. M. Forster
My Life and Loves, Frank Harris
Wuthering Heights, Emily Brontë
Bonjour Tristesse, Françoise Sagan
Vile Bodies, Evelyn Waugh
Pan, Knut Hamsun
Black and White: A Portrait of Aubrey Beardsley, Brigid Brophy
Lady Chatterley's Lover, D. H. Lawrence

I received a letter from my mom today. A pair of pink silk panties fell out of the envelope. Mom writes, "Speaking of *Deep Throat*, I found the enclosed item under your bed. Perhaps you can return it

to its rightful owner, poor thing, whoever she is." Does she say "poor thing" because the owner is going around without any underwear or because she had the misfortune to meet me?

My painting teacher, Murray Reich (a color field painter), studies my new Diebenkorn-influenced painting. He talks about Matisse's affinity for the color blue. "You have a natural handling for paint, and terrific taste," he tells me in confidence. Except I'm drawn to the Pre–Raphaelites, like Millais, Gérôme, Burne-Jones. That's bad, he says. I feel lazy when I think how good Schiele was at my age. Then I think how much better I am than most of my contemporaries. It's all relative. I feel the pull both ways. A set of contradictions. I scored 590 on my English SAT test, 550 in math. That's not so hot.

Movies
More (1968)
Joy House
Shadow of the Thin Man
Yesterday, Today and Tomorrow
The Assassination of Trotsky
The Garden of the Finzi-Continis
Chloe in the Afternoon
McCabe and Mrs. Miller
This Man Must Die
A Fistful of Dollars
Breathless (again)
Such a Gorgeous Kid Like Me
The Day of the Jackal

Spring Break in Minneapolis

Leave a party on Girard to go to Sutton's, the friendly gay bar where a guy like me won't get beat up, with irritable Lainie and cute Claire

who has pink, green, silver, and black curly hair. We found $110 in crisp bills in the parking lot. The girls are shrieking with delight. We dance and drink and go home and Lainie is determined not to succumb to my advances, is affecting anger at me, but it doesn't take much to change that. After the lights go out the fun begins. She begins to smolder. She's as lovely and passionate as ever. In fact, insatiable.

· · ·

Back at Bard, I'm sitting in the dining commons, and a dopey freshman comes up to the table crying. "What's the matter?" I say.

"Picasso's dead!" she blubs.

"Finally," I say.

"How can you say that?!" she cries.

"Look, he hasn't made a good painting in decades. It's all been schlock. He believed in his own genius too much. Didn't edit himself, just pure self-indulgence. What happened to him, did he choke on his own ego?"

"Fuck you," she said, and wandered off to find some sympathetic mourners who fall for Pablo's hype hook, line, and sinker . . .

· · ·

I'm flunking Medieval Art class, I thought it was gonna be knights and stuff, but it's about buttresses and boring tapestries. Not my bag. I find it almost impossible to learn things I'm not interested in. But today I painted for twelve hours, my mouth watering the whole time. It's a continuous struggle to incorporate good drawing with good painting.

The Hurricane Boys come visit me at school. We drink beer by the waterfall. Down to the city in an old Rambler, where we go to the top of the Empire State Building. We walk along Fourteenth Street past nail salons, soul brothers, multicolor Afro-fright-wig shops. Then

Kenny's Castaways with petulant Kristian Hoffman, who's Lance Loud's best friend from Santa Barbara. The Dolls are playing loud and sloppy. The Hurricane Boys got thrown out for being rowdy, so we got a cab up to Columbia to crash at Eric Li's. We had a bottle of Duncan's Scotch, the cheapest there is. Delivers the hangover *before* the high. Derangement set in.

Moderation evaluation by my art teachers (Matt Phillips, Murray Reich, Jim Sullivan, Jake Grossberg), whereby they assess my progress at the halfway point of my Bard education. I laid out six canvases, some drawings, twenty-five slides. They said . . . I had great vitality, a great sense of design and composition. Jake said that I am, and will be, an artist and occasionally make very beautiful paintings. My hand is consistent. My work meanders through style and quality. I don't do follow-ups. They say by painting a de Kooning–esque nude, and then a television set, I cancel myself out.

I replied that I was curious, open-minded, and only twenty years old. We all start out by aping somebody.

They said, "Yes, but it looks like you see something you like and then say, "I wonder if I could do that," and then you do, to prove to yourself and others that you can. It's a waste of energy."

"But I'm trying to pull all my interests together."

Phillips said (puffing on his pipe) that I have a crappy high-school hangover, with a tendency towards illustration (dirty word around here). He said I needed a world view, a stance towards the universe. "Do you think that anything you do is good? Huh?"

I had asked them what I would do upon graduation and they said bartend, drive a cab, construction. All that for my $24,000 education. "Why don't I just work as an illustrator?"

"Because if you do you will never be a fine artist," they answered.

"What about Homer? Hopper? Warhol? They were all illustrators."

They shook their heads in woe. "You have the capability to be a good third-generation abstract expressionist. Don't fuck it up."

"I don't think that's me." They're mad because I'm leaving. I want to learn to paint like Manet, if only to reject it later on. If I move into abstraction, I want it to be through the gateway of representation.

. . .

Masturbation on Campus. Last year Lloyd Bosca and I quietly crawled up a fire escape to peek at mysterious oddball W.S., a nerdy giant who would return to his room after dinner every night, lie on his bed, start playing solitaire, then get out a pot of Vaseline and his enormous schlong and begin masturbating, all the while playing cards! I swear to god. Very Diane Arbus.

Then there's D.G., who DuPrey discovered in downstairs men's room of the library, masturbating to his reflection in the mirror with a plastic bag over his head.

. . .

I was failing anthropology, but was told I could get a C if I wrote a paper, which I put off until the night before it was due. So, with the help of a bottle of Pernod, I wrote an extemporaneous paper called "The Masturbatory Cycles of Monkeys," fully illustrated with drawings of the onanist monkey's expressions at the moment of orgasm. The teacher wrote at the bottom, "Very funny, Mr. Hannah." (In fact, I was failing everything, but Nixon pulled an aggressive move in Vietnam, and the antiwar movement amped up. We were told if our demonstration activities conflicted with our studies, we could write a note to the dean saying so, and we'd be given a C for all our courses, which I did. Lucky break for me.)

One night I was sitting in Adolph's bar at two a.m. with Cy Davies, a junkie whose dad is a famous Washington, DC newscaster. I'm dressed up as a biker: my new motorcycle jacket, a greasy quiff, jeans, biker boots, maybe a little rouge. We were quite well oiled, talking about the Boston Strangler, when who should stomp in but

three members of the Kingston chapter of the Hells Angels. Uh-oh, I thought. Wrong time to be dressed as a biker. They surveyed the place, then their eyes landed on me. "Look what we got here! This cat looks like a faggot!" Another said, "Yah, he do look like a faggot!" With that, they hoisted me up and punched me in the face.

Davies said, "Who the fuck are *you*?"

The biker dropped me back into my chair and directed his attention to scrawny ol' Davies.

"Oh, so *you* the tough guy!" said the biker with a smile.

"Yah, maybe I am," he said foolishly.

"Meet me outside, then," says head-biker.

Davies follows him out through the side door and finds a .45 automatic aimed at his forehead.

"Still tough?" says the biker.

"No, sir," says Davies, white as a sheet. He turns and goes back in, hides behind the bar with Adolph, who's calling the police. The bikers took off with a roar of Harleys.

May 1, 1973

Down to the city with DuPrey to see King Crimson at the Academy of Music on Fourteenth Street. Many of their fans are stumbling around on Quaaludes. The band was lit by blinding silver light, like the Blitz, expertly executing their colossal science-fiction psychodrama like a pack of deadly lab technicians. I gripped the arms of my seat in terror.

. . .

There's a freshman dance major named Jordan. Very pretty. Very clean, like a Swiss miss. Big gray Madonna eyes. She has a half-moon smile, crooked teeth, lustrous light-brown hair. She wears a delicate gold cross around her neck. All the lesbians are crazy about her. At

closing time at Adolph's one night, we're all about to leave. "I like you, you know," I say to her casually. "Yes, I know," she says. "Are you still going out with Crystal?" I ask. "Not anymore," she says, smiling. "Then why don't you come home with me?" I ask. "Okay, I will." She's got an old green Triumph convertible with Jesus on the dash, smells like old leather. Drives us back to my little room. Candles. Undress. Urgent mouth. A lithe dancer's body, the curve of her stomach all toned and smooth. Beautiful breasts, with areolas that were the same color as her unpainted lips. Is this falling in love? We press close and look each other in the eyes. We get horizontal, a nudging cunnilingus, she tastes like the sea, she clasps my hard-on, she says "Don't come in me." "I won't." The gush from the cap of my cock arches over her taut torso to her breasts, filling up her belly button with liquid life. We're sticky and happy, listening to "The Girl from Ipanema." Entranced with our delicious secret.

So begins a new liaison, forged in lust, absorbed with each other's bodies and minds. She has a bottle of Quaaludes, which only make me fall down stairs, but then, I'm always drunk. I take nude pictures of her, underneath the posters of Jesus she's got on her wall in her sunny room in Manor House. I don't understand the Jesus thing, it's a first for me, but her faith doesn't seem to inhibit her carnality one bit. She dreams of Nijinsky. We hunt for a cat under the covers, only find each other. I did some ink drawings of her pretty vagina, very carefully, really looking hard. She's very acquiescent.

· · ·

Goodbye, Bard College. You were good to me. I learned a lot, in a roundabout way.

ATOMIC EEL

Minneapolis, Summer 1973

Early June. It's been raining for two weeks, everything very green. I'm going to summer school at the U of M to make up eight credits. Astronomy and sociology. Because Parsons is just an art school and my parents insist that I get a BFA. These two courses were conceived for stupid football players, I was told, "snap" courses that anyone could pass. They sure are boring. I doodle during class and never read my textbooks. My dad drives me there in the morning in his LeBaron convertible.

. . .

Wayward lass Lainie has got hair that smells like a haystack. She looks like she may not be playing with an entirely full deck. Her femme-fatale contours shifting under a thin dress (she's wearing a duck dress—you can see up her quack), her wobbly eyes in a faraway gaze. She's listening to Eddie Cochran's "Somethin' Else." She's got a scab on her elbow from roller-skating down Hennepin Avenue. Always the center of attention. She decides on a bath, so I sit on the pot to watch her naked eighteen-year-old self wash her hair. I smoke a Gauloises. Splish splash. I think of Bonnard. I think of Piccoli watching Bardot in *Contempt*. She's laughing and being her dizzy self. We go out dancing, where she causes a scene, spills her drinks, gets in fights, plays aloof, flirts, apologizes. Later in bed we iron out all the disharmony with gentle lovemaking, while a rainstorm rages out-

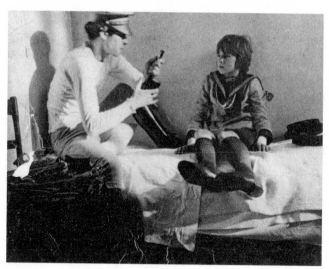

The Conformist

side. I knot her dirty brown curlies between my knuckles, squeeze her hand as she lets go. Everything is said in the bed.

Jimmy and I go see *The Conformist*, which blows our minds. Dominique Sanda pulling down her leotard and saying, "Embrace me." Jean-Louis Trintignant so good. It's been thirty years since WWII.

Summer films
Last Tango in Paris
The Conspirators (Hedy Lamarr)
A Place for Lovers (Dunaway and Mastroianni)
Arsène Lupin
Last Year at Marienbad
Night and the City
Stolen Kisses
Dillinger (Michelle Phillips)
Belle de Jour
The Mackintosh Man (Sanda)

Murmur of the Heart
The Return of the Thin Man

When Dad gets home from work, I say, "How's everything in the salt mines?" He says, "Thanks for remembering, Son." He puts on some classical music, then changes the record. "I hate sopranos," he says, sipping at his martini. He tells me that for every fifty dollars he gives me, he's got to earn a hundred and twenty. Taxes. We watched *Goodbye Mr. Chips* with Peter O'Toole and Petula Clark and he got sad. "Is it because it's about the new replacing the old?" I ask. He looked across the room at me, dressed in my sailor suit, and his eyes got like a basset hound's, and he said, "Yes." He told me I don't meet the requirements of leading a happy, successful life. "You've resisted instruction as early as you could talk." He's appalled that I don't wear underwear. He says I'm too critical and cynical. He's afraid I'm stoic. Mom's drunk and tries to summarize as if I weren't in the room, ends by saying, "In spite of the fact that you're a whole lot of trouble, we still love you." I feel queasy.

Records
On the Boards, Taste
About Us, Stories
Earthbound, King Crimson
Last Tango in Paris, Gato Barbieri
New York Dolls
Vintage Violence, John Cale
Pigmy, Keith Christmas
Mott, Mott the Hoople

Summer reading
Poems, Cavafy
Breakfast at Tiffany's, Truman Capote

The Day of the Jackal, Frederick Forsyth
Justine, Lawrence Durrell
La Maison de Rendez-vous, Alain Robbe-Grillet
Claudine, Colette
Brighton Rock, Graham Greene
The Story of Venus and Tannhäuser, Aubrey Beardsley
Ashenden, Somerset Maugham
Parties, Carl van Vechten
Hunger, Knut Hamsun
The Big Knockover, Dashiell Hammett

. . .

All our gang are concerned about the extent of our drinking. We all talk about how we are *not* alcoholics. But it is so addictive. It's everywhere. Aren't we too young?

I hope I'm not an egomaniac. I dislike egomaniacs.

Marlon Brando broke a photographer's jaw two days ago.

There's three billion people in the world right now, more than all the other humans since time began. The world's doubled since I was born. Not good.

Got my grades from Bard, honors in painting, pass in drawing, B minus in Victorian Literature, C minus in Medieval Art.

Sherlock Holmes said your mind is like a living room—you furnish it to your own specific needs, but most people put just any old lumber in there.

June 20

Kramer's new flophouse. Three sneaky-looking Siamese cats in the front yard, broken-down porch in back. He's got a cute girlfriend called Pauline. It's like she's on Spanish fly all the time, pulling me into the bathroom during a party for a wet kiss and a feel. She's from

the wrong side of the tracks. I've read books about girls like her, with titles like *Teenage Tramp*.

To be young and in Minneapolis in 1973. Down at Suttons, they're using amyl nitrate inhalers (poppers), which makes your heart explode. Lainie is the obnoxious belle of the ball. "Hey, punk," I say in greeting. "Oh, baby," she replies. She blinks dumbly, offers me her tongue.

Back at her apartment she sat naked at her dressing table. Lit a cigarette. Looking so young and pretty, her smudged face, her slender arms raised to do up her flaxen hair. She laughed, wrinkling her nose. A marvelous creature caught in the embryonic stage of her development. Filled with flights of fancy, believing in the absurd. I approach her and gently rubbed her shallow ribs, her white flanks. She tapped with her bare feet on the carpet.

We are students of love, entangled with possessiveness, feeding on jealousy and lust. Oh, the messy debris of our lives! We are all in the process of unraveling. "It's too good to waste," as Joni Mitchell says.

June 31

At the country club lying in a chaise longue by the aquamarine kidney-shaped pool. The umbrellas are a faded blue; they blow over in electrical storms. Watching the seventeen-year-old girls walk by in their shocking-pink bikinis. I launched a mechanical submarine in this pool when I was a kid. Gone now. The girls walk by again, brushing against my old blue White Stag jacket, then park themselves behind me. Wet explosion of a lean muscleman springing off the high dive, doing a can opener, splashing up a spray of chlorine and sending the inner tubes adrift. A blonde in a yellow bikini, the cups held together with a large white ring, is doing the frog stroke, smiles at me with white teeth, glistening in the sunlight. When she climbs

the ladder to get out, I spy, through my sunglasses, the yellow triangle from which a tuft of damp hairs protrude. Poolside voyeurism. "Brother Louie" is on the radio. Great summer song.

July 4. Smoke pot with Jimmy in the country-club bathhouse at nine p.m., getting ready for fireworks. Smells of wet towels. The pool is lit up in the dark, eerie turquoise glow, so we dive in, feels very sensual. Jenny Brown is there, tripping on acid with her posse. Kramer is dressed as a firecracker, black tights, red glitter, red hair, a huge silver wick coming out of the top of his head. Not afraid of making a fool of himself. He terrorizes the little girls, who then decide he is just a harmless madman. They start laughing and hitting him. The fireworks explode over the fairway of the golf course, big champagne bursts that sizzle down the night sky. Pale comets gliding up, glittery gold wafting down. Oh, yeah!

. . .

Jordan came to visit on her way back east after a dance summer school in Colorado. Despite her niceness and beauty, I wasn't into it. Poor thing. All she wanted was a sweet sexy summer romance. My drunkenness was a problem. I hit the garage with my dad's car one night pulling in. She snuck into my room in her sheer nightie after we'd all gone to bed, wanting more physicality, and I sent her back upstairs. Cruel. I drove her to the airport; she was in tears. I was a cad.

. . .

More cruelty. My old high-school chum Laurie drives me to school some days, as she's going to summer school as well. I smoke her cigarettes and play with the car radio as she prattles on about how sophisticated she's become, and do I think we'll have an affair (I sure

hope not), and tells me about masturbating with a Coke bottle in front of her boyfriend on a camping trip and did I think that was perverse? I just stared out the window and said, "I don't know."

. . .

Led Zeppelin at St. Paul Civic Center. I was hopped up on Pernod and amphetamines. Mashed in the crowd of eighteen thousand while the band unleashed their powerful dark magick. The lighting was like *Ready Steady Go!* Jimmy Page was amazing, so psychedelic. We were put into a collective, erotic spell. A sweet little rock 'n' roller of sixteen came wordlessly into my arms (such is the power of Page's witchcraft), grinding her crotch against my hips, and she was busty and suntanned and wore silver eye shadow and kissed me with abandon. They played for three hours. This was no ordinary rock show, this was *alchemy!* We left, bathed in sweat.

In May, 56,800 kids showed up for Led Zep in Tampa, largest audience for a single act ever. Half the world is under the age of fifteen.

. . .

Rock 'n' Roll Lust, continued. The Hurricane Boys are hired to play at some experimental hippie farm. Three hundred freaks. I'm souped up on white crosses. There are twenty kegs of beer. There's high-school crush Rachel, scampering through the fields. There's cute Little Black Betty, once an innocent in a velvet cape, now a super-teenage-ruin, rumored to be a sadomasochist and suffering heroin shakes. The band shows up with another drummer, tells me I've been replaced. Traitors! These were my best friends! Cowards! I'm bummed out. Electric guitars are raging.

Beautiful Jenny Brown comes over with an inch of bourbon for me. She feels sorry for me. Says in her husky voice, "Don't worry about it—those guys are just a bunch of assholes." Then she leans

in and starts kissing me. "God, I go for you just like the rest of your fans." The two of us look like brother and sister. Amidst all the chaos and screaming we stole off to the six-foot-tall bulrushes, lie down on the trampled reeds, which created our own small enclosure. The full moon had risen, which created a blue glow. We doffed our garments, white cotton (her), black leather (me). Her body was brown, except for the pale tan line around her breasts and divine pubis, where her bathing suit had been. She stood over me and I looked up at her flat, muscular stomach. Euphoria! We lay tasting and caressing for an hour in our own private domain. You never know what the day will bring.

. . .

Jenny called up a couple days later, and says she likes me now that I'm not a Hurricane Boy—now that I'm "outta that mess," as she put it. She tells me about her rabbits, Curly and Rags. She wants to make it clear that she is *not* picking me up. Says she's *not* like all the other dumb girls who chase me. She's the original mixed-up kid. But she does seem to have the power to draw me out of my body and into her own.

We meet at the Lake Harriet band shell. I look at her tomboy getup, her high cheekbones, her deliciously sculpted nose, her strong chin, her long brown shag. She holds me from behind, kisses my neck, whispering that we are incompatible. "Are you always suave, or are you ever just normal?" she says accusingly.

I remember her from the private girls' school, where she wore a navy-blue uniform. She told me she didn't want to fuck me, then took me home and did just that, on the kitchen floor right next to the refrigerator. When she removed her undies she said she had enough hair on her vagina for three girls. We were quiet so as to not wake her sleeping parents. Such a beautiful look on her face, smiling with

her eyes closed. After another bourbon, we slipped down to the dark basement for a second bout on a green exercise mat on the floor.

We meet at Al's Bar on Excelsior Boulevard on a sunny afternoon. She's a regular. She's hunched over a glass of bourbon. She asks if I'm tricking her.

"No."

"Well, the tricks you pull are the same ones I pull," she says, lighting a cigarette. Nothing is simple with her. Distrustful Jenny.

. . .

I love this bit of Shakespeare.

> . . . *this sceptered Isle*
> *This earth of majesty . . .*
> *This other Eden . . .*
> *This happy breed of men, this little world,*
> *This precious stone set in a silver sea . . .*
> *This blessed plot, this earth, this realm, this England,*
> *This nurse, this teeming womb of royal kings*
> *Feared by their breed and famous by their birth . . .*

My parents are away. American Bar Association convention in Washington. I'm feeling sad and romantic listening to the deeply melancholic *Last Tango* soundtrack while drinking a brandy-and-ginger. Getting myself into a right state. Romantic agony building up.

I wonder if I have emphysema.

I wonder if my crabs are gone.

I wonder if Jenny really loves me. (Her Bard boyfriend is shooting heroin because he "misses her.")

I wonder if I can paint well, write well.

I wonder how much I can see.

I wonder if I can ever give myself completely to another.

I wonder when the New York Dolls album is coming out.

I wonder what I'll be like in five years.

I wonder if things are getting better or worse.

I wonder what Bryan Ferry is doing right now.

I wonder if I see myself at all objectively.

I wonder if this is corny.

I wonder if I should make myself another drink.

I wonder if I will flunk my astronomy test. (I did.)

. . .

One evening Kurt was over, we were sitting in the backyard drinking cocktails and smoking. "Hey, I got an idea, let's put your mom's clothes on," said Kurt. So we went in her closet, and both picked out dresses, mine with big polka dots. We smeared on some lipstick and went back outside with a couple of fresh cocktails, laughing all the way. We both have long hair, but we still made a couple of homely-looking women. Big yucks. No big deal. *But* . . . a few days after my parents got home my mom came into my room with a troubled look on her face.

"What's the matter now?" I asked.

"I thought I told you that *no* friends were to come over."

"Yah," I lied, "and no one did."

"Well, someone did . . . someone strange," she said.

"What are you talking about?" I said, at a loss to figure out whatever evidence I had failed to conceal.

"Someone's been wearing my clothes. I had two dresses fresh from the dry cleaners, and now they smell of body odor. Plus my cosmetics are all a jumble. What kind of weird girl did you have here?" she said, truly upset.

"Oh . . . that . . . um . . . that was me . . . I wore 'em."

Her face clouded. "You? But . . . why?"

"Um . . . I was bored, and I thought it would be funny. It was. You should've seen me," I joked.

Long silence. Then, "Duncan, that's weird!"

"No it's not. It's not like it turned me on or anything. It was hilarious." She asked what I did for footwear and I told her I kept my sweat socks on. That made her laugh. Whew. Close call.

. . .

Jenny comes over and we exchange love vows. She reminds me of Eloise of the Plaza. Except that Jenny has more deviant games.

One day, after my morning class at the U. I took the bus to her parents' house on Humboldt. I climb three flights of white-carpeted stairs with the framed lithographs on the walls, into Jenny's private wing, where she is sleeping on her stomach, her broad back exposed. I stoop and smell her, feeling a little fragile and out of place. She slowly wakes, and grumbles sleepily, "Why can't I have you?"

I roll her over and say, "You can."

She says, "No, I mean all of you. Why can't I have all of you?" I climb in with her, and afterwards she says, "I love having boys come in me." "Boys," plural. She dumbfounds me. She says she's used to being the queen bee.

Later that night, we go see *Song of the Thin Man*. Nora is mixing drinks and Asta is prancing around merrily. Jenny leans over and whispers in my ear, "Mister, you can fuck me any time you want to." Wow. What a gal. No one can say "fuck" with quite the resonance she can.

. . .

Minnesota is on the cover of *Time* magazine (which I grew up with). Says it's *the* best place to live in the US. I can't wait to leave.

Two summers ago I was in Naples, standing on street corners

looking up narrow alleyways that climbed the hill precipitously, pennants of washing crisscrossing the way. I stood on the shore looking at the burnished sea, Capri faintly outlined against the horizon. I wandered idly, with the eye of an innocent (sort of). Seems like ages ago. Whatever happened was absolute.

DIVE

DUNCAN HANNAH

Hello, fresh clean pages.

. . .

My affair with Jenny continues. She jumped up and down when she saw me today. I drank the Love Potion Number 9. We're sitting on the front steps of her parents' house, waiting for Clifford. He comes loping down the street. "Here comes Jim, and Jim's cock," says Jenny (for indeed, Jimmy is very well endowed). She's got a burn on her inner thigh from the gas tank of someone's motorcycle. She uses my satin jacket to wipe up some beer.

Jenny sings "Wouldn't It Be Loverly?" She likes Eliza Doolittle. "Mind 'ow yer go, luv. 'Ere, do yer know wot I did larst night? I feel 'arf insane." She looks like French actress Zouzou, which of course fits right in with my Parisian cinema fantasy. We go to Ragstock, where you can buy a bag of clothes for ten dollars. We try on zoot suits, kimonos, sinister leather Gestapo coats with the collar turned up, Eisenhower jackets, WAC uniforms, negligées. We take pictures of each other. One minute she is Maid Marian, then an intergalactic space queen. She wears those panties with the days of the week on them. My baby loves the hanky panky.

Once when she was very drunk (which always makes her look like an innocent young girl) she said, "Oh, look, I'm wearing a brassiere for a change. See? Feel it." She asks me to put my hands on her breasts. She's proud of them, and rightly so. They have a lot of character.

She warns me that she's insane. Says she's been diagnosed as a schizophrenic, runs in the family. Says we're not right for each other, wait and see, I'll get my just deserts, then I'll be sorry. She throws her cigarettes all over the ground. Like a brat. I tell her I'll take care of her. "No you won't!" she says vehemently. She tells me to save my breath, because she doesn't have the slightest idea what I'm on about. She has many guises—boy, girl, man, woman. I see her scared, nervous and vulnerable, then strong and cruel. She breaks down crying, her beautiful face streaked with tears. She's the dominant one in this relationship, I have made very few decisions. They were all made for me. She's in Chicago now with her unfaithful boyfriend. I'm just her back street boy. It's driving me batty. I'm out of my depths. I'm getting my comeuppance.

. . .

A party at Kramer's apartment led to the roof. Our old friend Tommy Haskell drank a lethal concoction of liquor, then passed out. We left to go play pool at Lyle's. When Tommy awoke, he stumbled off the roof to the concrete alleyway below, breaking both his wrists and ankles, puncturing his lung, internal bleeding, etc. When we returned, there were cop cars with their cherry lights flashing. It was terrifying. He'd been taken to intensive care. He's one of those guys who should never, ever drink. His life is in a nosedive.

In the morning I'm on the phone, checking on his condition. Dad comes over and hands me a Bloody Mary. I've got my summer school final exams in a week, completely unprepared.

My mother and I talk art. She says my paintings look "lightweight" to her. She's right. It's because I skipped the basics and moved right into the deviant painters. I bought a Hockney poster for my wall. An etching with an Egyptian theme. I like the way the English interpret other cultures. Roxy Music's take on the American dream, Hockney's take on LA, Fleetwood Mac's take on Chicago blues.

. . .

In the car on the way to school, Dad tells me he was a virgin when he married Mom. Good girls didn't do it. He was being shipped out to war and didn't want to die a virgin. "But our marriage was a success. It might have been different if we'd played around beforehand. Your screening process is a bit more thorough than it was in my day." He said Jenny has been the only girl I brought home who has something to say. "She's quite outspoken, isn't she?" he concludes.

August 21, 1973

My twenty-first birthday. Am I supposed to quit goofing around now? Hah! Fee! I have to shave almost every day now. My parents gave me two hundred dollars for my present.

Jenny gave me her present in her bedroom, which is cluttered with cages full of birds and rodents. Posters on the wall by Gauguin and Matisse, photos of the Hurricane Boys, Humble Pie, and me. We make love and lie quiet. Jenny louder and softer. She puts a small white rabbit with hairy paws and black eyes on my hairless chest. We drink bourbon-and-gingers and listen to Terry Reid. She begins to cry because she's not great at anything, but thinks that I will become a famous artist, and that her on-again/off-again love only makes me sad. But she cheers up and we go to Dinkytown for Japanese noodle soup and across the street to the art house to see *Without Apparent Motive* with Trintignant and Dominique More-Going-on-Here-Than-Meets-the-Eye Sanda.

. . .

Went to see *Belle de Jour* at the Grand Illusion Theater on Cedar Avenue with Eric Li. As soon as Pierre Clémenti hit the screen we were galvanized. Pale face, coarse black hair, steely eyes, gold teeth, big

lips. Dressed in a wrinkled black velvet suit, rumpled beige silk shirt with collar bent funny, gangster tie, a large studded black leather belt, lavender socks (hole in toe), black patent-leather buckle boots, black leather SS maxi trench coat, and finally a sword cane. Plus a huge gleaming automatic. Wow! Every inch the killer. Seven stitches on his back ("a souvenir," he explains to Deneuve). We remembered him from *The Conformist* (the chauffeur), but this was something else. Our new hero. I must paint him. I found out he's currently in an Italian prison because the secret police planted drugs on him. Sartre, Fellini, Genet, Godard, and Buñuel all testified on his behalf, but to no avail.

On the way home we stop at Sutton's for some nightcaps. There's Jenny with her group of sad suitors. She's blowing hot and cold. One minute she's dragging me into the ladies' room, rubbing my cock to her cheek while she pisses, the next moment she is totally indifferent, couldn't give a shit, smoking a Havana cigar, and then she's a ten-year-old kid, welling up with tears, filled with *l'amour*. She's blunt. She's frank. It's beyond my control. I'm helpless.

· · ·

Jenny gave me the brush, I went to pieces, so as a consolation prize she drove us to a secluded spot off Lake of the Isles, doused the lights, we climbed in the backseat of her mom's Pontiac, dropped our drawers down to our ankles, and made cheap farewell love on the springy vinyl. As if Nurse Jenny could make it all better. It felt tawdry. General Motors emotion. She said, "I'm good and bad, but mostly I'm terrible." She left me in ruins, as she said she would. She was as good as her word.

· · ·

My parents came home from a party while I was having a few friends in. Mom screeches, "What's going on here?!"

"We're just watching *The Thin Man.*"

She unties my polka-dotted scarf and says, "I don't like this, you're drunk!"

"Of course I'm drunk, aren't you?"

Just then slutty Pauline stumbles out of my room.

Mom says, "And *who* is *this?*"

Pauline smiles dumbly and says, "I'm Pauline."

Mom knits her brows and says, "I *bet* you are!" She looks over at me and says, "What have you given her tonight?"

I couldn't remember the name "Spanish fly," so I said, "Just a little Bermuda fly."

Then Kramer appears, looking like Phineas G. Whoopee from the *Tennessee Tuxedo* cartoon. Mom says in her most sarcastic voice, "Well, look who we have here—my best friend, Steven Kramer. As far as I'm concerned, you need never come here again."

Kramer advances to her, gives her the raspberries, and walks off. At this, much laughter came from the dark recesses of my room.

"Get your creepy friends out of here!" Mom screams.

She's a fifty-three-year-old Washburn girl in the throes of menopause. Bad timing, her menopause and my coming of age.

· · ·

Saw Louis Malle's *Murmur of the Heart*, utterly fantastic. A miracle of a movie, about three naughty bourgeois French brothers. Loved the spinach tennis scene. A little light incest. We laughed for about ten minutes at the end of the film.

September 2, 1973

I'm trying to dry out before my fall semester at Parsons begins. I think about booze a lot. It's a big part of my life. I tend to throw myself away. There's a self-destructive thrill in that. We are the

mutant children of the hydrogen age. As Popeye is fond of saying, "I yam what I yam."

Visited Tommy in the hospital. Legs in traction, plaster casts, bolts sticking out of his bones, pulleys, pain relievers. Macabre tableau. He asks what we've brought him to drink. "Are you nuts? Your drinking days are over," we say.

End of summer heat wave. I was drinking in the afternoon with a pal in an air-conditioned suburban discotheque. He was telling me about the Beretta he just bought. Just like Bond's. I thought if he ever used it, it would probably be to blow his brains out. It would never be leveled at an agent of SPECTRE. Another round. It was dark and rather empty. Whirling lights. Diana Ross singing.

Two attractive mod girls (right out of high school) started talking to us, invited us back to a party. I got in the backseat of a cobalt-blue VW Bug with the prettier one, a blonde, and she started making out with me. Such an aggressive young hustler she was, name of Linda. Probably got her culture from nightly TV sitcoms. We arrived at a dumpy split-level suburban house, she led me through the drippy-looking party, filled with shaggy dullards, and took me to the dim basement, where there was a Naugahyde couch that smelled of damp. She said she trusted me, that I wasn't like all the others. (I should hope not, I thought.) She didn't seem terribly smart. I felt the space between us. Then she asked if we were going to make love. "Yah," I said, going along with her fast seduction. She pulled her clothes off and we got down to it. We spent a couple hours together in that dank basement; she had several easy orgasms, at one point stopping me to ask what my sign was. She said "Ohhhh" when I said I was a Leo, as if that explained everything. I felt sorry for this bland midwesterner, though she sure was trying hard to liberate herself from being preyed upon by the dumb jocks upstairs. She was taking some initiative. She was doing her *own* hunting. Still, there was an air of desolation. This sad young stranger. We were from two differ-

ent worlds. She would probably be trapped in suburbia for the rest of her life. Tied down with a litter of brats. I left with promises to call, knowing I wouldn't. Time to leave town.

. . .

Goodbye, Minneapolis. Hello, Manhattan.

NYC, September 1973

I can't believe it. I'm on the ninth floor of One Fifth Avenue, facing south. Apartment 9H, to be exact. It's a plush hotel suite being used as a Parsons dorm. My new residence. I love it! I have three room-mates, curly-haired Tom Fox from Florida (who doesn't yet know that he's gay, but I do) and two Chinese brothers in the next room. The living-room picture window looks out on Washington Square Park, and in the distance the World Trade Center looms like twin phosphorescent robots. I actually *live* in Greenwich Village, the historic

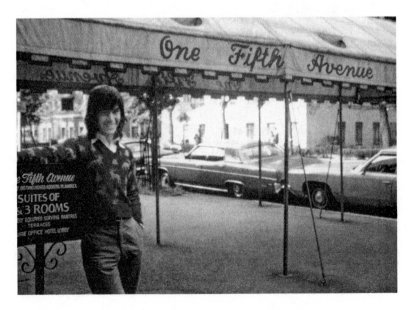

site of generations of madmen, jazz musicians, poets, painters, and revolutionaries. A dream come true.

The entrance is on Fifth Avenue, where I'm greeted by an Africano doorman in green livery with gold braid. The lobby is dark wood with huge mahogany pillars. "Number 9," I say to the elevator boy who works the controls. He deposits me in a mirrored hallway; my feet don't make a sound on the carpet, I turn the key and pad into my pad. I park myself in one of the big armchairs facing the windows, light a cig, and begin to write letters, telling everyone of my good fortune. Listening to the Stones' new record, *Goats Head Soup*. The single, "Angie," leaks out of every Eighth Street shoe store and boutique.

At night, in my bed, I can hear shots, screams, whoops, air-raid sirens. When I awoke, Agnew had resigned and the Mets were heading to the pennant.

Fall Movies

Women in Revolt
Une Femme Douce
"Pimpernel" Smith
The Inheritor (Belmondo)
Day for Night
Pal Joey
Machine Gun McCain (Cassavetes)
West of Zanzibar (Mary Nolan)
Dementia 13
The Petrified Forest
The French Connection
The Damned
England Made Me
The Bride of Frankenstein
My Night at Maud's

La Collectioneuse
Bed and Board

Fall Books
Borstal Boy, Brendan Behan
Teenage Porno Queen, Anon.
More I Remember More, Joe Brainard
Seventh Heaven, Patti Smith
The Wild Boys, William Burroughs
Exterminator, William Burroughs
The Black Book, Lawrence Durrell
Superstar, Viva
Chéri and *The Last of Chéri,* Colette
Confessions of Felix Krull, Confidence Man, Thomas Mann

Eric and I check out the new Warhol film, *Women in Revolt.* Drag-
queen feminists. Candy Darling, Holly Woodlawn, Jackie Curtis,
and (real woman) Jane Forth, whose eyebrows are just two dots. We
tie one on after, at a local joint called Shakespeare's. Eric says I will
die soon, it's a fact (he says). He also says I'm very influential, both
selfish and generous. He loves Beethoven and Chopin, and is study-
ing to be a concert pianist, but he doesn't know if he's got what it
takes, even though he's always been a prodigy. His face turns red
when he drinks (it's a Chinese thing). We decide that alcohol is ruin-
ing our lives, playing havoc with our self-respect. But the illusion of
freedom is so alluring. All seems possible. The joke's on us. Sinking
and smiling among the dying bottles.

My square roomie is giving me suspicious glances, thinks maybe
I'm a lunatic. But I'm just a punk, I spell B-O-Y. I put up my post-
ers of Uschi Obermaier, the sexy German model, in blue jeans and
nuthin' else but her pout. She holds a place of honor in my dreams.
It's what you do in college, yah?

Went to see King Crimson last night at the Academy of Music. Bad bridge-and-tunnel audience, flabby and mustached. I saw Al Kooper there. I'm a big fan of his old band, the Blues Project. He's cool. The band played demonically. For "21st Century Schizoid Man" they trained enormous anti-aircraft spotlights at us. Blinding. Terrifying.

. . .

My mother writes, "If you expect us to like you just because you aren't on heroin, and not wanted by the police, forget it. Those aren't very high standards." She's right again.

. . .

There was a nutty girl from North Carolina here last night, drunk on 7 and 7, she got on my desk and acted like an ostrich. Apparently she goes around NYC spraying Reddi Wip on piles of dog shit, then tops it with a cherry. Strange bird.

School life. Everyone in my drawing class draws better than me. Gulp. Some days I have life drawing for six hours, punctuated by Styrofoam cups of coffee and cigarettes. One of our models looked like she posed for Toulouse-Lautrec. Old lady with brilliant henna hair. She's good. Another model is pretty, young Esther, she's from Dublin. She makes a scruffy Olympia. I'm too impatient, I need more sensitivity to line, mass, and space. I've drawn flat up till now. I'll need to render if I want "mood." I want "mood." I need more articulation. Teacher asks me if I was stoned when I did my homework. Was I?

The Parsons lunchroom is filled with the fashion kids, none of whom eat, either. No hippies here. The girls get dolled up every day for school. The different camps cluster, exchanging gossip on the other camps. I usually sit with Suzanne and her chums. She says that when technology zooms to the future, fashion steps backward to nostalgia. There's an exotic student in fashion illustration called

Steven Meisel who looks like Rudolph Valentino with long hair. Very mysterious.

There's a busty nympho named Daisy who never stops talking about sex. "Parsons girls love dick," she says. Later, "I see I'm gonna have to educate you. Why don'tcha eat me, honey?"—which is meant to make me blush, I think. She's just talkin' soda pop. Says she wants someone to fill her with milkshakes tonight. Her older illustrator boyfriend painted her for *Playboy*. She's got a real 1950s cheesecake figure.

I spotted one of my favorite artists, Larry Rivers, across the Parsons lounge, so I go up to talk to him. He teaches here. Doesn't show up much, sends his assistant instead. But it looks good on the Parsons faculty roster. He resembles a hawk, with a hawklike gaze as well. Deep, velvety voice. He was wearing construction boots that were spray-painted copper. We talk about his friend, David Hockney, who is going from strength to strength.

One Fifth

Sopwith Camel are staying in this hotel. One of my favorite San Francisco groups. They open at the Bitter End tonight. Saw 'em out on the sidewalk with their guitar cases. Then I spied a pretty black-haired girl with super-red lips and brite green shoes. It's Jane Forth, Warhol Superstar! I paced around trying to look inconspicuous. She spotted me, so I made a beeline to Eli Wilentz's Eighth Street Bookshop to get lost in the shelves. Then crossed the street to Discophile, the cool import-record shop that's always got the latest. I love the atmosphere of record shops. One of my all-time-favorite pastimes is flipping through record albums.

I'm in love with love. I'd like a life of first loves. First comes curiosity, then exhilaration, then passion, then friendship, then maybe disillusion, disenchantment. The drug of female illusion. It's complicated.

· · ·

Art. I'm trying to find my own visual language from my mind's warped filing cabinet. Points of reference. If someone expects me to be good, I'll be better. Better than I have to be. That's the plan, anyhow. I currently like Paul Wunderlich, a German artist with erotic overtones.

NYC. I heard that in Manhattan you can hire a guy to kill someone for sixty dollars. NYC is dirty and broke. I'm dirty and broke too. I walk and walk and walk, getting my bearings. Riding the crest of crowds. A balmy Florida wind is blowing me through the myriad of faces. I feel radiant. Been here two weeks now. Wandered around Midtown. The cool marble of St. Patrick's Cathedral. I'd love to hear Booker T. on that pipe organ. I had a $3.50 chili dog and Coke in the Auto Pub, in the GM Building. Sat in a Formula One race-car seat and watched a simulated movie of a Grand Prix on the screen in front of me. Very *Clockwork Orange*. Strolling past Tiffany's, Bergdorf's, Bendel's, FAO Schwarz, Vidal Sassoon, Louis Jourdan, Cartier, and Rizzoli, where a new Egon Schiele book cost $125! But I want it! My allowance won't cover that. Too bad the rich don't know how to spend their money—oh, what I could do with it!

· · ·

My Chinese roommates had a noisy party. They danced to "Eight Days a Week." I was in the bathroom inspecting my new shipment of crabs. The Chinese shout "Chow hai," which they say means "stinky cunt." A drunk preppy girl wore a pink sweater (I'm a sucker for pink sweaters) and her brown buttons became aroused, and she simulated jacking off on my leg. Part of being drunk. My roommate says, "Donut, you look funny tonight . . . you gay boy?" and then bursts into hysterical laughter. He loves American soul music, the Spin-

ners, Four Tops, Temptations, Supremes, Labelle, Jackson 5, O'Jays, and the very moving Al Green.

. . .

I'm nervous. Jenny Brown is supposed to come visit me from Bard. Every knock on the door sends my heart to my mouth. I'm still carrying a torch for her even though she took my heart and stomped that sucker flat. She's a dream wrecker. Instead of Jenny, it's ace guitarist Rob DuPrey at the door, in brand-new Beatle boots, holding a bottle of orange soda pop. He tells me Jenny's not coming, she's too in love with my rival. DuPrey's with his sulky girlfriend, Sheryl, who's jealous because he and I have lots to talk about, and enjoy each other's company so much. We walk down to Washington Square Park and they say goodbye, leaving me to mull over my dashed romantic hopes alone.

. . .

I shared an ice cream with downstairs neighbor Regis Ingrid Redin. She's got beautiful everything, curly blond hair, flawless skin, etc. Actually looks like young Ingrid Bergman. Queen of cups in her peasant shirt. She should be painted by Lord Leighton. Maybe she was. She strikes me as a mama's girl, quite sensible, lacking the frisson of lunacy that typically engages me. I'd still like to pluck at her angel feathers.

Fall Records
These Foolish Things, Bryan Ferry
Todd, Todd Rundgren
See My Baby Jive, Wizzard
My Funny Valentine, Miles Davis
Berlin, Lou Reed

Pin Ups, David Bowie
Quadrophenia, the Who
Gene Vincent's Greatest Hits
Tubular Bells, Mike Oldfield
Mind Games, John Lennon
At the Scene, the Dave Clark Five
Edith Piaf's Greatest Hits
10cc
David Essex
Gerry and the Pacemakers' Greatest Hits
Soft Machine Seven

· · ·

Eric Li asks me why I'm so romantic.

"I dunno . . . How do you define 'romantic'?"

"Marveling over something simple."

Hmmm. Interesting. That's like being an artist as well. Putting on the rose-colored glasses.

October 15, 1973

School. I'm taking two illustration courses, two painting, two drawing, one printmaking, one photography. Twenty-four hours a week. I did a soft-ground etching called *My Holiday in Egypt*.

Weekend at Bard. Dressed in silk, velvet, and leather, Eric and I board the Amtrak train for Rhinecliff. A couple of glam rockers spending the weekend in the country. Bit of the old alma mater with the promise of conjugal reunion with Medusa the Seducer, Jenny Brown. Step off the silver tube into the steaming station. A posse of old pals from last year took us straight to the bar, where numerous rum-151-and-Cokes were downed. Bratty Jenny was there, said I could stay in her room, but not with her. Still giving me the old bum's rush.

Eric got picked up by a coed named Laura who was rumored to have worked in a massage parlor, so his lodgings were sorted.

A couple of drunken days later, after staggering around in the woods, play-acting French gangsters at a reception at haunted Blithewood, with sherry being served by young girls in white aprons, and just generally being degenerates, Eric gave me a pep talk about Jenny, how I was handling her all wrong, from a position of weakness rather than strength. How it pained him to see me lacerating myself with her rejection. He gave me some tough love. Start acting strong! Just try it. What have you got to lose? Who do you like? Alain Delon! Well, use it! Let it show!

So I got my chance, sitting in the bar ignoring her. Witness this scene. Transcribed verbatim.

JB: Well what's the matter now, you're mad I suppose.

DH: [*gazing off into the middle distance, allowing a stream of blue smoke to escape from nostrils*] No, why should I be?
[*Sipping at my bourbon.*]

JB: [*begins to get interested*] You are so incredibly handsome.

DH: Hmmm . . .

JB: I don't think I've ever seen you look quite so handsome as this evening.
[DH *laughs.*]

JB: Let me loosen your tie, you'll suffocate in here.
[*While she's doing that, DH stares at her with no expression. It is an illusion. Inside he is feverishly thinking about Eric's advice, which is actually working.*]

JB: You're too much competition for me. When I'm with you, no one notices me. Plus I've got to get my artwork up to a higher standard before I start hanging around with you.

DH: That's shit and you know it.

JB: [*surprised at this assertion of authority, widening her eyes and lowering her voice*] Dunc, you know I'm in love with you.

DH: That's good.

JB: I always have been.

DH: [*sardonically*] Sure.

JB: [*exasperated that DH isn't gooing and gahhing over this, surrenders in anger*] Okay, I never planned on telling you this, but here it is. I have been obsessed with you ever since I first met you. Four years ago! I have never been so in love with anyone in my whole life, and I never will be again!

DH: [*nonplussed, calmly*] I don't believe it. When did we meet anyhow?

JB: See, you don't even remember! It was the school prom. You were playing drums and all the girls were enraptured. I loved you the minute I saw you. I would have given up anything for you.

DH: Yah, I remember that night—the band and the audience were all on acid. Kramer quit because he couldn't hear his piano. Clifford quit because he could see the notes coming out of his bass. Brooks was frustrated with what he was playing, so after playing a brief Jimmy Page parody, he threw his guitar down in disgust. That left me to do some kind of Motown drum solo. Horrible night. When we were introduced, I said, "How are you tonight?" and you scowled and said "What do you mean by *that*?!" So I figured you were one of those sensitivity-training, encounter-group, analytical-bullshit people.

JB: Well, see, that's why I'm like this. I'm flipped out that you even like me. I can't understand why you do. I can't handle it.

DH: Is any of this true or are you making it up?

JB: [*desperately*] It's true! I swear to god! Four fucking years!

That's why I got so upset when you fucked Lucy, my own best friend! I wanted you for myself.

DH: But Jenny, you *threw* her at me. You orchestrated the whole thing.

JB: I can't help it. I'm crazy that way. I push you away because I can't afford to lose you.

I was shocked that Eric's stage directions paid off. Now that Jenny was softened up, my indifference slowly vanished, and with it, the hold I had over her. I lost my cool. As I reverted to my affectionate self, Jenny was back in her protective, snotty shell. It was a Catch-22. Can't win. Ironically, the jukebox was playing "The Love I Lost."

October 21

Saw the Dolls on TV. Local heroes make good.

Art-school romance? Somehow my friendship with the stunning Regis Redin turned intimate. It started when she took me out on the town, Serendipity for caviar, then Truffaut's *Day for Night*, then a drink at the Auto Pub. Her face is as readable as a book . . . but it's a confusing book. I can see her brain making decisions. Equal parts Liv Ullmann and Shirley Temple. We're mismatched. But how do you keep a friendly distance? I'm not good at it.

"Are girls magic?" asked Jean-Pierre Léaud. One might well ask.

A CINEMATIC REVERIE

DUNCAN HANNAH

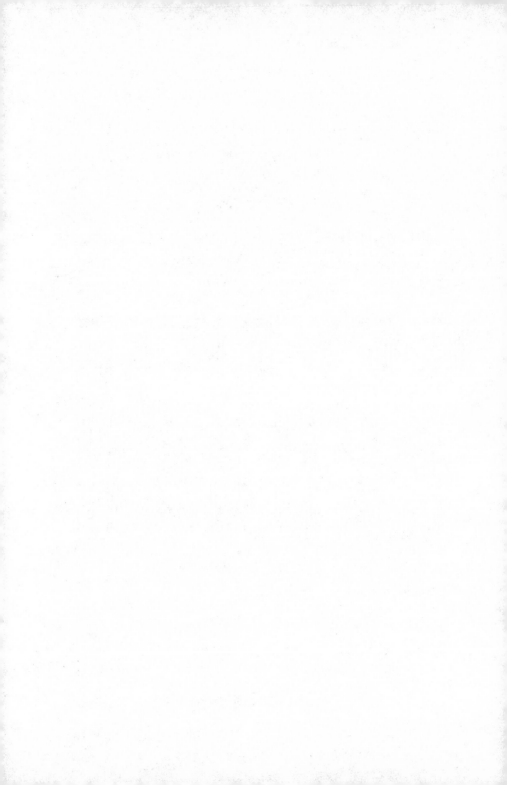

Dear Diary. Regis sends me notes in my inbox at school. Heart-shaped chocolates. She came down from upstairs, voluptuous in her nightie and robe, and we smoked some pot and watched *Pal Joey*. She says I'm schizophrenic (she's not the first to suggest that), says she's confused by me. I don't blame her. I'm liking Kim Novak tonight. "Who's the mouse?" says Sinatra. "What do I care for a dame?" Sinatra is such a jerk. "Hangovers run in my family."

Friday I spent in the school darkroom developing new black-and-white photographs, pretending I'm David Hemmings. Eight hours of inhaling those chemical fumes. My teacher is interested in these eight-by-tens of my wild friends. But he cautions me to "see" and not worry about making pictures.

Eric Li came to my digs around seven, we had some drinks in preparation for the big Parsons masquerade party. We went over to the girls' dorm, to pick up the hard-drinking Detroit girls, pretty Shelly Dunn (dressed as the Goldfinger girl, the girl with the Midas touch, but don't touch too much) and her roomie, Carol (dressed as a stripper with gaily colored balloons applied to her tits). In the lobby was Todd Rundgren, sitting on the couch, legs crossed, waiting for his date, I guess. Eric and I asked him if he wanted to start a band with us. He paused, scrutinized us, and said "No" in a decidedly noncryptic manner.

We floated up Fifth Avenue and up the elevator to the party. I was tap dancer Tommy Tune, in gold satin suit and spectator shoes; Eric was his hero Lao Tzu. There were nuns; a pregnant girl; a mummy's

daughter (Him-Ho-Tut); Daisy with a giant pink satin cock; a seven-foot-tall Chiquita banana; Dracula (of course); the Children of the Damned; a naked skinhead painted white; and various Martians. A proper art-school ball. We drank, we danced. We got a cab up to Radio City Music Hall for a midnight show by England's own Mott the Hoople, who roared through their hits. Raucous audience. Great fun.

My mother is arriving at Kennedy Airport in two hours and I'm stoned out of my mind. She thinks I'm nutz anyway. Teach me to disguise. I paid my thirty-five cents to go uptown to see her. She was staying with her fancy friend Peggy Hawkins in the United Nations Tower. Peggy's very condescending to her. Mom was drunk and babbling a mile a minute, dressed in one of her homemade Chanel suits (she makes her own clothes based on what Audrey Hepburn is wearing lately). Peggy smiled at her arrogant ad-man husband as if to say, "Bunny is sweet, but not too much up here." I felt embarrassed for her.

October 31. The New York Dolls are hosting a Halloween party in the ballroom of the Waldorf Astoria. The pomp and gilded splendor of the fabulous hotel was a surreal contrast to the gathering hordes of glittering rock kids, parading up the carpeted stairs holding on to the handrails for dear life lest they fall off their elevator shoes. They had been working on their costumes for weeks. There was Zacherley, Satan, the Jolly Green Giant, phantoms, she-creatures, faux Hollywood starlets, and short little Eric Emerson, the wandering minstrel. Todd Rundgren was jerking his girlfriend along by a leash. He said to her, "C'mon, Elmer." Rodney Bingenheimer stood around looking dumb. David Johansen looked elegant in white satin tails and silver top hat, ever the showman.

Syl Sylvain asks onstage, "How she dance?"

"Close. Very, very close," responds David, rolling his eyes.

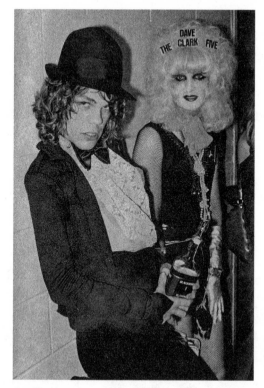

David Johansen and Wayne County

DuPrey and I are wandering in the lobby. I'm in my Mister Freedom black velvet overalls, with no shirt, displaying a lot of skin.

A guy in a fatigue jacket says in a New York singsong drawl, "What are you, a movie star?"

"No, just an art student."

"Well, you *should* be a movie star."

"What's your name?" I ask, figuring him to be a dozen or so years older than me.

"Danny Fields."

My mind raced. I knew that name. From Elektra album covers.

Hold on . . . I got it. "The Doors, the Stooges, the Velvets, the MC5—
that Danny Fields?"

"Mmm-hmm," he said lazily. "You get high marks."

"Very pleased to meet you. I'm Duncan Hannah and this is my
pal Rob DuPrey."

He introduces us around—to magazine editor Lisa Robinson (*Rock
Scene*), Leee Black Childers (Bowie photographer), Wayne County
(drag rocker), Steve Paul (the Scene, Blue Sky Records), Lenny Kaye
(*Nuggets*), Cyrinda Foxe, etc.

Danny asked us over to his place on Twentieth Street after the
show to smoke some hash. We accepted readily, filled with questions
for this behind-the-scenes tastemaker. Down at his dark mini-loft,
we got so high we could barely finish our sentences, but asked about
our favorite rock musicians—what's he like? what's *he* like? Danny

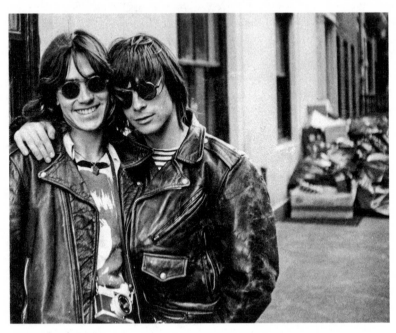

DH and Rob DuPrey

answered every question the same way. "He's an asshole." Finally I said, "Wait, you say that about everyone we asked about."

"All rock musicians are assholes . . . It's okay, I love them too, it's just the way it is." That was our first lesson. There's a big photo of naked Iggy on the wall by Gerard Malanga, with a big dick, as one would imagine. Iggy acts like a guy with a big dick. Danny's got loads of taped telephone conversations with everyone from Jim Morrison to Pete Townshend. We smoke some cigarettes and Danny serves brandy, then he finally kicks us out. DuPrey and I walk down Fifth Avenue, thrilled with our good luck to have befriended this NYC legend. I suspected we had just walked through the looking glass.

That jezebel Jenny Brown is down for a visit. We go to Enrico & Paglieri, an Italian joint on Tenth Street where you can have spaghetti, garlic bread, and all the red wine you can drink for ten bucks. We take advantage of that and consume countless carafes of plonk. She says, "You're good at something but I'm not sure what." Her new saying is "It's a pain in the eye." We get in a fight. She screams, "I don't want to live in a French movie!" She sleeps over, but is unresponsive. Then I wake, and she has sucked me to a stand, but she still wouldn't fuck. We listen to the incredibly sad soundtrack to *The Garden of the Finzi-Continis*. It is *not* happening. We go back to sleep. Wake up a third time, this time our bodies did come together in a coital manner, but it wasn't like before. Jenny held back. It was a mercy fuck. A one-sided affair.

. . .

Meanwhile, Danny Fields has been very attentive. He invites me over. He went to Harvard! He works for 16 magazine and *Datebook*. We talk about the Dolls night where I'd met so many of his hip underground friends. "It was a spectacular debut and you handled it well. You have a quality about you that the rest of the mimps"—as he calls us—"don't have," he says. "Everyone's been calling me to ask who

was that star with all the people following him." This is Danny's stock in trade, discovering beauty and talent. I realize that I will be relegated to the position of dumb blonde, but hey, let's see where this leads. He says, "Perhaps one day you'll make me cry."

He takes me up to a Times Square gay disco, Le Jardin, where Patti Smith is giving a performance in honor of Arthur Rimbaud's birthday. Palm-tree décor bathed in blue light. We sit in front just below her, and Danny is taking photos with his fancy Nikon. Patti is wearing tight black silk pants and an old white T-shirt that says PER-FORMANCE on it, with crossed checker flags. Her Keith Richards

Patti Smith at Le Jardin

shag. Lenny Kaye joins her for some simple electric guitar accompaniment. A red Gibson Melody Maker and his black framed glasses. Patti jokes and ad-libs, talking in her Jersey accent about how this is her way to ally herself to her heroes. Piaf, Moreau, Pallenberg, Hendrix, Morrison, etc. Their works, their faces, their voices. I can relate. Poetry meets pop. They do the Marvelettes' "The Hunter Gets Captured by the Game."

Danny introduces me after the set. Patti says, "I like your sneakers. You're so beautiful."

"So are you," I reply, blushing.

She giggles. Danny gives me his rolls of Tri-X to develop at the Parsons darkrooms.

· · ·

Leee Childers asked me to go to Reno Sweeney on West Thirteenth Street the following night to see Holly Woodlawn's debut. He's with Jamie Andrews and Tony Zanetta, refugees from Warhol's Factory, plus Leee's roommate, Wayne County. They work for MainMan (Bowie's management company). They're on an expense account! Champagne! Ringside table, limosine waiting outside. All on Bowie's dime. There's publicist Susan Blond, Dory Previn, Tommy Tune, Yoko Ono, Rex Reed, Tammy Grimes, Robert Mapplethorpe. I get the feeling from this society that New York takes care of its own, that all these eccentric characters have found a niche no other city would have provided for them. In the limo Wayne takes hold of my exposed inner arm, gazes at it, and says, "Ohhhh, you'd make such a beautiful junkie." Leee says, "Just leave his arm alone!"

Leee drops me at the One Fifth awning, a gallant southern gent in a white double-breasted suit. I feel like Dorian Gray being squired around by these older homosexual men. So far there have been no passes made, nor have I been made to feel like I owe anybody anything.

I go over to Danny's. He says, "Look through my records"—three thousand of them!—"and see if there's anything you want. Promise me you'll never buy another record again." We smoke hash, snort coke, and drink cognac. Watch *The Petrified Forest*. He calls me "Super Tot," or "the Tot of the Town." I leafed through his clippings, his copies of German magazine *Twen*. He tells me stories about Tim Buckley. Fred "Sonic" Smith drops by, a survivor of the crazed MC5. I'm surprised at what a Neanderthal man he is. Very primitive indeed. Very literal, no sense of irony, which is essential for humor.

I'm impressed by the respect that everyone shows Danny. Everyone. He's always on the phone, gossiping with his pals. Candy Darling is dying and everyone knows it but her. They do a recap of every night's activities, every showcase, press party, Max's, Ratner's (the all-night Jewish deli on Second Avenue that caters to drag queens), etc. I tell him about my heart palpitations and he says, "Poor baby, let me send you to a heart specialist." He also said he'd buy me a gray novelty tweed suit from a West Village boutique that seemed like the one Bowie wears on the back of *Pin Ups*.

· · ·

Steve "Looking for the Magic" Paul and chauffeur David Newman pick me and Danny up and take us to the Philharmonic for Ray Bolger's "Salute to the Broadway Musical." A revue of revues starring Hermione Gingold, Beatrice Lillie, Gwen Verdon, Tommy Tune, and Fred Astaire himself, big ears and all. Afterwards Max's, where Alice Cooper and the Dolls hold court in the corner booth. I order the surf 'n' turf because it's on Steve's tab. Groupies table-hopping with their tits hanging out. Outrageous flirting going on. A smattering of male hustlers. Taylor Mead. We sat with theater critic Donald Lyons, who looks like Terry Thomas. We talked about Clémenti, Delon, and Sanda.

I smell like booze all the time now, but it's expensive booze for a

change. Perpetual hangover. I never seem to have a spare second to write anymore. I'm living faster than I can write. Now that I actually have something to write about, there's no time to do it. I only sleep about four hours a night. Strangely enough I'm getting all As in art school. Did a painting of Clémenti from *The Conformist*.

Danny showed me an advance copy of the December 6 *Rolling Stone*. On the society page, in an article by Lisa Robinson about Patti Smith, it said, "Among those who gave her a standing ovation [was] Duncan Rathbone Hannah . . ." Something to send my parents to show them that I'm doing well. My life is an inexplicable mystery to them. Danny turned thirty-two, so I gave him a drawing of a shaggy youth. We went to a press party upstairs at Max's for a new English band called Blue on the RSO label. Talked with Marty Thau (Dolls manager), Garland Jeffreys (who fucked my old girlfriend Lainie), Patti Smith, Robert Stigwood, Terry Ork (from the bookshop Cinemabilia), Steven Gaines (*Circus* magazine), Lenny Kaye, little blue-boy Steve Paul (the albino Winter brothers' manager), and scribe Lisa Robinson. All of us soaking up the free drinks. Record companies throw good parties.

Then Danny and I cabbed uptown to see *The French Connection*. Sandwich at the Stage Deli, French cigarettes, then back to Danny's to watch *Funny Face* at one a.m. with Steve Paul and his hashish. We sang along with the lyrics. Steve was shocked I was so well versed in Gershwin. I grew up with the soundtrack playing on the family hi-fi. My parents' favorite. I kept freshening my drink in the kitchen and finally passed out. Danny woke me in the morning, saying, "Duncan, don't be alarmed, you're at Danny Fields's!"

I doused myself with lemon water and Lavoris, trying to extinguish the smell of alcohol that permeated my body, walked seven blocks down Fifth Avenue to school, where I dutifully drew for three hours. The model gets me horny as I stare into her eyes. She is dressed up like Vampirella with her ya-ya exposed. I take extra-

special care getting her nipples just right, and the delicate arrangement of her cunt. Finally I can leave.

Back in my dorm Regis comes up to photograph me. She's been trying not to like me. She disapproves of my new lifestyle, says she doesn't get it, what's the appeal? I potter about my room, not having been home in a couple days. Despite the rack and ruin of my nocturnal habits, the photos came out showing an innocent, with a mischievous smile. Weird. It *is* like Dorian Gray!

Went up to the Guggenheim to see a big Richard Hamilton show. I love his use of collage with painterly bits. The *Vogue* cover series was

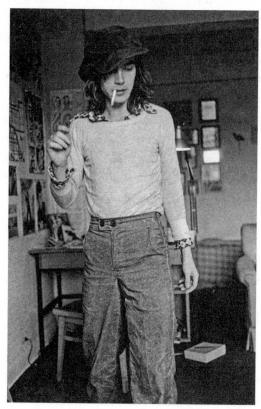

DH in his "dorm room" at One Fifth Avenue

particularly good. He was Bryan Ferry's art teacher. Then on to Hundertwasser, whose primary colors make me feel very dull indeed. An exquisite Hockney print show. De Koonings and Diebenkorns at the Met. A nourishing afternoon looking at *real* art. Raising the bar high. The more I work, the more I understand and enjoy others' work. It's one of the benefits of being an artist. It gives you a kind of visual access. I know what they're doing, what they're thinking, what they're feeling. I'm not nearly there myself, but at least it's in motion.

I went up to Danny's, brought him my last journal to read (at his request). I sat in the living room looking through his archives, letters from Nico, photographs, postcards, fanzines for aspiring Stoogelings (*Popped,* everything you want to know about the boys from Ann Arbor), a stack of French teen magazines called *Copains* with lots of color pix of Delon. I was listening to Syd Barrett. Meanwhile I could hear Danny laughing in the other room.

Danny said he was amazed at my journal for a number of reasons. Surprised to see how much was on my mind, surprised to see what a heterosexual I was. He said it was very modern, the highest compliment he could pay anything. I asked if he thought I sounded shrewd and calculating. He burst out laughing.

"What's so funny?" I asked, bewildered.

"I'm sorry . . . it's just that I never read anything quite so uncalculating or unshrewd." It's touched with genius, he said. Well, he *is* the editor of *16*, so a diary by a pretty debauched rock kid *would* be right up his alley. I take his praise with more than a grain of salt.

The phone rang, I answered it saying, "Danny Fields residence, Duncan speaking, how may I help you?"

Danny got on with his jaded gay accent and said, "I'm just reading Duncan's diary, it's incredible, the kid has talent, the sex scenes are *vivid*! It's so cute!"

We walk over to Max's about one in the morning, Danny takes his usual booth in the back room, with the gray carpet on the walls and

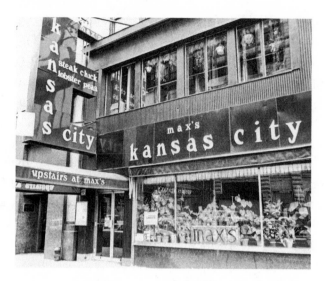

the Dan Flavin neon sculpture burning in the corner. Danny dons his dark glasses and broods over his Rémy. Fran Lebowitz sits with us and complains about her latest trick. Dolls drummer Jerry Nolan comes in with a gaudy chick in leopard skin, zippers, and frosted hair. Real skanky. Fran slips off.

Then Danny shouts, "Louis, Louis, come join us!" looking at the entrance to the back room. I crane my neck to see who he is talking to. Gulp. Standing there in an alcoholic stupor, looking into my eyes, is the avatar of decadence and perversion, the legendary Lou Reed! Looking thin in a gold leather jacket and denim trousers, he seems confused, thinking I'm the one yelling "Louis, Louis," even though my lips aren't moving. He walks over to me in a daze, finally looks across from me, then his face breaks into recognition. "Danny Fields!" he says with a crooked smile. He sits down, and Danny introduced me using my full name. Lou asked where I'm from.

"Minneapolis."

"I was there," he said matter-of-factly. He's talking very slowly

and thickly about how he wants to kick Lester Bangs's balls in. How everyone should shoot speed. About his last encounter with Nico in Paris, how she was "completely off the wall," how her filmmaker boyfriend broke pieces of furniture over an interviewer's head while Nico kept babbling on in her deep German voice, oblivious. How the MC5 drummer, Dennis Thompson, told Lou he needed some Motor City impact and he was Lou's man. About seeing Faye Dunaway and Peter Wolf necking in a corner of the Chateau Marmont, while Lou was talking to Iggy and Sable Star. Lou said Patti Smith amounted to nothing more than a haircut. He ordered two double tequilas at a time, and ended every sentence with "as it were." Eric Emerson strolled over in silver hot-pants, strumming his beat-up acoustic guitar, and serenaded us with a new song that was dedicated to Lou. I thought it was pretty good, but evidently I was in the minority.

Then Lou turned his jaundiced eye to me. When I told him I lived in One Fifth, he related how he'd been to a party there, and some drag queen was trying to get Lou to notice him, so he hung out the window by his hands, and finally dropped to his death. It made all the headlines. Lou shrugged. I was trying to think of what to say to Lou, my hero, when what should come on the jukebox but "Walk on the Wild Side." I asked him to "doop-dee-doop" along with the "doop-dee-doops." And he did! He keeps fixing me with these weird stares, then bursting into laughter.

Lou starts talking about reading Raymond Chandler. Now I'm on firm ground here, having read his entire works recently. I interrupt him at one point, saying enthusiastically, "I know that bit, it's great, but it's not from *The Little Sister*, it's from *The High Window*."

Lou stares at me. "Hey, Danny, she's talking. Do you let her talk?"

Danny smiles and says, "She does as she likes."

Lou goes on with his Chandler story. Even though I've been chastened for participating in Lou's diatribe, I can't help but jump back in

a second time, with some pertinent detail about how Chandler lifted something from Hammett. Again Lou glares at me. "Danny, she's doing it again. What is she, a big reader?"

"She's a very talented art student. She has a mind of her own."

"Where did you pick up this one?" Lou asks Danny.

"I found her at the Waldorf. She's the talk of the town. Everyone's after her."

All right, so they like to talk about me in the third person like I'm not there. Plus I'm a "she" now. Must be a Max's thing. I'm thinkin', this is *their* turf, and these are *their* weird rules . . . it is humiliating, true, but I let it roll off. Big deal.

Danny gets up to get us some Gauloises filters.

Lou says, "Well, Rathbone, uh . . . do you have a curfew tonight?"

"No."

"Well, where do you go, then?"

"Home."

"To spend the night?"

"Uh-huh."

"Do you belong to Danny?"

"No. Danny is my friend."

"So you're just friends with Danny. He's my friend too. You know, you look like David Cassidy. Do you like David Cassidy?"

"No."

"No? I do. You could be *my* David Cassidy. How would you like that?"

"I wouldn't."

"I tell you what, I got a hotel room tonight, and we could go back there and you could be my little David Cassidy. How about that?"

"Uh-uh."

He leans into my ear and whispers, "You could shit in my mouth. Would you like that?"

"No."

"Okay then, how's this? I'll put a plate over my face, and you can shit on that . . . and then I'll eat it . . . How would that be?"

"I wouldn't like that, either," I answered in a monotone. I'm disgusted, which I presume was the point. My hero worship is immediately over. Ick.

He stares at me a long while and says, "You'll be missing me tonight. Gotta split." He downs the rest of his tequila and leaves me alone in the booth to ponder my missed scatological opportunity.

Danny eventually returns, excited. "Lou's in love with you!"

"How do you know?" I say sullenly.

"He told me in the men's room!"

"Yah, and you know what he wanted me to do? Shit in his mouth!" I said, making a face.

"Oh . . . didn't you want to?" says Danny, all concerned.

"*Nooooo!* What is with you people?!?"

. . .

Last night I saw Visconti's *The Damned.* Helmut Berger played an elegant, androgynous, incestuous, sadistic, druggy, alcoholic Nazi. Beautiful Charlotte Rampling was his sister, playing doctor under the piano. Sick but riveting. In the lobby I saw Antonio Lopez model Donna Jordan, very slight and blond and beautiful and gap-toothed. Sigh.

Party at Cherry Vanilla's (she is Bowie's publicist) Chelsea abode for a telecast of Bowie's *1980 Floor Show,* filmed at the Marquee Club. Her large apartment is Bowieland: Bowie dolls, Bowie paintings, enormous Bowie photos, Bowie collages spliced with tasteful tinted porno, the walls painted as a blue sky with powdery airbrushed clouds. I snoop in the bedroom, made infinite by mirrored tiles, a pink chiffon canopy over the bed, which I sat on to watch a tape that's

on of Angie Bowie on *The Tonight Show*. Carson asks her, "What's it like being married to a rock star with all the girls after him?" Angie replies, "Honey, what about the *boys!*? We pick up a lot of slough!"

A very tall, emaciated woman in black with exotic eyes entered the room, and stood right in front of the TV screen I was watching, so I swatted her on the ass. She whirled around and slapped me full across the cheek. Then she squatted down to my sitting position, put her arms around my neck, and said in a foreign accent, "Dahling, ah vee vighting already? Vee've only just begun," and kissed me on the mouth. I was somewhat terrified. She laughed at my naïveté and joined the rest of the party. I then remembered her from *Interview*: Cheyanne.

Party is in full swing. Big fat Tony Ingrassia (who is working on Bowie's stage production of Orwell's *1984*) never left the snack table. Cyrinda Foxe in black suit next to Leee, who is going on about how New York City will fall in two years, so he is here to capture the dying embers of affluent, bored, transsexual madness on film. Like the fall of the Roman Empire. Two cuties from MainMan, Teresa and buxom Dory, sit on the couch cutting paper dolls and sewing Christmas stockings; *Interview* photographer Christopher Makos is looking a bit like one of Robin Hood's men with his faint beard and bondage getup. He is rumored to be kept by Tony Perkins. Jamie Andrews got a new perm, looks like Harpo now, calls me Duncan Donuts, pours me drinks. Couple of faux Bardots tart around. Tall, handsome Stephen Demerest (a dead ringer for Richard Chamberlain) has got all the girls in a tizzy.

Bowie came on at 12:30, and all the people who worked for him went crazy. The Troggs had opened with their "Wild Thing," and the emcee was Veruschka. She introduced Marianne "Face-full" and said "Very strange" after each number. Bowie's best was the Merseys' "Sorrow," done as a chess game in black-and-white. The girls screamed over Mick Ronson, the psychedelic surfer from Hull. The show was unlike anything I'd ever seen before, very modern and risqué.

At two-thirty a.m. Danny and I hopped into Steve Paul's limo, bound for his estate in Greenwich, CT, that used to belong to Rita Hayworth. Over the door is a brass plaque that says "The House That Frankenstein Bought," alluding to the Edgar Winter hit song that Steve guided to number one on the hit parade. He made a bundle. Danny made pancakes for me and Steve; we pretended we were starving orphans begging from door to door. At six a.m. we went out to

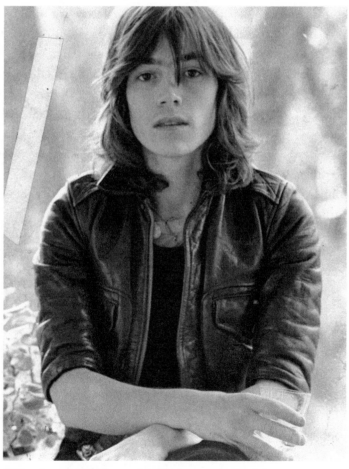

DH at Steve Paul's Connecticut house

184 · DUNCAN HANNAH

the chilly dawn chorus, walking by the stable, the pool, the ghostly gazebo, and the empty tennis courts, our boots crunching on the November ground as we strode past granite sculptures of Cupid. The shock of nature.

Saturday Danny took six hundred pictures of me, by the pond, in the sun porch next to the ferns, and in the spacious stone living room, which was equipped with a high beamed ceiling, suits of armor, and George Gershwin's grand piano; more like the set of an English horror movie than the weekend getaway of a rock 'n' roll businessman. Black-tiled bathrooms with floor-to-ceiling mirrors, discarded copies of the *New Musical Express* by the toilet.

Danny looks through the shutter, says, "Think of something sad," *click,* new lens, *click,* new roll, *click,* "Give me more," *click,* "Fantastic!," *click,* "Okay, that's good, but really give it to me," *click,* "Okay, you just lost your lover," *click,* "Moisten your lips," *click,* "Hold it," *click,* "Pull your legs up," *click,* "Great," *click, click, click,* all day long, exhausting. I watched *The Avengers* and took a nap.

Dinner in the kitchen at a long glass table. First course, hashish and artichokes, then roast beef and cauliflower, listening to classical music and show tunes. Brandy-and-ginger-ales. Steve says, "Turn on the TV, there's an old Duncan Hannah movie on." I went to bed to read Colette.

· · ·

Eric and I went to the Academy of Music to see Hawkwind, who weren't to my taste, but the after-party at Hayden Planetarium was great. Talked with Peter Lester, English gossip columnist for *Interview* (the house organ for this bizarre society); Dolls photographer Bob Gruen; miserable Jane Forth (who said to me, "Oh yeah, you're the boy with the smile . . . The prettiest ones are always the poorest . . . Oh, well"); golden Donna Jordan in NYC souvenir T-shirt; Anglophile Ira Robbins; Spencer Davis; Fran "the Best of the Worst"

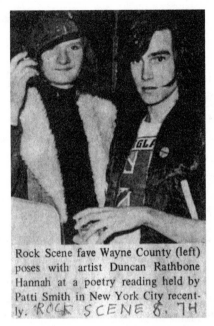

Rock Scene fave Wayne County (left)
poses with artist Duncan Rathbone
Hannah at a poetry reading held by
Patti Smith in New York City recent-
ly. *ROCK SCENE 8. 7H*

Wayne County and DH in Rock Scene
magazine

Lebowitz; gun-shy Peter Gabriel; Dave Marsh; Richard Meltzer; Jackie Curtis, teasing his hair; Alice Cooper with his girlfriend, Cindy Lang; Stevie Wonder, bumping into things (his shades a bit too light, could see his eyeballs rolling around); unintelligible Terry Ork; and Patti Smith. She was fun, said I was the cutest kid there. "Every inch the English schoolboy."

"That's the point, isn't it?" I said.

"I like people who have a point of view when they dress," she said. Patti introduced me to her boyfriend, Allen Lanier, from Blue Öyster Cult, and pretty Janet Planet, an ex–child star who goes out with Syl from the Dolls. I got my picture taken with Wayne County for *Rock Scene* magazine.

A couple nights later I am summoned to Steve Paul's Gramercy

186 · DUNCAN HANNAH

Park apartment, and Danny Goldberg (runs Led Zeppelin's Swan Song label) drops by to ask Steve for some advice on the band Queen, who I don't like. Then we smoke some *too* strong grass and Steve works some of his mind fucks on me. He'd used this psychobabble on hitmen in the sixties, when the Mob wanted to take over his club, the Scene. They were taking him on a one-way trip to the dumping grounds outside JFK, and he dosed them with acid and talked them out of murder as a profession. I'm outta my depth here. He says he wants to put me through some changes, and he wants me to put him through some changes, too. I had to get out of there, so I return to One Fifth about three a.m., heart pounding and feeling jangly.

I unlock my door, walk to my bed, and see a movement out of the corner of my eye. A phantom floats out of my roommate's empty chamber, some sylph in a peroxide-blond wig, white-faced and dark eyed. Oh, god, it's coming towards me! How do I escape? Is it a vampire? It slinks. It's laughing! It knows me! She pulls her wig off. It's Eden! Scandinavian Eden from Minnetonka, who I've known since 1970! Eden, the ringleader of a girl gang that included old flames Lainie and Angie. How the fuck did Eden get in here? She's laughing her head off at the terror in my face. I'm still too stoned.

Eden's a stripper now. Dances in Jersey under the name Frosty, because she's so pale. Loves the girls she works with. She explains that she just got off her shift. Someone told her where I lived, my roommate let her in, and she lay in wait for me. She couldn't resist scaring the shit out of me. Surprise! Christ.

We walk to the all-night Waverly Coffee Shop for some ham and eggs. It's snowing. She looks very androgynous, like a cute blond teenage boy. She's wearing a black flight suit, knee-high Crayola-green leather boots, and a short white rabbit-fur coat. We realize we have been in similar situations, accepting the kindnesses of new acquaintances and then fending them off as they try to claim their reward. Two alien outcasts from the Midwest making our way in big,

bad New York City. We drift over to her fourth-floor walkup in the Village. A black-and-white studio with a bed and a TV, that's about it. It's five in the morning, so I ask if I can stay, as I'm suddenly sleepy. So I strip down to my boxers and climb into her girl-smelling sheets.

She stands over me in her undies and bra and asks if I want to see her tits, as if they're funny or freaky or something.

"Sure." They're small, nicely shaped, and have puffy nipples.

"Eden, you have such pretty tits, they're adorable!"

"Do you wanna touch them?" she says, her face changing from its usual comic expression to one of more sensual nature.

I switch gears, going from seeing her as a brazen, boisterous figure of fun to the rather lovely, freckled young woman she is. So there we are, heads on the pillow. She says she feels funny about messing around with a guy who's been passed around to all her friends. "It's such a cliché," she says. Nevertheless, we start playing around, her taut body bending like a serpent, pliable in the dark, her golden pussy guiding me in, and despite the fact that we're both so bony that our hips gouge each other, we're good at it, moving slow and tight through consecutive orgasms. She was so different from the girl I thought I knew, here in the other realm of Eros. Just what the doctor ordered. A balm for these wacky times. It was very romantic in that cheap apartment, with the snow falling on the street outside, smoking in bed in postcoital bliss. Doing what bohemians had been doing in Greenwich Village for many decades past.

"I can't believe it, you fuck like a black guy! Who'd have thought?" she says, laughing.

"I don't even know what that means," I said, interested.

Eden's had a short history with black jazz musicians, reputedly cutting a small swath through the Ann Arbor Blues Festival, so I reckon she knows what she's talking about.

Still laughing, she says, "You know, soulful. Like R & B. . . . groovy."

"That's good, then."

. . .

Sunday brunch at Pat Loud's, of *American Family* fame, with daughters Michelle and Delilah, Chris Makos (who was dancing to the infectious David Essex single "Rock On"), Parsons student Mary Jane from Cleveland, and Tennessee Williams's pal Dotson Rader. He lives in the Dakota with Ruth Ford. He tweaked Mary Jane's nipples and said, "What are these?" He said artists were prisoners of the rich. He tells me I should be more ambivalent. Danny is mad at me for drinking so many Bloody Marys. Makos drives us downtown in his 1959 Cadillac to another brunch at Cherry Vanilla's cloud-filled apartment.

This party is wilder, everyone is already plowed, the sexual vibrations are intense. In the middle of it all, in a see-through black dress and no underwear, is Angie Bowie (formerly Jipp Jones); she's very loud and squealy, dancing around in her spike heels, flashing her tits and pussy to all. Two long-haired eight-year-old boys are playing with a two-headed black dildo. Mott the Hoople is blaring. Cherry grabs me and says, "Duncan, you must meet my girlfriend Annie, because she loves you and has nice tits. What are you doing after the party?" And there is Annie, a beautiful, diminutive high-fashion thing, who admits to every word, and hands me her phone number scrawled in eyebrow pencil.

Some funny English guy says to me, "You know us British, we have an olde saying back home that we like to say to boys like you, that goes like this, 'Helloooo, sailor!'" Ha, ha. I *was* wearing a sailor suit, which always attracts the kinkies.

Leee Childers has a phrase he uses a lot, which is "Well, this one over here . . . ," and he will point at me or Wayne like we're not present, which denotes our incorrigible factor. Leee leads me over to Mick Ronson and says, "Mick, I'd like to introduce you to my fiancé, Duncan Hannah." We shook hands, he was very friendly, he bums

a Sherman off me. We talked of various things. We both love Jeff Beck. I wanted to stay there forever, but Danny says don't overdo it. Time to leave.

. . .

I walked a couple miles south to Eden's apartment over the pizza parlor. She's upset because she's falling for me; it goes against her principles or something. "It's so weird being around you because I'm not used to people who are as crazy as I am. You're used to having your way, and I'm used to having mine! And now my vagina is all fucked up like it always gets when I start falling in love with someone. I forget everything I think or do. You upset my equilibrium!"

And yet her eyes say "Special when lit." My little go-go girl. I want nothing more than to stare at her face in the candlelight. Her face looks different in bed as opposed to on the street. She tells me to stop looking through her with my X-ray pupils. McCoy Tyner is sputtering on the radio. A glossy of Fred Astaire is on the empty fridge. The shades are drawn. The room smells of us. We get under the quilt. My breath escapes with a shudder. The sex makes us lazy and languid.

. . .

Went to a Rohmer double feature with Eric uptown at the New Yorker Theater. *My Night at Maud's* and *La Collectioneuse*. Afterwards we sat in Caffè Reggio and reminisced about the old days when we'd take acid to go to high school, and by trying to uncross our eyes we'd only screw them up more. He's an intrepid soul, going against his very strict, conservative Taiwanese father. He's off to Philadelphia to see the Who.

. . .

Eden saw Bob Dylan somewhere and she went up to him, grinned, and said, "Hello, I'm from Minneapolis."

"Go back," he replied.

I take a roll of pictures of Eden in her black bikini go-go outfit, with her blond pubes sticking out the sides. Some topless too. She laughs when I tell her that my sister calls me Beebo, my mother calls me Darling, and my dad calls me Donkey. We go uptown to kiss in Rockefeller Center and to see the Xmas tree, smell the pine needles, inhale the floorwax and cleaning fluid in St. Patrick's, buy a Hockney drawing book in Rizzoli, down to the East Village to eat omelettes in a dark, sawdusty coffee house, and then to bed.

Danny takes me to see the Angels of Light, the San Francisco drag troupe. Strangely heart-warming. They sing "I'm Always Chasing Rainbows." The trucks, where the leather boys fuck, were outside. Jack (*Flaming Creatures*) Smith was there. The Modern Lovers' Jonathan Richman too.

Next night Danny and I join Steve Paul's table at Mario's. I sit across from Johnny Winter, the surly cross-eyed albino blues guitarist, who is muttering in his Texan accent how awful life would be without drugs and alcohol. Tiny Rick and Liz Derringer are there; we go to their apartment next door, used to be Teddy Roosevelt's, large French provincial mirrors like Versailles, gold records on the wall ("Hang On Sloopy"). We're all getting high. Then Wayne Fontana shows up! (He'd sung "The Game of Love") with the Mindbenders, who were great in *To Sir, with Love*. We took this strange menagerie down the block for a Patti Smith show at Reno Sweeney. Patti opened with Kurt Weill's "Speak Low," then sang "I Get a Kick Out of You." Then some tune about how Jesse James and Billy the Kid got in a quarrel over Patti, and Billy got shot dead. We all loved her, she's very winning.

December 11

I sit with Leta Warner in drawing class. She's a beautiful, aristocratic girl from Washington, DC, très chic, very leggy, eighteen-inch

waist, metallic eyes, barrette in her hair, the works. She smells like new-mown hay. She invites me to her Upper East Side pad, but now I'm spoken for by a brash striptease dancer. Bad timing! But I go, and meet her precocious kid sister Georgie, visiting from boarding school. (She's a stunner.) Swanky pad, Art deco furniture, a David Croland portrait on the wall, wooden venetian blinds blotting out the cars and trucks skittering in the rain below on Second Avenue. Leta served spaghetti and we talked about the energy crisis and suicide and Klimt and Nolde. Weegee shot their grandmother at a society ball. I felt like the proverbial fox in the henhouse. Love the sound of their heels clacking on the parquet floors. Strictly top-shelf broads, as Sinatra would say. After dinner, we walked in the rain under an umbrella to Cinema i to see *Don't Look Now*, starring Julie Christie and Donald Sutherland. Also in line, under an umbrella, was rat-faced Johnny Thunders with Sable Starr. During the scary bits, Leta would grab my arm and bury her head in my black leather shoulder, asking me in a whisper what was going on. Kisses left untasted.

· · ·

Thrift-store shopping with Eden. I'm trying to capture that early Keith Richards look with a girl's striped jacket, Eden trying to capture who knows what with gray and lavender satin tennis shoes. Her hair is standing on end. In a cute way. I reach up under her letter sweater in a changing room. She tells me about a black dude at the club she dances at who offered her twenty dollars for her panties. "I would have done it, but I wasn't wearing any!" She eats hamburger after hamburger. Jelly candies. On the way home she's goofing and asks passersby if they "wanna buy a leetle pussy?" in a fake Puerto Rican accent.

Eric and I go see double bill *Bed and Board* and *Last Tango* (fourth time). We spot the belle of Bard College, Zabo Stanislav, at the candy counter. I swoop that blond Venus up into my arms. She's filed under

"The Ones That Got Away," due to my own immaturity. Not unlike the awkward fumblings of Antoine Doinel himself.

Afterwards Eric and I stroll down Christopher Street, looking in the windows of the gay bars. We decide to stop in Ty's for a beer, just to see what it's like. We are men, after all. We enter, the noise stops. Eric and I pretend we know what we're doing. The bartender leans forward. Says, "You better watch your Ps and Qs."

"Whaddya' mean?" I ask.

"You're the prettiest thing we ever had in here. Watch your cock and ass. Everyone will attack you."

I say incredulously, "You mean physical danger?"

He shrugs. I order two Buds.

Some hard-faced lumberjack chiseled out of granite steps in and says, "You're *soooooo* beautiful," and I laugh and thank him for the compliment.

Then he says, "Now get out of here. You don't belong here. Go home and make love with your friend. You belong somewhere beautiful . . . not here. Go to Morocco." I say okay, and Eric and I walk through the gauntlet of hands reaching out to grab our velvet-covered asses. As my mother would say, "So much for *that* bright idea."

We drank elsewhere. It started snowing. Eric got on the subway for the perilous ride to Harlem, and I went home to One Fifth, where young Eden was asleep in my bed. A nice surprise. I slipped in with her, and I slipped into her, and she's whispering, "It's so good, it's so strong," and she cries from joy.

In the morning we went to the Upper West Side to see her stripper friend Velvet, who reminds me of a blond Italian movie star (Mariangela Melato, who appears in one of my favorite magazines, *Continental Film Review*). She usually wears a beret over her goldilocks; heavy-lidded stoned eyes. She's going with the Dolls' sax player, Buddy Bowzer, who comes over, too. He's nice. It's cold out, Velvet lights a fire in her prewar apartment. We smoke some grass and

drink white wine. Eden and I take the IRT downtown for a couple of quickies before my evening engagements.

Dinner with Danny at El Quijote, in the Chelsea Hotel. Eggs and vinegar, veal and onions, French bread, ice-cold beer, and caramel custard with espresso. Danny was in an expansive mood, talked about Harvard Law School, how boring he found the beat movement, and his friendship with doomed starlet Edie Sedgwick, who lived with Danny for a while. Before her heroin overdose, Edie knew, fucked, and radiated over everyone. David Johansen is in the booth next to us with Monroe-esque Cyrinda Foxe.

We went to Max's for a nightcap and sat with Lenny Kaye. He and I discussed the new German book *Rock Dreams*, featuring rock stars in positions you always wanted to see them in. Done by Guy Peellaert. Leee arrived with Wayne and Angie, kisses all around.

· · ·

Dinner with Steve Paul. I get a fortune cookie that says, "While proceeding with caution you may miss some opportunities." He decrees this to be cosmic. He wants to set up house together, but that's an impossibility for so many reasons. He gives me 1920s sheet music for a song titled "You May Be the World to a World of Friends, but You're More Than the World to Me." Oh god, what a mess I've made! I'm not meaning to be a cocktease, but that's what it comes down to, in these men's eyes.

· · ·

Wednesday I apply myself to schoolwork, and at seven Eden shows up, carrying a large green hatbox. She's all keyed up and wants to get drunk to calm her nerves, so we go to a college mixer, and then *The Exorcist*, which freaks her out even more. She tells me she believes in God and reincarnation; I tell her that I don't, but that it doesn't make any difference since we've both arrived at the same place anyhow, that

we love each other, that's all that matters. But she's getting more upset, and wants to convert me to save my soul, etc. Somehow she spilled her drink in my eye, and the Scotch stung like hell. Dizzy dame!

· · ·

Back in Minneapolis for Xmas. Lainie and Angie say they've gone lezzie, fed up with us boys. Everyone's trying to be the center of attention. Everyone adamantly, voraciously alcoholic.

I go to my rich uncle's annual Christmas party, the one I go to every year and usually bring a date, which perks up my dad. This time I've got Eden in tow, and she's dressed in an abbreviated Santa's-helper outfit, red velvet with white rabbit-fur trim, with jingle bells on her wrist. Green tights and knee-high boots. Eyes rimmed with kohl. She looks great . . . but she *does* look like a stripper. We entered the front door to the living room, where a crowd of old square relatives solemnly sat around sipping their drinks. Eden spread her legs, shook her bells, and said, "Merry Christmas, everybody!" The place went silent. Pacemakers failed, dentures fell out, drinks were dropped. It was as though I'd brought a Hennepin Avenue hooker to the family party. My mother glared at me. It wasn't seen as a bit of Christmas spirit. We didn't stay long. Oh, well . . . they looked like they could use a little shaking up. My mother said she stayed up all night crying. Because of "appearances." However, my dad says I've got a lot of spunk.

Eden's a bit of a kleptomaniac. Stole a Stradivarius (she says, though I wonder . . .). A four-hundred-dollar camera. She looks like Bugs Bunny. Red-hot-bunny lover. Something about the teeth. She gets weirder and sexier all the time. "You came, you saw, you conquered . . . me," sings Bryan Ferry.

· · ·

Back in NYC, so alive. This place is a monster.

Last night Eden made $150 dancing above the bar, another $50 in

tips, $25 for selling her panties, and got $40 when a guy asked her to touch his cock. She grabbed the money and ran to a waiting car in the dark parking lot. Sounds dangerous to me. These joints are crawling with Mafia guys. You wouldn't want to disrespect the wrong fella. You might end up with a permanent ear-to-ear smile.

New Year's Eve, 1973

Danny and I snort some coke for the NYC return of the new, improved, *Raw Power* Stooges at the Academy of Music. We settled ourselves in front-row-center seats. The Dolls open, they're a gas. Intermission time, Danny says, "Let's go up and say hi to Jim"—Iggy's real name. We start climbing the stairs to the dressing room, and we can hear Iggy howling like a werewolf, getting himself psyched. I'm *very* psyched! One of my all-time-top heroes, Iggy Pop, the craziest rocker of them all. Iggy was lying in the doorway, dressed only in pink hot pants and thigh-high boots, admiring his ribcage in a mirror. When he sees Danny, he jumps up and gives him a hug, and asks to be introduced to his friend. Me. Yipes. This legendary reptile grips my outstretched hand and grins madly through his chipped teeth, says in his Detroit accent, "Hi ya, Duncan, glad ta meetcha—any friend of Danny's is a friend of mine! C'mon in and meet the boys." In that small, smoky room, littered with Fender amps, makeup kits, rock graffiti, booze, and Sable Starr, stand the sinister Asheton brothers, Ron and Scott, dressed in fascist attire—storm-trooper boots, iron crosses, etc. There's James Williamson, who packs more hair-raising violence and cubist terror in his licks than any gun-slinging guitarist going. Iggy is circling the room, hissing and snapping like a rabid junkyard dog. This is gonna be good! History in the making.

We leave them to their tuning up and descend to the stage, where Todd Rundgren and his Playmate girlfriend, Bebe Buell, are wearing matching astro-mobile suits, that look like they were made from

nylon shower curtains. Mackenzie Phillips is having trouble stay-ing erect, due to Quaaludes no doubt. She mumbles weakly, "Yah, Stooges," and then falls over on her face. There's the Blue Sky Records contingent, cute Rick and Liz Derringer with manager Steve Paul, who scolds me for looking cheap, because I have on my gold satin suit from Alkasura and a little makeup. There's Johnny Thunders and English scribe Nick Kent, in a feather boa. The groupies were on the prowl, for Iggy is the king of beasts.

Showtime. The curtains part, the band marches out, and Ron steps up to the mike and says something like "Ich verboten due weisstiche der fuhrer ich nine ach spiegal-hausen unt der Stooges!" and they break into "Down on the Street." But no Iggy. They play on. Still no Iggy. Where is he? He was primed and ready just fifteen minutes ago. Iggy appears, thrown out from the wings. Not looking too well.

He gets up, and staggers into the drums. Falls onto his back, too fucked up to make monkey faces, or dance, or sing, or do much of anything. He crawls to the front of the stage, and falls off. When he was shoved back up it was clear he had wet his pants. It was pathetic. Expectations dashed. The Stooges were clearly pissed off. This was to be *their* night. No front man. He'd been disabled by a few lines of elephant tranquilizer, courtesy of Sable Starr. A couple of roadies carried him off, and the Stooges sputtered to a halt. Defeat wrestled from the jaws of victory.

Danny and I went back up to the dressing room. Iggy gone. Bad vibes. We drank some vodka with the band, who were talking about quitting. Ron had a swastika on his arm. Said he was gonna write a book about Larry, Moe, and Curly. Fuck this shit. Danny and I left at midnight, not wanting to stay for Blue Öyster Cult, to go to some depraved parties, and I danced with a Prince, a real one.

Having a freakout like there's no tomorrow.

January 1, 1974

I woke at nine a.m. on Danny's couch, still dressed in (now rumpled) gold satin, makeup smeared, face puffy with drugs and alcohol. I grabbed a Herman's Hermits album and limped down deserted Fifth Avenue to Eden's on Bleecker Street, where we spent the day in bed, laughing and loving, testing brand-new 1974 to see if it felt any different. We splashed out on dinner at Reno Sweeney, and Peter Allen came over and bought us a drink. He said I looked like Peter Pan. Tried to pick me up right in front of Eden. She gave him the stinkeye and told him he was rude.

She looked so pretty, her chalky face bathed in red light. She's dizzy and doubtful and belligerent but she's in love with me, against her better judgment. I tell her about the time when I was on a bender with Kurt and Steve back in Minneapolis, and we called up a sanitarium and asked for an ambulance to come pick us up, they asked why, and we said, "Because we're crazy." They hung up. Kurt said, "Christ, a guy can't even get committed anymore?!" Eden likes this. We go home to bed and watch *Seaside Swingers* starring Freddie and the Dreamers, and Eden says if I leave her she'll kill herself. She says this time she really means it.

Next day she's coming down with bronchitis, which is making her act like a grave injustice has been done to her. She's acting selfish, irritable. Mean Eden. In spite of the fact that we're swilling gin and listening to Roxy Music's incredible third album, *Stranded.* "When could we, how could we, why?" Great sound, great lyrics. Bryan Ferry never disappoints. Mixing high and low cultures into an aggressive, sophisticated pop form. Reaching today's youth with literary references, fashion slang, sexed-up society, old Hollywood, Greek myths, etc. All in an accessible package that you can dance to! How good is that?

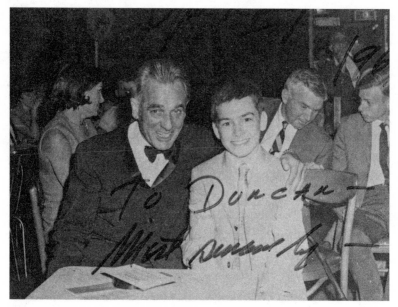

Gene Krupa and DH at Café Metropole, ca. 1967, flanked by his parents

Gene Krupa died. I heard him in the Metropole on Times Square in 1967, sat by his high hat while he growled his way through the set. Looked like a werewolf in a dinner jacket and bow tie. Had my picture taken with him. He took me up to his shabby dressing room, where he had an egg-salad sandwich on whole wheat and a glass of chocolate milk. Signed an eight-by-ten glossy for me: "To Duncan, Good luck with your drums, Gene Krupa."

. . .

Eden's on the warpath again. She's mad because I'm an alcoholic. She's mad because I won't marry her. She's mad because I "talk in visuals" (whatever that means). We go to Max's to drink Pernod. She spots an old boyfriend named Dorian Gray (really), so I go sit with Leee. He says, "You're wearing my favorite color, leopard!" Johnny Thunders is staggering around under the weight of his big hair. I

ask Leee who the cute blond rocker in the doorway is. He says it's a new hustler in town called Richard Lloyd that's got all the guys hot and bothered.

Eden and I quarrel, get a cab back to her room, and snort some THC. Strange drug that takes us back through the five years that we've known each other. She says she's tougher than me. Certainly has gotten in more dicey situations than me, though I've had my share. I can see and feel the mood of those times ago. Eerie new perspectives. The powdery whiteness of her face looking down at me. Her eyes, lengthened at the corners by eyebrow pencil, show an unnatural brilliance. I'm infatuated with her. "You're my cavalier," she whispers. "You have a thousand faces."

Winter 1974 Albums
(*No Pussyfooting*), Fripp and Eno
Stranded, Roxy Music
Diana and Marvin, Ross and Gaye

Winter 1974 Movies
Pierrot le Fou
A Woman Is a Woman
British Agent
The Exorcist
Kaleidoscope
Sunset Boulevard
The Young Lions
Two English Girls
Jules and Jim
Partner
Stand-In
A Hard Day's Night
Shoot the Piano Player

Banana Peel
Paper Moon
The Mother and the Whore

Winter 1974 Books
Bel Ami, Guy de Maupassant
Pentimento, Lillian Hellman
Memoirs of a Shy Pornographer, Kenneth Patchen
Short Stories, Dorothy Parker
Arthur Rimbaud, Enid Starkie
Nausea, Jean-Paul Sartre
Short Stories, Graham Greene
Berlin Stories, Christopher Isherwood

School Daze. My photography teacher says I chronicle colorful degenerates who act publicly intimate. That's good, but I lack a point of view, he says. That's bad.

. . .

Eric and I picked up Eden at her dance class (Murray Louis Dance Company), where I found her frolicking to Chopin in gray dance tights. She kisses me as if I was her husband, changes, and off to a Belmondo/Karina double bill at Carnegie Hall Cinema (my home away from home), both by Godard, very Euro audience. Fantastic modern French fables of mad love I can identify with. Belmondo's frustration and addiction to a remarkable, beautiful woman who blows chilly, then exalted, seems totally familiar. The modern girl is self-created and self-sufficient, a slave to her imagination. Creating a drama wherever she goes. Getting delayed by a mirror. Elaborately doing nothing. It's easier to understand people in movies. How inventive life can be, lending substance to airy nothings.

Eden has buck teeth. She'll do anything for a laugh . . . or a carrot.

January 17, Washington, DC

Back at Holly's for ten days. She made her famous lasagna.

It's a rainy Saturday on 646 East Capitol Street. Coffee, cigarettes, my diary, my sketchbooks, and a black-and-white TV. Watching *British Agent* with my favorite old matinee idol, Leslie Howard. He hasn't been out of his tailcoat yet. A cultivated man who passes lightly over everything, accepts events without asking questions. He stares out with an expression of bemused inquiry, then sparkles with amused laughter. He's cool.

Now it's *Tarzan and the Leopard Woman*. Cheetah is playing Dixieland on his snake charmer's horn. That leads to *The Picture of Dorian Gray*, marred by the casting of Hurd Hatfield. Not pretty enough. Imagine Bowie in the role. Someone to make one gasp. The book was a zillion times better.

Brokenhearted DuPrey comes over, having just split up with his cute girlfriend, Sheryl. We drink bourbon in the pale blue living room. We smoke Tijuana Smalls. Talk about the difficulties inherent in romance. We drive off in his mom's car, past the palatial mansions of Georgetown in the drizzle, to our old haunt Apple Pie. We meet Bard pals, horny poet Doc Bray and pirate-faced Cy Davies. Serious drinking ensued. Bray invited me to join him in a ménage à trois with a luscious blonde he was with (his Nordic cousin). I asked her if she minded, she said, "No, I don't mind if I do," in a soft, sexy voice. Our table was very merry, the joint was crowded with gyrating, oversexed youths, lots of cognacs. But I lost my wallet, and the bill was large, so we attempted to sneak out, but the bouncer caught me by my English army surplus greatcoat and dragged me into the kitchen for a good pummeling. DuPrey and Bray rescued me in the nick of time. The ménage à trois didn't happen, spoiled by a night on the tiles, as usual.

I woke up in a bare room, on a bare mattress, after nightmare

sweats. Am I in a concentration camp? No, it's only DuPrey's basement. Head pounding, bloodshot eyes and parched lips, and very little memory. Done it again.

Back at Holly's I listen to Mahler's Symphony No. 1. I like it. I think about all that's ahead in my life, much that will be fine and fulfilling if I can only find my way. DuPrey said last night, "We'll be thirty before we know it, even though it's a long way away." I know it too. I feel a sweet sadness. It's the Mahler, I guess. I stare out the ivy-covered window at the overcast sky. It's all gray and green.

Eden calls long distance. She's been sick. Her eyes turned yellow. She's thin as a bone, just a bone in bed, watching TV. Somehow it's my fault, because I'm having a nice time at my sister's. Eden's sabotaging us.

As it turns out, she's got hepatitis and jaundice. Now she's in the hospital. My sister is worried that I'm contaminated too. Because she's pregnant. Did I use her toothbrush? My low-rent life has come to jeopardize hers. She's mad. She's justified. Poor long-suffering sister.

I escape with DuPrey for a couple days, where we hang out amongst teenagers in revolt, or perhaps they're revolting teenagers. We go to an erotic film in a Georgetown arthouse, where we watch a young blond girl remove her panties, sit on a soccer ball, and rock back and forth for quite a while. This seems to make her feel unusual. We both agree it's pretty good. Afterwards we walk in Dumbarton Oaks, then the Botanical Gardens, pretending we're in a Jules Verne story. We're Victorians in modern times.

Time to return to NYC.

CRIME OF PASSION

(dedicated to Pierre Clémenti)

DUNCAN HANNAH

Late-afternoon beiges and pinks at the Trans-Lux. Symphonies of crouched pastels. The colors of old Europe. I smooth my head back into place. I have a mechanism for seeing, called eyes; for hearing, called ears; for speaking, called mouth. I've the feeling that they're all going their separate ways. They're not coordinated. Senses, unite!

I go see the Modern Lovers with Danny and his new boyfriend, Richard Sohl. Richard and I talked about our shared love of NYC rhapsodist, Laura Nyro. Jonathan Richman sang "Here we are in dreamland . . . Look, there's your girlfriend." There was David Johansen teasing his hair, sayin' to someone, "I been busy hittin' the big time." Taylor Mead said to me, in fake olde English, "In what quaint apparel doth thou paradeth now?"

Went to visit sick Eden, whose liver is all messed up. No sex allowed. So we watch a ten-year-old film of the Stones at the TAMI Show (Santa Monica Auditorium). Jagger was twenty-one, bewildered by his power and this new pop phenomenon, and he kept testing his audience to see what he could get away with. Makes me feel like an underachiever at the same age. He's singing, "C'mon, cuz ah belonga you, 'n' you belonga me, so c'mon." Eden says she's got me figured out, and now she has to return to Minneapolis because her condition is deteriorating. Only 102 pounds.

I went to Max's with Eric. Lou Reed came in, looking like a skinny chimpanzee, in square sunglasses, studded black leather jacket, and

closely cropped hair. He and a girl took the corner booth, he turned off the light and proceeded to get very drunk. We sat with critic Donald Lyons gossiping about our screen idols, Delon, Zouzou, Sanda, Vitti, Stamp, Hemmings, and Clémenti, who used to drink and drug here with Viva. Eric and I finally crept home in our high-heeled shoes. It was bitterly cold.

Once a week I go over to Steve Paul's Gramercy Park apartment for another dose of his intense, provocative conversation. He told me I was a real cool guy, and also a real asshole. He told me he makes $250,000 a year. He took me to see Peter Cook and Dudley Moore in *Good Evening*. We met them backstage and they signed a napkin for me. *Bedazzled* was one of my favorite movies. Then we go for Chinese. In the new *Esquire* "Heavy Hundred" Steve is listed as a "miracle maker."

I went to see Bertolucci's *Partner* down the block from me at the Art on Eighth Street. It starred Pierre Clémenti as a guy named Jacob who meets his double. Dances with his shadow against a chipped, peeling wall. I love the way he grins bemusedly through his pursed lips at Stefania Sandrelli and Tina Aumont. When he leafed through a book on horror movies, he stiffened his fingers, stretched out his jaw, and *was* the Hunchback of Notre Dame. I sat through it three times, hoping it would permeate me. Bathing in Italian cinema. "À bientôt" he says to himself.

Friday, February 15 St. Valentine's Day Massacre with the NY Dolls show at the Academy of Music. They arrive on Fourteenth Street with a police escort and come in through the front doors, dressed as gangsters. I'm with Steve Paul's entourage, so we get to stand in the wings and more or less watch it from the band's point of view. Exciting. The Dolls are the glue that binds this scene together. Camp but butch. They don't take themselves too seriously. Well schooled in the

amped-up R & B they deliver. Champagne corks are popping, strings of pearls underfoot, girls mount the stage to give David a kiss, security rushes them away, two encores, crowd still nuts, David says, out of breath, "Do they really want us back?!" mopping the sweat from his brow.

Next stop, the Record Plant to watch Rick Derringer record his new album. Then up to Steve "the Original Hip Tastemaker" Paul's Greenwich house for the weekend, which entailed visiting weird Johnny Winter at his house. Me masturbating in the black-tiled shower stall that Rita Hayworth cleansed her body in thousands of times. The weekend also included having a fight with Steve, who won't accept my heterosexuality. "I'm sorry. I just don't have the desire with men! I do with women! It's simple," I explained.

He yelled at me, "You wiseguy, you punk! You break your friends' hearts! Well, I'm gonna punish you! You snot-nosed gypsy! You cocky little jerk!"

Ugh. What is with this guy? I told him he was mentally ill.

"Yah, sure I am, but it's the kind you want! You come here to tackle the big city, but you didn't bargain on me! I'm gonna make you smarter. I'm gonna make you perfect." Brother!

Next day we got back in the blue Lincoln Town Car and drove to Edgar Winter's house on Sands Point, Long Island. This is Fitzgerald country, the fictional East Egg. Big circular drive. When the front door opened, I could see straight through to the back, the sunset over the Sound. Gatsby! Yet inside this mansion was a rock band, dressed in their glitter sneakers and spandex, playing pinball machines and watching crap TV. Oblivious to their surroundings. Pearls before swine, I thought to myself. We listened to a rough mix of their new album, which sounded lame to me. Just loud, boring product for dullard youths. Rock 'n' roll can be incredibly stupid.

· · ·

Back to the relative sanity of school. My work has *got* to get a hundred times better. A letter (that includes some blond pubic hair) from Eden says, "I've got this missing feeling . . . this awfulness . . . why was I human again? I loved you, I even licked your strong hard vagina conqueror! Just get a new girlfriend, a French one who adores you, there must be so many . . ." She's feeling low. Her friend Claire thought she had come down with jaundice too, but it was just yellow eye makeup.

. . .

Went up to Marlborough Gallery to see a fabulous show by Kitaj. Great painting of the Thin Man. He uses montage to good effect. Manages to include history, erotica, film, architecture, all inside one canvas. Aspirational!

Getting to know SoHo, the artist hangouts, those macho guys with lined faces . . . from anguish? Spring Street Bar. Prince Street Bar. I like sitting under the fight pictures in Fanelli's. Six rounds in the ring. There's Rocky Graziano: "Hi, Rocky." There's a photo of a guy in a derby hat standing next to Joe Louis that looks just like my dad. I like the thousands of fire escapes, the cobbled streets, the loading docks, the old signage, the smell of spices . . . old, authentic New York.

Drinking with Dave the carriage driver, who's dressed all in black leather. He blends right in on Christopher Street. He smells like a can of night crawlers. I have to stand upwind from him. We're high on pot, soaking up the atmosphere of the West Village, free associating. Thoughts rushing. Words tripping over each other. Stoned. It's hard when you want to water your penis in NYC. So piss on a Cadillac! The rest of the world is so far away, all that exists is New York City.

Just for fun I quit eating for a week. I wanted to feel weightless, spiritual. Sunday I took the train down to Wall Street, where there

is no sky. Walked along the empty, wet sidewalk. I took the Staten Island Ferry in my hallucinatory state, stood on the bow in the freezing wind, and merged with the elements. I felt like I was dissolving. I felt holy.

. . .

Candy Darling died, I was at Max's the night Taylor Mead delivered the news. No more "showtime" for the former Jimmy Slattery. She chose fame as a way of life. I went up to Campbell Funeral Chapel on Madison Avenue with my new friend Kristian Hoffman. There she was, laid out in an open casket, all fifty-seven pounds of her. Her chin was dented where someone pinched her. I spotted Gloria Swanson (Miss Norma Desmond herself) with Andy Warhol. All the Factory gang was there. It was a bit macabre.

March 29, 1974

I have been delinquent in my journal entries due to hyperactivity. Writing is a discipline that is easily lost. Too busy running around, smoking, drinking, drugging, jacking off, seeing what's what. Regular social butterfly I am.

Went on a Parsons field trip to the Barnes Foundation in Philadelphia to see the Matisses, the Modiglianis, and the Cézannes. Never saw the worth of Cézanne, so I stared at a landscape until the foreground slipped back and the background came forward, and I felt the shimmer of nature. I get it now. It's like acid! I love his clusters of brushstrokes, vying for attention. The subject matter doesn't even make much of a difference, it's all in the way the picture is built up.

Eden's been gone a long time, but left me with a present. Gonorrhea. Green pus coming out of my dick. Yuck. It's off to the free clinic for me.

Saw *Borsalino* again, Belmondo's cigar sticking out of his mouth

like a large pacifier. He says, "I don't like that tone of voice, Dancer."
Saw *Last Tango* again, *The Conformist* again. I go into Cinemabilia,
for the hard-core cineast, which is right underneath Parsons, and
talk to the proprietor, bearded and kerchiefed Terry Ork, about Alain
Delon. He sends "Richie"—Richard Hell—back to the stacks to pull
some stills files. Terry gives me free stuff. Tells me to come see his
band.

"Wait . . . *you've* got a band?!"

He laughed and said, "Not *my* band, it's Richie's band, Television.
I'm the manager." He gave me a flyer with an endorsement from
director Nicholas Ray, Terry's old friend. My new friend Richard
Lloyd is in the band, white-haired rock creature with a punk attitude
who I always bump into in the clubs. They've got a good look, urban
and scruffy. DuPrey and I go hear them at the Townhouse, opening
for the Modern Lovers. Loved them instantly. Two great guitarists. A
little like a ramshackle version of the Count Five, of "Psychotic Reac-
tion" fame. Jittery, determined, authentic.

• • •

Broadway shows with Steve Paul. *A Little Night Music* with Glynis
Johns, *Over Here!* with the Andrews Sisters and new discovery John
Travolta. Dinners at the Plaza, Frankie & Johnnie's. He now has
finally ditched me for not devoting my life to him. He called me "a
namby-pamby loony bird." That's that.

There's an after-hours transvestite club that I've been to now three
weeks in a row, Club 82, it's called. Dark, subterranean joint with a
stage and some private recesses. The glam kids have been using it as
a HQ. I sat with Eden's stripper friend Velvet (twenty-six). Velvet was
looking good, dressed in white velvet. Her mouth is always a little
ajar, showing her pearly teeth. Sleepy blue eyes. Or are they *druggy*
blue eyes? She was putting on a new lipstick at our table, and she
asked if I wanted to taste it. I said "Sure" and leaned in for a kiss. It

did taste good; so did the tip of her tongue. She took me for a three-a.m. scrambled-egg breakfast at the all-night kosher deli, Ratner's, next to the old Fillmore, on Second Avenue. I asked her where she was going now. "Well, that's pretty much up to you, isn't it?" I took her home with me and took off her white velvet getup, complimented her on her pretty breasts, and put her to bed. Goose-pimpled nipples. She was a very willing accomplice. She loves a good poke. Both of us knowing we were betraying Eden. We're rats.

· · ·

Patti Smith told me she put me in a poem. She started a week's residency at Reno Sweeney. I go every night and sit at the bar nursing a beer, watching it on the closed-circuit TV, because I can't afford the cover charge. One night I had the misfortune to be joined by Bette Midler, who said through mouthfuls of food, "Gawd, what *is* this? Who does she think she is? Bob Dylan? Laura Nyro? Lawrence Ferlinghetti? This stuff went out of style in the fifties!"

Unable to contain myself, I turned to her and said, "Well, you went out in the forties, and I wish you'd stayed there."

Patti says into the mike, "I'd like to dedicate this one to Duncan Rathbone Hannah, who comes every night, but doesn't have the bread to get in. This is for you, Duncan." I was thrilled. Reflected glory!

One night I sat at Danny and Steve's table. Patti walked over after her set, dressed in her usual black outfit. She beamed at us all. She looked at Steve, and pointed at me, and said, "Y'know Steve, this is a real cool kid!" Steve looked mortified, as if someone had just fried an egg on his forehead. "I know," he replied, weakly. I enjoyed that, since he's always putting me down since I rejected his advances.

Television play every Sunday night at a biker bar at Bleecker and Bowery called CBGB. The decor is neon beer signs and giant blowups from bygone theatricals. Smells like dog poo. Photographer Roberta

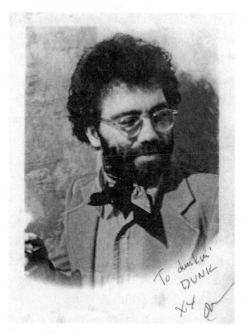

Terry Ork at CBGB

Bayley is the door girl, she always lets us in for free. She used to go out with one of the Flaming Groovies. She looks a bit like Claire Bloom. Gnomelike Terry Ork is always at the bar, and always buys us all the Budweisers we can hold. Television only have one set's worth of songs, so their second set is the same as the first. We like Richard Hell singing "UFO, comma comma, UFO, comma comma." I play (bad) pool with Hell. Anything goes here, this is *our* place. Only a couple dozen people show up, but there's a real rough excitement to this band.

One night I'm sitting in my pew at CBGB's with my gang, and Patti comes up and leans on my shoulder with her elbow. She says in her best Edward G. Robinson voice, "Well, what's this, a youth lineup? Hiya, kids! Good to see some youth in the room. Like some

fresh air. Kids are the smartest." She *has* to say something like that because she's dedicated to punkdom in every size, shape, and color.

. . .

I was in Max's one night with the MainMan boys (they call me "Veronica Donut" because of my peekaboo hair) and, lo and behold, Bowie's new single, "Rebel Rebel," came on the jukebox. DuPrey and I looked at each other with the instant recognition that this two-and-a-half-minute side of plastic perfectly captured our milieu. Especially in *that* room. It was the anthem of these outsiders. No lag time between the underground and the mainstream; it was simultaneous. Completely of the moment. All of this wrapped in a primitive, raw Mick Ronson riff. Made my hair stand on end. Pop perfection!

. . .

Reading about alcoholism in *Time* magazine. I fit the profile. I am unable to choose whether I drink or not, and if I do, I am unable to stop. I help my friends along with their drinks, too. When people tell me I'm drunk I get mad and sulk. I have to continually ask what happened the night before. I realize that these Sundays, which are so confusing, agitating, and sometimes hallucinatory, are in fact a form of DTs. I can't understand anyone who drinks *not* becoming an alcoholic.

. . .

On one of these Sundays, phone rang, it was Danny, who asks me to come over and look after Nico, who's just arrived from Ibiza. Yes! I ran up Fifth, entered Danny's, and sure enough, there, on his bed, in black Moroccan robes, is Nico herself. Enormous, candid eyes fixed on us. Shorn of eyebrows. I fixed us some vodka-and-grapefruit drinks, and we began to talk, she in the deepest, slowest, most Ger-

manic voice imaginable. I asked her about her old lovers. Clémenti: "Once you're crazy, you're always crazy." Delon: "He races horses now." She showed a picture of the kid they had together, Ari. Cute. We agreed that Lou Reed now looks like a dead monkey. I played her Roxy Music, which she'd never heard of, and told her that Eno called her the best rock singer in history. Danny was working on an article in the other room. Nico disappeared to the little girls' room. We heard a loud *boom!* from the kitchen. Danny and I both ran there to see what had happened. He shot me a disapproving look, since I was meant to be the babysitter. Nico was splayed out on the kitchen floor, legs akimbo. We all looked at each other in silence, and then slowly,

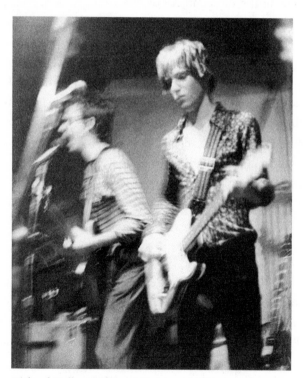

Richard Hell and Richard Lloyd at CBGBs

very slowly, Nico started to laugh. Then we all started to laugh, at the big, exotic loony bird on the floor.

I was telling her about the new NY band Television that's really good, kind of like her old band the Velvets. They're playing tonight, we should go! So we cab down to CBGB, I walk in with Nico, there's Eno fiddling at a mixing board (he's making demos of Television), he looks up, sees me (who he always snubs), sees Nico, then gives me a big smile. "Duncan, hellooo! How *are* you?"

Ha! I make introductions, "Eno, this is Nico. Nico, this is Eno." He took it from there. My work was done. I loved my afternoon with Nico.

· · ·

Went to see the three-and-a-half-hour *The Mother and the Whore* starring Jean-Pierre Léaud. After I found Donald Lyons at Max's and talked to him about it, he said, "It exposes the French male for what he really is . . . a fast talker. The two women around him are merely an audience. Don't you think?"

"Sure, I guess. But to me it is just another portrait of Léaud, the self-centered Parisian, who never quite manages to get his coolness to come off properly. He's just an overgrown child."

Kristian and I go over to Steve Paul's to watch *The Dick Cavett Show.* He's got the Loud family on, one year after their celebrated documentary, *An American Family.* Steve was lying on his blue-velvet bed, watching the broadcast projected on a huge screen. He was smoking something called stickweed that sells for twenty dollars a joint. I was drinking Kahlua. The Louds were all bitching at each other, Lance was fidgeting, hogging all the airspace. Weird watching it with Kristian, who was part of it. Then their band, Loud, plays their song "Muscle Boys." Lance was trying too hard, phrasing like David Johansen, bunching all his words up. The sound was poorly mixed.

Michelle and Delilah's backup singing was flat. Kristian was at the piano in the background, just a silhouette. Also Kristian was right next to me, dismayed at how poorly the band was coming off. Steve was moaning and groaning at the travesty of it all. Kristian bowed his head, his face obscured by curls, and pretended to be fascinated with a blue ashtray on the blue onyx end table. Really he was crying. Poor sweet Kristian.

. . .

I have a new gay friend, Norman Fischer. He's a middle-aged Floridian gent, resembles Montgomery Clift. He's an art collector and a cocaine dealer. Lives on Madison just below the Whitney. He never goes out, just stays in, surrounded by his collection of art deco, Americana, toys, cookie jars, Buddy Holly records, plastic gas stations with forklifts that really work, molded railroad tunnels, and Ed Ruschas. He orders hamburgers from Burger Heaven downstairs. He sits at his desk weighing white powder and puts small spoonfuls of it up his nose. He offers me the mirror with the lines all neatly laid out. I hoover it up, wait for the numbing sensation between the eyes. Acrid taste. I sip my red wine and light one of his menthol cigarettes. He looks up from his work and says, "I hate straight people." Just so I know the score.

Right on cue, Taylor Mead shambles in, with his hilarious sad-sack face. He tells a funny story about his latest drunk with Gloria Swanson. I remind him of the couple hours I spent at his apartment after Max's one night. He puts a dopey look on his face and says, "I'm sorry, I'm kind of burnt out."

I hit the street and walk up to the Sabarsky Gallery, where they are showing my hero Egon Schiele. Fantastic! They cost $49,000! I have been trying to draw like him. I'd love to play him in a movie. Such a great story. Dead at twenty-eight. Great haircut.

. . .

I'm in three shows at Parsons. I'm showing two nudes in the photo show, one of Kramer in an electrified bathtub, grinning madly, holding a goblet of wine, penis tip bobbing at the surface. The other is Eden, squinting at the light, featuring her high, compact breasts. My new illustrations are painted flatly from photographs in offbeat, muted colors. I've been looking at van Dongen.

Two years ago at Bard, I was sitting in a darkened lecture hall, following the march of art history. Then de Kooning blazes on the screen! I woke up! His paintings actually *scared* me. Even looking at the slides exhausted me. I couldn't imagine the scope that this white-haired magician had: this sliding into this, colliding with this, which leads over to that, *sploosh!* Like a piece of theater captured on canvas, something very dramatic happened here, at great speed, too.

Two years later I'm still in a darkened lecture hall, still smoking cigarettes, looking at the history of illustration, the twenties, thirties, forties, fifties, sixties. Hoping I will have a job when I graduate in a year's time.

The rites of spring in lower Manhattan. A fresh journal to catch all my scraps. Taking it in and spitting it out. Someday this will be a bygone era.

Kristian Hoffman and I were on a teeter-totter in Riverside Park. Evening sky pink over the Hudson. We're talking about this artist we met, Richard Gallo. He wears scary sadomasochism outfits: black leather hoods, fishnet body suits with the shadow of his pubic hair and shaft, clothespins on his nipples to make 'em bigger. That's his art! A surprisingly nice guy! We talked about Jean-Louis Trintignant, who we love. Kristian says we're typically American. "Speak for yourself!" I cry in protest. "Just like an American to go around pretending he's French," he countered.

Last week Danny, Lisa Robinson, Kristian, and I went to see the Dolls at Club 82. They wore dresses and wigs in deference to the drag club's thirty-year history. Plus their usual paraphernalia of platform boots, cap pistols, feather boas, and Jerry's bubblegum-pink drum set. Killer Kane, the outsized bass player, wore a baby pacifier around his neck. David's singing "Somebody stole mah bay-buh." A fight breaks out on the dance floor, so David Johansen, in his best Altamont style, says, "Be cool, kids, get another drink, just be a little cool . . . Dig yourselves, children." He threw silver Hershey's Kisses to the audience. They played a great new song called "Mystery Girls."

Lisa Robinson picked me up in a cab that stank of perfume, took me to see the Dolls again at the Bottom Line, where they opened for

Detroit's Suzi Quatro, glam-pop princess, who wore a form-fitting silver-zippered body suit. Super-sexy in her shag and low-slung guitar. We left with our ears ringing.

Spring/Summer Movies
Women in Love (fourth time)
Savage Messiah
The Boy Friend (third time)
Any Number Can Win (Delon, Gabin)
Love and Anarchy
All About Eve
Borsalino (sixth time)
Malizia (Laura Antonelli)
Blonde Venus
Public Enemy

Spring/Summer Records
Out of Borstal, Fresh
Diamond Dogs, David Bowie
Journey, Colin Blunstone
Rock Bottom, Robert Wyatt
Romance Is on the Rise, Genevieve Waite

Spring/Summer Books
I, Jan Cremer
Claudine at School, Colette
Justine, de Sade
City of Night, Rechy

One of my teachers, with the unfortunate name of Murray Tinkelman, looks through my portfolio and says, "No way you're not gonna be a smash. You're good. Odd. Contemporary. Classic. Auto-

biographical." He goes on to say that art is an entrance, a state of crisis, let it find itself. I actually did a plein-air painting of the Plaza and the Essex House while sitting atop a large boulder in Central Park. It wasn't bad, but it's baffling juggling all that visual information when it's right in front of you. I prefer using photographs, which already pare things down.

I go downstairs to Cinemabilia to say hi to Richard Hell, who wears Godardian dark glasses, has unruly hair, nicotine-stained teeth, and fleshy lips. Big sloppy grin. He's a runaway from Kentucky. He's only been playing bass for six months, but Television is sounding better and better. Lenny Kaye called them "the golden apple at the top of the tree." Danny said, "They're finally here, in full pathological innocence." Nicholas Ray said (without ever hearing them), "Four cats with a passion." Being a student of pop history, I had always regretted being born too late for the birth of scenes like the Who at the Marquee or the Stones at Eel Pie Island. But maybe this embryonic scene is mine. I'm at the right place, at the right time, at the right age. This is *our* music!

Eden's back in town after her convalescence from hepatitis. No longer yellow, but still temperamental . . . maybe just mental. We go to Club 82 to see Television, who are doing a residency there. We descended the mirrored stairs. There's Lance Loud, filled with manic energy in his Angels T-shirt, with Kristian, who's cut off his lion's mane. There's DuPrey, who yells out at a passing Johnny Thunders, "You're all washed up, Thunders!" DuPrey loves to get his goat. And who should sit right behind me? Bryan Ferry! He's on *my* turf! Listening to Hell as he sings, "I'm thinkin' . . . your thoughts!" They break into "Hard On Love." The jagged "Friction." I learned later that Bryan thought they were out of tune, but had a great visual appeal.

The following night I went back. Waiting in a short line to get in, I heard someone say, "Hello, David," so I turned around to look at the back of a henna-haired Bowie cut, one of thousands the city

over. But wait, this was no ordinary Ziggy do, this was the original! 'Twas Aladdin Sane himself, standing right next to me. Dressed in a quilted lavender space top, white Levi's, and flat dance shoes. My height! He turned, face too pale, black eyeliner, weary. He looked like he hadn't eaten in months. I nodded, he nodded back. I caught a glimpse of one of his fangs as he and Ava Cherry were whisked in to a cordoned-off corner table. I checked on him later, and he was engrossed in conversation with a slightly chubby black-haired guy who had a Long Island look about him. Who dat? I wonder. Oh no— it's the Electric Warrior, Marc Bolan! Already past his prime! Two former mods come to check out the New York underground. We have arrived! Bowie said they were the best band he'd seen from NYC.

Trouble with Eden. Nobody else makes me feel so lousy. No one else makes me feel so good. She's a lost lamb in a glass city. (Well, maybe not a lamb.) We were walking down St. Mark's Place, after a dinner of cheap roast pork lo mein, and a spade stops her and says, "You a ghost! Whazza mattah which choo, girl? You high or sumpin'? You showin' off your boo-wee!"

Went on a bus to visit DuPrey on a Saturday night in Rutherford, New Jersey, where he's finishing up college at Fairleigh Dickinson (or "Fairly Ridiculous," as he says). The air was sweet. Smelled like spring. The dark, empty streets echoed like Rod Serling's off-kilter America. *Twilight Zone* teens sitting on stoops. We retired to his small room to work on a stolen fifth of Scotch. And listen to "Rebel Rebel" over and over on his tinny Mickey Mouse record player. His Stratocaster in the corner, next to a stack of well-used *Playboys*. A painting of mine on the wall, called *Upstairs Maid*. These are the kind of haunts where plans are hatched, then scrapped, then hatched again.

Sunday I hit Max's looking for some fun, and found Richard Lloyd. I offered to buy him a drink, and he said, no, better yet, follow me, I know where we can get free tequila. So we go over to some guy's

apartment a couple blocks away and downed ten or eleven tumblers. He faced me, red in the face, and told me I was a *face*, part of the Television entourage. Someone at all their gigs who spreads enthusiasm. At the dawn of a new day, etc. He was very earnest. At five a.m. we parted. I was so drunk that I got lost on the way home, staggering down Avenue A, under the horror-film street lamps. Where am I? A car pulled up, a hand snatched the thirty-year-old black Dobbs gangster hat off my head and tore away. Fuck!

Back to Television. I was at Max's, someone was hassling tough little Elda (from the Stilettos) over a hundred-dollar bill, turned into a cat fight, Elda screaming "Fuck!" as the assailant pulled on her hair. Gallant Richard Hell joined the brawl, blows were exchanged, I moved off, Hell crashed on my table, the legs buckled, wood splintered, Hell on the floor, lying in the debris, shades broken, chickpeas everywhere.

I sat in a booth with intense Tom Verlaine and we had a staring match. We both snickered at the same time.

May 26, 1974

Eden and I broke up. She wanted all or nothing. Nothing it is, then. No longer under her microscope. Just this morning she had sworn never-ending devotion to me as she guided me into her snapper. Now, flown the coop. First plane back to the Twin Cities. It's for the best.

Meanwhile Eric Li and I find a railroad apartment at 174 Thompson Street, #5FN. Across the street from Rocco's Italian restaurant. The huge men's shelter on Bleecker is just on the corner. Two hundred and ten dollars a month, two bedrooms, tub in the slanted kitchen. High ceilings, arched windows, hot and cold running cockroaches, ancient moldings. We filled it with junk furniture that Eric got for free at Columbia. Forty bucks for a moving van. We painted the living room pink. My first apartment!

We have a temporary pal crashing on the living room floor, Jay Dee Daugherty, who's a drummer in LOUD. Kristian's over here using the typewriter and singing a Patti Smith parody: ". . . And then Rimbaud, he got my toe, and I was hot and bad . . . and then came Brian Jones . . ."

I saw Patti in the Laundromat on Thompson Street. She said she was "washing my old man's socks." Very unliberated of her, I thought. Patti asked if I knew a piano player she could use, so I suggested Eric. He practiced with her a couple times, but she cut him off during "Land of a Thousand Dances," saying, "Hey, Eric, when I sing 'Do you know how to pony?' I'm not talking about dancing." She gave him a lecture about rock and sex. Eric turned scarlet. He may not get the job due to his shyness.

One last dinner at the Plaza with stoned Steve Paul. As we entered, I winked at the lobsters in their death-row tank. It was the last mile for those scaly red monsters. One lucky lobster was about to become my dinner. As we ate (with much noisy sucking and chewing from Steve, his nose glistening in the subdued lighting, sending reflective beams across the room), he went on about his favorite subject, genius and insanity. The ones who went "too far out there" couldn't be responsible caretakers of their own genius. A friend of his was just found with eighty stab wounds in his body, plus his hands and feet had been removed, by a homicidal male hustler.

Lance comes to visit on a June afternoon. Horizontal light through the venetian blinds. He teases me about my looks. He says he was visiting Danny recently, who got out his Duncan Hannah photo book and raved, "Look at the beauty! What a beauty!" Then Lance makes up a little ditty: "Beauty equates Duncan . . . Duncan is beauty, la la la la la."

"Okay, okay, I get it already!" Wicked Lance. He says "Ghee-yodd!" for "God," and uses the phrase "snob appeal" a lot. We talk about the Kinks.

It's ten at night. Eric and I lived on baked beans and peanut butter, lettuce, and mayonnaise sandwiches all week. There is a plastic revolver floating in our toilet bowl. I guess this means I've solved the case. The windows of the airshaft are open, and I can hear the Italian mothers shouting, "Hey, Angelo, you know what I'm gonna do if you're not up here in ten minutes?" I lie in bed and write seven postcards to people. One to my sister, who's been on a tear about that creep Richard Nixon and the Watergate scandal. One to sex kitten Lucy Hood, who was always game for a roll in the hay with me. Even named her pussycat Duncan. Speaking of Eros, I haven't christened my new bed yet. I look over at a still from *Breathless* taped to the wall, Belmondo in bed with Seberg, he's gently holding her chin, trying to convince her to run away to Rome with him, before the dragnet closes in on him.

June 4, 1974

I got a summer job. I'm a cashier and sandwich boy at Sutter's French bakery on Tenth Street and Greenwich Avenue. I sit in a booth and punch buttons for $2.65 an hour. Thirty-two hours a week. All the waiters are homosexual. As they pass me they pinch my ass and say, "Those buns belong in a bakery." Much shrieking laughter. When someone does a good quip, the ringleader, Wayne Hooper, says, "She peed . . . she peed all *over* the stage!"

Roxy Music at the Academy of Music

Stood around in the lobby during the openers. Sharks (bad). Talking with rock writers Michael Gross and Ron Ross and Kristian (who's been drawing Donny Osmond for *16* magazine). A couple of Dolls, Milk and Cookies, etc. Apparently Atlantic Records is throwing Roxy a big party after, that we all *must* attend. But how?

Jungle noises came from the theater, so we scrambled to our seats. Out came Roxy to much excitement, and blasted into "Editions of You," "Virginia Plain," "The Bob," "If There Is Something," "Grey Lagoons," "A Song for Europe," "Serenade," "Mother of Pearl," "Re-Make/Re-model," and of course, "Do the Strand." They were tight. Bryan was doing a sort of twist, and when he unbuttoned his white dinner jacket, slid his hand into his black tuxedo pants to reveal a crimson cummerbund, there was much applause. The band had the manic theatrics of Bill Haley and the Comets, like Andy Mackay's upside-down saxophone, Eddie Jobson's violin solos, Phil Manzanera's blazing guitar, Paul Thompson's propulsive drums. Power! There's the sci-fi element ("Chance Meeting"), a single spot on Bryan while a lone oboe mournfully rose above a wash of mellotron. A slowed-down version of "Pyjamarama" brought tears to my eyes. Crowd went crazy.

Kristian, Lance, and I got the address of the party and walked to the entrance to Larry Rivers's loft on East Fourteenth Street. There was already a crowd of people who couldn't get in: Jane Forth, Donna Jordan, Cindy Lang. Not looking good. Apparently fifty people were invited, a hundred maximum. We went up to the security guy at the door just to give it the old college try—no soap. The band pulled up in a couple of Rolls-Royces and ascended the steps to a cry from the crowd. Then gay-pop-star-from-outer-space Jobriath pulled up with Mallory! I've slept with her! I asked Mallory if I could join her, so she asked Jobriath, who looked at me and my hungry posse, and said, "Just you, not your friends." I gave a farewell glance and hustled behind Mallory. It's every man for himself.

Up to the fifth floor, into the portals of the star-studded party. I went over to the bar, where Danny introduced me to big, tall Bryan Ferry, hair flopping over his eye, in a blue velvet jacket. I tried to engage him in conversation about the show, but he just kept saying "Yah?" and "Really?" as if his mind were on other things.

I moved over to my savior Mallory, who said, "Aren't you in heaven? Don't you love this party?" We had to clear out the crowded (twenty people) bathroom for Jobriath, who sits down to pee like a girl. They burst in anyhow and Jobriath began to cry. We had a couple more drinks. I adjusted my bow tie and said, "Look, there's David Bowie," and sidled over to him. He graced me with a glance, and I asked if he was collecting material for a new song at this very minute. He sneered his canines at me and said, "Yah, why, do *you* wanna be in my song?"

I sneered back, "Yah, what about it?!"

We kept up our grimaces like a couple of thugs, necks outstretched, until he broke out laughing. "No, sorry, I was just kidding, I didn't mean it, really!" Then he said he liked my suit. "I stole it from you!" I said, and he laughed some more. He took a swig from a can of Schaefer's beer and shifted his feet, as I looked at all the colors in his hair. We chitchatted a bit more. Then Ava Cherry came and whisked him away.

So. I spied with my little eye blond photographer Eric Boman, John Warner, Richard Bernstein, Shaun Cassidy, and Lisa Robinson running around getting in everyone's photographs. Pretty hustler Jimmy Sweeney. I told Andy Mackay he looked like Troy Donahue. He agreed. I went to Bryan again, tried to engage him in a discussion about Alain Delon, the icon of Euro romance. He seemed confused, and raised his glass to me, said, "Well, I've got to move along now. Get drunk!"

Okay. Who's next? Aha! There's John Phillips and his wife, Genevieve Waite, who I've had a big crush on for years. I brazenly went over and tapped on her bare shoulder. She turned, looking a bit wan in her peroxided hair with dark roots showing. "Yes?"

I'm afraid I gushed. Told her about how I'd seen *Joanna* five times, had a poster of her in my kitchen, how I draw her all the time, is it true you're going to be in a Broadway musical?, blah blah blah. She

looked at me patiently and then introduced me to her husband, who gave me a "Get outta here, kid" look. I get it, I'm a pest. À bientôt, Joanna!

I moved over to the youngest of Roxy Music, Eddie Jobson, who told me Bryan gets girls for him after the shows. At that moment, Bryan whistled for Eddie, motioned with his finger for him to come over, as he had a (presumably) willing redhead at his side. Across the room I saw Nureyev and Fonteyn, very briefly, exiting a freight elevator. Earl McGrath. Ahmet Ertegun. Taylor Mead. Holly Woodlawn. The Warhol Superstars. Warhol himself.

The bar began to close up. Everyone was going on to Club 82 for a nightcap. In the ensuing confusion, I somehow wound up in a hired car with Warhol, Ferry, and Bowie. Good company! I kept my mouth shut now, because I was practically legless with alcohol. We entered the 82, where I promptly sat down on a bench, not trusting myself to stay vertical. I inadvertently tripped one of those diesel-dyke bouncers, who picked me up to chuck me out. Jobriath (of all people) stopped her and pleaded my case. "Hey, look, I'm as drunk as he is . . . you might as well throw me out too. I'll make sure he doesn't get in any trouble." To no avail. She carried me up to the door and tossed me into the gutter, just like in the movies. The famous gutter that I've heard so much about. I made it!

Now here's where it gets weird. The next thing I know, it's morning. I wake up in a deserted room, with no recall. On the floor, in my party clothes. Bow tie, spectator shoes, double-breasted suit, silk shirt, and a little Mary Quant makeup. No furniture. No nuthin'. This is *not* my new apartment. Doesn't look like anybody's apartment. I get up and gingerly walk over to the window. Look down at the rubble of a vacant lot. Is this even New York? Dresden? I walk into the hallway, cradling my throbbing head, no one anywhere. I climb down many stairs, trying to find the exit from this dilapidated maze. I'm stuck in a bad dream? At last I found the door to the side-

walk. Blazing sun. I hobble down the street, until I spot a black guy and say politely, "Excuse me, could you tell me where I am?"

He sizes me up and down and grins from ear to ear. "You in the wrong part of town, motherfucker! And if you didn't look like such a sorry-ass clown, I'd kill you!" Then he bursts into laughter.

"Thank you," I said, and proceeded down the bombed-out street. I finally saw a sign that said 135th Street and Lenox Avenue. Wow. How the hell did I get up here? A hundred and thirty-three blocks north? With no money? Up to the fifth floor of a condemned building? No explanation came to me. I made my way to a subway, hopped a turnstile, and got on a southbound train. In my confusion I got off at the Battery, which was a giant excavation site. I tried to take what I thought was a shortcut, but was in fact just a huge expanse of industrial landfill. A yellow Caterpillar tractor turned on its axis and began rumbling towards me. I could see a brawny man in the cabin laughing maliciously. He wants to run me over! I started to run. He increased his speed. I flashed on *North by Northwest*. My only frame of reference for this scenario: crop duster = murderous tractor. I could hardly breathe. My heart exploding in my frail chest.

I finally made it to Thompson Street at nine a.m., made it to my new job at eleven a.m. I worked a six-hour shift, about to die at any given second. From the height of glamour to the depths of squalor, all in one, crazy night.

· · ·

Eden has been back in Minneapolis for three weeks, and I hear she's engaged to Kramer. Fast work. So much for broken hearts. Baisez-moi.

· · ·

Saw *Breathless* again last night. It's my mother lode, my Rosetta Stone. *New York Herald Tribune* headline says, "Police Identify Road

Killer as Michel Poiccard." Belmondo says, "I always fall for the wrong dames." But this mouse is "full of light."

Saw the Who at the Garden last night. We got seats that were meant for Danny and Lisa R. Moon was leaping around the stage yelling, "Hey, Townshend looks bored." Pete was entangled in all his cords and wires. Daltrey flew at the PA system and it crashed to the floor. Entwistle sang "Boris the Spider." Still, they were off. Eric and I walked to Max's, thinking of the Bryan Ferry lyric: "With every goddess a let down / Every idol a bring down / It gets you down."

We got to Max's and were invited over to Terry Ork's and Richard Lloyd's booth. We talk about the Patti Smith single Terry just put out, "Hey Joe," with the excellent flip side, "Piss Factory." Patti is having a secret affair with Verlaine now, although everybody knows about it except her boyfriend, Allen Lanier, who's away on tour. Terry laughs and says it's good PR. He told me to start a Television fan club, whatever that means. He told me to call it Stay Tuned. Or TV Guide.

I ask Richard how he got his money.

"I'm a whore," he said calmly.

"Oh," I replied.

That really made Terry laugh. Terry is a consumer of the Fifty-third-and-Third hustlers himself.

Lloyd and I walked down to the 82, and he told me the story of his life. Growing up in Greenwich Village with bohemian parents. Says he knows the Village brick by brick. About the shock treatment he was given in the asylum. He explained what a sexual deviant he is. How he tried to kill Terry once. About how he's wishing for an early death. How he's got no friends. Inside Club 82, we smoked some pot with a Bowie look-alike. I realized this city is German American artist Richard Lindner's future-shock vision come true. Bound in vinyl leopard skin and white pompadours. Weimar Berlin all over again.

In walk Entwistle and Moon, very drunk, with far-off looks in their eyes. The groupies hurriedly jump into action, to put a notch in

their belts. To fuck a Who! They probably didn't reckon on the abuse Moon was shelling out. We watched from the sidelines as Moon hit the dance floor, doing a macabre version of an angry escaped lunatic. Pretending to cram his fist up his frightened dancing partner's fashionable crotch, screaming at her what a stupid slut she was. Lloyd was telling me how he had got to be friends with Moon in LA.

"Well, introduce me to your friend, then," I said.

"What, now?" he said.

"No time like the present."

So we sidled over to the bar, where Moon was now guzzling alcohol like he'd never get another chance. Richard stood at his side and tentatively said, "Hi Keith."

Sweaty Moon turned to glare at him, quite fearsome to see, and said, "What the fuck do you want, cunt?! Why don't you *fuck off*!"

Richard and I walked away. "I guess he doesn't remember," I said.

. . .

DuPrey has moved in with me and Eric for a while. Lugging his little amplifiers. He sleeps on the living-room floor. He's joining Lance and Kristian's band, LOUD. DuPrey has such an expressive face. It registers all the mischief, pain, glee, and sadness that's roiling around in his psyche. So now we're breathing in each other's animal odors. The place is impossible to keep clean. We have no closets, so our glad rags lie in untidy piles on the floor. My secondhand bed is lumpy and tilted. I can hear Eric moaning in his sleep through the wall. The cockroaches get fatter and more content every day. We listen to Bowie's *Diamond Dogs* constantly. "Don't talk of dust and roses / Or should we powder our noses?" The downstairs neighbors complain about the noise we make. I've never seen DuPrey so happy. We're having the time of our life. The phone number is 477-1198. The phone is ringing, but I ain't answering, I'm busy!

DuPrey got a job working at the same café as me, where we pilfer

grub for our dinner, and money from the cash register for drink. I look out from my cashier's booth, having erotic fantasies about the fresh, freckled, and arrogant jailbait that frequent the place. Daydreaming to combat the dreariness. Sometimes lovebirds Tom Verlaine and Patti Smith come in for the tuna-salad platter. I slipped a note in the tuna, under a tomato. I watch as it gets caught in Patti's teeth. Rang up zero when they came to pay. They drift out entwined, walking and making out. "Public display is a big part of a Manhattan romance," Ork once said of the lovers.

Last night DuPrey and I went to Max's. We got a small table in the back room. Bowie's "John, I'm Only Dancing" was playing. Great song. Television entered straight from a rehearsal. They were incredibly soiled and wrinkled. We switched to their booth. Lloyd was his usual earnest, semi-corny, excited self. Some reference was made to the effect that Hell is an occasional user of hard drugs—i.e., heroin.

Bob Plotnik, aka Bleecker Bob, the obnoxious record-store owner and self-important legend in his own mind, stepped up, looking for trouble. He starts yelling at Hell because he didn't show up in the recording studio for a mixing. Bob's ponied up some cash for their first single.

Hell said, "It was unavoidable," pursing his chapped lips, "so piss off, man."

Plotnik burns with rage. "You need some manners! You gotta start practicing your bass because you're the shittiest bass player in the world."

Hell calmly says, "Yah, and you need a new mother, and a new father, a new brain, and a new heart. You need a new face, a new body, you need new eyes, nose, and new teeth!"

Plotnik twitches. His eyes bug. He leaves.

Verlaine says to Hell, "Oh, man, are you stupid? You gotta play along with an obnoxious bastard like that. You gotta eat crow."

Lloyd nods affirmatively and says, "I've eaten more crow than any-one on this planet."

Plotnik returns. Says, "The Max's gig is off. The 82 Club is off. Forget it." He leaves.

Verlaine follows him out, telling him that Hell is mentally ill.

Plotnik says, "I don't care. In thirty years no one has ever talked to me like that. I'm gonna see that he's murdered by tomorrow morn-ing . . . whether by my bare hands"—he's a black belt in karate—"or by my relatives"—Polish gangsters.

They both return. Plotnik has worked himself up into an insane temper, building by the second. It is incredibly tense. Verlaine and I are holding our heads in our hands. Lloyd looks like he's about to cry. Hell is going to be killed. Plotnik is screaming at him to come outside to back up his lip like a man before he breaks his windpipe on the spot.

Hell is now trying to apologize, but Plotnik is saying, "No way, the only way you're gonna pay for this is with your life. I'm gonna kill ya, man! You're dead!" Plotnik was violently banging the bench back and forth, pulling the bolts out of the wall. Staring off into the middle distance with a retarded look.

Hell is contrite. "Look, I know you can break my bones, man. I'm not gonna fight you. I'm sorry."

After what seemed an eternity, Plotnik's tone suddenly changed. It was a standoff. He left.

Hell hiccupped, "I thought those were my last words on earth."

July 3, 1974

Hot time, summer in the city. I had a housewarming party, and groupies Mallory and Velvet showed up, along with the rest of the gang. The degenerate soirée led to a two-week fling with a Parsons

girl, Mary Jane, a Myrna Loy look-alike. She went back to her parents' in Cleveland for the summer. She's afraid I'm going to vanish into the universe—POOF—like that. She's bewildered, scared of me, but likes joining me in bed in her nightie that's too small for her, so one pretty tit sticks out. We stay up all night talking and making love. She's going to stop shaving her armpits for me, French style. She wears green contact lenses and gave me an electric iron and wants to live in a treehouse. Who doesn't? I love her brown curly hair.

. . .

Danny's got a new column in the *SoHo Weekly News*, called "Danny's Dish." He read this journal, said it should be published word for word. "It's so sexy, so brilliant, so real." He's a flatterer. Can't take it seriously. He got all misty-eyed over my friendship with DuPrey, said it was very romantic. But my recklessness scared him. Said it might kill me.

There was a shootout on Thompson Street last night.

. . .

Richard Hell comes over to read the introduction I wrote to the first Television Fan Clubzine. He sat there drinking peach schnapps and laughing at his favorite bits. He said, "Man, we were made for each other!" Ork liked it too, said I'd gone above and beyond the call of duty. But then Verlaine summoned me to Max's to give me his two cents' worth. Ever since he hooked up with Patti, he takes himself very seriously indeed. Grooming himself to be the next Bob Dylan. I think he's been studying Dylan's cruel behavior in *Don't Look Back*.

I sat facing him while he began a bizarre assault on me. "So, I'm just wondering, you get up in the morning, you pick out a shirt, you look in the mirror, and you say, 'I'm Duncan Hannah, and I'm cute!' Do you stand in front of the mirror to perfect your smile? Is that what you do? Do I have that right?"

"What?" I said, struggling to understand.

"I read your thing. Let's get one thing straight: you don't understand me, you don't know me, you'll *never* know me. Okay? Just remember that—*you'll never know me!*"

"Look," I said, "I'm not getting paid for this or anything. It was all for love of the band. Plus, Hell liked it!"

He smiled thinly and said, "Yeah. Well, I'm not Richard."

I got up and wandered over to Danny's table. Noticing my long face, he said, "What's the matter, baby?" I told him.

"What did I tell you from day one? Musicians are assholes. He's an asshole! Spend your energies elsewhere."

Hell came over to apologize for Verlaine's venom.

One night at a Television gig at Club 82, Steve Paul, Lenny Kaye, DuPrey, and I pile into Lenny's trustworthy auto to smoke some dope and just generally see the streets from the inside of a moving vehicle. You know, just "go for a drive." Lenny and Steve start riffing about how the front seat (them) is better than the backseat (us). So we lip off to them, being punks and all, and we are all *soooo* stoned, and Lenny is driving like a lunatic, and we lost Steve's phial of supergrass somewhere in the backseat, and he's saying we stole it, and if we didn't cough it up in ten minutes they're gonna drop us somewhere dangerous. Steve says, "Lenny, it's cash and carry around here, and it looks like it's gonna be carry," whatever the fuck *that* means. I gotta pee, and the whole thing is getting weird. Lenny screeches to a stop in some desolate area, and Steve orders us to get out. I do, and they start laughing and say "Get in!" It's all some kind of film-noir goof. It had a sour taste. Somehow we got back to the relative sanity of the 82.

. . .

Domestic scene, Thompson Street. Fourth of July.

DuPrey's parked in the corner smoking a cigarette, looking like

238 · DUNCAN HANNAH

an uninterested Keith Richards. Two naked girls sit in armchairs, glistening wet from the bath, sipping coffee. They are groupies, but settle for me and DuPrey when it's an off night. No good bands in town. They sleep and snore in our beds, exchange girl talk, do their makeup, apply pomade, recite movie-queen dialogue, discuss tour schedules (who got Jimmy Page last time, who gets Robert Plant next time, etc.). One slips on the floor and lands *boom* on her bottom. This cracks DuPrey up. The downstairs neighbor bangs on the ceiling. Syd Barrett is on the hi-fi, singing, "You're the kind of girl that fits in with my world / I'll give you anything, everything if you want me." I draw a felt-tip tattoo on Velvet's arm that says "Lady Luck" enclosed in a heart. It looks like a southern whorehouse in here. Or maybe the railroad car of show-biz types in *Some Like It Hot*. On my new nine-inch Panasonic B & W TV set, Alain Delon is saying in his heavily accented English, "I could love a girl like you, you're beautiful like a child. You say I am immoral, that I don't know wrong from right, but does it do any harm?"

At night we go on the roof to smoke boo and watch the fireworks. It's like the end of the world. We walk over through the deserted meat market. There are Television flyers that Lloyd pasted up. We deface them with big dicks coming out of their jeans. *Diamond Dog* posters on building sites proclaim our doom. The fire hydrants are open and gushing, splashing over the bits and pieces of bottle rockets, cherry bombs, and Black Cat firecrackers. Smell of cordite. Crescent moon. A tinge of the apocalypse in the air.

Bacheloramu

Duncan Rathbone Hannah

Summer 74

We have the new German variety of cockroach that eats machinery. Another breed of Eskimo cockroaches that are cooling it for the summer in the icebox, sipping iced tea.

"And you're a prima ballerina on a spring afternoon," sings David Jo from the speakers. A new establishment opened up on our block. Down a few steps to a cellar. It's painted in red enamel, with ominous black stencil lettering that says VENUS SOCIAL CLUB. MEMBERS ONLY. What could that mean? What goes on in there? The mind boggles. Is it like a Robbe-Grillet thing? La Maison de rendez-vous? Can I join? Seems terribly sinister. One night, stumbling home from some serious drinking, I decided to chance it. I stepped down and opened the door, looked in to see a half-dozen fat old Italian guys smoking cigars and drinking espressos. They looked up and stared at me. "Get outta here, kid!" said one.

"Yes, sir," I replied and beat a hasty exit. They must be mob bosses. So *that's* what they do with their ill-gotten gains? Sit around in a crummy basement drinking coffee? Where's the fun in that, I'd like to know. Hardly seems worth it. Use your imagination, guys! You're gangsters! Live large!

An extremely pretty girl in a pale-yellow summer dress orders a lemonade from me at Sutter's. Annette. She's a dead ringer for young Claire Bloom. She never takes her wide eyes and Mona Lisa smile off me. Like she's in a trance. I give her the lemonade "on the house," and she asks for my phone number. She says she speaks five languages.

A couple nights later, Eric and I are drinking Pernod, and he's panicked at being broke, not having found a summer job. So I started singing "53rd and 3rd" to him, the Ramones song we hear at CBGB's. "Fifty-third and Third, I'm tryna' turn a trick . . . Fifty-third and Third, don't it make you feel *sick*?"

"Oh yeah, what is that about, anyway?" Eric innocently asks.

"You know those young dudes who hang out under those arcades at Fifty-third and Third? They're male hustlers. That's what Dee Dee does," I explained. Eric and I often passed those tricks on our way to the cinemas up there.

Eric was shocked. "*That's* what those guys are doing there? But Dee Dee has a girlfriend!"

"It's a job."

"But it's so gross. Who are the clients?"

"Probably closeted businessmen who want a blow job before they go home to their wives at night. They pull up in their car, boy goes over, negotiates price, and they drive off to a dark street."

"But how much do they make?"

"I dunno—twenty dollars for fifteen minutes, something like that."

"Ick!" said Eric, who was pretty homophobic, despite his androgynous looks. He even finds my camp shenanigans a little beyond the pale.

I went to the bathroom to pee, and when I returned, Eric was gone.

· · ·

Then the pretty girl I gave the lemonade to calls, wants to come over, and I'm ridiculously drunk. I figure it'll be a test, will she still like me in my Mr. Hyde mode? If she does, she's got some mettle to her. She arrives at the silver door that leads into the steamy kitchen, I introduce her to DuPrey and lead her back to my leopard-print bed-

room. All the while her big peepers are trained on me in a crazy way. I take her dress off and lay her down. A dark triangle on snow-white skin. Very beautiful. Very acquiescent. Lovemaking ensued. Then we collapse in the Burmese heat. I lit a cigarette. Eventually she began talking.

"We knew each other before. Remember? We were together in Hampton [?], exchanging secrets behind the curtains. We were just children. Remember?"

"No."

"Why do you refuse to remember? Remember how cold it was? Our thin arms holding each other tightly for warmth? The excitement in our eyes at the thought of being caught?"

"As much as I might enjoy your flight of fancy, I do not remember any of this at all. You're talking about past lives, yah?"

So this continued into the night. At about three a.m. she said, "You're very close to DuPrey, aren't you. I can tell."

"Yah, he's my best friend."

"I like him a lot. I could sleep with him," she offered.

"What was that last part?"

"I could sleep with him."

Silence.

"He seems like he needs attention tonight," she explained.

I was waiting for that. I said, "Okay, go on, then."

She left and I went back to sleep. An hour later she returned. Stared at me like a wide-eyed loony. She told me to touch her. I lit a cigarette and peered out the window into the dark tenement airshaft by the head of my bed. I looked at the clotheslines, the alley cat down below, and a nurse getting dressed for work behind wicker blinds. I listened to the sound of wind and arguments. I felt claustrophobic.

"Have I broken something?" she softly asked. Brother. I am out of my psycho cosmic depth.

Then, right on cue, who should come bounding in but Eric, drunk

174 Thompson Street

as a lord. I got up to see. He spilled his rent money onto the kitchen table. "Where have you been? What did you do?" I said, aghast.

"I did what you told me to. And on the way home I stopped at a real whorehouse, it had a red light on outside and everything, and I fucked a black girl! As a test! It was a real adventure! I gotta go to bed now, I'm exhausted."

He seemed quite happy. Unmarred by his first taste of male prostitution. Meanwhile, I still had a naked astral traveler in my bed. Vive la vie bohème.

After Miss Annette left in the morning, DuPrey said, "Thanks for the gift."

"What exactly happened?"

"She tiptoed in and started to give me a backrub, then I turned

over, I realized she was naked, and the rest is history. She said you were cool with it . . . you are, aren't you?"

"Yeah, sure, I guess. I think she's mad as a hatter."

"I got that sense too," he said.

· · ·

I often go to the Carnegie Hall Cinema, where foreign double features are $1.50 with a student discount. Great programming, and a faux-French café in the lobby. I saw a pretty young girl standing in line for a Fellini program. She was dressed in a black kimono with white dragons on it, and carried a well-worn black journal. Art-school girl. We exchanged phone numbers, and then she called a couple nights later. "This is Gretchen from San Francisco . . . I met you at the cinema," she said nervously. We agreed to rendezvous at a local gay piano bar, Marie's Crisis. She told me she loved me. Hmmm, a bit premature, but I know how crushes are, having had hundreds myself.

I learned over many, many drinks that she's sixteen(!), from arty parents, was in *Claire's Knee* just for a moment (her dad lives in France and is pals with Eric Rohmer), she was painted by Elaine de Kooning, wears a plastic ocean liner hanging from one ear, and never had a boyfriend until me (she said). We went back to her rich uncle's mid-century-modern apartment on West Ninth Street. Super-cool, like a *Playboy* bachelor pad. We listened to the Velvet Underground, and I drank a bottle of Scotch from her uncle's fully stocked bar, and talked and talked, expounding on life and love. We wound up naked in bed, but by that time I had alcoholic psychosis, and thought she was a boy, in spite of her ample breasts. My demons were out in force. Poor Gretchen, she finds the man of her dreams . . . and he's crazy.

In the morning, which was blessedly rainy and cool, I had some hair of the dog, then some more, trying to piece the night back together. But found I *still* had a beautiful, adoring, and cultured

teenager making goo-goo eyes at me. We went to Fanelli's for lunch and Bloody Marys, shuffling our feet on the sawdust floor. She was so happy and young and brave that I felt like the disreputable character in Donleavy's *The Ginger Man*, plying myself with drink. Night was falling, so we went back to Thompson Street to show her my sketchbooks and take a bath. I stuck my toe in her and pretended I couldn't get it out. All pink and pretty in the tub. I kept playing Robert Wyatt's "Sea Song" over and over: "You look different every time / You come from the foam-crested brine . . ." We go to Arturo's on the corner for beer and pizza, I lost my keys, so had to climb five flights up the fire escape and crawl in the window, avoiding detection from my hostile Italian neighbors. Finally she rebelled.

"Do you think watching someone get drunk is my idea of a good evening?"

"Yes," I said drunkenly, trying to dissuade her from a dissolute burden like myself.

She told me I was selfish.

"All right then, clear out."

But she runs up, embraces me, and says, "But I love you, Duncan."

. . .

The next morning I've got the shakes bad. Filled with remorse at what a creep I'd been to a nice, innocent girl. I had to go to work. I spilled some tuna fish on my leg, and Wayne Hooper shrieks, "Ooh, now you smell like a woman!" Then he screams over at one of the baker ladies, "Hey, Dolores, how's your *twat*?" Each day is Valentine's Day.

After I sobered up a little, Gretchen and I finally consummated our unholy union. She immediately called her mother long-distance in San Francisco, telling her she'd just lost her virginity, and then put me on the line!!! Her mother told me what a special girl she was, and to treat her right. Anyhow, she has reserves of energy that astound

me. I'm six years older than her, and I'll tell you, I've never felt my maturity quite so keenly. A man of my age needs his sleep! She'll drive me to an early grave! She's eager for her sexual-education sessions. She wants me to instruct her in the fine art of fellatio. Such a zealous student. She pulls my drowsy head down to the pillow again. Presents her precious twin pink-and-mauve discs to me, the points of her breasts and their areolas. Delicately sniffing me, the way they do.

· · ·

I turned twenty-two. Eric gave me some leopard-skin-print briefs. Velvet came over and gave me a red rose, a red jewel, a postcard of Naples, started to give me a backrub, then took me up on the roof and gave me the nicest present of all, a blow job, amidst the water towers and TV antennas. Lying on the tar looking at the purple sky.

· · ·

Fly to Minneapolis after New York overkill. Jet-age juxtaposition. On the plane I had a couple of Bloody Marys and read an article about the cholera and hepatitis epidemics in Naples. Back to the smell of cedar shakes and sound of crickets. My dad took a look at me and asked if I was supposed to be Gatsby (because I slick my hair back now). "No, the Thin Man," I said. He nodded wearily. My mother asked me why my love affairs don't last very long. She asked if I was an egoist. She said the life of an artist must be lonely. (Hah!)

Welcome-home party for me at Kramer's. He's got a large cylindrical cage containing about ten black and white rats, big ones, with names like Dr. Zhivago, Vice and Versa, David Bowie, and Kojak ("Which one's he?" "The bald one"). I could hear Eden screaming, "Steven, get that rat out of your mouth!" Someone bought me a bottle of Pernod. All my old pals were dressed like *Guys and Dolls*. It was fun until I toppled off the desk I was sitting on, and, without breaking my fall, landed face-first on the hard, rough concrete floor, slicing

half my face to ribbons. They all laughed at what they presumed must be a calculated pratfall. But it wasn't. They watched my astonished face as blood began to pour down. Eden put me to bed. I blurted out a slurred "Two more gin-and-tonics and a Band-Aid."

I awoke next to Kurt in the morning. One eye sealed shut, the skin yellow and purple, large dried scabs and abrasions lacing my tender skin like a gory web, a fat lip, and of course, the puffiness and tremors that come from drinking a quart of Pernod. I didn't dare go home to face my parents, so I stayed put where I was.

Twenty-four hours later my parents pick me up in their ice-blue convertible. They hunted me down. I dutifully got in and explained that I got beat up in a bar. Then the fun began.

Mom said, "What kind of monster are you? You've ruined your father's life! We were worried sick. What really happened in there, with those seedy criminals you insist on seeing? Were you having a gang bang?"

DH after the fall

TWENTIETH-CENTURY BOY · 249

I found these questions too ridiculous to answer. She gave me an ultimatum, asked me to choose between my friends and finishing up school.

I said, "Look . . . Who's the bad guy? *I'm* the bad guy! It's *my* fuckin' eye! I'm the guy who drinks so much! No one makes me do anything! I do it myself, for better or worse! My will is my own, and I'll take my own consequences. Thanks!"

Then she told me that I look like a queer. So I told her she was a hypocritical, superficial egomaniac. Then she started crying and said she'd failed as a mother.

Still, I'm only just twenty-two. There's more ahead than behind— unless an early death awaits. Dean, Schiele, Hendrix, Modigliani, Beardsley, Morrison, etc. Dad told Mom, "Well, we'll probably outlive Duncan." I am persona non grata around here.

Before I left town I did manage to sneak out to the Minnesota State Fair, where the Dolls were performing in a tent on the midway. They didn't go over big with the farm crowd, plus Thunders looked junk-sick. But David Jo is ever the showman, and it was kind of a gas to see them at this surreal venue, right near the butter-sculpture contest. He spotted me after their set, and said, "Hey, Dunc, nice to see a familiar face—though it looks like someone gave you a going-over. How's the other guy?" Ha ha ha.

· · ·

Back to the city of cities, NYC.

Mary Jane is back from Cleveland. I ask her if she can read my face like a book.

"Yeah, a comic book."

We're having a sweet romance after the summer separation. She wasn't faithful, I wasn't faithful, so it's a draw. We skulk against the backdrop of this glistening, squalid, futuristic megapolis, rubbing shoulders with the sodium lights. She purrs in abandon, this kitty

kat of mine. There's a current passing between us. As we pass Washington Square Arch, I say it was built in honor of our love. "You're a charmer," she says. She's dressed like a nurse, in a white seersucker dress, rosy cheeks and big green eyes. I need a nurse.

We were invited to hear the Dolls rehearse in a recording studio off Times Square. They were plugged into Twin Reverbs instead of their Marshall stacks. Dressed in their street clothes, Beatle boots, and French Ts, doing little staccato dance steps, rolling steel ball bearings between their stained fingers. So sharp. They were working on a real tough Boston Blackie detective blues, called "Downtown": "Down . . . down . . . downtown." We sat behind the glass and watched them in their own element, proud of New York's finest.

Lance has got his third bout of hepatitis. But he still comes out with me 'n' DuPrey to see the much-publicized underground double bill at that deca mecca Max's, Patti Smith and Television. Television had some great new songs, an extended rave-up called "Marquee Moon" and "I Don't Care," then their classic "Prove It" ("This case is closed"), and "Little Johnny Jewel," of course. Patti did a rendition of "Paint It Black" which included some shamanistic speaking in tongues about fallen pop stars. Plus her ode to love triangles, "We Three" ("Baby please, why can't we go on as three . . . don't take my hope away from me").

We goof around in Union Square after the show. It's empty and dark. We smoke some boo and climb on the statuary making monkey noises.

．　．　．

School is back in session. I got a paint box filled with Shiva oil colors. They smell so good. I painted a Gitanes packet on a small canvas, in a nod to Larry Rivers's Tareyton painting. I grab my sketchbooks, and off to school. Into the darkroom to develop summer snaps of pretty

boys on rooftops, Robin Flinn lolling on Riis Park beach, me and DuPrey on the Coney Island boardwalk, nudes of Mary Jane sweeping the floor, Eric Li laughing after he shaved his eyebrows off, etc. Went downstairs to Cinemabilia to show 'em to Hell and Ork. Hell said Mary Jane was hot. "Who's she belong to?" he asks, not entirely innocently.

Then a crit from pretty illustration teacher, Lorraine Fox. She holds up my sketchbook to the class and shows it page by page, saying, "I've arrived at a personal state in my work after twenty years, and here Duncan has found his own private world already. There's no rush, everybody works at their own speed, but you see, he's really obsessed—not that I really know Duncan, maybe he's really weird, but he's on top of things. I see a very unique point of view, like a misplaced European." Maybe there's hope for me yet. An encouraging word goes a long way. Gimme five more years and I'll really show you something.

I painted a red-and-white checker tile pattern on the kitchen wall. Take down old pictures, put up new ones. A London hotel receptionist (Alan Jones, not the artist) came over last night and told me gossipy stories about Maria Schneider, Uschi, Hockney, the leading lights of the seventies, including one juicy tale of Alain Delon.

· · ·

Kristian and I go uptown to the French bookshop in Rockefeller Center to pick up more foreign pop tunes (Michel Polnareff) in their flimsy, glossy covers and a copy of *Ciné Revue*, which has great color photos of my favorite Euro movie stars, fodder for my art. Then we dropped in on Norman Fischer, the elegant drug dealer on Madison Avenue, and received the snowy-white fruits of Norman's generosity on a round blue mirror. I sniffed up a lonesome trail of cocaine, then seconds and even thirds. Feeling so tingly. Too much, or not enough?

That's the nature of cocaine. He serves vintage 1969 red wine and tells us how much each piece in his art collection costs, with a wild gleam in his eye.

Customers came, so K and I split for Lincoln Center, the NY Film Festival premiere of the David Hockney movie, *A Bigger Splash*. In the lobby were all the faces in *Interview* you never quite recognize. There's costar Peter Schlesinger, Steve Paul, Hiram Keller, etc. The film was beautiful, honest, cool, funny. I love the way Hockney documents his life through his art. Just uses his friends. Theatrical domestic scenes. Making his privacy semi-public. Always working. An inspiration. He saw a headline that said "Two Boys Cling to Cliff All Night," and what crossed his mind was two boys clinging to pretty pop star Cliff Richard. This led to his painting *We Two Boys Together Clinging*, which comes from Walt Whitman.

On the way home we watched a car burning up in front of the Waverly Theater. We left before the gas tank exploded and laced us with shrapnel.

I bought a used light box for twenty-five bucks. Now I can trace with style. Kristian says, "Cheat, cheat, never beat." He is a fairly steady boarder, a good houseguest to have. Very tidy. None of us have ever seen him in his birthday suit. Mary Jane says, "Kristian doesn't have a naked." Once I tried to grab his bath towel away from him and he exploded with rage. I learned my lesson. He says, "Most of my friends are conceptually homosexual." He complains of being a spectator rather than a participator. DuPrey says he's like Big Bird from *Sesame Street*.

I'm happy. Nothing is required of me that I wouldn't want to do anyhow. I'm rich in my poverty. In the prime of life. And I *know* it. I can hold it, and scold it, and squeeze it, and please it. Mary Jane sleeps over about half the week. She giggles her way into bed. Moonlight playing tricks on her smooth, pale body. Tweety Pie is circling her head, chirping up a storm. "When you're slipping into sleep . . .

that's the time of no time / When you're slipping into sleep," sang the Small Faces. Feeling complete.

I've been making collages. I synthesize what I've chewed up and regurgitate it, hoping some of "the real me" will rub off with it. How will I ever get some rich person to pay two hundred dollars for one? Once you get them to believe you, it should be a breeze. I'll just play it by ear until I get my wings. I suffer from the anxiety of influence. Will I ever transcend my idolatry? Patti Smith talks about "the image of an image, not the image itself." The look of a look. I yearn for authenticity in all things. I strive for timelessness, yet I'm a trendy kid. I'm in a quandary.

"All the things they said were wrong / Are what I want to be," sing the Yardbirds from the next room. Next platter is "Cathy's Clown" by the Everly Brothers, another pinnacle of lowbrow artistry. "Here she comes . . ."

October 24

I watch the present unfold. Nothing has value except the moment we are living. It's difficult to grasp. I loved Alan Watts's book *This Is It*, which was about just that. The sheer mystery of being here at all. The universal.

Eric is boiling potatoes and singing a Bad Company song in that falsetto of his. We hustled up to the Playboy Theater to see Delon's new film, *The Widow Coudere*, from a Simenon novel. Delon is forty now. He never quite gives himself away. Restrained, underplayed. He's a murderer on the run. "No one could understand, no one ever does," he says. Brandishing his perfect teeth, his glittery gray eyes darting from side to side, he leads a young girl to a hayloft and has his way. In the finale he is shot, forty machine guns typing "The End" through his heart.

Eric and I go up to gorgeous Radio City Music Hall to see skinny

Todd Rundgren, decked out in last year's space suit. Playing Clapton's old hand-painted psychedelic Gibson SG from the Cream days. I've heard that guitar twice before. He plays the Move's anthemic "Do Ya." Eric and I laugh with glee. Todd's a fan like us. He's windmilling to his heart's content, full of swagger.

Fall Movies
Purple Noon
The 400 Blows
Darling
The Night Porter
Lacombe, Lucien
The Widow Coudere
Kiss Me Deadly
Screaming Mimi

Affection

Duncan Rathbone Hannah

October 27, 1974

"The object of my affection / Has changed my complexion / From
white to rosy red."

. . .

Bonjour, livre! It is I, the happy Frenchman, come to couple words
and chronicle my life and times!

Sunday, dusk. Feeling homy and content. Eric and I are boiling
potatoes, the only foodstuffs left for the rest of the week, till our
checks come from home. We've managed before, and we'll manage
again. I like coffee, and I like tea, I like java, and it likes me.

I'm kneeling on the living-room floor in a disordered litter of
paper, making collages, white Oxford-cloth sleeves rolled up, the
sound of scissor blades gnashing their teeth like an animal, smelling
the paste, juxtaposing my wonderful scraps retrieved from the side-
walk. Red meets green and they go electric. That rare artistic exhila-
ration occurs. I can do no wrong. I draw over everything, parchment
lampshades, bills, books, biceps. Work is play.

. . .

Charlie Baudelaire says, "Dandyism is the last burst of heroism in
the midst of decadence. It is, above all, the ardent need to make
oneself something original, contained within the outward limits
of convention. It is a kind of cult of the self which can survive the
quest of whatever happiness may be found in others. The pleasure

of astounding and the proud satisfaction of never being astounded." Hear, hear. I find conformity cowardly.

. . .

Kristian is moving out after his five-week stay, moving to Twenty-third Street with affable Lance Loud, seen in *Newsweek* this month, eyes closed. Onstage with his luckless quartet, Lance drops to one knee and sings, "Ya gotta be *stupid*. . . . if you wanna love me." Kristian says in a snotty voice, "Living in your flophouse was an enlightening experience." His cynicism wore me down. If there is nothing redeeming in anything, okay then, but I don't want to be reminded of it. Get off of my cloud. Don't rain on my parade. My own optimism is a discipline that I practice. I love the guy but he can be too bitchy. Now he can complain about Lance for a change.

I'm reading *Vogue*. You wouldn't even know I'm living in the same city as the place where all these glamorous parties are happening. My new crush, Aurore Clément (from *Lacombe, Lucien*) says in an inter-

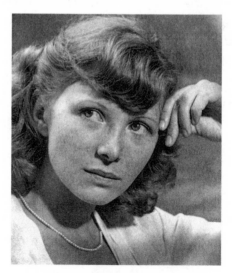

Aurore Clément in Lacombe, Lucien

view, "You only live once, so have confidence in yourself, and go get what you want, it's not important if you hit or miss, same in physical relationships with people." That goes double for me.

We're always thinking up names for stuff, books, pop combos, etc. DuPrey said I should call my journal *I Am an Idiot* by Duncan Hannah. I like *Trial and Error, Shadow Box, Abstract Espresso, Contemporary Ghosts*. But I settle on *Affection*.

. . .

Adrift in tinsel town. I walk through the teeming crowds of fertile Times Square, one great big pulsing abstraction, particles jiggling helter-skelter under marquees, tribes of pastel tootsie-wootsies chewing gum, a colossal oxidized Venus with a sugar-cone torch, little islands of filth and degradation, salt-shaker skyscrapers, small lives, big dreams.

New manifesto: I seek to retain the magical principles of childhood and assert them with an expanding knowledge of the world. I'm trying to *become* life instead of imitating it. I'm in an impressionable state. Bringing together the diffuse elements of the teen dream. These complex signals tell us who we are and what we might be. Fantasy is reality.

Went to Sonnabend Gallery to see the Jim Dine show. Great draftsman. Tools. Underwear. Then off to the movies. *Breathless* again. Popcorn and Baby Ruth. Feet up. Take notes. Jean Seberg plays twenty-year-old Patricia Franchini, pregnant with Michel's child. He's lying low with her because "there were no vacancies at Claridges." Piano and bongo music buildup. He shadowboxes. Says, "Women's hips get me. Here I am in love with a girl and she's a coward." He hot-wires a convertible sports car and they drive to Montparnasse, a smoldering Gitanes in his teeth. They pass luminous Place de la Concorde, they pass corrugated Deux Chevaux and dented Dauphine. He says, "I feel tired, I'm going to die." And indeed he is,

the police are hot on his tail, a motorcycle brigade in V-formation. One more cigarette before annihilation.

. . .

Mary Jane calls me her "little weirdo honey-bunny." Says, "Why do you act so nutty? I should keep you chained to the bed like a golden monkey." She gets up to find a chain. She takes birth control pills now, and that makes her breasts swell and her moods more erratic. At night she prays for dead astronauts, Walt Disney, and other random spirits.

. . .

My drawing teacher, Bill Clutz, says, "Ineptness is in this year." He looked through my portfolio and said what stood out was my romanticism, which saved it from being facile bullshit. Said it was strong-willed. Said it was about hope. The sensual activities of everyday life. Says I'm complicated. Reminiscent of a cartoon character. He should talk! He looks like a rabbit!

. . .

I played hooky and scoured the Strand for dusty treasure. Crawling on my hands and knees in the basement, I found a book on contemporary British art called *Private View*, with Peter Blake, Hockney, Procktor, and Kitaj. My forefathers. They graduated from the Royal College in 1962. I was ten then, sitting in my room drawing battleships and bombers, race cars and spies. Now it's a dozen years later, and I see their work as a touchstone to my own development. They were inclusive of the pop world around them, not sweeping it all away like today's minimalists. They had room for shooting-gallery graphics, cheesecake, tigers, drawing on modern life quite literally. A breath of fresh air in the increasingly pretentious art-world climate.

I'm also turned on by Rauschenberg's assemblages of multiple sensations inside one format.

I wake from a vivid nightmare in my loft bed, heart pounding, listening to the clanking pipes, the creaking floorboards, the canvas shades rustling, the rattle of the old windowpanes. All amplified into murderous fear. It's the downside of having your subconscious filled with crime films. I grab my hatchet and go down to investigate. No one there.

Movies Watched

Benjamin (Clémenti/Deneuve)
Mickey One
The Sicilian Clan
Le Départ (Léaud)
Steppenwolf
Love and Anarchy
Stavisky
Le Violons du Bal
The Servant
The Hireling
The Glass Key
This Gun for Hire

Every Sunday I model for one of my teachers, J. C. Suarès. He's a very successful thirty-one-year-old Egyptian-born illustrator, art director for *The New York Times* and *Screw*, carries the biggest switchblade you ever saw, smokes cigars, talks dirty, has a big mole on his face. Friends with Fellini! (Fellini called in tears, complaining he was too fat to find his penis!) He lives in a fancy garden apartment on West Sixteenth Street. He pays me ten dollars (and lunch) to stand in front of him in my motorcycle jacket while he sketches away in a

kind of Matisse/Picasso style, asking me my opinion on things. He says he's keeping in touch with the younger generation.

J. C. brought his pal Ralph Steadman into class to tell us funny stories. He said he fought for his country. "Where?" I asked.

"In bars." he said. Steadman told us future graduates to "insist on your point of view! Fight for your work! Above all, be *total!*"

. . .

I often see Elaine de Kooning in the Parsons painting studios, talking seriously to her students, chain-smoking in her capri pants. A relic from another bohemia.

Went to an opening at Marlborough Gallery for Larry Rivers's new Chinese coloring-book paintings. Great people watching. Everyone checking each other out. Drummer Elvin Jones was in the corner, grunting unintelligible guttural remarks. Helmut Berger was dressed as a Cossack (YSL). Sylvia Miles, Gerard Malanga, Richard Bernstein, Eric Boman, fur designer Larissa. The print room had an early Rivers, *The Boston Massacre*, some Diebenkorns, a couple of Kitajs. The reception had the reassuring drone of a beehive. Mallory arrived, said her aunt died and "left me a sum," which I happen to know is not the case. She works five days a week in a massage parlor. So does Velvet. They went pro, to supplement their super-groupie lifestyle.

We went to the after-party at Seventy-fifth and Central Park West. Could hear the music from the street. One to two hundred people were in a giant apartment belonging to Peter Brown from the Robert Stigwood Organization. A very elegant, classical setting with pop art on the walls, smelling of wealth and expensive leisure. Jackie Curtis was crying on Lance's shoulder in the bedroom; she looked like Bozo the Clown. Satyr Larry Rivers had his arms around my sexy school chums Carol and Shelly. Carol detached herself and came over to me with that "look" in her sultry eyes. We've fooled around in the past.

"I wanna make out," she said alluringly, and I thought, Why not, I'm drunk, I don't see Mary Jane around, why not grab a quick one? So we ducked into a bathroom and locked the door. Grope, grope. Then we resurfaced into the fray. A Chinese screen fell over on Carol, but a guy called John Berendt caught it before she was squashed. He led me through the party because he wanted Terry Southern (author of one of my favorite books, *Candy*) to meet me. We finally found Terry passed out stone cold behind an enormous mauve velvet couch. Very much the worse for wear.

Snooping around the bedrooms, I see one of my heroes, Oklahoma boy Joe Brainard, sitting shyly on a velvet loveseat in front of a vanity, wearing a brown velvet suit, green silk tie, and sneakers. He of the fancy brushwork, the Morandi of Pepsi bottles, sleeping lurchers, hot fudge sundaes, wildflowers, and spread-eagled Nancy (Sluggo's pal). So I got up my nerve and approached Joe, telling him how I felt like I knew him already because of *I Remember*. He mumbled, "Oh, really." I put a bunch of questions to him—who did he like? etc. I said he was one of the only funny artists around. He didn't have much to say, squirmed a bit. He seemed afflicted with some secret sorrow. He asked about my work and told me he'd been very lucky when he started out, because he had a lot of friends who helped him out, showing right away, didn't have to drive a cab, etc. I was going to ask if I could visit him on Greene Street, but then he was gone, like a ghost.

I see Mary Jane crying, and David Croland saying to her, "Don't cry, baby, it'll be all right."

John Berendt took us over to his classy apartment on West Seventy-sixth Street for a brandy. He pre-interviews the guests on *The Dick Cavett Show*. He asks me my life story. Mary Jane in a huff about the locked-bathroom incident. I'm in the doghouse again.

Home, listening to "Memories" by Robert Wyatt. Off a beat-up import LP called *Rock Generation*. "Memories can hang you up and

haunt you / All your life, you know / Get so you cannot stay / And yet cannot go."

What a spooky little number that is! I can't get it out of my head.

. . .

I'm doing my homework, listening to Fauré and nursing a bottle of Bordeaux. Eric walks into the living room, his finger outstretched in his coat pocket, and says in a foreign accent, "Giff me za microfilm . . . I know you have it . . . Hand over za microfilm, now!"

"You read too many comic books," I say. Eric turned a trick for fifty dollars recently. Who says love won't pay the rent? Poor Eric, he is the most unlikely hustler ever.

. . .

Christmas in Minneapolis, less to do with Jesus and more to do with breaking the law. A little family stuff, tennis with Dad in an indoor court, listening to my ancient grandfather Bunny Rathbun telling his well-worn stories over a big glass of bourbon. One story about returning a stolen diamond ring to a St. Paul prostitute on Xmas Eve of 1912 gets a look-in every year, but he tells it well. Beats the Three Wise Men. I have to answer a lot of stupid questions like "How's school, Dunc?" "You like it out there in New York City?"

One night my father handed me a Scotch-and-soda and said, "Dunc, you know on the way to work this morning, I was thinking that there is a communication breakdown between us. To understand me, you have to know one thing. In 1957 I had a nervous breakdown. I was paralyzed with fear of who-knows-what for three days. All I did was sit and cry. Of course I was embarrassed. But my dad diagnosed that it was something in my chemistry, something in the Matré"—his mother's maiden name—"genes. All the Matrés, at one point or another, broke down in a similar way." He looked sad, and told me

he still worries all the time, can't relax, plagued with insomnia. He hides it well.

I drove over to the Minneapolis Art Institute to view the new exhibition of contemporary art, including a couple of Schieles and a fabulous 1960 painting of Dick Tracy by Andy Warhol, complete with scumbled pencil and oily drips, back when Andy was still trying. So much charm in that painting. His portrait of Popeye from then is another winner. Now he's got assistants doing much of the work, and suffers because of it. But, of course, that's part of his point.

Parents left for a sail around South America in a large sailboat. They left me the house for six days, including a note a mile long about things *not* to do in their absence, and of course I disobeyed each and every one of them, and some more besides.

So, the big event coming up is old pal Kramer's wedding to my ex, Eden. The first of any of us to make that marital gesture. They're both completely mad, so this should be interesting. Plus, all us groomsmen are prodigious drinkers, so this will be an Olympian celebration.

Kramer's Stag Party, Wedding, and Aftermath

Kurt's new apartment on Hennepin. The hashish and Pernod flowed. Kramer singing, "I'm gettin' married in the morning / Ding dong the bells are gonna chime . . ." We were in the bathroom with the shower on scalding to make like we was in Venezuela (I don't know why, maybe to get our wrinkles out). Kramer eventually jumped in the tub, receiving second-degree burns on his arm, which began to blister immediately and had turned black by morning. As the apartment was slowly demolished, the landlord complained repeatedly, a neighbor entered with a sidearm in a hip holster, toting a double-barreled shotgun in the crook of his arm, and finally the police, who

cleared everyone out. In other words, a good party. As Patti Smith would say, "relentless adolescence."

Wedding day. Filling up our plastic hip flasks for the long ordeal ahead. We drive through the wintry landscape to Kramer's house, climb out of our filthy khakis and into our thirty-dollar rental tuxedos, doing up our studs. A fleet of autos left for the Methodist church, where Eric Li was playing Chopin on the pipe organ.

The priest caught us passing around a flask in the antechamber. He crossed his fingers that this unholy ceremony would go off without a hitch. We filed out, spacing ourselves three feet apart, hands folded in front of us, chins raised in sober (?) salute. Crosby said later it looked like a police lineup after a debutantes' ball: five shadowy, sinister visages dressed in our casino duds, packin' rods. Staring out at the squaresville crowd like gangsters.

Priest says, "If there's any man who objects to this wedding, speak now or forever hold your peace." Kramer turns to us with a dirty look, smirks at priest. Kurt whispers to me, "Hey, don't that babe do a strip o'er dere in Nordeast? Yah, that's Fifi la Fou!" Beautiful Eden is crying in her off-white lace gown. My old gal, who shared carnal relations with me, above the Pizza Box, less than one year ago, marrying that wild-haired lunatic, voted most likely to self-immolate. Ain't life funny? Then it was "I do" time, and we filed out.

A stuffy reception, aided by hashish consumption in the men's room. Then on to my parents' house for a blowout. Kramer was pissed off he couldn't come too. "Sorry, pal, you're marinated now," we said. Thirty people showed up. A crazy girl fresh from a nuthouse started to scream at everyone about nothing in particular. Juvenile Jimmy Clifford tripped a giant Viking one too many times, and the surly brute picked him up by the lapels of his dinner jacket, threatening him with a severe beating. Clifford squirming, saying, "Look, buddy, don't get shook, it's just a joke." The lunk wouldn't have it.

Someone came to find me, told me Clifford was about to get pum-meled, so I wandered out, sized up the fella, a good foot taller and a hundred pounds heavier than me, and said, "Excuse me, but as the host, I feel I must ask you to leave. Nothing against you, but it's just that you're causing a disturbance, and this party was intended to have a festive atmosphere. I'm afraid you're endangering that, so there it is."

The brute blinked, set Clifford down, and left with a bewildered look on his face. Much applause from the hedonists. You see, these tuxedos do something to you, bring you a certain sense of forceful grace. Put character and reason in your demeanor. Anyway, we drank the house dry by three a.m. I had to take a piss, went to the can, steadied myself with the towel rack over the toilet, saw about six Dun-cans in the mirror, fell backwards into the tub, where my mother was keeping her plants moist while she was gone, banged my head on the soap dish, crunched all the plants flat, snapping them at the base. Poor fronds. I struggled to get up, but the world was spinning too fast that night. Too loaded, man. I suppose I was as drunk as I ever could be, so I gave up. Conked out.

Next day the groomsmen were shaking all over, and I was no exception. Heart going thumpity-thump. All I could do was pace. Delirium tremens. I threw up a little blood and stomach lining. I swore if I lived through this I'd give up demon alcohol. Who wants to be dead? Plenty enough time for that at a later date. New Year's Eve tonight. Will I make it to 1975?

I fly back to La Guardia on the General Mills jet, with my jolly corporate-exec uncle. He gave me a barbiturate from his pocket, so I read Françoise Sagan peacefully. Caught a crystal-clear bird's-eye view of Manhattan from my window. Oz!

January 13, 1975

Television was making a rare appearance at their old club CBGB. They've come a long way in the past ten months. Once the most underground of the underground, now they sport a chic notoriety. The Velvet Underground of the seventies. Eno produced their demo (which they found too stylized). They signed to Chris Blackwell's Island Records. Their manager, Terry Ork, says, "They've got no bass, no drums, no rhythm, no lead, but music aside, they're the greatest." So it was like old times, all the glitter kids from the now defunct Max's Kansas City (yup), David Johansen gulping down chili with Syl Sylvain during the opening band's set, Blondie and the Banzai Babies, featuring the creamy former Playboy bunny Debbie Harry. Hatchet-faced Johnny Thunders made a guest appearance on his Gibson Melody Maker. Doing that one braying lick he's got.

I asked Lance Loud how have all the parties been lately. "Great! I *am* the parties!"

I asked him if his new motorcycle jacket was from the shop on Christopher Street called the Leather Man. He said "I *am* the Leather Man!"

What can we learn from this? That Lance Loud is *many* things.

Scrawny Patti Smith was boogalooing in the aisles during Television, pumping her fist, screaming, "Yah . . . yah!"

. . .

There was a rumor going round that Television was going to can their drummer. Verlaine wasn't happy with Billy Ficca's busy, irregular timekeeping. So he asked me what I was like. "Dave Clark," I said. He weighed this in his mind solemnly, nodded, and said he'd set up an audition to try it out. I'm not such a fancy drummer. But then Hell's not such a fancy bass player. Some might say that Hell is not a bass player at all.

So Friday I went down to Ork's Chinatown loft, where Television rehearsed. A bleary-eyed Richard Lloyd opened the door, tugging mismatched socks on his dirty feet. Their equipment was scattered about. Posters of *Last Tango* and *Il Conformista* on the wall. Roxy albums on the dusty floor. Lloyd, Hell, Verlaine, and I unwound with a Hendrix-type instrumental. Then we began with their songs, which I knew by heart. I laid down a much heavier beat than Billy was used to doing, eliminating all his skittering, nervous fills. I kept it simple. Hell was grinning at me, and I was having a ball, actually playing with Television! Especially thrilling were those white-heat crescendos they excel at. After one of 'em, where I had laid down a particularly slinky bit of syncopation, Verlaine winked at me and said, "That was something else." I screwed up on the numbers that had a lot of changes. It was good, but not to be. Verlaine kept Billy. And made me swear that Billy must *never* hear about my tryout.

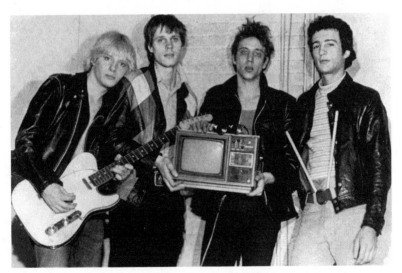

Television: Richard Lloyd, Tom Verlaine, Richard Hell, Billy Ficca

NERVOUS ENERGY

Caffeinated. On my hands and knees working on the kitchen floor. Art-school motor skills. Today I am the master of pubic hair. The shadow I cast is by artificial light. The street below is the color of smoke. The drizzle turned into a persistent rain. But I'm floating on a pink cloud.

. . .

It's hard to unravel people's origins in New York. They act cagey. Suspicious.

. . .

John Berendt came over to my apartment, to have a snoop, look at my work. I gave him a drawing of Alain Delon. Eric was sitting at the kitchen table working on a bottle of Beaujolais, listening to Freddie Hubbard.

Berendt took me to dinner across the street at Rocco's. Veal francese, with lemon and capers. Mmmm. We went to see the Lindsay Kemp dance troupe (from England) do a kabuki/drag interpretation of Oscar Wilde's *Salomé*. We went backstage afterwards and watched them remove their makeup. Blind Lindsay Kemp said to us, "Everywhere outside of New York is *awfully* provincial, isn't it?" One of his dancers is David Meyers, a beautiful blond guy who's chummy with Hockney's set. I hit it off with him. So I took Berendt and Meyers to

CBGB to see Television. They were soaring in V-formation onstage singing "I gotta fly everywhere in my UFO."

Jay Reisberg took me to the Upper West Side for an afternoon tea at the Salon d'Art Société (or "the Parlor of the City"). Three guys my age, graduates from Syracuse University, who live in a Victorian floor-through apartment in a brownstone on Eighty-second Street off Central Park West. The pomaded ringleader, David McDermott, a freckled Irish lad who resembles Alfalfa, hails from New Jersey. Then there's photographer Josef Astor, a tall, bespeckled blond from Akron, Ohio. Finally, George Hasbrook, who has the look of an extra from an old Warner Bros. movie, pencil mustache and all. They are time travelers, living somewhere in the early part of the twentieth century. Playing a crank gramophone, serving sherry, wearing tailcoats, surrounded by taxidermy, being gentlemen. David is a painter who studied with man-about-town Richard Merkin, a very good artist who's often seen in *Esquire*, *The NY Times*, etc., known for his dandyism and erotica collection. David shows me his own paintings

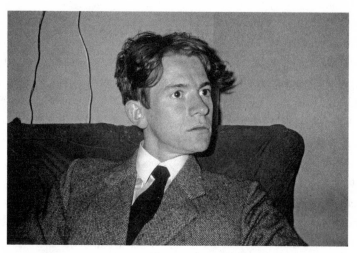

David McDermott

of Adolf Hitler, done in several styles. He is mad as a hatter but quite good fun.

More Movies
Scorpio (Delon)
Mississippi Mermaid
Murder on the Orient Express
The Godfather Part II
Emmanuelle
Love at the Top
Lenny
Man Hunt
Pickup on South Street
Be My Guest (Hemmings, Marriott)
La Prisonnière
Behind the Green Door
L'Amour
Les Enfants Terribles
Andy Warhol's Dracula
Going Places
The Romantic Englishwoman

More Books
The Day of the Locust, Nathanael West
My Gun Is Quick, Mickey Spillane
I, the Jury, Mickey Spillane

· · ·

Danny Fields took me to see the flick everyone is talking about, *Emmanuelle*. Beautiful Dutch girl Sylvia Kristel gets fucked by a wordless stranger in the bathroom of a 747 jumbo jet, in a squash

court in her tennis whites, in a Bangkok opium den, and mastur-bates beneath her cutoff jeans under a picture of Paul Newman. I was pretty turned on, but I was wondering what Danny was think-ing. So I asked him as we exited the cinema. "Oh, it was so pretty, it made me wish I was a lesbian." Ha!

Trying to think up names for the Lance Loud/Kristian Hoffman/Rob DuPrey band. The Bones, the Parents, the Cars, the Aliens, the Little Friskies, Lance Loud's Problems.

Eric and I threw an afternoon party in our Thompson Street tene-ment. It was raining, so things were in soft focus. We served Bloody Marys. Makos came with his Polaroid SX-70 and took party pictures. Nineteen-year-old coquette Georgie Warner was a big hit, a perfect nymphet, sporting a new corkscrew coiffure like Aurore Clément. She's just dropped out of school after only one semester. She was staring at me through big, beautiful eyes that I read as flirtation until all the other guys said they got the same look. What a doll. I had a couple of drinks after a four-week abstinence. School chum Carol is on the phone trying to hustle up a man for the night . . . John Hersey or Steve Rivers? Who's the lucky winner gonna be? The drink began to affect me, so I was talking to Craig Gholson, asking him why he never loses his cool like I always seem to do. Maddening, that degree of self-control.

. . .

Sunday dinner at mysterious Georgie Warner's apartment. What's her game? She looked very sexy in an oriental getup. We drank Guin-ness and ate fillet of sole. I was nervous because of my intense crush on her. She's *so* cool. She could have anyone she wanted. I wanted to take her away from the other dinner guests, into a dark bedroom, clasp her by the shoulders and say, "Georgie, let's settle some unfin-ished business," which would be the words she was waiting to hear, and we'd unleash our mutual desire. Instead, we watched a rerun

of the Beatles on TV. Then I excused myself to take the train down for the Sunday-night show of Television. I could breathe easier down here on the Bowery than I could with my classy uptown friends. They played "Love Comes in Spurts." Jovial nihilist Terry Ork bought me about ten drinks, and about twenty for himself. The Dolls were sitting around looking outdated in their tight Rod Stewart suits.

. . .

Dancer David Meyers took me to a dinner in Jasper Johns's studio on East Houston Street. It was a former bank that Jasper bought in 1965, from the proceeds from his maps, targets, flags, numbers, letters, etc. (That guy staked out a *lot* of territory for himself.) Jasper had the tellers' windows and stuff taken out, so he had an incredible amount of room. Bradford-born Mark Lancaster, an unsuccessful painter, acts as his personal secretary and housekeeper. Anyhow, Jasper was currently in the Mediterranean or something. Mark served wine, meat loaf, collard greens, then whiskey. He talked about studying under Richard Hamilton with Bryan Ferry at art school in Newcastle. He talked about the early sixties in austere Britain. Very amiable fella. David Meyers talked about his two-year round-the-world tour with the Royal Ballet, his dream dates with Nureyev, and the exultation he gets two hours a day, performing in front of a live audience. As we walked home David made his romantic pitch for me, telling me I seemed like a consumptive poet, pale and thin . . . and I had to put *him* off as I have many before him. It would all be so much easier if I *was* gay. I'd be cleaning up. Darn the luck! I don't mean to lead these people on, but I'm curious to know them.

. . .

Next night DuPrey's new band the Mumps debuted at Trude Heller's on Sixth Avenue. Shiny mirrored art-deco wall. They opened for Cherry Vanilla. It was a full house of the beautiful people. Amanda

Lear, Bryan Ferry's manufactured girlfriend, kept combing her blond hair, Nico-style. Leee Childers, with a new black crew cut, is off to Arabia, "to bring some chic to the sheiks." He massaged my clavicle. Mallory, in a new black rubber trench coat, was buying everyone drinks with her ill-gotten gains. *Interview* cover artist Richard Bernstein, Fran Lebowitz (walked out in a huff), Wayne County, Norman Fischer, Pat Loud, Chris Makos (too stoned to take pictures), and various toddlers and trendies. Band hit the stage at ten-thirty. They launch into their tricky, wordy songs. Lance's bull neck was bulging and sweaty, Kristian looked self-conscious and grieved, DuPrey looked Liverpudlian and unsmiling against the brick-wall backdrop, strobe lights flickering on his rock-boy face. They sounded a little like the arty period of the Kinks, with all those elaborate changes. A little contrived. But some songs were so good, like "We Ended Up" ("We ended up in places like this one . . ."), "Before the Accident," "Night Owl," "Kitty Kitty," and "Stupid." I wound up covering it for the *SoHo Weekly News*, taking over Danny's column as he's away somewhere. I titled it "Liber-teen Rock."

. . .

Lonely Wednesday. Ork and Lloyd just dropped in, bearing Heinekens and grass, made themselves at home, asked to hear some obscure English platters, so I flipped on Eno's *Seven Deadly Fins*, which removed the caps from our teeth. Then Bryan Ferry's sensational cover of "The In Crowd." They looked through my sketchbooks as Terry told outrageous stories about his old pal Nick Ray. He talks about Billy Halop, the cute Dead End Kid who went wrong. We talked about how persistence pays off. Ork kids me about never wearing the same outfit twice.

February 6, 1975

I don't have the rent money. Gulp. Here I sit, presiding over all the appliances. The drapes are closed. I don't answer the phone. I'm trying an experiment in being alone. I like it. I ain't been to school all week except once to draw a gypsy, which I made into an Egyptian. I took sanctuary in a nearby cinema.

Spending time with the ever-fascinating David Walter McDermott. A high-idealed lunatic. He did a thing at art school where he was "the man who forgot to put on his trousers," and walked to school through the Syracuse slum with his knee-high socks, garters, brogues, boxers, etc., everything but the pants. When this was pointed out in drawing class, he shrieked and ran home.

Went to a big party last night in a phantasmagorical pleasure palace on West Twentieth Street. There was a leopard lounge that put my crummy boudoir to shame. Barbara Nessims on the wall. (She used to be Marc Bolan's lover.) Norman held out white cocaine for everyone to sniff. Someone flashed a tit. Richie Gallo flashed a cock. A neon light sculpture put an electronic dawn on the shattered guests. Bowie hid under his enormous black hat. Thought of his song "Watch That Man" that goes, "Shakey threw a party that lasted all night / Everybody drank a lot of something nice . . ." A tiny Japanese television set was perched on top of a Greek column. Modern art.

Mary Jane is mad at me because there was another drunken night where Craig Gholson passed out and threw up in his sleep, and she found me kissing his pretty girlfriend, Susan Morris, who works at *The New Yorker*. I also had my hand under her white silk blouse playing with her exquisite breasts. Mary Jane took me by the wrist and dragged me away. Bad dog. Woof woof, bow wow.

. . .

If I admit I'm an alkie, then I gotta quit. And who wants to? My hangovers sometimes last for three days now. I'm twenty-two, my liver must be sixty by this point. Got a pain in my armpit. Is that the big hello of coronary thrombosis? Emphysema? My cold bones clatter against each other.

February 16, 1975

Big blizzard hits Manhattan. I bundle up, put a hat low over my eyes, and head south, past Prince, Spring, and Broome. No cars. No people. Just me in snowbound SoHo smoking a joint. I felt as if in a dream, the white flurries whipping at the industrial warehouses. At Canal I ducked into the red-and-white Pearl Paint. I got mesmerized by all the colors. I wanted to get everything . . . I spent sixty dollars on materials. An investment in myself. I flirted with the salesgirl. I'd seen her somewhere before. Very arty. Got a couple beers at Fanelli's on my way home. Trudging through the deep snow. Manhattan seems benign in the whiteout. A fairyland. Couldn't hurt a fly.

· · ·

Our lease is up in April. I'm tired of the cranky neighbors who make their threats about the noise. We have to tiptoe on the slanted floor at night. The twenty-five thousand cockroaches. The toilet that runs constantly, the stuck drain in the tub, shower don't work, hot is cold and cold is hot. I'd like a proper bathroom. I can't sit up in my loft bed. Ten electrical cords stuck into one jack. That's what's called an octopus. The surly bums on the corner calling me "faggot." Maybe I'll move in with beautiful Mary Jane.

Interview Valentine's party

I found a note in my pocket that said, "Call Ron for Bernstein party," and a number. I called. Art dealer Andrew Crispo answered and asked if I was Duncan Hannah. "Yah, have we met?" I asked.

He explained he and Ron (?) had met me at the Larry Rivers party and they very much wanted me to come to this one. Okay.

First an opening at the New School, curated by J. C. Suares, of David Levine, Ed Sorel, Brad Holland, and Ralph Steadman. Suares ogled Mary Jane and said with a leer, "You're not leaving her behind, are you?" "Nope, she's coming with me."

We high-tailed it to Gary Lajeski's Tower Gallery at seven p.m., just as a junked-out Genevieve Waite was leaving. Her Broadway show closed after two performances. Richard Bernstein was showing his iconic airbrushed photos of celebrities. He looked like a Jewish David Essex. Many Factory people were inside, Loud and Makos getting in everyone's photos. Fat Pat Ast, slick Fred Hughes, sexy Hiram Keller, shy Andy Warhol, theatrical Diana Vreeland, crazy Tinker-belle, grotesque Divine, winning David Jo, run-down Leee Childers, who I haven't seen since Club 82 ("the sperm cellar," as Leee called it) turned into a black club. Dotson Rader asked Lance what my status was; Lance said I was taken, Dotson said too bad, because "he's the most beautiful boy on earth," and because of my profession I would *have* to turn to men eventually. He warned Mary Jane not to let me drink too much, or else *he* would be taking me home. A bit presumptuous, but then he sees humanity as hustlers.

Got a ride in Peter Brown's station wagon to the after-party on Seventy-sixth Street. I'm exhausted from a full day of booze and no food. Never been good at pacing myself. Entered a big apartment, where there was a huge block of ice carved in the shape of a heart, lit by pink fluorescent tubes, melting very slowly. Had my photo taken with Fred Hughes, Tony Zanetta, Lance, Wayne. I sat down only

to discover that I was unable to get back up. Transsexual Amanda Lear sidled over and asked why I was so drunk in her crazy German accent. "Just am," I explained. She scolded me for a while with a big smile, lots of white teeth in there, then started joking about her jealous boyfriend, Bryan Ferry. She was wearing a sheer chiffon blouse that exposed her shapely silicone breasts, which I'd already seen in *Lui* magazine (being a guy who does his homework). She said she was recruiting models for Salvador Dalí, he's painting angels, and to give her my number so she could get in touch about that. I did. Whew. Time to go.

Drinks with Dalí

Rainy Sunday night. Reno Sweeney. Anita O'Day onstage singing some junkie scat. At the table next to us were Colacello, Warhol, Keller, and Amanda Lear. She was telling them how disgustingly drunk I was the other night. Andy turned to me and said, "Oh, I always thought you were British" (?). They left without finishing their drinks. Never understood how anyone could do that. It's the Scotsman in me.

The following afternoon she called, told me to meet her at 5:30 at the St. Regis for drinks with Dalí. I took the subway up. In the lobby was a young man slumped into a Louis XVI chair, wearing a raccoon coat, emerald-green suit, snappy shoes, and a ruffled shirt. A misfit like me, I thought. He looked up and gave me a smile. I smirked back. It was Rod Stewart!

Amanda entered the lobby, took me by the hand, and led me to Dalí's table in the crowded King Cole Bar. She started telling me her life story. Super-narcissistic. She's about thirty-five. She didn't pause for a breath, looking around to see the effect she was having on the businessmen in the room. "You're just like Bryan—your innocence

and shyness is just a mask," she said, wagging a finger at me, as if I was a secret degenerate.

Then there was a silence. We looked to the doorway, and there, arms spread wide, sporting a gold cape, was Dalí. He announced to the room loudly, "Dalí . . . is *here!*" He headed towards us, his cane propped in front of him like a sword. Amanda stood up as he kissed her hand, and they began babbling in a mix of Spanish, French, and English. I noticed his cape had *real* bees sown into the weave. It was all there: the ridiculous mustache, the bulging eyes (filled with cataracts by this stage of his life), the long, greasy hair. I stood to shake his hand. He sized me up. Appeared satisfied. "Will you model for Dalí?" he said.

"Um, yah, sure."

"But wait!!! . . . Do you have hair on your chest!?" he said fiercely.

"Er, no, I don't."

"Ah! This is good! Dalí does not paint angels with hair on their chest!" Then he considered another point. "But are you a professional model?"

"No, I'm not."

"Ah! This is also good. Dalí does not paint professional models! But then, what is it that you do?"

"I'm an art student," I said meekly.

Dalí threw his hand over his heart and said, "Ahhhhh, then you *LOVE* Dalí!"

Taken aback by this lunatic, I answered, "Oh, yah, we're all crazy about you down at art school." A total lie. We all think he is the worst. He said he was glad I was skinny and pale and European-looking. "You will make a beautiful angel for Dalí!" And with that, he made his grand exit, while the dumbfounded businessmen looked on.

Amanda took me upstairs to her dark room (the Dalí entourage lives in the St. Regis when they're in town). She showed me her port-

folio and her song lyrics. She took a Polaroid of me. I felt like a ten-year-old. I was completely thrown off by this exotic creature with the inside-out dick. I *don't* want to find out more. She began to change for her next engagement, shooting me naughty looks. "Should I wear this? Or *this?*" Uh-oh.

The phone rang. It was Bryan Ferry, on tour in Toronto. She was teasing him about the "nice boy" she had in her room. I could hear him getting upset—what boy? Why is there a boy in your room? She was laughing at him, saying not to be jealous, he's just waiting for me as I dress for dinner, he's just a pretty boy, ha ha. More squawking from the receiver, Amanda enjoying this immensely, tormenting him like a cat with a mouse. I felt sorry for Bryan, my hero; he's jealous . . . of ME! Fortunately, she had a dinner to get to, so I was spared any further spider-and-fly scenario.

I was walking home on Park Avenue ruminating on sexual identity and thinking about what I would order at Bun n' Burger when John Berendt sidled up and took me somewhere fancy instead, for cold trout, duck à l'orange, and crème caramel. Nothing like a free feedbag! He was amused by my story and asked what *does* turn me on, anyway?

. . .

Roxy Music at the Academy of Music

First splashed out on dinner at Lüchow's, which has been there for a few hundred years, with the same waiters, too. Schnitzel and spätzle all around. The Academy was buzzing with "Roxy types" in the lobby. All of my friends were there. Ferry was menacing, squinty-eyed, twisting away, in good voice. Icy charm. Andy Mackay doing the duck walk in his green jumpsuit. Futuristic fifties. Triumphant headliners delivered the goods. Doesn't get any better than this.

Afterwards Mary Jane and I stood by the stage door waiting for the

man of the hour. He and Amanda appeared, flashbulbs went off, and they ducked into a big black limousine, roaring off to the El Morocco club. We walked south, past the giant Cooper Union building, past the Colonnades (which houses the new hot spot Lady Astor's) to CBGB, where the Mumps were opening for Television. Blondie and the Ramones looked on from the wings. There's definitely warring cliques in CB's, now that the audience has grown and bands are getting signed to labels. Some of the innocence is lost.

March 1

The phone company burned down, so I am incommunicado. When it was turned back on, my first call was from Amanda Lear.

"Hello, darling, do you want to come up and play with Amanda?"

"Um . . . I can't, I've got homework. It's a school night."

"Don't be ridiculous, you *have* to come up, *The Legend of Lylah Clare* is on, it's my favorite movie, I want to watch it with you. Don't you adore Kim Novak?"

"Sorry . . . I'd like to, but I can't."

Then she blew up at me, told me that the Dalí modeling was off, and that I should learn to grow up. *Slam.* So that's that. Bye, weirdo.

. . .

Never believe what an artist says, only what he does. Teachers tell me to pick *one* idea and stick to it. Then start on a series of variations on a theme. Do it over and over; then the viewer knows you *really* meant it. I don't do that—too many ideas swimming about in my head. As old Whitman said, "I contain multitudes." The cracks in my head let more and more come in. I do research in the library, studying the last twenty years in the art magazines, receptive to this, discarding that. Takes a long time to hone your sensibilities. Each new wonder leads

me deeper into the wilderness. The more you know, the more you realize how much more there *is* to know. It's a lifetime profession, an endless process.

. . .

I got my hair cut at Mingus and Mary Jane dyed it L'Oréal blue-black. I'm moving up to her pad in Chelsea, a nice quiet block. So I'll be bidding farewell to Little Italy. I'll be a college graduate then, and will have to seek some kind of employment. Groan.

I was in a local gallery, and I spied with my little eye . . . owl-eyed and bleach-blond David Hockney! He was with his best pal from the Met, bearded Henry Geldzahler. I eavesdropped on their conversation. I passed him and said "Hello." Hockney paused, gave me a crooked grin, and said "Hi." So much to ask him, so much to tell him, that I remained mute. I watched as Hockney and Geldzahler went across West Broadway. Henry posed in front of a Grand Union, and David took pictures of him. *Pop!* Henry poked David in the ribs and pointed at me. Caught gaping! Blush. Someday I'll be his peer, I hope. It's a drag being a fan. That unequal-footing feeling.

. . .

Went up to the Hippodrome to see the New York Dolls, now that Londoner Malcolm McLaren has got ahold of them. I've seen him hanging around CBGB in a sharp powder-blue teddy-boy suit. He dressed them up in red patent leather and hung some kind of Soviet banner behind them. Old wine in new bottles. Or is it the other way round? Anyhow, three of the five Dolls have pretty heavy smack habits. Not good.

I went out drinking with Richard Lloyd, and tottered home at two-thirty a.m. Crawled up into my loft bed and found a grumpy Mary Jane asleep there. In the morning she explained why she was grumpy.

"I went to bed about eleven. Your friend John Berendt started buzzing from downstairs very late, demanding to be let in, and I kept telling him you weren't here. He wouldn't take no for an answer, so I gave in, and buzzed the door. He arrived with this creepy-looking English guy with a very round head. They were both extremely drunk and demanded to know where you were. As if I know!"

"Who was the other guy?"

"How should I know? Just some riffraff Berendt had in tow. He was very rude. It was horrible." She went off to school in a huff. Then Berendt called.

"You really blew it last night."

"What did I do?"

"You know who I was with last night? Francis Bacon!"

"What?!"

"Yep. I went to his opening at the Met, we were introduced, and were getting along, drinking champagne, and he said, 'Let's get out of here and have some fun.' So we went to a bar I know, and he said, 'Don't you know any attractive, dissolute young painters?' So I said, 'Just one, but he'd be perfect. He's in the Village, let's go find him.' We found your unfriendly girlfriend instead. Where were you?!"

"Out drinking with a pal. How was I s'posed to know you were gonna show up with Francis Bacon?"

"Well, you blew it. He was a scream. That guy can drink like no one you ever seen! Called you a cunt! Chance in a lifetime." Then he rang off. How weird to think of Bacon standing in my slum kitchen. Well, maybe not, considering.

. . .

It's spring. The girls are flying low. I'm a poor stray cat and the world is my saucer of milk. I walk into Washington Square Park, stomping grounds of the Beat Generation twenty-five years ago. Now populated by troubled nutcases raving with anguish. Met my new pal Craig

288 · DUNCAN HANNAH

and we went up to the Met for the Bacon show. I liked his small self-portraits the best, but mostly find him tricky and pompous, with those big gold frames and decorator colors. I like the myth, though. Down to Knoedler for Hockney drawings. The colored-pencil drawings of his friends are gorgeous. And those spidery Rapidograph drawings as well. That guy can draw like a motherfucker. Then on to Antonioni's new film, a beautifully existential vacuum with the very delectable Maria Schneider. *The Passenger* was marred by the casting of Jack Nicholson, who is a creepy ham, and far too American. What about Jean-Louis Trintignant? Wouldn't he have been just right?

· · ·

Television say they've broken up. Verlaine (twenty-six) wants DuPrey on piano. Hell wants DuPrey on guitar. But he sticks with the Mumps out of loyalty. He's a bon homme.

Had a treat in my painting class. The model was the beautiful Annette, who slept with me and DuPrey on the same night last summer, when it was hot like the jungle. All the boys were going nuts over her reclining nude form on the stand. I painted away on that creamy form that I had carnal knowledge of. Her stomach leading to her thatch. She stared at me the whole time. At the break, she put on her kimono and came over to me, whispering about our past lives and stuff, her huge, unblinking eyes never veering from mine. So my fellow classmates' (and teacher's) jaws dropped at my obvious familiarity with this somnambulist goddess. My peer-group rating went *way* up among this oil-paint-spattered crowd.

· · ·

J. C. Suarès had been telling me to take my portfolio to the *Times*. I didn't think I was ready. He asked me to bring my collage books to class. He told the class to get to work, and told me to follow him.

"Where are we going?" I asked.

"Just shut up and follow me," he answered. Down eleven flights in the elevator. Into an uptown cab, to *The New York Times*. Up to the art department. Into Steve Heller's office (op-ed page).

Heller says, "Hi, J. C., what can I do for you?"

"Give this fucker a job."

Steve looks through my books and says, "Okay. Do you like opera?"

"Uh-huh," I lied.

"Okay, a horizontal spot, five columns wide, on opera for Friday at ten a.m. You can use our picture collection."

Let's see . . . fifty dollars a column . . . that's $250! "Great," I say. Then J. C. leads me down the hall to Ruth Ansel's office (she's art director for the *Sunday Magazine*).

"Hi, J. C. How can I help you today?"

"This is Duncan Hannah, I want you to give him a job."

She eyed me suspiciously and said, "Let's see what you've got." She flipped through the pages and said, "Okay . . . I've got a full page on an article about how they're teaching pop culture in colleges, called 'Pop-Eyed Professors.' How's that?" she said.

"Good!" (Another $250.) There was a spot that went with it. (Another $100.) So within the week I was in the *Times* twice, with my large-ish rubber-stamp signature there for all to see. And dispose of the next day in the trash bin. It was a very good start to my new occupation.

May Day, 1975

A new cascade of ink.

Manhattan, where it's always night, and they keep the lights on to prove it. Now in 3D! Words carved out of colored electricity. There's a guy in jail who's eatin' all the lightbulbs.

. . .

Yesterday Mary Jane and I were walking north on Fifth Avenue to school. I heard what sounded like a garage band playing "Brown Sugar." Loud! Outside! At ten-thirty in the morning? On a weekday? What is this? There was a small crowd in front of the Fifth Avenue Hotel on Tenth Street. We were on the east side of the street, looking at the back of a large flatbed truck. That's where the live music was coming from. From under the partition I could see rolled-up Levi's and Frye boots. I ran around to the front, maybe four people deep from the lip of the stage. It was the Stones themselves! They threw a press breakfast party for all the NYC journos inside Feathers restaurant, whose windows face Fifth. The scribes were reportedly pissed off that the Stones hadn't shown up at their own press party to promote their extensive summer tour, only to have them roll right up in front of them and begin to play. I caught the end of their first number, then they raced into the next. They looked appropriately scruffy in denim and worn leather, good shag haircuts, Mick's lips, etc. Their backdrop was a giant eagle with jet engines (drawn by one

of my favorite illustrators, the German Christian Piper). Then the skies broke, and the rain came down in earnest. Police cars began to arrive. The truck began to drive slowly off, a gaggle of kids racing behind it. I finally saw the Stones!

. . .

Been with Mary Jane ten months now. The air has a different flavor. Still talking as though you could tell each other everything you've ever done or seen or said or thought. Two hearts beat as one. She calls me "lamb." We're playing house in her nice one-bedroom apartment. Living in sin. We're on the fourth floor, looking south over green, leafy urban backyards. Just this side of paradise. I can hear someone typing away, punching out a chattering percussion like the machine guns in *All Quiet on the Western Front*. Mary Jane says, "Aren't I like a bowl of rice? All fluffy and flaky?" She grabbed the hem of her dress and pulled it over her head, leaving nothing on but the radio. "Let's get this bed on the road. What's the matter, have we run out of feathers?" Her mouth is like a pink flower. Time for beddy-bye. Mating on the mattress.

New Records
Slow Dazzle, John Cale
Let's Stick Together, Bryan Ferry
The End, Nico
A Wizard, a True Star, Todd Rundgren
Chet Baker Sings
Jack Johnson, Miles Davis
In the Wee Small Hours, Sinatra
Astrud Gilberto
Mickey One, Stan Getz
Metamorphosis, Rolling Stones
Fellini scores, Nino Rota

New Books

Scars on the Soul, Françoise Sagan
Astragal, Albertine Sarrazin
Kerouac, Ann Charters
James Dean: The Mutant King, David Dalton
Really the Blues, Mezz Mezzrow
Strangers on a Train, Patricia Highsmith
Tales of Beatnik Glory, Ed Sanders
Call Me Brick, Munroe Howard
The Romance of Lust, Anonymous
The Rachel Papers, Martin Amis
Stranger in Paris, Somerset Maugham
The Postman Always Rings Twice, James M. Cain
French Tales of Love and Passion, Guy de Maupassant
Modigliani, Pierre Sichel

New Movies

A Streetcar Named Desire
Le Samouraï
Flic Story
The Passenger
Just a Gigolo
Chinatown
Farewell, My Lovely
Superfly
Swept Away
Caged Heat
Dog Day Afternoon

· · ·

I read a lot of spy books, hoping that I'll miraculously wake up a secret agent!

So I am no longer a student. I'm a bachelor of the arts. They gave me a gold medal in the graduate show for my piece *Peter Lorre*.

David McDermott presented a one-man show of my work in his Salon d'Art Société. It was really only the opening, lasted two hours, then the show came down the next day. But he went to a great deal of trouble, which consisted of him framing my collages on Masonite boards that he had wallpapered with a beige-and-green floral print, also buying me a used tuxedo and having it fitted by an old tailor in Jersey City. He ordered engraved invitations. Cases of champagne. He's all about presentation. Don't think he cares for my artworks at all. But he does care about me. I was feeling bad about the expense, feeling beholden to him, so gingerly asked where he was getting the money.

"Have you heard of the Chase Manhattan Bank?" he asked.

"Yes, of course."

"Well, my father is the president." I was surprised and relieved to hear this. (Shortly after, I found this to be completely untrue, David had no father, and he worked as a messenger boy.)



HANNAH OPENING

LE SALON D'ART SOCIETE

Request the pleasure of your company
for the inspection of the works of

MR. DUNCAN RATHBONE HANNAH
Painter of Pictures

On Saturday 17 May 1952 ___1975___
From six to eight o'clock in the evening

David Walter McDermott
9 West 82nd Street
and Central Park West
City of New York



. . .

Eric Emerson was killed by a hit-and-run driver. What a way to go. I shall miss his puckish presence. No more yodeling. No more nothing. Everyone was mourning his passing at the party I went to at the old Factory on the west side of Union Square (now the Factory is on the north side, just above Rizzoli's, sometimes you can see Andy with his back to the window), currently inhabited by Viva's husband, Michel Auder, and Anton Perich, who one sees everywhere. This is the place where trigger-happy Valerie Solanas shot Andy. Creepy. They used to shoot laser beams from up here across the park into Max's. Someone greets me with "If it ain't Dixie Dunc, the man with the plan to stick you in the can." Huh? I watch a girl with Edwardian hair and science-fiction breasts. I feel the party's force fields, currents of strength, currents of weakness. "The love that dare not speak its name" just won't shut up these days. Gayness has lost its underground status in NYC and is busy becoming the dominant sensibility. Lots of affectation. Sad when things turn to parody.

· · ·

Kurt has arrived from Minneapolis, and is currently crashing on the single bed in the studio/living room. He's singing a little ditty that goes "Transfusion, confusion / Never never gonna speed again / Put a gallon in me, Allen / Shoot the juice to me, Bruce." We have been partaking of alcohol and tobacco. We adopted a female cat named James Bond. She biffs me on the chin.

Kurt and I have a new hangout, the 55, just off Sheridan Square. They say the Lion's Head is for writers with drinking problems, and next door at the 55 it's for drinkers with writing problems. Great jazz jukebox. Paul Desmond's "Lady in Cement" a particular favorite. Kurt's writing a book (he says) called *I Sailed to Tahiti with an All-Girl Crew*. Or maybe *The Crazy Cunt of a Lazy Wife*. He is in the throes of Bukowski worship currently. Kinda shows. Also Nelson Algren and Tennessee Williams.

298 · DUNCAN HANNAH

. . .

Saw Melville's *Le Samouraï* last night. Bliss. The confetti-colored signs of Paris that read "Orangina," "Gelletta Molta," "D'accord." The gleaming subtitles changing formation. There's our hero, the calm and deliberate contract killer, arms swinging loosely at his side. The wounded wolf of Paris, Alain Delon. He says, "I never talk to men holding guns."

"Who are you?"

"Who cares."

"Then what do you want?"

"To kill you."

. . .

Being flaneurs, Kurt and I take a walk without a fixed destination. It was a fine Parisian evening (in New York). Gauloises and garlic sat lightly in the air, cars and people were moving with subdued hysteria. The sky pale as though drained of blood. The young NYU girls wore loose cotton dresses with little makeup and fastened their hair with elastic bands. We head east where dead motor cars are parked under trees. Yellow doorways were full of painted whores arguing with workingmen. One leggy fifteen-year-old black girl says, "Going out tonight, boys?"

"No thanks."

"Why not?!?" she screams back.

I turn to Kurt and say, "Kurt, I think she liked you . . . And you've been complaining of your minimal female companionship this summer . . ."

He laughs and says, "No scratch for her snatch."

. . .

People who buy modern paintings are very often more interested in gaining admittance to the world of young artists than they are in the piece in question. Confidence is the essential prop. Confidence is alluring. Finding no nucleus with which to cling, we become a small nucleus ourselves. Gradually we fit our disruptive personalities into the contemporary New York scene.

· · ·

The sun is trying to make me feel guilty about being indoors. I like being indoors. I put rum in my coffee to kill the bugs. "The doctor said I should take a drink every 15 minutes," I heard someone say. The city is inevitably linked with Bacchic diversions. I'm caught in the tempo. I'm compelled to live in downtown's disordered mind. Young people wear out early here. Frayed nerves are strewn everywhere. My heart makes a dizzy tour of my chest.

I'm riding in a yellow cab between very tall buildings under a mauve sky. Radios blare in the street. Headlines say "A Baby Kills a Gangster." Image and language cover the city like an enormous comic book. Past billboards, Korean delicatessens, Chinese laundries, green neon florists, and cramped tailor shops. One big whoosh of modern commerce.

CBGB. With the cool four hundred. This smelly room teems with cliques, coteries, and circles. Many clones of the Ramones. The Ramones themselves playing pool in the back. Fox terriers in skirts on the make. Look who it is! That waif in a grubby black suit, black silk shirt, chopped black hair, cute as a bug's ear . . . It's Patti. We talk about Schiele at the bar. She likes anyone with a St. Sebastian complex. She loves martyrs. Early deaths. She tells me about how she had to let Mapplethorpe go when his passion for men overrode his love for her. "I mean, like, what ya gonna do, right? You gotta let 'em go." The jukebox is playing Bowie's

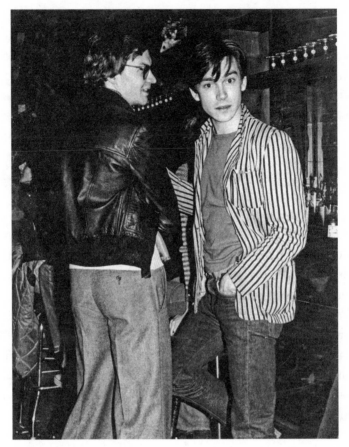

Craig Gholson and DH at CBGB

"We Are the Dead" with that great line, "I love you in your fuck-me pumps."

I ask Mary Jane if she wants to go see the new Rohmer movie. "No thanks, I saw one once, it was like watching paint dry." It's true, it's all dialogue. The least visual of the New Wave. Speaking of which, I thought I saw Belmondo down by the gay pier. Smoked like him, squinted like him, smiled those huge sun-baked wrinkly smiles, picked tobacco off his tongue, but it wasn't him. I knew from *Wom-*

en's Wear Daily that Belmondo was in town, but what would he be doing down at the piers? What would I, for that matter?

. . .

I went to a party at Larry Rivers's loft, thrown by his son Steve, nice guy who saw the world in the Navy. Now he works in TV production. Goes out with one of those Detroit girls. The guests were chattering in the kitchen. They're listening to Motown. This was the scene of the Roxy party one year ago. This time I was free to wander around, half a city-block length given over to Larry's studio, as big as an aircraft hangar. He's saved some of his most famous pieces. In the racks I saw *Me and My Shadow, Lampman Loves It, Don't Slip*, a Gauloises pack, even his nude portrait of Frank O'Hara in construction boots. The holy grail. The space was covered with his photos, stencils stapled to the wall, assemblages, constructions, collages, light sculptures, littering the place like he didn't give a shit about them. I'm in awe. Alone in this cathedral. Will I ever have a working situation like this? What a setup! What a funny guy! What a dynamo!

. . .

I heard through the grapevine that my old acid buddy, Tommy Haskell, got out of the asylum in South Dakota his dad had thrown him into (electroshock therapy) and got hit in the face by the side mirror of a Mack truck three days later, while he was stumbling along the side of the road. It's just one thing after another with that guy. One time he drank a bottle of glue. Can't catch a break. Walking disaster area. He's the first of our gang to bottom out. Why him?

Positively Seventh Avenue

Mary Jane comes home from work, says, "What have you been doing all day, Mr. Smart?"

"I was just reading an eviction notice from the landlord. It seems they didn't care for our last party."

We go to dinner at Pete's Tavern on University Place. It says on the wall, "Big City of Razzle-Dazzle, Little Old Baghdad-on-the-Subway." I assume that's by O. Henry, since this was his watering hole. We assess the 1970s so far. What are they? Conservative? Bored? Stylized? Unstable?

Last night I was standing on Bowery and Bleecker talking to Patti, she was wearing an old paisley shirt, her hair glinting blue in the street lamps. She was horsing around like she owned the whole street. Photographs of Eric Li's Marbles and Television were slathered on the white exterior wall of CBGB. The dull roar of electric guitars leaks through the doors. David Godlis was taking pictures of Patti. She had just rescued a little runt of a black kitten from a murderous dog, and she was holding it up by the scruff of its neck, presenting its tiny white paws. She said, "Hey, Duncan, why don't you adopt this little guy, I would, but I already got a couple. He's funny-looking. I like him." Which he was (asymmetrical white blotch on his nose), so I accepted, and named him Nick Charles on the spot. Lucky guy moved to Chelsea that night. He was most grateful.

. . .

Being high, living low, staying young. Had a little party for the newlywed Kramers, who have just moved to the city. Mary Jane and I snorted PCP (horse tranquilizer), and in five minutes the world was bathed in a fine emotional haze. I felt like kind of a bright insect. Content with my coma, we took the party out for a nocturnal walk, through narrow winding streets, the buildings leaning in on us like *The Cabinet of Dr. Caligari*. We were coated with soot and sweat in the sweltering summer heat, listening to the baying hounds of bohemia. My heart ricochets around my ribcage.

August 10, 1975

Parents are in town, staying at the Waldorf. They came over on Saturday morning, carrying bags of fresh groceries from Jefferson Market. That'll help stave off scurvy. Also gave us a Waring blender. They like Mary Jane, because she's a "good girl," a stabilizing influence on me. They liked the apartment, the living room freshly wallpapered in handsome stripes by David McDermott. We had dinner at L'Escargot and a stinger in the Rainbow Room. Dad told brief, precise jokes, as only a lawyer can, and then Mom would retell it, only ten times slower, with lots of slurred stuttering, ruining whatever subtleties there might have been.

Dad said he'd had twenty-two years of trouble from me. He amends that, says I was a good kid until I had friends who were old enough to drive. I thanked him for taking me on trips to Europe at a young age (ten and fourteen). Thanked him for the good schooling. But then asked for help. I'm broke. Dad emphasized that (1) I'm *not* a rich kid, and that (2) they're *not* rich! There's no big inheritance coming to me. So after a lengthy interrogation, Dad decided to bail me out of my financial doldrums until the work starts coming in. A small allowance to cover expenses, for a *limited* time! He was emphatic about that. An unwilling (though kindly) patron of the arts! Whew.

Bloomingdale's Incident

Kurt and I go uptown cuz he needs new horn-rims. Bloomie's. First we go to the men's room cuz he's gotta lay a cable. He disappeared into a stall, and I stepped up to a porcelain trough, wedged between two gentlemen. I pulled out my willy and waited for the pee to shoot out the end. I sensed the man next to me wasn't pissing at all. I rolled my eyes to the side and, through my dark glasses, saw that

he had an enormous erection, and he was stroking it slowly with his thumb and forefinger. Skin stretched taut like a sausage. I looked up at his face, he being quite a bit taller. He wasn't staring at me but at a spot in the middle of the tiled floor. His face was red, his eyes bugged, his teeth clenched, the veins on his forehead clearly outlined. I looked behind me. Leaning against the stalls, maybe the exact same one Kurt was pooping in, was a foreign-looking man, his arms crossed over his brown summer suit. He seemed aware of what was going on. Was he waiting for the wanker to leave, or was this skit staged in his honor? What a strange little vignette. The wanker stepped backwards and to the side so that he was even more noticeable. I gave up any thoughts of pissing myself, zipped up, and went over to the sink to wash my hands. I took a final glance at the two of 'em and left. I waited outside for Kurt, feeling half nause-ated, half excited. Kurt appeared.

"Did you see those guys in there?"

"What guys?"

I gave him a brief description of the toilet-trade drama and urged him to have a look for himself. He declined. So we went down to the lingerie department to look at the girls. Maybe those two fellas are still up there.

. . .

I often go over to Columbia dropout Craig Gholson's air-conditioned apartment on Horatio Street to read. We actually read together. He wrote a poem about me called "The Boy Who Wanted to Go to Paris." We have matching penny loafers, God's most perfect footwear. We also have matching thirsts. He's good about freshening your drink. Craig described Mary Jane as Ophelia. She sleeps a lot. She cries a lot. I give her a lot of guff. She and I go to Times Square to see *Fare-well, My Lovely*, with the great Robert Mitchum as Philip Marlowe.

Charlotte Rampling as the sultry sex bomb, shimmering in the Technicolor LA twilight. Moose Malloy just wants his Velma.

· · ·

Kurt and I traveled up to David McDermott's for a visit. David sang opera for us in his screechy Irish tenor. He served Jack Daniel's. We sat amidst the stuffed ducks, squirrels, and other rodents, whose glass eyes followed us around. Very Norman Bates. David is gay and lovelorn, thinks he is unattractive, so sets his sights low. He tried to summon Abraham Lincoln with his time-traveling experiments. Always a surefire seduction ploy.

Two a.m. We took the A train home to West Fourth, up the subway steps past Cube Steak House, and walked north on Sixth Avenue. A large crowd was gathered around O. Henry's. Kurt wondered what was going on. "Probably just a murder," I said. We squeezed through gawkers to the yellow crime-scene tape that kept the people back. Several cops were milling around; two were carrying a covered-up stretcher into a morgue wagon. We saw a gigantic pool of bright crimson being blotted up by an already saturated sheet. We read in the tabloids the next day that a twenty-eight-year-old "laborer" stabbed a transvestite to death after a brief argument. The wounded tranny stumbled across the avenue and crumpled to the sidewalk in front of O. Henry's. This is why they call NYC Fear City. Very Weegee.

· · ·

I go visit DuPrey in his fifth-floor spartan flat on MacDougal Street. It's painted ivory. He's got porno playing cards pinned up, that say "Play with Me." DuPrey says he wants to join the CIA because it's the last frontier. He's just read about "the hidden persuaders." He says that the word "fuck" is subtly inscribed on every *Playboy* centerfold. Do masturbators really need that suggestion? I thought "fuck" was

Rob DuPrey in Chelsea apartment

rather the point in the first place. He smokes pot and slumps on his couch, looking disheveled in a sweatshirt and thin-wale corduroys, eyes hidden by shiny black bangs. Pot doesn't seem to relax anybody anymore, just makes us self-conscious. We're a pretty jumpy crew anyhow. I bite my nails.

August 22. Now I really went and did it. I turned twenty-three! What a sap! I was reading an article about Warhol in the *Voice* when Craig came over, blindfolded me, put me in a cab, drove to Lafayette Street, led me upstairs to Lady Astor's (I could recognize the Duke Ellington music). Blindfold ripped off, and there's a crowd singing, "For he's a jolly good fellow." They laughed at my embarrassment. There was a devil's food cake that said "DH 23" on it. There was a gun and a pair of dark glasses stenciled on the brown frosting. Kurt gave me an expensive book on Egon Schiele's portraits that he stole from the

Strand. Mary Jane gave me a beautiful silver ID bracelet that said "James Dean" on one side, and "Mary Jane" on another. Craig gave me the new Dean biography by David Dalton. The assembled group gave me a Mr. Coffee machine, because I am . . . Mr. Coffee. I was chuffed to see that Shelly's date was Larry Rivers, who wished me a very happy birthday, with a big, warm smile. My hero! McDermott was dressed in a tailcoat. I felt the love.

September 6

Chelsea domestic scene. Listening to Astrud Gilberto. Kurt's reading Thurber, Nick is high on catnip and laid out on the leopard chair, cat-on-cat. Nick is featured on the back page of the September issue of the *Trans-Oceanic Trouser Press*, being held up by Arista recording artist Patti Smith in front of CBGB. Buy this magazine or we'll kill this cat! Nick's got street cred. He is quite literally a Bowery Boy. He loves to root through the garbage, just like dem bums do. I love my little kitty, his coat is so warm, and if I never hurt him, he'll do me no harm, that's what cats are made for, that's what cats are paid for . . .

Kurt and I been drinkin' in old men's bars. Five Brothers for quarter beers, and Uro's on Sixth. One night I was at the 55 with Craig, listening to Coltrane's "It Never Entered My Mind" on the juke. A guy next to us said, "I couldn't help but overhear what you guys were saying about what friends should be. Let me give you a bit of advice. You can give your best friend anything, your money, your girl, anything but your hat!"

"Huh? Whaddya mean?" I asked.

"Well, lemme tell ya a little story. I had this hat once, and my best friend asked to borrow it. He said he was going off to England, and he was really gonna need my hat. Told me not to worry, he would promise to give it back. So I said, 'Well, I guess so, just be sure you return it, because that's my hat!' About a month later I saw my friend

on the street, back from England, wearing my hat. I didn't approach him, cuz I was gonna see him later that night for dinner at my place."

Craig and I were rapt. The guy went on. "So I says to him, 'How's old England doin'?' And he says, 'Aw, really swell!' so I go, 'Say, can I have my hat back then?' and my friend said, 'Oh god, I'm afraid I've got some bad news for you, buddy. I accidentally left it in England. I'm so sorry.' So I know my friend's got my hat the whole time. I saw it on his head that very day! See what I mean? If you got a hat you know what it's like."

I mulled this over. "Boy, that's rough. I got a nice one too. What kinda hat was it anyway?" picturing a vintage Borsalino, or a dapper panama, or maybe even a perfect tweed newsboy number.

"Aw, it was just a dumb old ball cap . . . a red ball cap. But it was *my hat*, for chrissakes!"

End of story. So many questions! What was a New York barfly doing in England in the first place? It was like talking to Gogol.

Richard Merkin

Yesterday David McDermott took me over to Richard Merkin's apartment on Eighty-fourth and West End Avenue. Three p.m. David calls him "Buddy Business" because he's so good at making a living. A merkin is a pubic wig, of course. Sprawling, cluttered prewar pad, his studio in the living room, where he was working on a very large panel with his charcoals and his gouache. He was dressed in shorts and a striped French sailor's jersey, just like a real artist. He cordially offered me coffee and a Turkish cigarette with "Krazy Kat" printed on the paper. "I have them made for me," he explained. We talked for three hours. He spent a summer in London living with pop artist Joe Tilson and becoming close to Peter Blake and Ron Kitaj, which influenced him radically. Now he shows at the very chic Dintenfass Gallery and teaches at RISD. His paintings go for about two grand and have

words sprinkled throughout them. So interesting and intelligent and bawdy. He showed me bits of his extensive erotica collection. Some framed and hanging for all the world to see. He was listening to British crooner Al Bowlly, and we discussed jazz and lyricists and William Seabrook and Burroughs and Richard Lindner and on and on. I'd brought my summer workbook to show him and gave him a collage which had a shard of Day-Glo pink nylon, a Clark bar wrapper, a photo of a dime, and a remnant of graph paper. He suggested I produce large paintings and distort my drawings more than I do. He gave me some flyers and a poster of him sitting in the Coney Island Wax Museum reading the paper with a bowler hat on, sitting next to the fifties London serial killer Christie as he chopped up a victim in the bathtub. Photo by Deborah Turbeville. I couldn't take it all in . . . it was heaven. There were Mickey Mouse dolls, Carl Van Vechten and Walker Evans photos, Big Little Books, art deco furniture, Charlie Chaplin posters, cigarette billboards, and racks of custom-made "pimp shoes." He told me he'd once been written up in *Time* magazine *just* for painting Alvin Karpis, the thirties gangster. "Those were the days," he said with a twinkle in his eye. He told me about going to a prizefight in evening dress with Jean-Paul Goude. When he came home, he had the red blood of the champion on the bosom of his boiled white shirt. I was most impressed. This Merkin character is the mother lode!

September 11. It's autumn in New York. On the wagon. Went to a party for Andy's new book, *The Philosophy of Andy Warhol*, at Leo Castelli's downtown gallery. I drank ginger ale. Makos introduced me to David Hockney, who looked great, with jutting chin and motorist's cap pulled low over his round glasses. I asked about his possible show at the Met (it's off, people won't lend works), his trip to Alexandria, his crazy dad who wears two watches, both broken, and his love for Fire Island ("I went for three days and stayed three weeks"). Then

some strapping homosexuals whisked him away from me. Also there was Kenzo, luminescent model Sarah Kapp, Mapplethorpe, Richard Bernstein, Florinda Bolkan, Jane Forth, the Louds, Ronnie Cutrone (who makes Andy's paintings), Henry Geldzahler, Taylor Mead, Leo Castelli with his Dalmatian dog, and Andy himself, blinking and smiling that awkward smile. Hundreds of models who all looked the same. The idle rich, and out for kicks. The hip intelligentsia. The cult heroes. The select few. The tastemakers. The ghosts from the past. The weirdos. The latest things. I left.

McDermott had a sixties theme party. Craig dressed in a kaftan, short hair parted in the middle, as though he was waiting for it to get long but his mom wouldn't let him. Blue jeans and sandals, love beads, and a copy of *Siddhartha* prominently clamped under his arm. We talked about the big summer story of the twin gynecologists, the Marcus brothers. *NY Post* headline said "Twin Docs Found Dead in Posh Pad." A bizarre story: one died of barbiturate withdrawal, the other lay down next to his twin and just . . . died. A neighbor recognized the smell "because I'd been in Korea." And they look exactly like the Everly Brothers! Hence, I am doing a double portrait of them, oil on canvas. Anyhow, I got plastered and the devil got his money's worth that night.

Kurt and I were watching the capture of Patty Hearst on TV. Brand new Minneapolis transplant Crosby comes over, looking like a mad scientist from an Edgar Allan Poe story. He's bubbling over with excitement about NYC, like a child who's found a hiding space that no one else knows about. He asked us if we had noticed that parts of the city are very pretty. Yes, we had. He asked us if we had noticed there were a lot of homosexuals here. Yes, we had. He asked if we had noticed that many of them wear beards. "Yes," we laughed, pointing at his beard. Crosby says "native New Yorker" like it's a Fulbright scholar or something. Any dumb cluck can park his butt in Sheridan Square, but to pee right in the middle of it, because you know it's okay, that's something else again. The street giveth, and the street taketh away.

: The Sacred + the Profane :

Fall 1975

Manhattan

Duncan Hannah

Fall 1975

What is that beat? It is myself. I'm pacing between the bedroom, the bathroom, the hall, the kitchen, the living room, navigating its length like a caged animal. I move things around, I empty ashtrays. Cognac pounding behind my eyes, behind my ears. One could get struck down at any moment. I write to seek redemption. To try to get a handle on things. To slow down the maximum speed of things.

A guy on the street pointed a plastic pistol at me. I went down automatically. Get out of here, kid, and fast! I slip through the street, following a girl with a big mop of hair, thinking about the breasts that are concealed by her navy sweater. A pain stabbed my heart at the thought of this girl who I did not know. Would never know. The world is too damn big. Excess of zeal.

I go down to Pearl Paint with Crosby. He's studying Old Master techniques at the Art Students League. He likes to say "Bend over, Luke, so's I kin rim ya" in a hillbilly accent. I bought seventy dollars' worth of supplies. Long taffy folds of Belgian linen. Cans of dangerous sprays. Charcoal. I also wanted the girl selling compasses on the fourth floor. Felt the prick of sexual desire. It's called "satyriasis." I'm low, loose, and full of juice. We trudged back and watched *The Third Man*, digging the zither music, marveling at Joseph Cotten's character, western writer Holly Martins. Loved Trevor Howard's duffle coat. The cockeyed angles.

I finished my *Twin Gynecologists* painting. Overtones of Schiele in

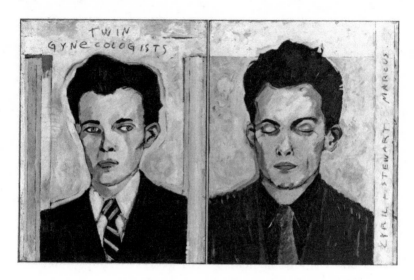

it. (I practice drawing like Egon all the time.) Wrote a little tune to go with it. To be sung to the *Patty Duke Show* theme.

> *But they're doctors, identical doctors,*
> *And you'll find,*
> *They walk alike, they talk alike,*
> *At times they even die alike,*
> *You will lose your mind,*
> *With twin doctors,*
> *Who are two of a kind.*

I did another new painting called *My Manhattan*. It's a tall, thin canvas of a map of NYC featuring my haunts, the Strand, the 55, CBGB, etc., using stencils. I was so excited about it that I fell off the wagon. Crash! Nick had a little Kahlua-and-milk with me on top of his catnip buzz, and fell off the desk and broke his tail. Now it looks like a crank. Acting like the Bowery bum he is. Nothing like loving a sweet, dumb, comic animal. He's better than the neurotic schnauzer

I had as a kid, and better than Nancy, his predecessor, who split this scene via the fire escape. She was very disapproving of the goings-on around here. She wanted some nice old lady.

. . .

I'm meant to be taking my portfolio around, but I loathe rejection (who doesn't?). I took it to *Penthouse*. They said it was "fun." No job. I'm just stalling for time, stalling for breath. I'm a person of promise living among other persons of promise. I'm crazy for knowledge. I play the fool. There's so much I don't know. Don't ask me.

Kristian and I crashed the preview of the new David Essex movie, *Stardust*, about the perils of being a pop star. It's a sequel to *That'll Be the Day*, which was excellent. This one was depressing. Marbles manager Alan Betrock got me into the press party, on the forty-fifth floor of the Time & Life Building. The theme was "All the Fun at the Fair," so there was a carnival setup with junk food to grow pimples with. I was more interested in the open bar. Eric and I secured a couple Scotch-and-sodas and started circulating. We spotted the bygone glitter stompers Slade, whose single "Cum On Feel the Noize" we'd delighted in as youths. We saw the great Roger McGuinn of the Byrds, who wrote some of my favorite songs ever. We chatted with Leee Childers and Danny Fields, who reproached me for being drunk already (only 9:15). Eric had to go, but I stayed on, in the grip of free drinks. I had four more, sitting alone at the window, looking out at the shiny steel and glass below. The PA system boomed the Ronettes, and the TV broadcast the remaining inning of the World Series. I went back to sit at the bar, and was joined by Steven Tyler of Aerosmith, whose hit "Dream On" can be heard everywhere. I eavesdropped on him, was surprised at how stupid he seemed. I'd had enough. I was bored. I passed David Essex in the hall and said "Rock on!" (the title of his hit single). He laughed. Down the elevator, down to the Village, down to Craig's apartment, down to Reno Swee-

ney for unneeded nightcaps, and finally wobbled home. Completely stewed.

Crawled into bed at two a.m. Fell asleep immediately. At three-thirty I got up to pee, and being too lazy to go the extra steps to the bathroom, I went to the bedroom window, which I assumed was open (it wasn't). So I pulled out my cock and began to whiz. It ricocheted all over, which woke Mary Jane up. She tried to stop me. I pulled the venetian blinds over my head and kept peeing strong. *Splash splash.* Mary Jane was yelling at me, so, sensing disharmony, I punched out the window. *Biff bam boom.* I finished my pee through the broken window and crawled back to bed. Mary Jane is crying, because her boyfriend is crazy and stupid and a jerk. After a bit she gets back into bed, only to find it wet! He's peed in the bed too? No, it's sticky. Smells like salt! Red corpuscles! She turned on the light. EEK! Blood everywhere! She gets up. I've got a gouge on the inside of my wrist that's gushing. An artery? She drags me into the bathroom, puts my arm up under cold water, waiting for the blood to start to clot. Puts a tourniquet on me. She looks at my face. I'm not there. I begin babbling some noir dialogue: "Hah! Your pretty face won't look so good once the boys are through . . . But I'm smart, see? Those big shots think they got me . . . but I'll get them first . . . see? Get the picture?"

Mary Jane has stopped the bleeding and leads me back to bed. She blots the blood with a towel, and sits up crying.

Next morning I crack open one eye and viddy the gore. I have no recall. I say, "What happened here? Did I try to kill myself or something?"

She says in exasperation, "I don't know what you tried to do." She's filled with horror. She's looking at me funny. She leaves for work after leaving a big note on the refrigerator door that says, "Don't Drink!"

The landlord came a-knocking to see what happened in the middle of the night. I told her a hatstand had toppled over and broke the window, while Kurt hurriedly balled up a bloody sheet so that she

couldn't see. The landlord was very suspicious, but said she'd send the super up to replace the glass just the same. Kurt and I walked down to Fulton Street to have lunch at Sweets, oyster stew and fresh broiled sea bass, musing over the perverse fictions my mind travels in. The fresh air of the South Street Seaport did me good.

. . .

A mob of us went down to a new disco (Ones) at 111 Hudson Street. We all got bombed and danced till four in the morning. I was kissing all my friends, boys and girls alike (as I tend to do when I'm in my cups) and wound up slow-dancing with a nutty girl named Judy, which was pretty exciting, her alien body rubbing close to my hard-on. Swaying on our pegs. Smoothing her shy breasts. She planted a big fizzy kiss in my mouth. "Cute as lace pants," as Raymond Chandler says. Yow! Anyhow, Crosby was sulking and gloomy, seemingly plagued by demons, and ran miles and miles in the rain, holding a lead pipe and smashing car windows. It's a bad week for windows, it's all-out war!

. . .

Go to a party at Chris Makos's. It's filled with the fringe people that New York so warmly welcomes. Cynical Dotson Rader arrives very drunk. Kisses everyone. He says, "I hear you are unmakeable . . . a virgin." Very disapproving. When he leaves I say, "Catch ya later, Dot."

Kurt and I go over to Crosby's new loft on Eighteenth and Broadway. He's got a couple of dopey roommates, Steve and his girlfriend Kris, who once remarked, "I love the way my tits smell in the morning." I pointed at a tailor's dummy standing in the middle of the rough floor and said, "I wonder where Kris got that?" Kurt replied, deadpan, "She cloned."

Halloween party. Lance wore a Groucho nose and played Nino

Rota records. Parsons girl T.F. came as the Crimson Princess, in a transparent blouse, so in vogue these days. I have an eye for detail, especially where nipples are concerned. McDermott was dressed as a Bloomingdale's girl called Robin. He was fun until he had too many screwdrivers, became falling-down drunk, lurching, spilling, ricocheting around. I aimed him at the bed the coats were on. He was out cold. Later he slithered to the floor, where he vomited on himself, his wig, my portfolio, the carpet, everything. Crosby passed out next to him. They made a cute couple. I answered the door somewhere during the night and faced two of our "men in blue." Uh-oh. I'm stinko. The Everly Brothers are blaring "(Till) I Kissed You." They said someone had called the police because a fight had broken out in the hall. "No problems here. Don't know anything about it," I said meekly. They were nice, maybe daunted by my full-dress tails.

In the morning my teeth were chattering due to my toxic content. Felt lousy. So I took an hour-long shower, hoping to steam out my cobwebs. The downstairs neighbor appeared at the door, in a hysterical state, I had somehow flooded her apartment due to my negligence. I set about mopping up my rain-forest bathroom, throwing on towels, pajamas, submarines, deep sea divers, destroyers, any old thing. Then the Spanish superintendent came up (a Jehovah's Witness) in a rage, eyeing the litter of dirty glasses and empty booze bottles with disbelief, a degeneracy beyond his imagination. He ordered Kurt to come downstairs and mop up the poor lady's apartment. The building was alive with discontent at my misbehavior.

After we did what we could to appease the unhappy residents, we scrammed to the White Horse on Hudson, where Dylan Thomas had his last whiskeys. His last words before lapsing into an alcoholic coma were "I've had eighteen straight whiskeys, I think that's the record." It was a long day. Later that evening I ran into my old girlfriend from Georgetown, the beautiful Genowefa, who threw me

over for Eno. She was with a new boyfriend, and they were wearing matching jodhpurs, which set me off for some reason, and I started growling and barking at them. I went all feral. She asked Craig to take good care of me.

· · ·

I have a new friend named John Meaney who I met at Carnegie Hall Cinema. He's a twenty-eight-year-old film director who wants me to star in a production of *Dorian Gray* he is planning. He looks like a cross between Howdy Doody and Dirk Bogarde. We rendezvous at the 55 and listen to Sinatra's "Angel Eyes." I love the sad atmosphere in there. Lost in time. I ask Jimmy, the black bartender, for a Johnnie Walker Red, and he fills a cocktail glass up to the top, for $1.35! Scotsman's dream, in more ways than one. There's a thirty-pound bar cat there called Crazy. A big sign outside says NO DANCING! I like that. I start to nod out, and Jimmy says, "Hey, you can't sleep here, this ain't no boarding house!" We say bye to Crazy and leave.

November 13

Lunch with Kurt at Umberto's Clam House, where Joey Gallo got shot back in 1972. Doesn't look like a gangland kind of place. We gobbled down some fried cunts chased by Pepsi on ice. We talked about moving to Paris, being wild expats, making that existentialist scene. I went home and started stretching a canvas as I listened to *Come Out* by Steve Reich, an interesting, monotonous modern sound collage. I walked into the bedroom and saw Mary Jane peeking through the slats of the venetian blinds, so I started singing "Peek-a-peek, peek-a-peek." She turned around, and her face was streaked with tears. She was sobbing. "What's the matter?" I said.

"This record is driving me crazy." So I turned it off. Quite a tribute to the artist.

. . .

Friday night at CBGB. Freezing out. I got paid ten dollars for doing the pseudo–Larry Rivers Marbles flyer. Marbles are on tonight and played "Him or Me" by Paul Revere and the Raiders. Howard Bowler had a beautiful new cherry-red twelve-string Rickenbacker that he used to great effect. Eric looked real sexy and Chinese. DuPrey was heavy-lidded due to all the hemp he smoked. "Boy, you really look like a worm lately," he told me. What's *that* supposed to mean? Redheaded actress Lisa Persky was wearing some kinda kinky S&M getup, with cock rings, black boots, etc. I'm going to play her husband in an upcoming film production of Maupassant's "Elaine, a Story of Lost Love." Someone's complaining about the social diseases that Richard Hell has been spreading as he cuts a swath through the female rock 'n' roll contingent. Word has it that he's got a twenty-five-dollar-a-day junk habit now. I was asking Marbles drummer Dave Bowler about that girl Judy that I slow-danced with at the disco that night a couple weeks ago. He said she was a fashion wholesaler, an uptown girl, not an easy lay, and, yes, she did look like young Shirley MacLaine. I asked him what she wanted out of life, and he pondered this for a moment, and then said, "Shoes."

I went up to Atlantic Records with my portfolio to show Paula Chwast, Seymour's wife. She was nice. When I unzipped it on her desk, three cockroaches dashed out. She shrieked. I said, "Sorry." She went through carefully, said it was the sloppiest portfolio she had ever seen. "I like that, but you may have gone a bit overboard. I like that your collages are on such shitty paper." She went on to call my work magnificent and amazing, but I will have trouble with art directors taking a risk with me, because of the recession. She said there had been much talk about my *Times* pieces last spring, but no one dared use me again because my work seemed personal, not literal or

universal. While I was jotting down her suggestions, my Pelikan 120 exploded in my hand, showering sepia ink everywhere. I held up my paws for her to see, and said, "Do you have a Kleenex?" She shook her head and said "God, you're too much!" We both laughed.

November 24, 1975

Home sick with the flu. ConEd is after me for the forty-two dollars I owe them from last June. My bank account is overdrawn. But, *New York* magazine came out today with my illustration of Paul Simon ($100). And, I'm reading a huge biography of Modigliani that is incredibly inspirational. I identify with him in a big way, which is both good and bad. At twenty-three, he was already a wreck, sitting slack and stupefied in an artificial paradise of alcohol and hashish, living badly but working calmly. Careless, reckless, childish, prickly, uproarious, frenzied, undomesticated, rooted in unreality with the rest of the damned, resilient enough to rebound, a sensitivity brought to the breaking point, living on nerve alone, then not living at all.

. . .

Kurt and I saw *Eclipse* at a Fifth Avenue cinema. Antonioni begins with spare imagery, a fan blowing Monica Vitti's hair, lawn sprinklers, geometric landscapes, and the contemporary wastelands of Rome. She dresses up like an African tribal dancer and swivels her sarong to the beat-beat-beat of the tom-tom, the boom-boom of the drum. She meets sharp twenty-five-year-old stockbroker with sports-car eyes, Alain Delon, who's obsessed with buy and sell. "The beast is calling for me, I'll see you tonight." She's a vulnerable Madonna of true love, he's a money-grubbing swinger. In the inevitable seduction scene, Delon is following her through an Old World apartment, brutally rips her white satin dress. She picks up one of those pens with

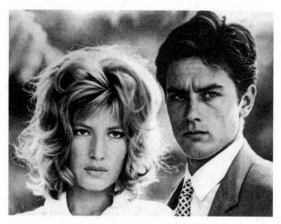

Monica Vitti and Alain Delon in Eclipse

a Petty Girl in a one-piece bathing suit, and when she turns it upside down, the suit disappears and there's the same girl, front and back, in the nude. Delon is clumsy and confused by this ethereal beauty who is worlds away from him. The theater is silent except for the ticking of my watch. Delon dramatically pushes her onto the bed, holds his hand over her breast for a full forty-five seconds. He raised a brow over his bedroom eyes, five, four, three, two, one, contact. They consummate their tense attraction. Vitti finds she has actually fallen in love with this shallow creep, but her love is a faith healer, which pulls the ground from under his feet. He is in unknown territory, the land of love. Finding out that they can't part for even a moment without feeling totally lost. They didn't know what they were getting in for. They go over the scenes of how they first began, which take on an ominous importance. Antonioni ends the film this way, the same locations but devoid of life, to the haunting score by Giovanni Fusco. The drip-drip-drip of modern civilization.

Will they go on to a happy-ever-after future? Or will decay set in? Does love always lead to pain? These and other questions must remain unanswered.

Thanksgiving, Coney Island

Spent the raw, overcast day clowning around on the deserted beach with the Minneapolis expats, the Atlantic Ocean crashing up to us as we pass a bottle of dark Bacardi rum between us. "Big Sky looked down on all the people looking up at the Big Sky," sang Ray Davies. And indeed, the scarlet fingertips of sunset tousle our hair. There's the Day-Glo Wonder Wheel set off against the gunmetal gray sky. We're dressed like Depression-era bank robbers. We smoke Camels on the wet sand. Read Herbert Asbury's *The Gangs of New York* aloud, about such notables as Louie the Lump and Kid Twist. Talking about girls and art and beatniks and Dash Hammett. Talking through our hats. Pissing under the boardwalk. Feeling free of the familial commitments that we had all grown up with. Getting down and getting with it, as the revolutionaries would say. Walking out on the breakers to suck in the sea air. Euphorically drunk. The sheer ecstasy of realizing each moment. When we squint we can see all the way across the ocean to France, and just barely make out the Eiffel Tower. Hooligans on holiday!

Thanksgiving dinner was fried shrimps and French fries at Nathan's Famous Franks. Cold beer.

· · ·

Beware of good taste. So many friends of mine fall into the trap laid by the crossword puzzle of New York culture. Taking their media injections of reviews, trivia, in-jokes, and fashionable opinions. Sliding into the niche of the preordained chic taste, with its comfortable boundaries, a schematic reference point from which to stand above it all. Get your hands dirty! Nothing ventured, nothing gained! There is no empirical truth. Good taste can dampen creativity. Make you inhibited. Make you shy away from out-of-reach glories.

. . .

Pasolini is dead, bludgeoned to death by seventeen-year-old rough trade, then run over by his own sports car, fulfilling his predestination.

I went up to John Berendt's for dinner. I sat on his brown velvet couch and drank Scotch while we listened to Miles Davis's *Porgy and Bess*. On the walls were original Peter Arno cartoons. He made pork chops. He's a consulting editor for *Esquire* and *New York* magazine. Friends with Peter Beard of Harvard. Was at the famous Democratic Convention in Chicago with Genet, Burroughs, Ginsberg, etc. Michael Herr's *Dispatches* were originally organized by John for *Esquire*. So he's been around. Interesting cat. When he found I didn't have subway fare home, he slipped me a ten spot "for the starving artist."

. . .

David McDermott proposed marriage to Mary Jane. He's waiting for the opportunity of my eventual leaving, so he can "get the dirty dishes." He wants to be Andy Hardy, he says. Mary Jane's diary says, "I live with the most inconsiderate and irresponsible boy I ever met in my life."

. . .

A bottle and two glasses. Crosby and I are drinking rum and smoking marijuana while watching *Kiss Me Deadly* on the late show, an apocalyptic movie if there ever was one. Marijuana brings me into the present. Presently, Nick is chewing on my hand. If I died, he'd eat my arm off. I look above the little white TV to my big cork bulletin board. There's a silk screen of Eddie Cochran on it that I got at Let It Rock on Kings Road. Also a cutout of Uschi Obermaier, with her hand down her unzipped jeans, her bangs in her eyes, her pouting mouth, her nipples standing straight up. She's part of some

anarchist German group, but still manages to model for Avedon and screw Keith Richards. She's the one who slipped ace guitarist Peter Green too much acid and he lost his mind and gave her radical group all his money. A modern-day femme fatale, to be sure. Crosby says, "Nick, quit stamping your feet." When he gets up to leave, he says, "Time for these boot heels to be ramblin'."

. . .

I'm making the rounds of some art dealers. They say they can't launch an unknown. No coterie backing me. Nothing solid underfoot. It's a Catch-22 situation. My day will come.

. . .

Roxy Music at the beautiful Beacon Theater. Larry Rivers was in the lobby with his girlfriend, my Parsons pal Shelly Dunn. Larry looks good with his long silver hair swept back, his lined face, his hook nose, cowboy shirt, painter's pants, and long silver-fox fur coat. I talked with them a little while, asked him too many questions. But I'd just seen *Pull My Daisy*, which blew my mind. Larry played a subway train conductor. Kerouac's spontaneous voice-over was so pretty and lyrical ("Up you go, little smoke . . ."). Ginsberg and Corso mischievous beatniks. Delphine Seyrig was Larry's wife. David Amram's lovely score. The theme song I shall want played at my funeral. That's how good it is!

Xmas in MPLS

Cocktail hour with Dad before dinner. When Mom calls "Dinner's ready," Dad says, "Let's have a rammer," which is a glass of bourbon to be thrown down the hatch thirty seconds before you sit down to the dinner table. Candlelight and wine. Dad discusses the troubled world we live in. It gets him down. He turns the conversation to me

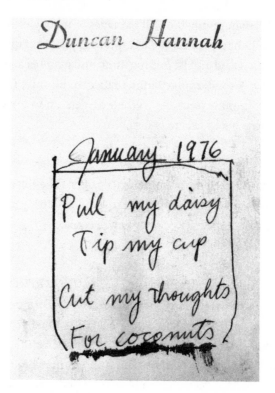

and my struggle to "make it." At one point he says, "Look, I don't know anything about art, and I don't care." Will it be ever thus? It's snowing outside the window.

. . .

Back in NYC. Blondie's playing at Max's. They were fun. Getting professional. Clem Burke is a real show drummer. Crosby and I were drugged and rummed-over, passing a pint under the table, pouring more spirits down to keep spirits up. He says of Debbie, "I would gladly eat her nylons, wouldn't you?"

I say there are a number of things that come to mind that I'd rather do with Debbie, but okay, sure, if that's your thing, man.

. . .

I'm reading through the night (with wide eyes) a biography of Sax Rohmer, best-selling creator of Fu Manchu, who's been something of a talisman to me. Sax was a born raconteur. Gave nicknames to everybody. Belonged to the Eccentric Club. The Côte d'Azur, Cairo, Limehouse, Paris—this is where you can find Sax. His walls were decorated with unframed photographs of girls, overdressed, under-dressed, or not dressed at all. God bless Fu Manchu.

. . .

Also reading Ann Charters's bio of Kerouac, which initially thrilled me, but as his alcoholism took over, scared me. He finally hemor-rhaged on his mother's basement floor in Florida while watching *The Galloping Gourmet* on morning television. Only forty-seven. The booze turned him into all the things he'd been against. He became homophobic, Commie-fearing, bigoted, right-wing. A sad trajectory. So this is my role model? I don't want to end up like that! I must reassess. If all my romantic plans are nothing but pipe dreams, then I've been delusional. Precious youth is eking through my fingers. I promptly went on the wagon.

OUT

OF

CONTEXT

a journal by Duncan Hannah. FEB, 1976.

Volume Eighteen

Norman Fischer had a party for the Mumps in his new Abingdon Square penthouse, with a terrace that looks out over Greenwich Village. Henry Geldzahler was there, admired my smooth forehead. He introduced me to rumpled genius Robert Frank. I gushed to him about my admiration for his body of work, which I realized was a mistake. He said, "Who cares." I shot craps with Jane Forth. I sat with singer Robert Palmer, who wondered where I got my haircut. "Mary Jane in the kitchen," I said. He wanted to make an appointment, thinking it was a salon. I laughed. Then he wanted to know where I got my corduroy suit. I told him it was an old Brooks Brothers number that I dyed with plum-colored Rit in the bathtub. He seemed disappointed that he couldn't go out and get this stuff. But it's all do-it-yourself around here.

I stayed late, sniffing cocaine and drinking liqueurs. Norman said, "Don't worry, I'm not going to try to seduce you, though you wouldn't do poorly to take on an older man as a lover. But as for me, I'll take whatever I can get. If that means friendship, I'll take it." Lance returned from his sexual ramblings, and we watched the sun come up, the arrival of another new day. We felt the mystery and strangeness of a world out of whack. I was wasted. I have a tendency to throw myself away. No parachute. Free fall. Fucked up. Lance gave me a bath, like a brother, wrapped me in a robe, and put me to bed. He's always been protective of me.

. . .

Josef Astor got a job as Irving Penn's assistant.

DuPrey got a 1957 Ampeg amp called a Reverberocket.

Richard Lloyd got a job as a bartender at a new joint called Pix.

Eric Li is working as a computer programmer by day, rock star by night.

John Meaney is driving a cab, and got kicked in the face by a fourteen-year-old black kid in Harlem.

The best new band are the Talking Heads, preppy RISD kids. They have a great song called "Tentative Decisions."

I've been working for a new periodical called *New York Rocker*. For the first issue I did a map to the stars' homes. (Where all the underground pop stars came from.) I was paid with a two-record set of psych/pop band the Idle Race, Jeff Lynne's band before the Move or ELO.

. . .

I bought an AstroScope (an opaque projector) from Pearl Paint, which means I can utilize photographs to a greater extent. This triggered a burst of painting with acrylic. Direction comes from working, not from my critical brain. Critic's time and creator's time are not the same time.

1. *Je'taime Jane B*, of Jane Birkin standing in a doorway with her hand down her blue jeans
2. *Subtitles*, done from a still from *Breathless* of Belmondo and nude in an interior
3. *Crime of Passion*, gun still-life and my poetry with Jasper Johns monochromatic scumbling
4. *The Prince of Bohemia*, Modigliani

5. Carol Lynley, topless, in front of the Vlaminck brushing her hair

I was in the Eighth Street Bookshop and spied Hockney, who I'd had a dream about the night before. He was hunched over in a tan overcoat, his roots showing. I approached him and said "David?" He turned around, eyebrows raised in curiosity.

"I'm Duncan Hannah . . . I met you at a party." We talked, he gave me his number, I gave him my card, which said "Painter of Pictures" on it. He smiled. He peered closely at me. He invited me over for tea at 33 West Ninth Street.

I arrived, playing it by ear, not knowing what to expect. We sat around a glass coffee table drinking tea in Henry's basement. Several large gray cats prowled about. David and Henry quizzed me about my painting, my income, my parents. We discussed art. "If art *really* progressed, then *that*"—pointing at a generic abstraction on the wall—"would be better than Caravaggio," David said. He is such an intelligent, funny, and classical man. Henry rubbed his socked foot against my penny loafer experimentally as he pontificated about his views on art history. David rolled his eyes and said, "You must take everything Henry says with a grain of salt. He tends to go on a bit." We laughed.

They smoked cigars and argued about contemporary art. I smoked cigarettes and jumped in when I could. Henry asked David if he was going to draw me. "I don't know, maybe, we'll see," he said in his broad Bradford accent.

So began a week of Hockney. The next night they took me to a small dinner at his dealer's house, Robert Miller, who had married a Johnson & Johnson heiress, which explained the deluxe Upper East Side brownstone they lived in. I wore the YSL black velvet suit I got at Barneys, with a striped sailor's jersey, and my best burgundy loafers

from Botticelli. Miller kept playing Pachelbel's Canon over and over, which has been newly rediscovered. Hauntingly beautiful. I asked him what it was. He told me. I couldn't hear him right, and said, "Taco Bell?" incredulously. "Pachelbel!" he replied angrily. Oops. I had offended the host, who seemed put out that David had brought a nobody guest. His mother was there. It was all terribly civilized. David and I kept up a steady conversation with each other about art history, agreeing on most things. He did not condescend, ever. It was like we were peers. A very generous attitude for a guy who was an international art superstar.

We took a cab home, and as we passed my street, I said, "I can hop out here." They said nothing. The cab kept sailing down the avenue, turned on Ninth, stopping at Henry's. I wondered what was expected of me. The moment of truth was upon me. I got out and extended

David Hockney in Chelsea apartment

my hand, saying, "Thank you so much, guys, what a fun evening. I hope to see you tomorrow." They exchanged a glance and shook my hand silently. David said, "Yes, well, all right, I'll give you a ring." I disappeared, feeling like Cinderella. Shall I turn into a pumpkin at midnight?

David came over for tea the next day, sat on the divan in my studio, and leafed through my drawings and collages, studied my paintings, all without a word. He smoked a cigar. He told me about seeing Elvis in Vegas. I took a couple snaps of him. Very surreal seeing him sitting there, under a framed photo of himself, on which I had inscribed "For my dear Duncan, lots of love, XXOO, David H." I had forgotten it was there, but it didn't escape his eye, and he looked at me with a puzzled expression. He left.

He called later and told me to meet him at Balducci's, where he was picking up a few edibles. When we were outside, I said, "David, it was great you came over to look at my work, but you didn't say anything."

He paused. He'd been expecting this. "We've been talking for a few days now. You're obviously a very smart guy. I don't have to tell you about your work. You already know. I'll just say this . . . you're selling yourself short in an attempt to be stylish. There's something of the zeitgeist in your work that weakens it. You're probably worried about having a look. Don't worry about that. That will come by itself. Just work hard, and you will evolve into yourself naturally. Don't choose who to be—grow into yourself through hard work. All will be revealed. I guarantee that if you paint a still life, it will have *your* personality in it. You have to trust that. The best things I saw by you today were your self-portrait drawings, because they had no artifice. Your drawing is a bit heavy-handed in the American fashion. The English draw in a finicky way. The French have got it right. If *I* was you, I would strip away all your flashy gimmicks and dare to make 'plain' paintings. You *will* be original, you have to take it on faith. You know what to do. You'll get where you need to go with time and

hard work." I nodded and thanked him. I knew I was hearing the truth, and appreciated his candor. But still, it was very sobering to hear it from someone I respected so much. He left the next day for Los Angeles.

. . .

Today I found a copy of the French glossy *Réalités* in the basement of the apartment building. Cover had a color picture of Nureyev. Someone had scrawled across his regal face with black magic marker, "Commie Faggot Shit." America hates beauty and is continually trying to destroy it.

Reading List
You Can't Go Home Again, Thomas Wolfe
Hope of Heaven, John O'Hara
Quiet Days in Clichy, Henry Miller
This Gun for Hire, Graham Greene
Standing Still and Walking in New York, Frank O'Hara
The Big Laugh, John O'Hara
Notebooks, Claes Oldenburg

Records
Helen of Troy, John Cale
Jazz Impressions of New York, Dave Brubeck Quartet
Captain Marvel, Stan Getz
Ruth Is Stranger Than Richard, Robert Wyatt
The Troggs Greatest Hits
The Royal Scam, Steely Dan
Wild Honey, the Beach Boys
Between the Buttons, the Rolling Stones
She Was Too Good to Me, Chet Baker
Communications, Stan Getz

Desire, Bob Dylan
Blue Afternoon, Tim Buckley

Movies
Bambina
Algiers
Pépé le Moko
Les Créatures
Je t'aime, je t'aime
The Naked Kiss
The Lovers
A Very Private Affair
Flesh
Le Doulos

It's already springtime, tweet tweet. Nick got his balls cut off at the vet on Tenth Street. I waited for him at the Lion's Head. (He'll take a fishtail, turn it into a fish scale.) Meaney's got a friend of a friend who got castrated by some S&M guys last week. Eric got mugged when he was high on downers. Guillemette Barbet got her cameras stolen. E. S. Wilentz's Eighth Street Bookshop burned down. There's a full moon all this week that's got all the ghosts and skeletons jittery. It gets crazy around here, and none of us have stuntmen to fill in for us.

David Hockney is off on an exotic vacation with his studio assistant, Gregory Evans. I got a postcard from him. It was a picture of a South Sea island, and, written with flourish, it says, "Love from Bora Bora, XX OO David H." A real sentiment to replace my forged sentiment.

· · ·

Crosby and I sit down to drink a bottle of cheap Beaujolais. Crosby has the long-suffering look of a man forced to live with mental defec-

tives. He resembles the actor Herbert Lom. He suffers from a kind of grandiose flamboyance. Morbid self-attention. But he's funny. He says, "It's a naive domestic vintage, but I think you'll be amused by its pretension." Here we are, the creative poor, locked in our grimy hobo towers. Talking about pencil lines, and gestalt, and flying fish, and torch singers, and grades of canvas. We smoke some pot and hit the street. Pass a garbage truck in flames. We go over to Phebe's for some rum and overhear an NYU girl introduce her gay friend to her mother. "Mom, this is Karl, he's the most pretentious guy I know . . ." Karl beams broadly and says, "It's all true!" It's the height of wimpiness.

．　．　．

Crosby returns home with me to watch some old movies on TV. *A Place in the Sun* had us biting our nails as tragic destiny unwound itself. Poor Monty. Then *Bullets for Ballots*, about racket busters, then *Crossroads*, with William Powell as an amnesiac and that beautiful *Ecstasy* girl, Hedy Lamarr. (She invented sonar.) When it began to get light out, Crosby said, "Throw a couple of drops of ink in the dawn, will ya, Dunc?" When I eventually went to sleep I dreamt I was being tried for murder.

"Nothing creates a bohemian faster than a steady check from bourgeois parents."

—GEORGE BERNARD SHAW

Up at McDermott's salon. He is putting out a "society" magazine called *The Cottage*. Four pages long, printed at Insty-Prints. Kristian lives with him now. He excels at rude remarks that pass for humor. He utilizes a brittle, mechanized wit. Very *Arsenic and Old Lace.* Kristian's collections of dollys and Beatles memorabilia have been

relegated to the closet. The Kramers are sitting on the couch chewing gum and wearing baby clothes. Kramer is quiet, no longer a big fish in a small pond. NYC is a giant rubber-coated playpen, and all the nuts equalize each other out. We go out for a walk in Central Park, through the Ramble, where young men make wordless assignations. Up to the Castle, a weather station that looks down over Shakespeare in the Park. McDermott is decked out in his turn-of-the-century finery. Skateboarding children shriek at him, "Hey, mister, are you gay!?! Ha ha ha!"

Last night Craig and I went to the Bottom Line to see the first post-recording gig of the Ramones. It was short, sweet, and to the point. Hilarious. I was meant to be shooting for *New York Rocker*, so I had to elbow ten other photographers with their two-foot lenses. Headliners were England's Dr. Feelgood, featuring guitarist Wilko Johnson, a skinny, demented lad who abused his Telecaster relentlessly.

Afterwards, we went to Rockefeller Plaza at midnight for a fifteen-thousand-dollar press party (outdoors) for Aerosmith, who had just played the Garden. A cha-cha band played under the 30 Rock building, the lights twinkled on the fountain and the huge gold sculpture of Prometheus. I was reminded that this was where *Sunday in New York* was shot, with the alluring Jane Fonda. She's not here tonight. But Leee Childers is (next best thing). We sampled the buffet (roast beef, croissants, etc.). Saucer-eyed girls with red mouths and telltale nipples prowled for pickups. The crème de la crème. Wine stewards everywhere. I joined Warhol and Lance, who has just resigned from his posts at *Interview* and *Circus* magazine. (He's also getting evicted.) Andy smiled at me with curiosity, and shyly said the three of us should get together some night. We said we'll take him to CBGB to see the Talking Heads.

Craig and I left the party at two-thirty, took the subway downtown for a bottle of Bud at the 55, where the literary drunks were installed,

and to play "Pull My Daisy" on the juke, capping off a perfect night. Bless our immortal souls.

New Paintings
L'Alcool
Hotel
Film Noir
Ignition (Delon)
Coloured Girl (Aurore)
Accomplices (Birkin)
Espionage (Bogarde and Ogier)
Ivory (Sirpa Lane)

Joe Brainard had a show at the Fishbach Gallery of hundreds of small collages. Inspirational! He has an odd color scheme, gray, peach, turquoise, black and white. His themes are martini glasses,

SELF PORTRAIT
FEB 1st 1975

shirts and ties, snowing paper clips, Ritz crackers, tropical fish, ciga-
rettes, travel stickers, stamps, sandwiches, posies, ashtrays, plaid,
TV sets, etc. There's an article about him in a new magazine called
People. Johns is at Castelli. Klimt and Schiele at the Austrian Insti-
tute. Motherwell (ocher, brick, beige, black, gray). Twombly scrib-
bles white crayon over wet gray oil. Phony documents, blackboards,
ghosts. Try it! I like the cubist painter Roger de La Fresnaye.

Strolled down to Pier 42 and its burned-down twin, an evil-looking
place. Spray-painted signs warn innocents about danger. Nude sil-
houettes of male buttocks slide across the windowsills. I talked with
a beautiful girl, Apollonia von Ravenstein (I think), who pulled up on
her white Raleigh. Black hair, no eyebrows, red lips, Bronx voice, tiny
jean jacket over bursting white T-shirt, turquoise velvet pants, wine-
red Italian boots. Yum, yum. I asked her what the little crystal piece
around her neck was. "Balls," she answers. She pedaled off.

CBGB with Warhol

Lance and I escort the Prince of Pop to a ringside table for the Talking
Heads show. Andy orders us a round of Jack Daniel's. Lance warns
him, "Watch out for Duncan's drinking. Didja ever see a balloon on
a radiator? Well, that's Duncan. He becomes a ghost of his former
self." Andy seems to have a child's sense of wonder, very inquisitive,
very sweet and polite. He gives me an American flag that he has auto-
graphed, "a bicentennial gift," he says. He slips Lance forty dollars
spending money. The Heads are playing a song called "Artists Only":
"I don't have to prove that I am creative . . ." We were joined by Chris
Blackwell, of Island Records, singer Robert Palmer, and the very
ambitious Robert Mapplethorpe. "They're so cute," drawled Andy of
the band. "We should do something on them for the magazine. Do
you think they'd like to come up for lunch?" I said that yes, they prob-
ably would. (Duh.) I'd arrange it.

Tuesday lunch with Warhol. May 26, 1976

I got to the Factory a little early, being let in by English-rose recep-
tionist Catherine Guinness. Andy was alone, and offered to show me
his studio. There were a lot of pet portraits on the wall.

"Do you have a pet?" he asked.

"Yes, I have a little black cat called Nick Charles," I said.

"Aw, what a good name. Do you think Nick would like his portrait
painted?"

"I'm sure he would, but I don't think his finances would cover it."
I smiled.

"What about your parents? Would they like a portrait of Nick
Charles?" he asked. Seeing where he was going with this, I marveled
at his chutzpah. He was used to rich kids dropping in, and probably
had a pretty good success rate at getting commissions off them. "Oh,
they're not really fond of cats, Andy."

"Oh, too bad," he said, frowning. "I've been seeing your name
everywhere." He showed me a copy of *FILE*, where I was mentioned
with Richard Merkin and Josef Astor. "You're really hot right now.
Tell me, what do you paint like?"

"Um, I've been trying to paint like Balthus."

His face brightened. "Oh, gee, what a good idea, we should do that
too." And he yelled over into the next room, where an assistant was
fiddling around with a silk screen. "Hey, Ronnie . . . Duncan's trying
to paint like Balthus, can we do that too?"

"Sure thing, Andy," came the disembodied voice from the other
room.

Andy turned back to me. "Maybe you should work here. You know
Lance just gave up his music column, why don't you take that over?
Do you like the new Lou Reed album?"

"I'm afraid I don't," I said.

"Ohhh, that wouldn't do, he's our friend. What about the new Donna Summer album?"

"I'm afraid I don't care for disco very much," I explained.

"Ohhh, that's too bad, she's our friend too. We love disco. Maybe it wouldn't work out."

I see how his patter works. He deflects all questions about himself, as if there is no "there" there. And yet he seems totally fascinated by others, that what they're doing is infinitely more interesting than what he's doing. He's in the moment, no one else exists but you. It seems sincere. It's flattering. So people open up. He's nosy, and because it's Warhol, people tell him anything. That's how he brought out the kink in all those freaks who performed for him. He seems nonjudgmental. He doesn't seem to know he's Andy Warhol.

The Talking Heads showed up, as did Lance. We moved into Andy's conference room, dark paneling, deco furniture, a stuffed moose head, concentric-circle light fixtures overhead, deco paintings by Jean Dupas, and a big oval table with Andy seated at the head. We ordered out from Brownies nearby. Tuna on whole wheat with carrot salad, drinking white wine and brandy. Lance conducted a three-hour interview with his Sony tape recorder. David Byrne was stiff and a little nonverbal. Tina got locked in the bathroom, where she was freaked out by a bloody khaki shirt hanging on the wall. Her dad is an admiral in the US Navy. Drummer Chris from Kentucky was charming. They had all studied at RISD with Merkin. Makos suddenly appeared with cookies, tripped and crashed to the floor. Lance was animation itself. Andy seemed to be enjoying himself.

After lunch we moved into the light-filled office, where I took two rolls of Tri-X of the band against a stark white wall. Andy was kind of acting as my assistant, which was bizarre. Then Lance took my camera and told me and Andy to get in the picture with the band. What fun!

The Talking Heads at the Factory . . .

and with Andy Warhol and DH, photographed by Lance Loud

I got a contact sheet back from the lab . . . brought it to show Andy, him saying, "Oh, these are so good, look how cute they are!" We picked out the best one. Laid out on the floor was a selection of Andy's new cock paintings. Cropped from navel to mid-thigh, rough silk screens of big dongs. Victor Hugo's?

"This is what we've been doing. We should do you. Do you want to pose for one of these?"

"Um, I think probably not."

"Are you sure? It'd be great if you did."

"I think I'm gonna say no," I repeated.

"Oh, well," Andy said, looking down at the array of pricks.

I went back to the lab to get a print made. When I picked it up a few days later and brought it to the Factory, I was told Andy was in Iran doing portraits, but that art director Marc Balet would assist me. He studied the print and declared it unfit for *Interview*. "No, Andy already okayed it," I said.

He gave me a sinister grin and said, "Well, Andy's not here and I'm in charge. You have to shoot them again, this is *Interview*! They should look like the Andrews Sisters."

"You've never even heard them! They're nothing like the Andrew Sisters! This photo is in keeping with who they are!" I protested.

"I don't care. I want it to look like a George Hurrell photo."

"George Hurrell! I wouldn't know the first thing about trying to do that. That's all tricky Hollywood studio lighting. This band is all about do-it-yourself minimalism!"

"I don't care. Get them back here." So I did, and we fumbled with lights and shadow, but the happy vibe was gone, and the published photo looked rather generic as a result. I was paid sixty dollars, forty of which I'd spent at the lab.

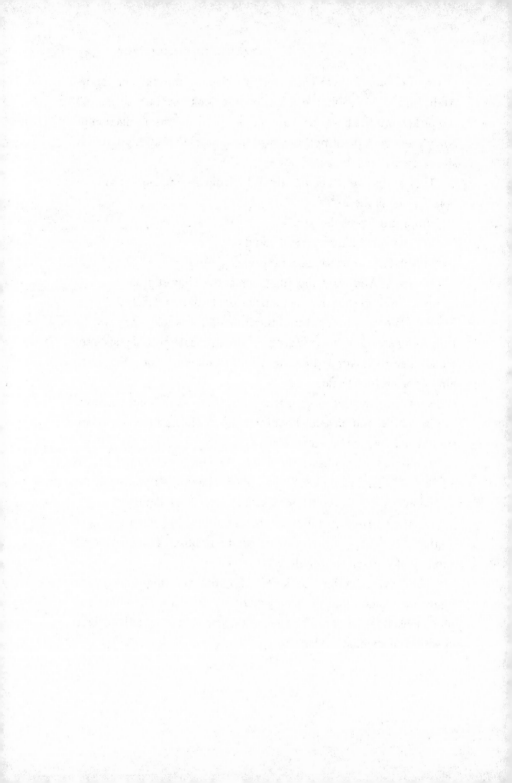

UNMADE BEDS

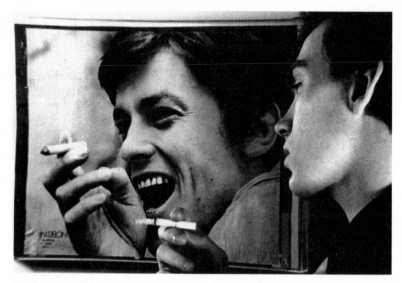

DH in Unmade Beds

I met Amos Poe (who made the film *The Blank Generation*, nonsync sound) on a photo shoot for *New York Rocker*, we were doing something on his friend Ivan Kral, guitarist with the Patti Smith Group. I saw him again at Max's, where he leaned into my booth and said, "Hey, I was gonna ask, do you wanna be in my movie?"

"Sure, what would I play?"

"The lead," he said calmly.

"The lead?! I'm not an actor, I'm a painter."

"That's okay, I don't want an actor. You could pretty much just play yourself."

Then I realized it was probably a short. I said, "How long is it?"

"It will be a feature."

A feature!? Then I figured he meant months in the future, which would give it time for the project to fall apart completely. "When do you start shooting?"

"In a couple weeks."

"A couple weeks! In that case, you better give me the script as soon as possible!"

"Uh, I haven't written it yet," he said. It transpires that he's already got a distribution deal set up. A shoestring budget of six thousand dollars (uncle's loan and credit card), the use of an empty apartment at 110 West Thirtieth Street (Amos is a super and a cab driver). He's cast Robert Gordon as the angel of death, Debbie Harry as the blonde. It will be a pastiche of New Wave flicks, *Blow-Up* and *Breathless*. Sounds good. Nobody's made an underground film in NYC in quite a while.

Amos put an ad in the *Voice* looking for actors to be in a Godard-type film. Two people from the Lee Strasberg workshop showed up: a busty brunette from Cincinnati named Patti Astor, and a noisy twenty-four-year-old French kid called Eric Mitchell, who has the look of Belmondo. Amos rounded up a cute club girl, Baby Adams, my sweetheart Mary Jane, black-leather Cowboy Dave (Forshtay). We met with Debbie Harry at her loft on the Bowery that she shares with boyfriend Chris Stein. Arturo Vega's paintings of supermarket specials are clustered in the front room. We talked in Debbie's bedroom, TV on, she on the mattress on the floor, which was littered with comic books and sci-fi magazines. They're big potheads. We plotted our scene: I'm a photographer, she comes to see me for head shots, jump cut to us in our underwear (presumably having just made love), and she sings me a song called "Sweet Thing" in her black lace bustier. I smoke expressionlessly, and then she leaves. It'll be a nice little showcase for Debbie's a cappella talents.

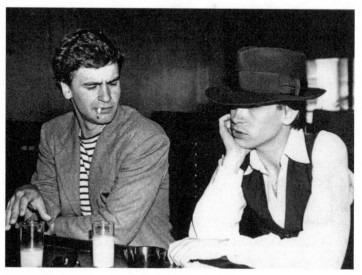

Eric Mitchell and DH in Unmade Beds

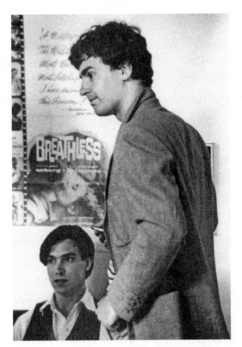

Note Godard reference in the background.

Ivan Kral made the piano-and-guitar music. Amos wrote the script each night before the day's shooting. He had a volunteer crew of ex-NYU film students. He screened *Breathless* for us all before the shoot. From conception to the first day was two weeks. The shoot lasted nine days.

Amos gave me a bottle of wine each morning to get prepped. One day we were shooting a scene in the re-opened Max's, and there was a problem with the 16mm camera, so the on-set photographer Fernando Natalici shot Eric and me clowning around onstage, drinking Pernod, while we did a voice-over on the Nagra. There was a morning scene shot in Washington Mews, where I was meant to be drunkenly making out with cute Baby Adams. How to act? Just do

it! I'm getting the hang of it! Free pass to French-kiss and fondle an attractive stranger. Acting is great!

I couldn't memorize my lines, so Amos taped them up around whatever room we were in for me to read. I'd ask Amos to direct me, but he'd just say "Be yourself," which is hard when there's a lighting man, a sound man, a cameraman, etc. staring at you. Eric fared much better, being a real actor, and devoid of self-consciousness. He strayed from the script in exciting ways. His energy came through. His off-the-wall humor. Especially a final scene on his fire escape, where he literally threw the script into the air, which fluttered down to Third Street, looked in the camera, and said, "Fuck Amos Poe!" and blasted the viewer with a cap pistol. *Blam, blam, blam!* "Fuck Jean-Luc Godard!" *Blam, blam, blam!*

I still don't know if *Unmade Beds* is meant to be a tragedy or a comedy. Amos appropriated as many references as he could to the French New Wave. It's a document of something, I'm just not quite sure what. The amazing thing is that he got it made at all.

· · ·

I turned twenty-four.

Summer Records
Greatest Hits, King Pleasure
Super Nova, Wayne Shorter
Native Dancer, Wayne Shorter
Five Leaves Left, Nick Drake
String Quartets, Debussy and Ravel

Summer Films
Charlotte (Vadim)
Spirits of the Dead

The Missouri Breaks
The Man Who Lies
L'Immortelle
Four Nights of a Dreamer
Une Femme Douce
La Notte
Puzzle of a Downfall Child
Honey Pie (XXX)
Taxi Driver
Le Magnifique
Le Flic
The Night Caller
Edvard Munch
Small Change
Weekend
Salon Kitty
Marathon Man
L'Amour Fou
Out 1: Spectre
The Last Tycoon
Providence
Andy Warhol's Bad
The Eagle Has Landed
Annie Hall
The Odessa File

Summer Books
Being Geniuses Together, Robert McAlmon
A Moveable Feast, Ernest Hemingway
Living Well Is the Best Revenge, Calvin Tomkins
Speedboat, Renata Adler

Appointment in Samarra, John O'Hara
Sermons and Soda Water, John O'Hara
Stranger at the Party, Helen Lawrenson
Archy and Mehitabel, Don Marquis
Nigger Heaven, Carl Van Vechten
Who Walk in Darkness, Chandler Brossard
Nightwood, Djuna Barnes
Go, John Clellon Holmes
Hollywood Babylon, Kenneth Anger
The Instrument, John O'Hara
The Last Words of Dutch Schultz, William Burroughs
The God of the Labyrinth, Colin Wilson
The Sex Diary of Gerard Sorme, Colin Wilson
Ritual in the Dark, Colin Wilson

September 8. Screening of *Unmade Beds* at the Preview Screening Room at 1600 Broadway. I had mixed emotions watching it. It's a clumsy pastiche. Not nearly as good as the films it salutes. Hard to separate the fun of shooting it with the finished product. I am certainly wooden, in my vain effort to mimic Alain Delon. I seem devoid of a sense of humor, which makes my character, such as it is, unsympathetic. Eric is much better, loose-limbed, combustible. Debbie is great.

Richard Merkin and his sidekick, graphic designer Kenny Kneitel, come as my guests, and take me to the popular new restaurant One Fifth. Cunard Line art deco. The dining room is assembled from the RMS *Caronia*. We all drink bullshots (vodka and beef bouillon) and they discuss the new skin mag, *Chic*. Oiled bodies and blinding sharp focus. Overlit. They disapprove. Too gynecological. Too slick. This must be what metropolitan life is like. We are men of the world! We have preferences for our porn!

September 14, 1976

Mary Jane and I have moved to a ninth-floor (the top) mini-loft a block away. It has west and south exposure. It has access to the rooftop (the tar beach) and a huge water tower looms above. A fire escape runs past the bedroom window. A gay bathhouse called Man's Country is directly across the street, so I see men in towels staring into my studio. Torch Art Supplies is on the ground floor. Thomas Wolfe lived next door. There's a methadone clinic in the building, so there's toothless junkies in the elevator. Sometimes they sell the "spitback" to the addicts loitering outside. Bless our pad.

· · ·

I re-read *The Subterraneans*. Eric Mitchell and I go east to Kerouac's Paradise Alley, where salsa replaces Symphony Sid, and Eric's malcontent mocking tease replaces the near-hallucinatory beat exaltations of the 1950s East Village. "Hollow-eyed, and high . . ." said Ginsberg. Kerouac wrote, "Pull my daisy, tip my cup . . . Cut my thoughts for coconuts."

Cute, dopey Nick Charles is gone after fourteen months of cohabitation. Went out one of our eight windows. That big expanse of rooftops got the better of him. He left ten days ago. I scoured the neighborhood for him, calling his name, looking under parked cars, and a Spanish super said there was a nasty tomcat who preyed on weaker animals, and he may have killed him. Unspayed male cats hate spayed male cats. Poor little Nick might've been murdered. It's too awful to think about. I thought he'd be around till I was thirty-eight or so. I really miss him. I still see his hairy black shape out of the corner of my eye as I make a tuna sandwich. I see movement. It's only the curtain blowing. I loved you, Nick, wherever you are.

PALPITATIONS

DH

October 1976

I sleep through the morning noises of the bouncing trucks rumbling down the block. The sound of flamenco dancers across the street in the rehearsal studio rouses me. I wake and reach for the paperback I was reading the night before. I read, "The first time I ever got in bed with her without any clothes on, I thought that this was a joy which would last forever." John O'Hara. I'm on an O'Hara kick lately. He's so good, but has slipped through the cracks. I even go to eat at Artists and Writers (213 West Fortieth), a faded restaurant off Times Square that he used to lunch in. There's a dusty suit of armor in the corner. Try to imagine it in its heyday. It's hard to do.

. . .

New cat, a sleek black panther called Miles. The prince of darkness. Muscular street cat. Takes a dim view of us apprentice beatniks. He's cooler than all of us put together and he knows it.

Drinking and drinking. I've fallen out of life, enjoying the physical world by risking its total loss. Mary Jane is away every day working at Bloomingdale's. Sometimes Patti Astor comes around for a little love in the afternoon. Pulling a pint out of her purse, taking Joni Mitchell off the stereo and putting on the Stones instead, to get the right groove going.

November 18

Mary Jane went to Cleveland for a little R and R. So while the cat's away, I took the opportunity to catch up on my drinking. Went on a nine-day bender with ex-Hurricane Boy bandmate Steve Brooks, my pal since the age of fourteen. Every time we ran out of money he'd call his banker and get more moolah. We saw the fabulous Stan Getz at a jazz joint on Sixth Avenue. I ran into Stan in the men's room, urinal to urinal. Told him how much I loved his playing. He sized me up and said, "Fuck off, kid." Wow. That was unnecessarily rude, perhaps?

The next night we went to the West Eighties to score some pot from an old Blake boy. Coming down the front stoop we were accosted by two black dudes who demanded our money. Brooks started talking to them about the book he'd just read, *Soul on Ice*, and how he completely understood these guys' oppressed plight. They looked at each other in complete surprise and amusement, as Brooks continued with his rap. Instead of killing us on the spot, they let us go. We were too ridiculous to mug.

The following day, we were trying to decide where to drink next. "How about the United Nations?" We got a couple quarts of Miller High Life and sat on a bench outside the UN and watched the international ambassadors go to work while we mused on espionage. We drifted over to the East Side Cinema and saw that the first showing of *Maîtresse* was about to begin. We got in line behind a man and a blond woman, who were eyeing our sozzled selves with curiosity. It was director Barbet Schroeder and star Bulle Ogier! They told the ticket seller that we were with them. "Thanks!" I said. Bulle smiled. We filed in, and sat behind them in the empty theater, listening to them talk in French. When the lights went down, we both fell asleep. Only waking periodically to witness some gruesome S&M activities. When the lights went on, we realized the pair had left, no doubt see-

ing the state their new film had put us in. I hope they didn't take it personally.

Later that night, as Brooks and I watched TV with a bottle of Myers's rum, Crosby's girlfriend Olive buzzed from downstairs. What could she want? I let her up, and she was drunk. She, like me, turns carnal when intoxicated. She lay on the couch and fixed me with a certain look from her pretty Modigliani face. So I led her into the pink bedroom and pulled her jeans down over her slim hips. This seemed to be exactly what she had in mind. We'd had a spontaneous combustion once before, after a sweaty night of dancing at the Cobra Club. We enjoyed each other then, we enjoyed each other now. Nature took its course. Once, twice, thrice. Good chemistry. Then Crosby called on the phone, wondering if I'd seen Olive. Gulp. "Uh, no, wasn't she going to a party tonight? She's probably still there— you know how she gets," I offered.

"That's what I'm afraid of," he said. She hurriedly dressed, looking extremely flushed with sex, and left for the five-block walk back home.

The marathon drunk finally ended, and left me with a wretched case of delirium tremens. Time to pay the piper.

November 28. I went to the second performance of *Einstein on the Beach* at Lincoln Center and talked to Hockney in the lobby during intermission. He's a fan of real opera, whereas for me, I can't stand the stuff. Too histrionic. So this Philip Glass is easier for me.

January 1977

Winter in New York. Happy but confused. These are the days when it all goes by so fast. Liquor, entreaties, jokes, promises, aspirations, hopes, wishes, dreams, wants, desires. Stolen moments that all blend

together in a mishmash of love and youth. Sexual coupling with Mary Jane, Patti, and Olive. Oh, what a wicked web we weave, when at first we start to deceive.

Been hanging out hard and heavy at the Bells of Hell on Thirteenth Street, the Cedar Tavern on University, the 55 on Christopher, One Fifth on Eighth Street. Going from ecstatic laughter to teary spasms that leave me retching yellow bile. Valiums, speed, coke, pot, rum, Pernod, Scotch, bourbon, gin, tequila, Campari, brandy . . . WHEW!

. . .

Larry Rivers had a drawing show at Marlborough that was fantastic. He's got a unique line, and I love the way he carves away at his drawings, reconfiguring them with tape and staples. Went to the opening with best friend Eric Mitchell, where we mingled with Taylor Mead, Sylvia Miles, Henry Geldzahler, Christopher Scott, Beverly Johnson, Babe Paley, Maxime de la Falaise, and Shelly Dunn. Eric was down in the dumps, so we went back to my place, and somehow we persuaded Mary Jane to try a three-way. As the sexual melodrama unfolded, I realized I didn't really fit in. Didn't know what to do. Eric seemed to be covering all the bases at once. I didn't feel jealous, but nor did I feel turned on. So I called Patti Astor and told her what the yelps from the other room were all about. She told me to get over to her East Fourth Street pad immediately, so I threw on my trench coat and walked over there for conjugal relations. Returned home in the morning to find Eric lounging in my robe, smoking a cigarette. A little awkward. Mary Jane not quite sure how her romance with me has unraveled to the extent it has. How did a nice girl from Ohio wind up in an affair like this? My pernicious influence. I'm to blame. I also blame Colin Wilson, whose book *The God of the Labyrinth* has got me enthralled. It's about testing the limits of sexuality. He writes, "Merely for the will to spring erect and *want* something is enough to

set the wheels in motion. If we all realized this, we might will more. What deters us is the possibility of wasting our efforts."

January 29, 1977

Party at Victor Bockris's apartment on Perry Street. Victor is an English eccentric, a literary man, does quirky interviews with his partner Andrew Wylie. Small, pointed, and well dressed. Guests include Lance Loud, Makos, Mapplethorpe, Anton Perich, Victor Hugo, Gerard Malanga and his roommate, the notorious poet Albert Napoleon Rene Ricard, who resembles a gay Huntz Hall. He claims to have slept with Thomas Hart Benton. Is featured in Warhol's *Kitchen*, with Edie Sedgwick. Also *Chelsea Girls*. Rene has one of those lightning-fast acid wits. I innocuously propose that we become friends. He is taken aback.

February 2

Going out on the town with Rene Ricard tonight. I'm sure he hopes I'm as dumb as I am pretty.

He told me he'd never fuck me in a million years (which Lance cautioned me was the oldest line in the book). I better stay on my feet tonight.

Went to Mickey Ruskin's Locale, where we had a hilarious time with sozzled Taylor Mead. The cook, an aspiring painter named Julian Schnabel, gave us a free order of fried zucchini. Came out and sat with us in his stained apron. So did *The Paris Review*'s Fayette Hickox. I *did* get too drunk, and Rene and Gerard saw me home and tucked me in.

February 4

After an afternoon painting René Clair, I go to the 55 with Eric
M. and Kramer, where we meet a sad middle-aged guy called Billy
Buttons, a typist for the homicide squad and a failed concert pia-
nist. Kind of a Boo Radley type. We're playing "It Never Entered
My Mind" on the jukebox. Billy likes this song too . . . and we get to
discussing sad songs. After fifty dollars of drinks (which is a lot of
hootch in that underpriced dive), we go over to Billy's ghostly Mul-
berry Street house so he can play piano for us. A dim, shabby, non-
descript room. We were being a bunch of wiseguys until he started
to play a piece he had written. It was the most heartbreaking music
we had ever heard, exposing the devastating loneliness of this bril-
liant, lost soul. When the last note faded, he finally looked up at us.
His face was streaked with tears, and we thanked him solemnly,
and quietly made our exit.

"Wow. That was like something out of Edgar Allan Poe," said
Kramer.

"My hair is standing on end," said Eric.

"That poor guy!" said I.

In the ensuing days we asked the barkeep if Billy had been in. He
said he'd never heard of the guy. Didn't know who we were talking
about. A couple of weeks later we tried to find his Mulberry Street
apartment building again . . . It was an empty lot, and had been
for quite some time. We felt sure we had the location right. So that
means that Billy Buttons . . . was a ghost?

February 4

Double show of Mapplethorpe's photographs. One show is flowers
and society portraits, one show gay S&M shots. Out in a wolfpack
with Malanga and Ricard. Leads to the Locale, where I'm talking

with one of Rene's old boyfriends, architect Christopher Lethbridge, who looks a lot like me. He says the same. He warns me of the danger in Rene's changing moods, that he can be quite violent. As if on cue, Rene says in a snarl, "Look at Narcissus gazing at his reflection in the pond. Aren't they *bee-yoo-tee-ful!*"

I say, "Knock it off, Rene."

With that, he throws me over in my chair. Crash! I get up, look at Rene's enraged face, and Gerard says, "You better get out of here, Duncan." So I beat a retreat upstairs to the sidewalk, shocked at how things turned so ugly so quickly. I hear footsteps behind me. I turn to see Rene's fist careen into my cheekbone. I fall to the concrete. Curl up in a fetal position as he begins to kick me with his motorcycle boots, all the while screaming about what a fucking cocktease I am. A rescue party emerged from the Locale, Gerard and Chris, who had seen the murderous intent in Rene's eyes and followed him. They pulled him off, each had an arm. I got up and looked at Rene, purple-faced, spittle-flecked, insane. I was terrified. Gerard said, "Duncan . . . GO . . . right NOW!!" I ran south to SoHo, my lip bleeding, my eye swelling, my chest heaving, sobbing, hysterical. What the FUCK! I darted into a doorway to catch my breath. FUCK!

Then who should approach but my antagonist, in shadow, weeping, saying, "I'm sorry, I love you, give me another chance, please, I love you." It was like a horror movie.

I said, "Stay away! Get back. Just forget it, okay? You broke my face! Forget the whole thing!" as I inched away from the lunatic. I disappeared into the darkness and made it home. The phone rang every fifteen minutes for the next twenty-four hours. I'd been pummeled pretty good. Looked like I lost a prizefight. I finally talked to him on the phone. He said he liked the freedom I took with him, but that he had forfeited that trust. He wrote a short poem about it.

· · ·

Went on the wagon immediately. Reading *Let It Come Down* by Paul Bowles. It's the house of trauma around here. Mary Jane had an abortion. Bye-bye baby, bye-bye.

Party at the Chelsea, where drug-addled Gregory Corso is telling me about Flann O'Brien's *The Third Policeman*. He's speaking a kind of gibberish that I can't follow. I walk home to play with my new girl kitten, Kuku. She can walk on her hind feet, and does, just for the fun of it.

February 15. Saw *Providence* with John Berendt. Gielgud says, "The good thing about being conventionally unconventional is that it's a mask behind which you can hide your true squalor."

Amos gave me a copy of *Black Sun* by Geoffrey Wolff. "The brief transit of poet and publisher Harry Crosby," who died in a suicide pact with a pretty Boston socialite at age thirty-one. My kind of guy. I have a new (negative) role model. Amos wants to make a film of it with me as Harry and Mary Jane as his wife, Caresse. They had two dogs, Narcisse Noir and Clytoris.

February 23. Allen Ginsberg and Robert Lowell at St. Mark's Church. Rene and I sit in front of Corso, who has brought a noisy baby. The baby disrupts Lowell, recently out of the madhouse. Then Corso begins to heckle Lowell, who is only held together with Scotch tape and spit. Is it a fight between the beats and the academics? Not a fair fight. Lowell is as fragile as a basket of eggs. Allen hushes Corso, and Lowell continues with his hesitant, wobbly delivery. Afterwards Rene introduced me to Lowell, who had a very weak handshake. His alienation and vulnerability were palpable.

Dinner at the Locale after the reading with Malanga, Mitchell, Ricard, and a paperback Liz Taylor called Ruth Kligman, mistress

of de Kooning, Kline, and Pollack. I read her book, *Love Story*, about being an ab-ex groupie. She seemed vain and crass. Made me wonder what those cats saw in her. Tits?

February 24

Rainy day. I bought a brand-new novelty tweed suit at House of Cromwell on Lexington for ninety-eight dollars. For tonight is the official premiere of *Unmade Beds* at Rizzoli. The guests include David Byrne, Josef Astor, cute punker Susan Springfield, actress Anna Levine, Rene Ricard, Ellen Burnie, Taylor Mead, John Berendt, and Marcel Just. Ork was meant to bring Nick Ray, and Catherine Guinness was meant to bring Warhol. They didn't. This was the fourth time I saw it. I noticed the lack of connection between the ill-defined characters. The reaction was "Okay," not like the bomb it had been the other night at CCNY, where the audience was put to sleep. I wish it was better. At least it could've had some nudity. That always saves the day. Someone asked Taylor after how he liked the film, and he said, "I don't know, was I in it?"

February 26

Rene took me to the live filming of *Saturday Night Live*, written by two old prep-school classmates Tom Davis and Al Franken. Blake boys make good in broadcast television. The musical guests were the Kinks. The hosts were Lily Tomlin and Steve Martin. Afterwards we went to the cast party at Broadway Charlies, near 30 Rock. I sat across from Steve Martin at dinner, and was startled to observe how unfunny he was. I mean completely! Ray Davies didn't seem like a whole lot of fun, either. "You never know what kind of squirrel cage a man goes home to at the end of the day," my dad always tells me. Somehow Rene seems to know everybody. I meet so many people

through him that I can't keep track. He drills me, endorses me, contradicts me.

March 5

Rene and I to a dinner party at painter Robin Brugh's studio, but I'd been drunk for so many days that I asked the hostess if I could lie down and try to sleep it off. Sure. So I did. I awoke a considerable time later. Woken by loud dance music. What happened to the quiet dinner party? I opened my eyes and stared into a dog's face that was opposite me on the pillow. A Weimaraner. Wait! I recognize the dog! Not just any Weimaraner . . . it's Man Ray! "Are you Man Ray?" I ask the dog. Dog licked my face. "Where am I, then?" I saw it was a different room than the one I'd passed out in. I was lying on a lot of coats. I got up and opened the door a crack. Big dark loft, filled with people dancing and yelling. A stern man came up to me and asked if I was feeling better. "Are you William Wegman?" I asked. "I am. Rene brought you here, thrown over his shoulder like a sack of potatoes. I told him he couldn't come in with an unconscious person, but he assured me it was all right. Is it?" he said coldly.

"Yes. I'm very sorry . . . afraid I'm a bit worse for wear . . . heh heh."

"Well, behave yourself," he said, without a smile.

March 10

Amos calls me up and says we have to go to New Haven for a screening of *Unmade Beds* at Yale. Tonight! "Impossible. I can't, I'm too drunk," I say.

"You have to, they're waiting for you. Everything is paid for. I'll give you some speed. Meet me at Grand Central." So I did. Turns out he had a woman lined up who wouldn't fuck him unless he brought me.

"Why me?" I asked.

"I don't know, her friend wants to meet you or something. They're having a big party for us at someone's house off campus. We're rock stars!" he said, laughing. He gave me a black beauty, and the pill started jump-starting my aorta.

Fast-forward to the party. Amos disappears with his paramour, and an eager slip of a girl with a shag hairdo invites me upstairs to her bedroom. She's called Diana. She's wearing a satin baseball jacket. She unzips it, and guess what? Nothing on underneath. This is more like a porn movie than the Ivy League. I told her I couldn't participate in what she had in mind because of the amphetamines coursing through my bloodstream. She said, "But you can do anything you want . . . You can fuck me in the ass, do you like that?"

"Whether I like it or not, this just ain't our night. I'll take a raincheck, honey."

"But you *have* to, my dad's name is Duncan and *he* fucked me, and my brother's name is Duncan, and *he* fucked me too! And now *you're* going to fuck me!" Aha, a grade-A nutcase!

"I'm very sorry, but I'm not fit for fucking anybody tonight. I can't even find my dick to pee."

Amos and I were dropped at the New Haven station for the last train back to NYC. "I hope you appreciate the supreme sacrifice I made for your overworked libido tonight. I am exhausted!" I told Amos.

March 17. St. Patrick's Day parade. The *one* day when civilians are as drunk as I am. The winos think they've died and gone to heaven. The whole of NYC is plastered. Pissing on the Plaza.

March 18. Iggy at the Academy of Music. Blondie was the opener. Kramer gives me some powder to sniff that wipes out my motor con-

trols. PCP? THC? Rene and I go to the concert just the same, but I am so bleary and rubber-legged that it's hard to enjoy. Even with Bowie on keyboards. Iggy doing his Egyptian dance. Looks like Michelangelo's David up there.

April 5. Was shot for *New York Rocker* by mystery man Steven Meisel at Anna Sui's Sixteenth Street pad. She looks like Anna May Wong. She's from Detroit. We all crossed paths at Parsons. She lives with Walter Lure from the Heartbreakers, the band of junkies I shot at Max's recently. Good song called "Chinese Rocks."

April 7. Kramer and I go to Diamond Lil's strip club on Canal Street. There's a dancer named Magic who we all are in love with. Beautiful young brunette with the body of a *Playboy* centerfold. Mother nature was extremely generous when it came to her. An ethereal look in her eyes. An enigmatic smile. She squats on the side of the stage for the Japanese tourists, who are at eye level with her sex, peering inside her like they're searching for something. Jimmy Hoffa? Judge Crater? Their car keys? They put greenbacks in her garters.

. . .

Big Easter party here on the sunny tar roof. Pals from all walks of life, rockers, disgruntled artists, Method actors, etc. We must have listened to Iggy Pop's "Funtime" a million times. "Hey baby, we like your lips . . . Hey baby we like your pants . . . *fun!*" Our new alcoholic Portuguese friend Joaquin literally set his pants on fire, from the cuffs up. People crawled in the water tower.

The other big song is "Be My Wife" by Bowie. "Sometimes you get so lonely . . ." It's like a cubist cutup of an uptempo love song, all the tropes scrambled, non sequiturs left dangling, and yet with that

James Crosby and DH on tar roof

infectious pleasure that a perfect pop song delivers. It's *about* the pop song, and yet simultaneously it *is* a pop song! That's why Bowie is a modern master.

. . .

I'm still carrying on with Olive (secretly). And Patti less frequently, because she's carrying on with Kramer, too. At first me and Kramer alternated weeks, then days, and finally, when it got to hours, I bowed out. One's coming as the other's going, as it were. It was a bit like an Italian sex comedy. But Patti was glowing at the attentions of two young lover boys. Meanwhile, Mary Jane has been having an affair with J.K., a modern composer who I went to Blake with. I found out by using my Sherlock Holmes powers of deduction. Applying the double standard, I acted outraged, like the hypocrite I am. Made quite a scene befitting a drama queen such as I. Milking the situation for every last drop of indignation and self-pity. My friends say, "How can you be upset? You ignored her for two years!" True enough.

. . .

One night Crosby and Olive had a party in their Union Square loft. The Talking Heads came. I succumbed to inebriation early and crawled up into their loft bed. Later Olive did the same. Finally Crosby climbed up as well. There we were, like the three bears, sleeping soundly. In the morning I cocked an eye open and saw my secret mistress next to me, with her boyfriend snoring on the other side of her. She had that naughty gleam in her eye, hangovers making us both horny. I slid my hand in her knickers and brought her off. Once. Twice. She caressed me too. Rolled over on her other side and guided me in. We could make no noise, no jostling of the mattress, lest we wake the slumbering beast next to her. It was highly erotic, working within these restrictions. Periodically Crosby would snort, and we would freeze in our tracks, then his breathing would return to its methodical rhinoceros pace, and we would again permit subtle motions. A long drawn-out guilty session. The crisis came, and we stifled our exultations of pleasure.

We all got up a half an hour later, Crosby none the wiser for the betrayal that happened right next to him. We drank coffee and pieced the party's high points together. Olive took a shower and reappeared in her blue dressing gown. Crosby had to get up to art school for some reason, and Olive and I watched from the fourth-floor window as he headed toward the subway. She gave me that look again, and off came the robe for round two. We certainly weren't practicing the golden rule that morning. What can I say? We were in the throes of a kind of madness.

May 22. Read *Tender Is the Night*. Scary tale of dissolution. A cautionary tale.

May 23. Mary Jane moves out to her own pad on St. Mark's Place. She's had it. Who could blame her.

· · ·

I show my portfolio to Arista Records, *Esquire,* etc. No soap. Go to a modeling "go-see" for *Viva* magazine, photographer Robert Farber is doing a Gatsbyesque soft-core photo spread with a pretty Daisy Buchanan. I don't get that gig, either, plus he kept the B&W photos of myself that I was asked to bring with me. I'm too short to get fashion work (5'9"). Still, I get spots from *New York* magazine regularly. Especially now that J. C. Suarès is art director and John Berendt the editor. I do have my pockets of supporters.

Books

Memoirs of Montparnasse, John Glassco
Count d'Orgel, Raymond Radiguet
Shadows of the Sun, Harry Crosby
The Stranger, Albert Camus
The Horn, John Clellon Holmes
The Delicate Prey, Paul Bowles
The Party's Over Now, John Gruen
Monty, Robert LaGuardia
Thérèse Raquin, Émile Zola
Up Above the World, Paul Bowles
Selected Poems, John Wieners
Ripley Under Ground, Patricia Highsmith
The Spy Who Came in from the Cold, John Le Carré
Tremor of Intent, Anthony Burgess
The Gentle Degenerates, Marco Vassi
A Dandy in Aspic, Derek Marlowe
The Girl Beneath the Lion, André Pieyre de Mandiargues

My Life and Loves in Greenwich Village, Maxwell Bodenheim
Hunger, Knut Hamsun
David Hockney, David Hockney
Snowball, Ted Allbeury
Crime and Punishment, Dostoyevsky
Delta of Venus, Anaïs Nin

Films
Cul-de-Sac
The Trial
The Heiress
In the Realm of the Senses
Star Wars
The Big Sleep
A Bridge Too Far
The Deep

Records
Hejira, Joni Mitchell
Deaf School
The Idiot, Iggy Pop
Closing Time, Tom Waits
Horses, Patti Smith
Providence, Miklós Rózsa
The Peacocks, Stan Getz
Low, David Bowie

It's June, and Crosby and Olive have left their loft and moved into mine, helping with the $350 rent. But Crosby has gone off to Vermont to paint landscapes with his guru, grumpy old Frank Mason, who paints in a faux-Velásquez manner. He once threw me out of a party at his house for expressing love for Modigliani. Closed-minded oaf!

Anyhow, this turn of events leaves me with Olive, who's about to go off to Prague in five days, but until she does, there is much sexual intercourse to accomplish. We are well suited to the task at hand. It's all so good. Like a drug. More, more, more. We surpass ourselves. I'm reminded of the journalist who asked Woody Allen if he thought sex was dirty. "If it's done properly, yes," he replied. Leaves us laughing. Leaves her with a painful bladder infection.

I joined the Twenty-third Street YMCA in a feeble attempt to restore some kind of fitness to my weedy self. Sweat out the booze in the steam room. Avert my eyes from the cruising that goes on in there. Play paddleball with a couple pals. Run laps around the track like a rat in a trap.

· · ·

The first singles from the Sex Pistols and the Clash are out here as imports. Much anticipated. Been reading all about them. "God Save the Queen" certainly has a snarling charm. Great guitar sound. Quite addictive. On the other hand, I have a secret love for Fleetwood Mac's summer single, "Dreams," that wafts from everywhere—something so melancholic about that song. Mick Fleetwood's shuffling drums never sounded better. As a rock snob, I am supposed to reject the Americanized version of the band (and mostly do) out of reverence for their English incarnation, led by genius Peter Green and Jeremy Spencer. But I can't help it. A good song is a good song. "Don't Go Breaking My Heart" by Elton John and Kiki Dee is another example. A guilty pleasure.

Amos is plotting his next feature, *The Foreigner*, to star Eric Mitchell this time, and me to play a supporting role as a guy called Shake, who's leader of a gang called the Bags. It begins shooting on June 17th.

June 20. Shooting in my studio. Weird Robin Crutchfield, Kramer, Cowboy Dave, Mary Jane. They are all in black leather except me (which pisses off the very controlling Eric, who's decided this is *his* movie, not Amos's. He's become increasingly contentious). Amos gave us a bottle of Chivas Regal to prepare. We've also got a bottle of Locker Room, which is amyl nitrite and sold in tobacco stores. One sniff of the vapors and you go off on a blinding rush. My character is meant to instruct this bunch of punks on the stalking, terrorizing, and eventual killing of Eric Mitchell's character. Why? I have no idea.

Collage of Kramer, DH, Patti Astor, Mitchell, Terry Sellers

In fact, the film seems to be an excuse for a series of timely set pieces to prowl the sleazier sides of Manhattan's downtown underbelly, featuring, once again, the gorgeous Debbie Harry singing in an alleyway, ghoulish rockabilly band the Cramps playing in CBGB, and a couple of attractive dominatrices seen around the rock clubs, Asian Anya Phillips and redhead Terence Sellers. Plus, the *now* platinum-blond Patti Astor.

· · ·

Anyhow, we prepare for a scene. I'm putting on some makeup (eyeliner and rouge) and making sure my Egon Schiele haircut stands up just so. Kramer just smudges the stuff all over his face.

Amos calls "Lights?"—Ready. "Sound?"—Ready. "Camera?"—Ready. "Actors?"

"Just a second, Amos!" and we all greedily inhale the amyl nitrite, so when the camera rolls, we are in a severely altered state. No need for fake Method acting. We are legitimately out of our heads! Cinéma vérité. At one point, on camera, I read a porno book to my henchmen, as Kramer pounded his head against the wall. Hard.

Another scene was shot on the Staten Island Ferry, the fresh air bracing as the amyl nitrite does its job. We try to intimidate Eric, then pretend to chuck him over the side.

On the final shoot we meet over by Battery Park, where Richard Merkin, in full sartorial 1930s splendor, shoots Eric in the back with a .357 magnum. I smirk. The End.

· · ·

Drunk-sick again. The bile I was throwing up went from piss yellow to brown to swamp-water green. Very autumnal. My urine was brown. My heartbeat goes from a flat tire to a race-horse. Sweats, nightmares, dizziness, *ugh*! Four days of hell.

The Haunted Portrait

One night I refused all offers of party-time fun and vowed to stay in and paint. There wasn't a drop in the house. I was sober as a judge. I devoted myself to a portrait of Harry Crosby on a 20-by-26" canvas. It wasn't going well. I was rusty. Hand-eye coordination minimal. The last thing I remember was trying to give it a bit of African tribal stylization, which Harry would have approved of, loving all things savage. Trying to make it sing.

The next thing I knew, I was being woken by the buzzer. It was eight a.m. I was still dressed. Rene was at the door, coming in from a night out at the discos (with Bianca Jagger and Lauren Hutton). He was still high and smudged with their lipstick. He asked if I had passed out in my clothes again.

"No . . . it's a mystery, I was painting, and then . . . I don't know . . . you buzzed."

"Let's have a look," he said.

We rounded the corner and looked at the painting on the easel. It

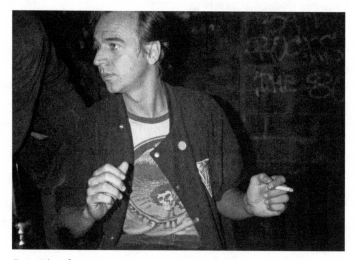

Rene Ricard

was a shimmering jewel. Harry looked out at us with large, wet eyes. His lips as if about to speak. Both angel and devil. The background was vaporous. Rene burst out crying.

"It's *sooo bee-yoo-tee-ful*," he sobbed. "This is the first painting of your career. The first to achieve the promise you held."

"Yah, but . . . I don't paint like that . . . I don't paint anywhere near that good. It doesn't have my telltale handiwork at all," I said, shocked.

"Well, then, who did—ohhh, I see what you're getting at . . . you mean . . . ?"

"Yes. It's not mine, it's *his!*" I said, pointing at the opalescent image before us. Creepy, yet wonderful.

· · ·

Drug dealer to the avant-garde Norman Fischer died in California after an unsuccessful operation for skin cancer. Kramer's Easter duck, Little Lukie, died as well. My drug buddy from 1969, Dave Winsor, has a year to live with a malignant cancer. Death is lurking around, looking for business.

· · ·

Rene modeled for Alex Katz, and I modeled for Rene. Turns out he draws a bit like Degas. Most nonartists draw in a similar, awkward way. Not so Rene. He sat me down with a book on French impressionism and said, "Let me explain art history to you," and he did. Deep pockets of knowledge about every reproduction in the book. He was particularly good on Bazille, who died young. Another time, over at Crosby's old loft, he got out a copy of John Wiener's *Hotel Wentley Poems*, read the whole thing aloud, cover to cover, weeping quietly as he did so. That was a good lesson in poetry. Quite moving. I love to see the way others are struck by art, what kind of personal dialogue and response they may have with a painting or a poem. Of course

Sketch of DH by Rene Ricard, 1977

most people have none at all. But for some it's top priority, extremely important. Aristocrats of aesthetics.

July 2

Party at Bockris/Goldberg's for their new zine, *Traveller's Digest*. Meet Diego Cortez. I danced with ex-Catholic Terry Sellers, the redhead in Amos's movie. I bit her on the neck as part of my mating ritual. She liked that. I took her home with me and peeled off her fuzzy angora sweater and Capri pants. Beauty! Which led to hanging out with her all week. She lives at 101 St. Mark's Place under Ted Berrigan's apartment. She's pretty accepting about my wild ways, having grown up with alcoholic parents. She's not one to cast stones, because she works as a dominatrix, catering to masochistic men, at a mob-owned joint on East Fifty-third Street. No sex involved, verbal abuse being her

specialty, but still, a dicey way to make a living. She's doing research for a book she's writing. So by night she's a scary creature from de Sade, by day she's a love-struck bobby-soxer. She studied Latin and Greek at St. John's in Sante Fe. A scrambled egghead.

I've never had an interest in S&M personally, which I explained to her. Not drawn to it in the slightest. She laughed and said it wasn't part of her needs—"Don't worry about it, I'm just doing it for background for my book." So began our carnal adventures. I made her promise to never bring her work home with her, not with me. I admit I ain't no angel, but I do find it a bit unsavory.

One downside was to do with Miles. He took one look at her, scowled, and went out the window to his rooftops, never to be seen again. What does he know that I don't? It was as if he said, "If she's stayin', I'm goin'."

July 10

Terry and I venture to a little cabin she has access to on the Severn River, near Annapolis, Maryland. We read, swim (she floats, she's a floater), make love on the screen porch, draw, write, eat shrimp, listen to Tom Waits. I call her Pony Girl because of her ponytail. She resembles an inflatable dinosaur. Or a goose . . . Also looks a bit like Stéphane Audran, Chabrol's muse. A five-day oasis of calm in an otherwise insane summer. I'm charmed by the little-girl quality about her. I jotted down her observations on a walk in the woods. "It's the ginkgos that make such furry shapes against the sky . . . Isn't that pretty, there's beans on that tree, there's flowers on that one . . . Look at that blade of grass, growing out of that step! . . . Look, little fruits. Pretty. These are my favorites. Smell . . . mmmm."

We hear the sound of panting. A dog walks by. "Look at his face! Look at that fiendish dog! He's laughing! That fiendish mouth was

made for yapping. He's a whitey." It's like being with a nine-year-old. She's given to the odd statement such as "Snakes know the future."

July 18

Meanwhile, back in the city, Son of Sam still up to his .44-caliber tricks.

I was meeting John Meaney for a drink last night, before the cinema, at the high-toned Sign of the Dove at Sixty-fifth and Third Avenue. Not my kind of place (expensive) but I was enjoying a vodka tonic nonetheless, looking at my Timex periodically. There was a nice-smelling man next to me in a bespoke seersucker suit. I couldn't see his face, but admired his fancy platinum watch, and the gold signet ring on his pinky. A dandy for sure. I hazarded a glance at his face. Oh my god, it's Lee Marvin! What?! I took a slug of my drink. I snuck another peek. This time he was smiling at me with a look I've come to know. "Hello there," he said suggestively. Fuck! How could Lee Marvin, of all people, be a "friend of Dorothy's"? This shakes the very foundations of belief. I looked closer. *Not* Lee Marvin at all, but someone who looks like his gay twin. "Uh, hi," I said, relieved that the world was restored to its former order.

July 21

Olive and her sister return from Prague. Since I fell for Terry in her absence, she switches over to Kramer, who's got a loft a block away on Fourteenth Street. There is much coming and going between the two residences. I had a tar beach party with Rene where we read *Howl* aloud, which was heightened by the rooftops around us and the Miles Davis floating out the windows. Very immediate. Very romantic.

August 10

I switched exclusively to oil paints this summer. Oil paint is the big game to me. At first it seems like they're working against you, colors getting muddy quickly. But then you find how forgiving they can be. Everything can be changed. Plus, when you're done, there's that satisfying mineral surface, unlike the plastic glare of acrylic. I like the smell. I worked on a painting of Jean Gabin in *Pépé le Moko* that was set up like one of Peter Blake's girl-wrestler pictures (borders within borders). Working on canvases of Rene, Colin Wilson, and Wyndham Lewis as well. Started a larger canvas that is a take on the famous photo of Burroughs and Co. in Tangier. I juxtapose me, Kramer, and Crosby into the gang. Trying to enter the Beat Generation with my oil paints.

I see a dapper art dealer around the scene, Julian Pretto, who asks if he can come see my work.

"Of course."

He does, and I get my ragtag group of canvases out, while he silently stares at each one. Finally he says, "Is this what you do?"

"Yah."

"But these are like 'real' paintings."

"I hope so," I say.

"Isn't it hard to do?"

"Yah, very hard. I hardly know what I'm doing, I'm learning as I go along. Trial and error."

"Then why do it?" he says.

"I just always wanted to be a painter."

"Hmmm. I just assumed you did something else." I could tell from his disappointed voice that he meant "something cool." Something more conceptual. Something that required little effort. Something that had quotes around it. If I was a young man about town, why would I devote myself to a dying medium? Didn't *ArtForum* proclaim

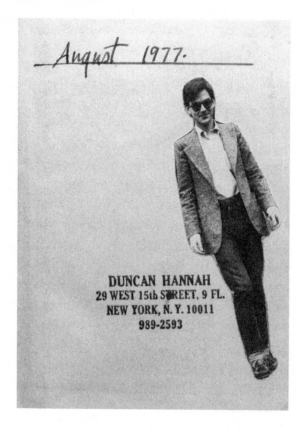

August 1977.

DUNCAN HANNAH
29 WEST 15th STREET, 9 FL.
NEW YORK, N.Y. 10011
989-2593

that painting was dead? Why would a bright guy like me persist in an obsolescent practice? He left.

August 14

Drinking at the little table in the 55 with the acerbic poet Jim Gardner. I passed out, he left, and when I came to I'd had my wallet lifted. I've finally been rolled! Whoever did it cashed a forged check for twenty dollars. Didn't even attempt to mimic my handwriting. But I lost my Social Security card, driver's license, etc. Serves me right to suffer.

August 16

Elvis Presley est MORT! Died on the crapper. An article in the *Voice* calls him "the World's Greatest Solipsist," which was a word new to me. (I know a lot of solipsists. Not a good way to be.) Elvis had been an embarrassment for many, many years. The fat! The schmaltz! The superhero capes! Vegas! Nixon!

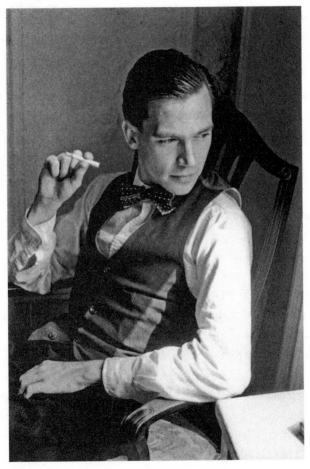

DH in dandy mode

August 21

Terry takes me for my twenty-fifth birthday dinner at Café des Artistes, where Harry Crosby made his exit in a friend's studio upstairs in 1929. Speaking of Harry, the portrait "I" did of him did not rest easily on my wall. It rattles, it quietly mutters, its eyes seem to move. I assumed I was simply losing my mind, due to the summer's excesses. I told no one. But then Kramer brought it up tentatively. He described the same paranormal activities that I had experienced. I corroborated his observations. Too creepy. The irony is, Harry was longing for the ultimate kick, death, which he assumed would deliver him to a phantasmagorical afterlife. But it appears he's still here. Stuck in limbo. In a state of unrest. Poor sod.

. . .

I hosted a birthday party for myself on a hot sunny day, sent out a xeroxed invite by Kramer, which portrayed me with a canine body, saying "Dog-gone it, how did I ever get to be 25?" The party attracted Ray Johnson, Diego Cortez, Anna Sui, Steven Meisel, various rockers, reprobates, miscreants, cigarette girls, denizens of the demimonde, inverts, nut jobs, and groupies. One arrival told me to open my mouth as he entered, and popped a pill in it. A Quaalude, I think. Whatever it was, it left me down for the count in a half an hour. I was forced to retreat to my bedroom while the party roared outside my door. I missed all the fun. Behind the eight-ball once again. Joey Ramone's cute girlfriend slipped in at one point, sat on the edge of the bed, and suggested we meet alone some afternoon, somewhere private, so that we could get to know each other better. She gave me her phone number written on a scrap of paper, and an open-mouthed birthday kiss. If Terry found out she'd kill me. Her worst fears confirmed. There is no wrath like that of an angry redhead.

September 2

Unmade Beds plays the Deauville Film Festival. Amos, Patti, and Eric are there partying with Warhol and John Waters. Godard and Truffaut saw it. Godard *liked* it! How is that possible? I stayed in NYC because my lease is up in a month, the building is going condo, and they want thirty thousand dollars for my small loft. Out of the question. I'm looking for a new place with Terry. The Village has suddenly got expensive. But we did find an ad in the *Voice* that said "Artists Studio, $450 a month," so we went up to take a look.

The old Hotel Alamac stands twenty stories tall at 160 West Seventy-first Street, overlooking what was once called Needle Park, left over from the late-sixties heroin epidemic. In fact, Jerry Schatzberg shot some of *The Panic in Needle Park* in the building. There was a Whelan's Drugs downstairs where the junkies would congregate.

The second-floor corner apartment used to be the Swedish Institute of Massage, a legit enterprise to teach Swedish massage. The second floor is all offices, which means no nighttime neighbors. A large commercial space, many doors, no kitchen, but a subway-tiled bathroom. Big central room that could be my studio, high ceilings, across from the beaux-arts Dorilton. West and north exposures, looking up Broadway to the Ansonia, where Flo Ziegfeld and Babe Ruth lived. A second bedroom Terry can use as her office. A block from the IRT subway station. Two blocks from the Hudson and three blocks from Central Park. Two blocks from John Lennon, in the posh Dakota, where Polanski set *Rosemary's Baby*. Plus, it would get me away from all my beatnik friends who drop in constantly with liquor, adding fuel to the fire. Those downtown snots won't schlep uptown. The way things are going, I'm not getting nearly enough work done living in the Village. And I won't improve without actually practicing my trade. Being "cool" ain't gonna cut it. They promised to install a

stove and fridge. We signed a lease. Dad has offered to chip in $150 a month, which will pay a third of the rent.

Later that night, about midnight, I was home working, and I get a call from Terry's place of work, the dungeon. "Someone went nuts with a gun," Mistress Vivienne said. "Terry's in the hospital . . . she's calling for you." Panic. Imagining her dying of gunshot wounds.

I rush up to New York Hospital and find her on a gurney, her forehead being sewn up with ten stitches by a nice doctor. What happened was, she was sitting at the entrance to her torture chamber, and an Italian gangster came in for a stickup. Wanted the cashbox. She refused, and he pistol-whipped her. It could have been a lot worse. A pretty face isn't safe in this city.

September 9

Rene takes me up to the Dakota for Leonard Bernstein's daughter's birthday party. Never been in there before. LB has a sprawling, plush second-floor apartment looking out on Central Park. The party is full of her snooty Yale friends. Amazing to be in this large sitting room, grand piano in the corner, on which he composed *West Side Story*, etc. The Ivy League kids are carrying on, blasting the Stones over and over. They don't care where they are. They're spoiled brats. At one point there's a lull, so I slip over and put Leonard's own copy of *West Side Story* on the hi-fi. It didn't last long. Some privileged motherfucker glared at me and said, "Are you trying to be funny?" He took the LP off noisily, *vrrrrrpt!*, and put the Stones back on for the tenth time.

Rene and I had a snoop around, looking at the celebrated man's interesting memorabilia. We even ventured into the master bedroom, where we were discovered being nosy by the returning Mrs. Bernstein. She was a bit alarmed, but Rene was instantly telling her about her Belgium lace collection. How does he know about *that*?!

She's very intrigued, getting on her knees to pull out drawers of the stuff. He elucidates her on each piece. Goes on for quite a while; she takes his phone number, with a promise to call. We left, deciding to take in the roof first.

"How do you know so much about Belgian lace?" I ask, as we look out over the panorama of nocturnal Central Park.

"I know about a lot of stuff," he says enigmatically, lighting up an unfiltered Camel. His conversational jujitsu keeps me on my toes. He is a wit atomizer.

"You'd never know there's so much trouble in this city judging from the pastoral view before us," I said.

"Olmsted's dream," says Rene.

Rene tells me about Fairfield Porter, the 1950s impressionist who went against the grain, transcribing the "dailiness" that lay before his eyes. A painterly response to poetry. Fairfield was in love with the poet James Schuyler, though married with children.

· · ·

I've been painting ghosts. An Arp-like shape hovering inside or outside a location of my choosing. Like Harry Crosby's bathroom, Monty Clift's townhouse, Shakespeare and Company. Also been painting the new apartment. Painted the living room Gauloises blue. The bedroom a dark-grayish brown with gold trim, that should help with hangovers. Terry painted her office a dark symbolist green. She loves Gabriele d'Annunzio. Writes in purple prose herself. She says, "Don't talk with your mouth open."

October 2. Wim Wenders's *The American Friend*. Love the scene where Bruno Ganz listens to the entire "Too Much on My Mind" by the Kinks in his workshop.

October 5. Terry's twenty-fifth birthday. Saw a matinee of Pasolini's *Salò* at the Cinema Village. I was periodically disgusted but Terry was turned on by the images of submission and brutality, and spontaneously gave me a blow job in the mostly empty theater. Kneeling in front of me in her Charles Jourdan boots on the sticky cinema floor.

October 6. The return of IGGY. Audience filled with phony Bolsheviks, trying to look mean, but instead just looking grouchy. Iggy turned on some hecklers tonight, saying, "Thanks, creeps . . . You were never that smart anyway . . . Do you know you're gonna die? How can you stand your face in the mirror? Thanks, fuckheads . . . Can you feel it? Can you feel that I'm better than you?"

October 23. Bill Evans at the Village Vanguard. He's bearded, bloated. Hunched over his piano, playing his sad songs. I heard he lives a block from me with writer Gene Lees on Seventy-first and West End Avenue. On a related note, the other day I was standing in line in the local branch of my Chase Manhattan bank. There was a drifter in front of me, dressed in a dirty double-knit denim leisure suit. I looked down at his feet, which were exposed in a pair of crappy sandals. Gross toes. Who is this junked-out desperado? He turned and scowled at me with his deeply lined face and sunken cheeks. It was Chet Baker, he of the angelic sounds. Sometimes bad people do good things.

Films
The American Friend
Salò
Mr. Klein

Julia
1900
Saturday Night Fever
Cry of the City
The Big Combo ("You're a beautiful woman, Rita,
but you're stupid.")
Thieves Like Us
They Live by Night
Kiss of Death

November 15. Balthus at the Pierre Matisse Gallery. He's a no-show. Does he not enjoy New York?

I love his combination of Courbet and French psychosexual melodrama.

December 17. Ray Johnson party. He looks like Sluggo. When I try to tell him a funny story, he just says, "Mmmm-hmmm." But then I'll get a missive in the mail, with some detail of my story that was completely beside the point, but *that's* what he focuses on. He's a lot like a cat. It's on his kooky terms.

February 23, 1978

Victor Bockris presents a one-night-only show of my paintings at his apartment. Alan Lewis Kleinberg took moody photos of the proceedings. Alan used to do hair for Avedon. Victor said John Lennon was coming; he didn't. Victor Hugo did, and offered to trade one of my paintings for a cum-stained sheet by him. "But you have to make me hard!" he added. No thanks. The things I have to put up with!

I showed:

1. *Twin Gynecologists*
2. *Harry Crosby*
3. *Montgomery Clift*
4. *Françoise Sagan* (sold)
5. *James Dean*
6. *Laurence Harvey*
7. *Burroughs in NYC*
8. *Alain Delon*
9. *The Strand* (self-portrait)
10. *Colin Wilson*
11. *René Clair*

Domestic melodramas. Terry and I are as bad as each other. I with my drinking, she with her delusional psychosis. We inflict mutual mental tortures on each other, loosely laid out like a semblance of love in El Madhouse. One night I was in an alcoholically induced state of paranoia. I was convinced there were Nazis in the other room looking for us. I made her lie on her back on the bedroom floor, and began to cover her with books, because they would "protect her." I was whispering, lest the Nazis hear me. The Nazis are usually burbling around in my subconscious. I hate Nazis.

She also has a side to her that is definitely "crazy." Jealous, brittle, schizo. We go together like guns and ammunition. Hope we snap out of this downward spiral. Will we look back on our present sufferings with a smile? For all our disharmony, our sex life remains healthy. We sometimes wake up in our sleep to find we are fucking. That's a first for me.

February 26. *The Foreigner* opens at the Millennium. J. Hoberman writes, "Max Menace, the anti-hero of Amos Poe's sodden attempt at

a 'blank generation' *Alphaville*, arrives in New York, moves into the Chelsea, and watches the Sex Pistols on TV and waits for instructions, which never quite come together. Neither does the film. A dead-ringer for Dobie Gillis, Max (Eric Mitchell) is terrorized by assorted thugs, shadowed by a female private eye, captured by a Lower East Side dominatrix, beaten up in the toilet of CBGB, chased down the Bowery, and, at long last, crucified in Battery Park. Punk deserves better."

April 30. *The Foreigner* plays at the Whitney as part of the New American Filmmakers series. The *Times*'s Tom Buckley gave it a very bad review. "No one in the cast, which includes a couple of comely young women, has the least idea of how to act, the story is infantile and the photography, sound and editing are primitive in a way that stopped being amusing ten years ago." He called it "the cinematic equivalent of kindergarten scribbles." Amos used this last quote on the poster. He embraces his liabilities.

June 8–12. Little off-season vacation in East Hampton, staying at the Hunting Inn on Main Street. Took the train out, rented two three-speed bikes from the hardware store. We pedal by the potato fields, Georgica Pond, the Maidstone Club, the graves of Sara and Gerald Murphy. Fresh air and sodomy by the sea. Terry eats garlicky frogs' legs. She likes dipping into the ol' terrarium. She says, "I could eat frogs forever." There's a very good used-paperback store that is chock-full of treasure. Nothing I love more than inspecting a row of pocketbooks. Mysteries inside! I always have a look at the bookcase in a strange apartment—know the books, know the man! I'm reading Faulkner's *The Wild Palms*, which is terrific.

Records

Symphony of the Winds, Stravinsky

Piano Works, Erik Satie

Trois Chansons, Maurice Ravel

Music for 18 Musicians, Steve Reich

Sarah Vaughan in Hi-Fi

One sifts through the endless cultural offerings. It's a bombardment of sensation. That's what Manhattan is all about. One must be discriminating. I'm tired of the irony of pop art. Irony is overrated. Tired of the ambivalence so in vogue. I'm not swayed by the flavor du jour. Give me Jules Pascin any day. Or the two dozen self-portraits by Schiele over at Sabarsky.

I was shopping in the Pioneer supermarket on Columbus Avenue, picking up some apples and Raisin Bran. Who do I spot but Dashiell Hammett's old girlfriend Lillian Hellman, looking like she had just smoked a trillion cigarettes. He left her briefly for ingénue Patricia Neal, and they made mad passionate love at 20 West Tenth Street. I'd have done it too.

EUROPE

Time to go back to Europe. Been six years for me. *The Foreigner* has been accepted at the Deauville Film Festival and Amos assures us that we'll be put up royally. We sublet the apartment to a Eurotrash Italian named Paolo and left.

September 2. NY–London. Ridiculous punk clones on the Kings Road. Spitting. Giving everyone the finger. Give me a break, you cookie-cutter morons.

Took the ferry from Dover to Rouen, Pernod in hand, standing on deck with a sense of history, squinting into the sea air. Spent the night, then got on a train for Deauville, where we found Amos ensconced in the Normandie Hotel. He answered the door in his robe and said, "Duncan, Terry, what are you doing here?" Not a good start. We walk to the casino, which is the festival headquarters. JFK's pal, Pierre Salinger, is kicking off the proceedings in the main theater. He's making a speech to welcome us to the fourth annual festival, and inviting notables onstage, such as King Vidor, Gloria Swanson, Robert Stack (Eliot Ness!), Kirk Douglas (van Gogh!), and then . . . Duncan Hannah. What?! I am hungover and jet-lagged, but pull myself together and trundle onstage in my blue jeans and black leather jacket, going through the gauntlet of these luminaries shaking hands. "How ya doin', King?" I mutter to the ancient director. Amos and Terry are called out too, so we're all standing up there, fac-

ing the press, the film industry, the fans. We're impostors! Just some lowlife from downtown Gotham. Surreal!

Thus began a week of screenings, parties, and just lolling about in the main lounge of the casino, quaffing down the free champagne contributed by Mumms (12 p.m.–12 a.m. every day . . . trouble). "Let's stay high on champagne the whole time," says Terry. She speaks French, so translates for me. Trouble is, she translates English for me too, headstrong Irish girl that she is. We were put up in the très élégant Normandie Hotel, completely free of charge. We watched our morning lovemaking in the big mirrored wardrobe, our room-service-breakfast litter on the polished desk. We had fun dressing up every day for the deluxe events, tidy receptions, pretty garden parties, etc. Everyone has chic clothes, lots of style, lots of cash.

Photographer Marcia Resnick showed up at our room, direct from Paul Bowles's joint in Tangier. She's got pictures to prove it. She's crashing the festival. Savvy Marcia.

We met some Parisian film kids named Rémy and Berndt. Berndt, who always wears an ascot, gave me a bottle of Guerlain's Vetiver, because I had commented on how nice he smelled. Sweet. They wanted to hear firsthand reports from the NYC front line about the Ramones, Blondie, Dolls, etc. I wanted to hear about Delon. They said he was a right-wing pig and a murderer. Just another mainstream asshole. "You like him?!" dapper Rémy asked, disappointed.

"Well, isn't it interesting that a guy who often plays killers is, perhaps, a murderer?" I ventured.

"It's like being a fan of Robert Redford . . . mainstream!" they explained. "He's just part of the ubiquitous French scenery. Tell us about Johnny Thunders," they said.

"Johnny Thunders! He's just a moronic junkie!" I countered. I guess the grass is always greener. We lamented the death of Keith Moon, just three days ago. OD.

Down and out in Deauville. Milling around the lobby waiting

for screenings and press interviews were Susan Sarandon, Robbe-Grillet, George Peppard, Leslie Caron, John Waters (who told us dirty jokes), and the mayor of Deauville. The press says our film, *The Foreigner*, "captures exactly the sense of rootlessness, moral ambiguity, and alienation which makes up a major part of the atmosphere of America's major cities." Highfalutin.

One day, Amos, Terry, and I had lunch with King Vidor (who's really a queen, not a king) and Gloria Swanson outdoors on the boardwalk. I told her I'd seen her at Candy Darling's funeral. "I don't know who that is," she said sharply. She was very like Norma Desmond. A creature from another time. Amos asked King questions about filming in the silent era. One year he shot fourteen films. After lunch I walked the beach with Berndt, who drew a Tyrannosaurus rex in the sand. He told me of his suicide attempt and how sometimes it is so hard to live. I was reflecting on how I'd been to Deauville with my parents twelve years ago. We'd been to Normandy beach, wandering through the endless field of white crosses, from all the American boys who had died on D-day. They found it hard to live, too. They was robbed. Gypped.

The rumor going around was that John Travolta was holed up in Trouville with his friend. We wanted him to stop being such a star and come down and play with us! Funny John Waters in particular wanted his company. Finally the big night of the *Grease* premiere came, and Travolta and Olivia Newton-John arrived, looking stellar. Terry and I sat behind them in the cinema and we watched the movie together. It was great, I have to say. At the end, there was a standing ovation, and John turned around and flashed his thousand-watt smile on the rapturous audience. Star power! The spotlights reflected off his gleaming white teeth and beamed around the nineteenth-century theater.

Terry and I weren't invited to the closing night's party, but watched the guests file in on the Grand Palais's muffled floral carpet as the

flashbulbs popped. Françoise Sagan herself walked along the regal hall, past the chandeliers and gilded mirrors. She was laughing. She'd probably been here a lot, this being the kind of place favored in her books. Where the idle rich come to gamble and misbehave.

September 13–27, Venice

We got a night train from Paris to Venice, filled with American fashion models going to Milan for the collections. Bottles of red were produced from bags, passed around. I envied their gypsy lives.

· · ·

Casa Frollo on Giudecca is our new home for two weeks after the nonstop party that was Deauville. Large bedroom, breakfast in the piazza. I'm reading *Roderick Hudson* by Henry James. Plus, Harry Crosby's diaries (*Shadows of the Sun*), which are very funny. He's like a naughty kid. I crouch on the stone floor and make collages with the scraps I've picked up during our trip (and glue from the stationers). European packaging has much better color than the USA's. The collages instantly look more classical, more European. Listening to the new silver transistor radio which pulls in the distant Radio Luxembourg. Is that Kraftwerk? Or just static? Hard to tell. Wearing my new V-neck sweater. Playing with the two elegant Italian switchblades I bought. Such beautiful objects. Not writing so much anymore because I'm reading more? Too drunk? Living with a writer? Terry *is* writing all the time.

We take the vaporetto to the mainland. They're filming *A Little Romance* with Laurence Olivier and Diane Lane in San Marco square. Sit and watch the action with a retsina and the pigeons. Have another cocktail at the Gritti Palace. Another at crowded Harry's Bar. We wander into the night, get lost in the watery maze, wind up where we started off, it's like a dream. Dinner at Trattoria Ai Cugnai. Stand-

Giudecca collage by DH

ing in an illuminated courtyard, with long, sinister shadows. Like a Balthus stage set. Balthus must be here too, he's the featured artist at the Venice Biennale. Walking over an arched footbridge, I see a dead cat in the canal. My stomach is full of rough grappa. We miss the last launch to Giudecca, so we get a water taxi, a low-slung Chris-Craft of polished wood and leather. I'm flopped in the back as we surge into action; the Rialto recedes from view. The mossy pilings punctuating the black water. Colors that would swallow up all colors. I hear the liquid music of the Venetian night. I must paint this sensation, to be drunk in this runabout, the blurred lights of Venice merging with the rooster tail of churned-up froth. This is intoxication at its finest. Euphoria.

We venture to the long, skinny Lido, walking towards the beach through the shaded Gran Viale with its striped tents, full Italian ices,

DH in Venice

soccer balls in nets, straw hats. *Death in Venice* fluttering through my mind. Tadzio. The Excelsior Hotel. Uniformed bellboys. The season is over, it's deserted. I strip down to my boxers and step into the icy Adriatic and swim out as far as I can, because Harry Crosby did, a long time ago. Dead man's challenge. My heart is stunned by the freezing temperature. Is this it? No. I live to face another day.

Peggy Guggenheim's small museum. She herself is sitting in the garden at the exit. She's been around the block a few times. Starts asking me questions with a slightly flirtatious manner.

September 27—Drunk in Paris

Staying on Boulevard Raspail, at the Hotel de la Paix, room for two about $18. I pee in the sink. Modigliani's studio was in this old building. The Dôme just at the corner for my morning café crème and croissant. Mansard roofs everywhere. We drink at the legendary local joints, La Coupole, the Jockey, Closerie des Lilas, and the Rotonde,

where gypsies make a spectacle of goats climbing a stepladder and climbing back down.

We visit Père Lachaise Cemetery, where Amedeo Modigliani (1884–1920) and Jeanne Hébuterne (1898–1920) are laid to rest. She defenestrated at age twenty-two, unable to live without her Modi. Bit of hard cheese on their daughter. The black marble slab plastered with wet yellow and orange autumn leaves. Reverie for the dear departed. Pungent smell of chestnuts.

One night I met Amos and his French girlfriend, Lily, for a few drinks in Montparnasse. (Terry was back in the room with bronchitis.) Upon leaving them, I promptly got lost. I was happy to wander the empty cobbled streets in the mist. Found myself by the outside wall of a cemetery. A figure fell in beside me. I could see his breath out of the corner of my eye. Hear his breathing. It was Modigliani. Black corduroy suit, maroon scarf, broad-brimmed hat, workman's boots. Ghastly pallor, as if he was made of tallow. Vaguely phospho-

DH at Modigliani's grave in Paris

rescent. What could one say? I was both honored and frightened. He's been dead for almost sixty years. It struck me that this poor guy never moved on, why is he still here? He should be in some kind of paradise. We were walking abreast of one another. I finally said, "It's you."

"Yes . . . you summoned me," or something to that effect. Did we speak English? French? I don't know. Was it telepathic?

"Are you here?" I asked sympathetically. I hope not.

"I'm everywhere," he said. That's good, I thought. Everywhere is good. We walked on. I could hear our footsteps in tandem. *Clop, clop, clop.* He turned his drawn face slightly towards mine, his moist black eyes glittering like marbles in the gloom. "You carry on," he advised. And with that, he forked off, and disappeared in the mist. *Poof.* Good exit. I was profoundly moved by this paranormal visitation. I stopped and breathed in deeply. It makes sense in a way, my psychic extremities being conducive to the afterworld's switchboard.

When I finally found my hotel, Terry was in one of her jealous rages. Demanding to know who I'd been with. Just Amos and Lily, I repeated. She said no, I'd been with someone else, she knew it! Who! Who! Who!

I relented, and said, "Okay, I *have* been with someone."

"Who?!"

"Modigliani." She screamed that I was a liar and pitched an ashtray at my head, which narrowly missed my eye. So much for my encounter with the shadow world. Modi didn't prove to be much of an alibi.

· · ·

One night a gay guy we met in Venice (Patrick) had a dinner party for me and Terry in Paris. He thought we were like Scott and Zelda. (Gays love Terry because she's a bit like a drag queen herself. They appreciate her bitchiness. Me, not so much.) He warned me not to

overindulge, because he was going to invite some Parisian intelligentsia that could benefit my career. I showed up very drunk, and was seated next to international art dealer Ileana Sonnabend, an old crone who I found to be extremely pompous and condescending, and eventually told her so. I do not suffer arrogant fools gladly, when I've had as many beverages as I'd had that day. She was going on about the spirituality of Kupka (a painter I've always found rather tepid), and I asked her how would she know, since she was devoid of a soul? My host turned green. Time to go. I lurched out.

In the morning Patrick called our hotel room. I began to apologize, and he stopped me. "No, no, no, it's fine, you were a huge hit, they couldn't stop talking about the young 'ange maudit' from New York."

I was shocked. "But I behaved abominably, why did they respond like that?"

"Because Charles Bukowski was here last month, and was so rude that everyone decided he was a genius. Now you come along, with more of the same. They loved it!"

Ha! Saved by Bukowski! They think boorishness is the latest movement from the USA. Maybe it always was.

. . .

One day Terry and I were hanging out by the Pompidou Center, having just seen a Tamara de Lempicka show that was pretty cool. And who should we run into but old pal Josef Astor, who has relocated to Paris to do some male modeling. He was with Brion Gysin. We go off for a drink and Josef fills me in on news from NYC. Apparently there was a roof party in TriBeCa with the old Minneapolis gang. Kramer was drunkenly dancing on the rooftop's edge in oversize cowboy boots, playing the daredevil for some girls (his old party trick). They turned away so as to not encourage him. When they turned back he was gone. They looked over the edge. He'd not gone down the twelve flights, but only one and a half, landing on his face. A pool of blood

was spreading. McDermott and Peter Nolan Smith climbed down a ladder to see if he was alive. He was. But he'd broken most of the things you could break. They got him into an ambulance with great difficulty.

Consequently, he was pieced back together from photographs (his head was the size of a jack-o-lantern), lots of traction, bolts, wired jaws, etc. Horrifying. The writing is on the wall. This is my second friend to go off a roof.

. . .

The rest of Paris was a blur of the Louvre (love David's self-portrait), Eiffel Tower, Pigalle, Harry Crosby's apartment at 19 rue de Lille, the Ritz Bar, the Pont-Royal bar, Cour de Rohan (Balthus), Beat Hotel (9 rue Git-le-Coeur), Lapin Agile, boat pond in Luxembourg Gardens, Le Palace discotheque, etc. Real French poodles.

ADRIFT IN NEW YORK

October 12, London to New York, 1978

In the cab on the way home from JFK the radio newsman says Sid Vicious is in jail, being held for the murder of Nancy Spungen in the Chelsea Hotel last night. Welcome home. I remember my one run-in with her. I was going to visit Kristian and Lance. She lived in their building. A stripper and a junkie. We got in the elevator together in the lobby. As the doors closed she asked if I was going to visit those guys. Yes. She asked if I had any drugs? No. She said I was cute and offered me a blow job. "Not today, thanks," I said. I didn't even know who she was. When I got to Lance's apartment, I told him about my ride with his skanky peroxided neighbor. "Ha ha ha, you've just met Nancy Spungen. It's not the first time she's propositioned one of our visitors. She's a pest!" He thought this all very funny. The trick is to live as if you're going to die, and then not die. Didn't work out that way for Nancy.

Our Italian subletters had trashed our apartment. Plus run up a $515 long-distance phone bill. Ugh. At least Kuku the cat is okay.

Books
Piracy, Michael Arlen
The Razor's Edge, Somerset Maugham
Those Who Walk Away, Patricia Highsmith
The Human Factor, Graham Greene
The Honorary Consul, Graham Greene
Humboldt's Gift, Saul Bellow

Vanity of Duluoz, Jack Kerouac
Delta of Venus, Anaïs Nin
Exiles, Michael J. Arlen
The Flying Dutchman, Michael Arlen
Truffaut/Hitchcock
The Sheltering Sky, Paul Bowles
Without Stopping, Paul Bowles
Tristessa, Jack Kerouac
Exile's Return, Malcolm Cowley
My Name Is Archer, Ross Macdonald
The Tremor of Forgery, Patricia Highsmith
The Paris Diary and *The New York Diary,* Ned Rorem
The Green Man, Kingsley Amis

The Brothel at 211 East Fifty-third Street

I stop at Terry's on my way home from a night of drinking down-town. She's with a client, so I sit in the "waiting room" of the straight whorehouse down the hall, run by the same mobsters who operate the torture chamber. Eight women per shift. No décor to speak of. We might as well be in a doctor's office. The girls are friendly enough, offer me a drink. Not particularly attractive. Gaudy getups. They're talking about who cocked their pussies last. They get fifty dollars an hour. They yawn. They smoke.

Terry comes in, with a whopping wad of cash from tonight's slaves. She doesn't have sex with her johns, far from it. She messes with their sick psyches. I don't know how she can do it. She's not exactly a testament to sanity herself. I fear this will push her over the edge. It *has* to take its toll on her. How could it not? What about karma? But you know what they say about people who live in glass houses . . . I'm not exactly a saint myself. I'm fucked up! We get a cab home. Terry reads her tarot cards. She is studying the occult.

White magick, she says. What if she gets black by accident? Summon a demon by mistake?

· · ·

In my dreams I write books. Literally. Then I read them. They're not bad. I was reading one in my dream, and marveling at the beautiful prose when Doc Bray appeared at my apartment door. I let him in, and told him that I'd just been reading something *so* lyrical! How amazing it was, the brain, to be able to write, then read, all in a

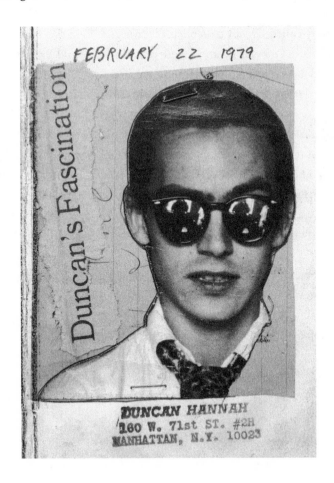

dream! "I can still see it," and closed my eyes and read aloud the after-image of the text. When I finished, I said, "Pretty good, huh?"

"Yah, and it always was, too. That's the last paragraph of *Moby-Dick*, you dope."

"But I've never read *Moby-Dick*! How could it get into my brain?" He didn't believe me, but I checked in a bookstore later, and sure enough, those were the words I saw. Where did they come from? Who *else* is using my brain?

. . .

Doc Bray called Crosby a "foolish dirt mound." That's an insult I've never heard. One day he and I were mooching around Brooks Brothers, and I looked at the person across from me, sorting through men's pajamas. Brown watch cap, brown overcoat, slacks, brogues. A woman. I recognized something in the eyes and mouth. GARBO! I played it cool, and somehow we all drifted into the elevator, Doc Bray too. That most private of all retired film stars bowed her head. I gently gave Doc a kick in the shin as we rode up to the third floor. I gave him a sign with my eyes as to the third of our grouping.

"What is it with you?" Doc said. At three Garbo made a speedy exit, knowing her cover was blown, at least for one of us. She was gone.

Doc said, "What are you up to?"

"That was Garbo, you blockhead!"

"What, that old bag in men's clothes? No it wasn't."

"It totally was, and you scared her off!"

New Paintings
Maurice Ravel
Paul Bowles
Harry's Bar
Kuku's Garage

On the Channel
Pascin in the Rotonde
The Ghost of 61st Street
The Haunted Bookshop
Ned Rorem
Archery
The Girl With the Flaxen Hair

New Movies
Diabolique
The Wages of Fear
Violette
Remember My Name
Cabaret
Days of Heaven
Apocalypse Now
The Shining
Close Encounters of the Third Kind
Céline and Julie Go Boating

New Records
Chairs Missing, Wire
Manifesto, Roxy Music
The Rascals' Greatest Hits
Goodbye and Hello, Tim Buckley
The Lodger, David Bowie
Hot Rats, Frank Zappa
Preludes, Debussy
See You at the Fair, Ben Webster
Desmond Blue, Paul Desmond
E.S.P., Miles Davis
Seven Steps to Heaven, Miles Davis

Blues and the Abstract Truth, Oliver Nelson
Something Cool, June Christy
Lionheart, Kate Bush

December 1

Film premiere of *Elaine: A Story of Lost Love* at One Sheridan Square. J. Hoberman writes, "Andrew Horn and John Meaney have adapted a de Maupassant story into a well-crafted, if precious, vehicle for Black-Eyed Susan and other luminaries of the Ridiculous Theater Company." With Adam McAdam, Lisa Jane Persky, and me. Showing with *Still Moving—Patti Smith* by Robert Mapplethorpe, *Joan's Face* by Barry Shill, and *Tarzam* by Rudy Burckhardt (starring Taylor Mead). Showtime at 11 p.m. $2.75. It was black-and-white but tinted with colors.

· · ·

A work of art needs a set of rules. In an avant-garde world the real risk might be in being a neoconservative. Sometimes painting is a form of wishful thinking. Escapism. A way to balance out an irrational world. I'm interested in an art that lasts.

· · ·

I walked down to the only rock club in my neighborhood, Hurrah. Run by impresario Jim Fouratt. Tonight there was a kerfuffle, because dim bulb Sid Vicious, who's out on bail, had a brief altercation with Patti Smith's brother, Todd, and in no time at all he cut Todd's cheek open with a broken glass, narrowly missing his eye. There was screaming and shouting and overturned stools and cops. I was thinking, if this is punk, forget it. Stupid, mindless posturing from a sodden moron. Back to Rikers for Sid. I walked back home.

· · ·

Jean Seberg dead at forty. She was found in a car in Paris with a bottle of barbiturates. She'd been undergoing psychiatric treatment. The FBI had been hassling her.

I went to a Brassaï photography show at Marlborough and the man himself was sitting alone in a corner. Big, bulging eyes. Also Matisse drawing show at the Guggenheim.

I have a new friend, Bart Gorin from Chicago. Came to New York to be a hustler. Best friends with Ray Johnson. They go down to the Anvil every night. He is very funny and debonair in a rumpled-preppy kind of way. I go over to his apartment on Seventy-second Street to watch a cable TV show called *TV Party* hosted by Glenn O'Brien. It's like a new-wave version of *Playboy After Dark*. Glenn loves Hugh Hefner. Who doesn't?

Also Jimmy DeSana, a diminutive photographer I met through the *FILE* magazine crowd. He had a famous image of himself hanging by the neck naked (with an erection). His boyfriend is Robert Stefanotti, who has a Fifty-seventh Street gallery. Jimmy lives on Sixth Avenue. Cruises in Bryant Park at night for cutthroat Puerto Rican boys. Jimmy is quiet and droll, and likes to go to parties with me. He looks a little like Tyrone Power. He hardly drinks.

My body is trying to kill me. My heartbeat jars my vision. The jangle of my own blood is in my ears.

Saw the Clash at the Academy of Music. Fucking great!

We've got a beautiful new kitten called Lucien. He's gray and white, and Kuku is in love with him. So am I. Nothing like a kitten to bring a smile to your face. He is chronically unemployed. Loses interest fast. Hired and fired with a switch of the tail.

· · ·

Terry went to DC to visit her (separated) parents. I laid in some supplies. I went to the *New York* magazine Xmas party and checked my new brown tweed herringbone topcoat from Brooks Brothers (gift

from Dad). I had several drinks, wandering around the desks, thinking about office parties I'd seen in the movies (e.g., *The Apartment*). I said Merry Christmas to Mayor Ed Koch. "How am I doing?" was his stock reply. I had to get downtown to Tier 3, so looked for my coat. I found one that *might've* been it, so put it on and took the train down to West Broadway, where X from Los Angeles was playing. Gordon Stevenson is married to singer Exene's sister, Mireille, so I was introduced to Exene and frontman John Doe. Exene came on to me in a catlike way, telling me she and her husband, John, had an "understanding." She must've smelled the doom in me. Some girls are attracted to beauty in ruins like moths to a flame. It's a kind of bad chemistry. I didn't fancy the idea and took my drunken leave.

I must've overshot on the subway, because I couldn't find my apartment building. They all looked alike to me. It was snowing pretty hard, and I was running out of gas, so I stopped in one that vaguely resembled mine and pushed the elevator button. The doorman said, "Hey, where ya goin'?"

"Home," I replied in a surly voice.

"You don't live here!"

"Aw, leave me alone," and I curled up on a couch in the lobby.

"Hey! You can't sleep there! Get outta here right now before I call the cops!"

I collected myself, cursing the inhumanity of the world, and stepped back out into the blizzard. By some miracle, I *did* find my apartment building, and took the elevator to the second floor, dug in my coat pocket for the key. No key! Wrong coat! *Fuck!* I had a bright idea: the laundry room was on my floor, and there was an empty closet that I might tuck into for the night! I wandered in, and sure enough, there was just the spot for my drunken slumber. I closed the door behind me and settled on the dirty floor. Zzzzzz.

In the morning I awoke in my dark chamber to the sound of a nice

yuppie couple doing their laundry. Hmmm, what to do? I listened to their gay repartee, presuming themselves alone. Ten minutes went by. Only one way out. I stood up, brushed some dust kittens off my gray flannel suit, straightened my fedora, and entered the brightly lit room. They stood back, horrified. I tipped my hat, and said "Good morning" and sauntered out. That's a scene they won't soon forget.

· · ·

I did a job with M. & Co. (25 West Thirty-ninth)—Tibor Kalman and Carol Bokuniewicz—for Paragon sporting-goods store. Pretty awful. Then they borrowed my collage book and did a record cover for the Stones. A collage. Coincidence? Maybe not. I did spots for *High Times*, CBS Records, lots of *New York* magazine. Still living below the poverty level. But it's moving. Stasis is the enemy.

· · ·

e.e. cummings writes about Harry Crosby:

> *2 boston*
> *Dolls; found*
> *with*
> *Holes in each other*
>
> *'s lullaby and*
> *other lulla wise by Unbroken*
> *LULLAlullaby BY*
> *the She-in-him with*
> *the He-in-her (&*
>
> *both all hopped*
> *up) prettily*

More Books

Ghost Story, Peter Straub
Mysteries, Knut Hamsun
Our Mother's House, Julian Gloag
Other Voices, Other Rooms, Truman Capote
The Country Girls, Edna O'Brien
The Girl with the Green Eyes, Edna O'Brien
Spy Story, Len Deighton
The Disenchanted, Budd Schulberg
The Pat Hobby Stories, F. Scott Fitzgerald
The Big Knockover, Dashiell Hammett
New Work, Joe Brainard
Selected Work, Joe Brainard
Le Chat, Colette
The Crack-Up, F. Scott Fitzgerald
Miss Lonelyhearts, Nathanael West
The Snow Was Black, Georges Simenon
The Deer Park, Norman Mailer
The Final Diary, Ned Rorem
Giovanni's Room, James Baldwin

February 27, 1980

Beyond the New Wave, an exhibition of representational paintings at Club 57, 57 St. Mark's Place. It was the brainchild of McDermott, who brought in a couple other painters. We rented the kooky nightclub for the night from almond-eyed Ann Magnuson, for a hundred dollars. We were hoping to lure *real* art dealers from SoHo or Fifty-seventh Street, so we could start being *real* painters. I showed eleven paintings, the most expensive being the *Twin Gynecologists* at $750. McDermott pulled out a couple days before, because we vetoed some screwball idea he had. I said it was a democracy. This inflamed him.

19 rue de Lille *(Harry Crosby's Paris bathroom)*

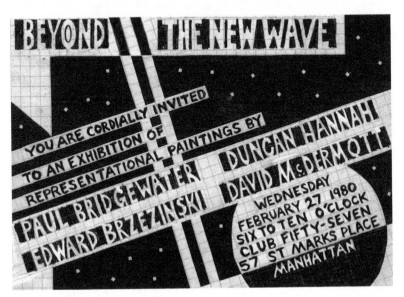

BEYOND THE NEW WAVE

YOU ARE CORDIALLY INVITED TO AN EXHIBITION OF REPRESENTATIONAL PAINTINGS BY PAUL BRIDGEWATER EDWARD BRZEZINSKI DUNCAN HANNAH DAVID McDERMOTT

WEDNESDAY FEBRUARY 27 1980 SIX TO TEN O'CLOCK CLUB FIFTY-SEVEN 57 ST MARKS PLACE MANHATTAN

Flyer by DH for the Club 57 show

He said, "Who cares about painting anyway, I don't!" and left with a slamming of the door. He thought us losers should all be grateful to be under the wing of a genius P. T. Barnum–type entrepreneur, such as he. Edward Brzezinski enlisted a second-generation New York school poet, Tim Dlugos, from Washington, DC, to write an essay for our Insty-Print program. He bought one of my pictures, called *The Second Ghost Painting* ($500). We invited all our friends.

Ray Johnson came, smelling of Acqua di Selva. Bart in a cowboy hat (Black Bart). Painter Frank Moore. Joe Brainard. Blond appropriationist Sarah Charlesworth. Howard Read from Robert Miller. The *East Village Eye*. Betsy Sussler. Kathy Acker. Amos Poe.

· · ·

So much of contemporary art seems like empty things for empty people. Clichés aren't clichés if you happen to believe in them. I use the New York Picture Library for illustration, and also for my "personal" work. Nothing like poring through folders full of pictures to get the imagination going. Images that trigger the mind in different directions. Staircases, viaducts, embankments, motorboats, mirrors, curtains, subways, a kind of visual free association. I spend a lot of time in there, accumulating a stack of mounted pictures that I'll check out and ponder for a couple weeks. A representational painter needs subject matters dear to him, or at least challenging. "What could I do with that? Maybe incorporate that thing that Hopper does?" Plus, I can travel through the ages, not restricted by "today," which I'm not aesthetically sold on anyhow. Free to roam. Walking in others' footsteps to see how it feels, how it fits. The endless collective image bank crying out for reinterpretation. A vast resource of raw material. It's a great way of honing my sensibilities. Fine-tuning my antennae.

One of my themes is a dream of Europe. Not necessarily the way it is, but the way it existed in my mind before I had a handle on it. I

remember when I was ten and seeing it for the first time, how every-
thing seemed foreign, even the gas stations and airports, things that
were familiar yet alien at the same time. I know this, I don't know
this. Forced me to look harder, which is what separates painters from
civilians. So I'd ask myself questions. What is the visual information
that is unsettling me? What's different? What is the essence of "old
Europe," of "foreignness"? What might that look like? How could you
add the atmosphere of a thriller to a cityscape without painting like
a pulp illustrator? How to suggest psychological tension without any
actually being enacted? How does "love" look?

· · ·

Big Picasso show opens at MoMA. Love the early work. Rose period.
Saltimbanques. Sloppy neoclassicism. Before he began to believe in
his own myth.

May 1980

Saw the Pretenders at the Academy of Music. What a sound. They
tore it up! Proper rock stars.

Went to a loft party at Vito Acconci's with writer Judy Lopatin. We
were drunk on cheap red wine. It was dark and loud. Who should
enter, most incongruously, but French film idol Jean-Pierre Aumont
(*Lili*) and his naughty daughter Tina (*Partner*). Looking like a couple.
So glamorous. Checking out New York's underground. Judy and I
retired to a corner to make out.

> "I hope that before the no-wavers disappear into some
> irresistible sewer someone decides to make a film in which
> there is some tension between the camera and its subject:
> The Mudd Club à la Late Visconti."
> —*SoHo Weekly News*

New joint opened at 77 White Street in TriBeCa, called the Mudd Club. Situated in a narrow industrial street, with deserted alleyways. Very noir. Darkness stained with light. Inside, a whole new crop of arty kids getting high. Hard-up artists being good to their mad little sins. Second-string literary figures in their mucked-up finery. Mr. Miltown and the Cognac Cowboy burying their faces in fumes. Doing them good by doing them in. A gaggle of ugly girls in major-ette boots ashamed of being unhappy. New boys at large looking for hot monkey love. A climate of narcotics. A neurosis in the air mis-taken for energy. The new pissiness.

Saw a fresh new band from Athens, Georgia, called the B-52's. The singer wore a seersucker jacket and white bucks like he was going to a southern country-club dance. Pencil mustache. The girls had bee-hive hairdos and satin prom dresses. The crowd of aspiring whatev-ers loved them. Dancing to their single, "Rock Lobster." Afterwards we had chocolate egg creams and cheeseburgers at the brightly lit Dave's Luncheonette on Canal Street.

We've been running into the new bohemians as they settle into this new scene that's unfolding at the Mudd. Cookie Mueller, gor-geous Anna Schroeder, pale Wendy Whitelaw, William Coupon, Kirsten Bates, Edo, Maripol, Kate Simon, Bobby Grossman, Stephen Mueller, Jean-Michel Basquiat, Marcus Leatherdale, Claudia Sum-mers, Anita Sarko, Stephen Saban, David Armstrong, Lisa Stroud, Glenn O'Brien, Tina L'Hotsky, Hal Ludacer, Gordon Stevenson, James Chance, Lisa Rosen, James Nares, the Lurie brothers (John and Evan), Duncan Smith, Haoui Montaug, David Rattray, and Dr. Mudd himself, Steve Mass. All regulars at this den of iniquity. They go night after night and the night after that. Terry and I even brought director Jerzy Skolimowski down there. We loved his new film *The Shout* (with Alan Bates and Susannah York). We'd interviewed him in his hotel suite for the *SoHo News*. Funny to see a European intel-

lectual survey this decadent scene with gravitas. Rubbing his chin and casting his eyes left and right.

Saw the Cramps play the Mudd, and Bockris and I went down to the basement dressing room. They were ghoulish and sweaty, and Lux Interior made a running dive, catapulted over the back of the couch, and landed on his head on the cement floor. Knocked himself unconscious. Poison Ivy looked on uninterestedly. These guys are hard-core.

New Films
Gloria
Lou Lou
Every Man for Himself
Stardust Memories
Peppermint Soda

Terry and I go over to Kathy Acker's East Village apartment, which is *full* of books. She's one of the most passionate readers I've ever met. I don't really care for her work, sadly, but I certainly like her. Totally lively, funny, nonjudgmental character. She used to perform in live sex shows on Times Square. We talk about Scottish author Alexander Trocchi, and she lends me several out-of-print editions.

Kathy and her current boyfriend, Jeff Goldberg (who's writing a book on opium called *Flowers in the Blood*), invite me and Terry up to Bard for a reading she's giving. Not a good idea, because I've been on a long, exhausting bender. It's kind of like having the flu. Never sober and yet always hungover. Totally in the grips of John Barleycorn. I have to let nature take its course. I would be hard pressed to describe a bender at this point in my life as "fun." But we go nonetheless, get on the train in my beautiful caramel-colored tweed Cerutti suit and small valise full of vodka bottles. The Hudson whooshes

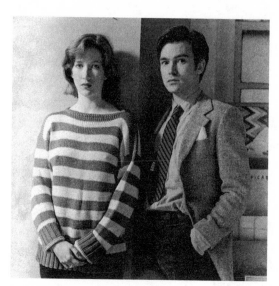

Terry Sellers and DH

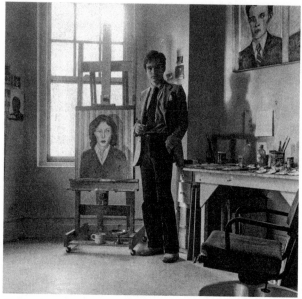

DH in his West Seventy-first Street studio with portrait of Terry Sellers

past. We arrive at the Manor House for the reading, which is straight out of an old English drawing-room murder movie, and we're sitting in back as Kathy reads. I begin to flip out. I start heckling Kathy. She laughs and has some fast comebacks for me. The students shush me. The English teachers are angry. The only person who *doesn't* mind is Kathy herself! She thinks it's theater! Bless her.

The next chapter of this blackout finds me alone and lost on the campus roads, under the dark brown sky, perforated with stars. The dark so dark it had motion. Security discovered me ranting to no one in a ditch in a horizontal position. When I stood up my pants fell down. Bit of slapstick humor thrown in for good measure. How ignoble! I was returned to the room we were given, Terry was hearing voices in her head, and she stabbed me in the chest with a small penknife she keeps in her bag. The little blade bounced off a bone. A searing bulb of pain. Ouch! This because the voices were teasing her about my so-called "harem."

"Terry, there is no *harem*!" But the voices insisted. I couldn't talk her down.

All in all, a disgraceful return to my alma mater.

. . .

Back at the NY Public Library, atoning for my sins. Looking up files on attics, the sides of ships, tunnels, movie theaters, burglars, military schools, gates, garages, poplars, lion tamers. I'm gonna try painting with spiritual butter. The trick is to keep on wanting something.

. . .

"Duncan had his telescope out, spying on Manhattan," said Terry. One day we're walking up Fifth Avenue, and Terry pops into Charles Jourdan. Yoko Ono is trying on boots. John Lennon is sitting next to her, in slouch hat, leather jacket, and blue jeans. A Beatle! He looks up at me, the ghost of a smile crosses his face. I give a tiny nod.

Terry's oblivious to all this. She asks my opinion on a pair of boots in a stroppy voice. Then John *does* smile, because we're in the same boat, out shopping with our headstrong lady friends. Yoko asks him a question and the connection is broken.

. . .

Jimmy DeSana had a party at his loft by Bryant Park. Big sweaty crowd. I was talking to tall, gaunt photographer Peter Hujar about Marcus Leatherdale. Peter said, "His name sounds like a retirement home for leather queens." Indeed, Marcus looks like he was created by Tom of Finland. Upstairs neighbor Keith Haring is there. He asked me to visit his studio a month ago, and I saw his black-and-white graffiti drawings of dogs and babys. I thought, This poor guy doesn't have a chance. But of course I didn't say that, I told him it all looked good. Sweet, awkward guy. Meanwhile, jazz-funkster James Chance gets into a fistfight with someone much bigger than him. The crowd backs up as they fall to the floor slugging. James is getting pounded, now bleeding. It happens at almost every party I go

to. James must have a pugilist nature. He always loses. Always got a black eye on the boil. He's got a nice pompadour, and looks good in his lamé Vegas getups, fronting James White and the Blacks. Terry's gonna be on the cover of his *Buy* LP in a skimpy blue bikini designed by James's girlfriend, Anya Phillips, part of the new-wave dominatrix circle.

Meanwhile, as the party gets noisier and noisier, I'm getting quite pissed, as is my wont to do. I need to use the john, but there's a long line, and whoever's in there is in no hurry to come out. Sex? Drugs? Death? I can't hold it any longer, so go to a secluded window that I *think* opens on to an airshaft. I aim and let loose a golden shower. Ahhhhh, that's better. I zip up and go back into the fray. Just then, photographer Francesco Scavullo storms in, enraged. He'd been leaving the party when suddenly a stream of pee rained down on his trademark black fedora. "Who did it?!" he demands of Jimmy. "Who?!" Scavullo has never had such an indignity perpetrated on him in his entire life! He's livid! Jimmy doesn't know, but he has a pretty good idea, and apologizes profusely for whichever of his disgusting guests urinated on his hat.

Jimmy calls me in the morning to ask if I happened to pee out his window last night. I confess, and he scolds me in his mild way. I secretly find it very funny. Peeing on Scavullo's hat? What a capital idea!

. . .

Terry smiles in this knickerless lunar night. Her mouth is full of stars. Irish nudity in repose, muddy white. Breasts palely touched with freckles. Schoolgirl skin. Rabbit ears folded back. Two eyes roaming. A tiny moist mushroom rises from her ginger-haired triangle and says . . . hello! I put an index finger in her pleat. Cunt like cashmere. I rise above her starfish body, take her in and take her out. We're deep divers. We're sunken ships. She was streaming, she was

undoing everywhere, singing from her loins. Head flung to the side. We are alone in the whispering wet dark.

I'll walk out of here tomorrow, and it'll be New York. "Everything screwy is normal in this damn town," I'll think to myself. I'll pass Verdi Square, where the time and temperature is on the old Central Savings Bank. Crossing Amsterdam. Crossing Broadway. Past cornices and colonnades. I'll walk down to the river shimmering with snakes of light, in the shadow of approaching rain. I'll look at the jumble of colored smudges, and the sunset over the Palisades ablaze with crimson and gold. Better today, better tomorrow.

Terry did a reading upstairs at the Mudd Club with the legendary Lester Bangs. She went on first, and was reading a piece on the etiquette of a slave to his dominatrix. It had appeared in the new issue of *BOMB*, illustrated by me. It got pretty gnarly. Lester was very drunk and stoned on barbs, sitting in the front row, and he began to groan. Terry paused politely, then continued with her text. Lester lurched to his feet and stumbled towards her, paused, and then careened to her left, collapsing behind a screen. We wouldn't be hearing from him again tonight. He was gone. People fall apart all the time.

· · ·

Every day the mailbox is stuffed with invitations to various events. We went to a white-tie party for Giorgio Armani at Studio 54, the elegant playground for the international jet set. There was fake snow, fashion models, pulsing music. There was Truman Capote hanging over the light booth, transfixed by the dance floor, pinned on prescription drugs. He looked like a waxwork from Madame Tussauds. A zombie. We wandered from catwalk to balcony, viewing the spectacle. Danced to Chic's "Good Times," an oddly melancholic song. As if there were no good times. Said hi to Andy and Bianca, took in the fevered scene in the unisex lavatories. We walked home in our fancy

dress like a couple of Cinderellas, Terry's ice-blue floor-length gown trailing behind her. I say "C'mon, Clarabell."

Did a job on children's friendships for *Self* magazine at Alexander Liberman's request. I loved his book on artists' studios. They paid me $600. Another on botulism for *New York* magazine for $300. One for *Rolling Stone* on the pinball game Space Invaders. Another for *Esquire* ($300). *Essence. National Lampoon* ($2,000). It gets easier.

KEEPING UP

I got very excited by composer Ned Rorem's *Paris Diary* and *New York Diary*, written by a young man on the make, obsessed with art, sex, and alcohol. Big identification. I found an LP called *Songs of Love and the Rain* by Rorem with a beautifully sad piano piece that I play over and over. I knew he lived on Seventieth Street, so I walked up and down his block off Central Park one night listening for the sound of a piano. Didn't work.

Poet Tim Dlugos came over one afternoon, loved my small oil portrait of Rorem, and said, "I know Ned! Let me give him a call and see if we can go over there." We did. Ned ushered us in, still very handsome, with a blue scarf wrapped around his neck. He had a cold. He introduced us to his cat, Wallace. Served us tea and cookies. Gossiped with Tim about New York School poets they know in common. Tim funny and laughing, Ned not so much, talking out of the side of his mouth with a pronounced lisp. He was lamenting the loss of his youth and beauty, which he has been lamenting since he *was* young and beautiful. That's his thing. A self-fulfilling prophecy. I asked him something about his old friend Paul Bowles, and Ned quoted himself (I had heard him on *The Dick Cavett Show* tell the same anecdote last week). I admired his art collection, Joe Brainards, Jane Freilichers, Cocteau, etc. Ned seemed to eye me with suspicion, and Tim told me to get out my portrait, which I did, and propped it up on the carpet in front of the TV. Silence. Wallace came over and sniffed it, then wandered off.

"I don't think Wallace likes it," Ned said without smiling. He con-

tinued. "I know the photo you used for your painting. Henri Cartier-Bresson. That's when I dyed my hair blond, of course. My suit was brown, not blue, and my tie was red, not green."

"Uh, yeah, well, I only had that black-and-white photo," I replied shyly. That seemed to be about it, so I put the painting back in its brown paper bag, we thanked Ned for the visit, and filed out.

Tim was embarrassed and said, "Sorry about that . . . I thought he'd be a little more enthusiastic. Maybe it was because of his cold."

"That's okay Tim, I guess he just didn't like it." I hope when I'm in my late fifties, some young kid brings over a portrait of *me* that he's done. And, I must add, it's a fucking good painting. Not that all my paintings are, but this one is.

· · ·

Terry's touchiness is always on alert. Sometimes I'm damned if I do and damned if I don't. I can sense a fracture in her life. She says I'm trying to control her by offering her advice. When she has an attack of the crazies, she can get quite violent. Once I was standing in the doorway of her office, and she was screaming at me for some imagined infidelity, some groundless fears, the energy was escalating, and suddenly she launched her heavy electric typewriter at me. I did a quick two-step, and it crashed where my feet had been. There would have been some broken bones had I not Nijinskied out of the way. Once she told me that I was never going to get out of this love affair alive. It seemed to be more than an idle threat. It's coming up on three years now. There's been quite a bit of deterioration since the relative innocence of the first flowering of romance. Emotional fatigue. Now it's flowers of evil, to borrow a phrase from old Charlie Baudelaire.

The Times Square Show, June 24, 1980.
201 West Forty-first Street

A group show organized by Colab, who have taken the bull by the horns. They got the use of an empty massage parlor off Times Square. I have five paintings in it (in spite of not fitting in with the show's agenda), portraits of Ned Rorem, Colin Wilson, Wyndham Lewis (which Glenn O'Brien bought for $300), and two nudes, one of Italian starlet Leonora Fani and the other of Jane Birkin. Hung near a couple of Walter Robinson's pulp paintings. Most of the other work has a rough political edge, do-it-yourself antifascist art done with cheap materials. Rats, hypodermic needles, barrio boys, hookers, this is the general tone. *The Village Voice* put artist John Ahearn on their cover, with some headline about the new presence of young voices who demand to be heard. These scruffy ghetto dwellers are barging into the art world, it said in effect. It worked on the dealers. Jimmy's boyfriend Stefanotti asked me to have a show in a few months' time. (Me being the lesser of evils contained in the Times Square Show. My pictures would not seem to have an axe to grind with art history. I am the safe choice.) The Times Square Show is a chance for all of us to see what everyone else is doing, since none of us have representation and we work in a vacuum. We only see each other at scuzzy nightclubs. On record covers, in underground magazines, on flyers.

· · ·

Life magazine runs a picture of Amos Poe in bed under a poster for *Unmade Beds* (with image of me taking a photograph). It's an article on the "new new wave." Amos "takes his characters and icons from vintage B-movies—cops and call girls, gangsters and hit men—and weds them to themes of alienation and violence. New wave performers play the parts, and the new music serves as its soundtrack," says the article. The underground is slowly surfacing overground.

The Reader

Books

Bright Orange for the Shroud, John D. MacDonald
Laughter in the Dark, Vladimir Nabokov
November, Georges Simenon
Self-Portrait, Man Ray
Blue Movie, Andy Warhol
The Paper Snake, Ray Johnson
Helen and Desire, Alexander Trocchi
The Carnal Days of Helen Seferis, Alexander Trocchi
White Thighs, Alexander Trocchi
The Woman of Rome, Alberto Moravia
Lunch Poems, Frank O'Hara

The Basketball Diaries, Jim Carroll
The Love Object, Edna O'Brien
Life with Picasso, Françoise Gilot
Brideshead Revisited, Evelyn Waugh
Dispatches, Michael Herr
Echoes of Celandine, Derek Marlowe
I Want It Now, Kingsley Amis
That Uncertain Feeling, Kingsley Amis
First Love, Last Rites, Ian McEwan
The Cement Garden, Ian McEwan
Miss Silver's Past, Josef Skvorecky
Delmore Schwartz, James Atlas
The French Lieutenant's Woman, John Fowles
A Waiting Game, Michael Powell
Heaven and Other Poems, Jack Kerouac

October 7

Reception at the Mudd Club for a serigraph I did of Harry Crosby, called *Lullabye*, edition of fifty. *BOMB* magazine ran a study for it, full page.

One day, while I was on a bender, I was proofing the silk screen with the printer, and afterwards found myself standing on the corner of Sixth Avenue and Fourteenth Street. Who should appear but beautiful Annette, the dreamy girl who screwed me and DuPrey on the same sultry night. Long time, no see. "Are you drunk?" she asked. I nodded. "Good," she said, and took me to her nearby apartment after picking up a bottle of champagne. We went straight to bed, and feasted on each other like starving carnivores. "You've become more sexual over the past five years," she said, smiling. "I thought you were ethereal before." She took me to One Fifth for dinner, and wrote on the inside flap of a matchbook, "I love you and NY" with

her eyebrow pencil. Passed it across the table to me. It was a memorable, spontaneous, romantic interlude, the kind Greenwich Village is/was famous for. It was the only time I actually cheated on Terry. I followed the old adage: "If you're gonna do the time, you may as well do the crime."

We went to see Siouxsie and the Banshees at the Academy of Music. New album is *Kaleidoscope*. Afterwards we went to Gordon Stevenson's loft for a small after-party. Gordon's in an unlistenable band with Lydia Lunch called Teenage Jesus and the Jerks. Gordon's wife, Mireille, was killed in a car accident. They'd made a film together called *Ecstatic Stigmatic*, a gnarly mash-up of Catholicism and S&M. Like Gordon's loft, which is heavy on the crucifixions and bondage apparatus. Terry's talking with Siouxsie's drummer and boyfriend, Budgie, a good-looking bottle blond. I attempt to talk with Siouxsie, a chilly and formidable singer wearing a lot of makeup. I like her, but she's hard work. It is very late, and I am on the wagon and want to go home. Terry says under her breath that Siouxsie and Budgie have invited us back to their midtown hotel.

"It's three in the morning," I say. "Why would we go there at this time of night?"

She raises an eyebrow. "Want to?"

Oh, I see now. Bit of swinging with the Banshees. I cannot imagine getting cozy with Siouxsie, and I don't particularly relish the thought of watching Terry getting boned by Budgie. "I don't think so, Terry," I said. She shot me a look that said volumes about what a repressed square I was. Tried to talk me into it. "Sorry, there's nothing about this that appeals to me." She goes over to the English rockstar couple to decline the offer, feeling very uncool. Sulks all the way home. It seems she's outgrown this romance. She makes me feel like an anchor chained to her ankle.

I'm trying to pull out of my personal nosedive, while she wants to fearlessly embrace her dark side, overcome her Catholic hangups. I

don't have any religious repression to rebel against, don't know much about Jesus, never much cared. What's all the fuss about? Original sin? I don't understand. So this is where we come apart. Apparently the rules have been changed.

October 17. Sam Green works for John and Yoko. He asks if I can do a mock-up logo for Lenono Records, a Rising Sun morphed with a Union Jack. Overnight. I do. I get a check in the mail for $75 signed by Yoko.

I also did some jobs for *High Times* and *Mademoiselle*. Did a cover for Dennis Cooper's anthology called *Coming Attractions*.

Halloween, 1980

I finally figured out that Terry was having an affair with shitty Gordon. For six weeks! I feel a fool. Betrayed, insulted, lied to. And now that I know, she's furious at me. Her guilt turns to anger. I talk to her calmly, she gets hysterical. She doesn't listen, only lashes out. She wants to be "bad." She's vain, conceited, selfish, hypocritical. She's finally turned into the dominatrix she was pretending to be a few nights a week. Full time now. She says she's got "guts" to indulge in any urge she may have.

Says Gordon was cuckolded by the deceased Mireille, so now he's getting his own back. Gordon is a bisexual creep. He tried to kiss me, too. He looks like a reptile, sharp widow's peak, the pallor of a chronic masturbator. Slave bracelets. Motorcycle boots. Tattooed. Beady-eyed. My rival. Yuck. He's led Terry along, preying on her insecurities and schizophrenia.

November 8, 1980

In response to my being cuckolded, I embarked on a long, joyless, drawn-out bender, as if demonstrating that if anyone was going to hurt me, it would be *me* doing the hurting. I'm perfectly capable of hurting myself, thank you very much! Tim Dlugos dropped by and found me in a semi-comatose state. He was horrified at the condition I was in, no food, just vodka, so made a call, and made me promise to go to an address in the neighborhood the following noon. I did, and I found to my surprise that I liked what I heard, so I continued to go every day to learn about this disease that has been calling the shots in my life. I felt hope. They said I didn't *have* to drink. A novel idea, of course I *have* to drink, it's what I do. Not today you don't, they said, tomorrow's another day. It's only a day at a time. You don't have to quit for the rest of your life. I told someone there I was wary of getting brainwashed. He said, "Well, no offense, but your brain could use a bit of washing."

. . .

Sadly, I still live with Terry. If she would just move in with her rotten Don Juan it would be a lot easier. She tries to provoke me, taunts me, tests me. Doesn't like my new sobriety. She can't take my disapproval. Tough shit. I don't have all the answers, I'm tired of who's right and who's wrong, I'm just a twenty-eight-year-old alcoholic painter. I want no more scenes.

There *was* a doozy of a scene. She came home one afternoon, after a night with her bit of rough trade, Gordon. They're reading Nietzsche together. She told me they want to kill a homeless person and roll him into the Hudson, so they can tick *that* sin off the list. I told her she was crazy. She told me I was a conservative, repressed bore. "Just because I draw the line at murder?" I said. "Okay, then, if that makes me square, I guess I am."

This ignited her fury. She followed me into the kitchen, my back was to her, but a second sight made me suddenly duck. She had hurled a full glass jar of Hellman's mayonnaise at my head, which exploded on the wall in front of me with such violence that the pieces were propelled into every corner of the apartment, not just the kitchen. It sounded like a grenade going off. It would have stove in my skull. I turned, my adrenaline giving me immediate superhuman strength. I walked over to her, lifted her up by the neck with one hand, as if she weighed a pound. Her feet were dangling in the air. I looked at this fucked-up bitch and realized if she could just cease to exist, all my problems would be gone. It was a powerful impulse, one that I've never had before, and hope to never have again. I said, "Okay, that's it, you've pushed me as far as I can go, but you can't push me anymore. That's it, you're done. Now I want you to get out of here, because it's not safe for you here, not now. So get . . . the fuck . . . out!" And then I saw something in her, in her terror-stricken face, that made me sick . . . a wave of admiration passed over her, even desire. I squeezed her neck one last time, and set her down. She left. I was still pulsing with a murderous energy like I'd never ever felt. I went to the bathroom mirror to see who I had become. I hardly recognized myself. I looked completely feral. Like the Wolf Man, my teeth bared, my nostrils extended, my eyes ablaze.

I've come to see that it's a blessing that Gordon stole Terry away. In fact it's the best thing that could've happened. How would I have ever gotten out of that toxic relationship otherwise? Maybe I thought it's what I deserved, water finding its own level, etc. Alcoholism does a real number on your self-esteem. We didn't have to be together; in fact, it was a terrible idea. I'm free, white, and twenty-eight. I've got a rosy future ahead of me.

It's so nice to wake up without a hangover. My imagination roams freely. I experience nuances I never knew. Attentive to little sensations. I have been my own worst enemy for years. I do a painting

called *Pink Clouds* that is of the rooftops of Montmartre. It looks the way I feel. Out of the storm.

. . .

Saw Tom Waits on stage. He sang, "If I exorcise my devils, well my angels may leave too." I used to think that too. I don't anymore. Suffering is not imperative. Being cynical is a cop-out. Hip negativity is just another form of conformity. If I feel the world is horrible, to be horrible myself would just be adding to the problem. The path of least resistance would be to submit to the inevitable course, and just become another fatality of bohemia's wicked ways. As if I was passively going along with the downward flow. That's not me, not who I was, not who I want to be. I have a choice in the matter. I can fight back. Wouldn't the brave option be to try to live a positive life? Wouldn't *that* be rebellion?

December 1980

I was interviewed by Patrick Roques for *Vacation* magazine out of San Francisco. Article called "The New Romantic." I told some of my ghost stories. Talked about how misconceptions can be an asset. Bohemia. The nobility of being a painter. I did another interview with an artsy magazine out of Belgium called *Soldes*, with some nice photos. The interpreter was an English painter, Michael Bastow, who lives in Paris. Terrific draftsman. We become pals.

December 8, 1980

Terry and I were having a hamburger up on Columbus Avenue. I saw John Lennon's face on the TV above the bar, sound off. He's always in the news because of his *Double Fantasy* album. That album about the bogus love affair between him and Yoko. We pay up and walk

down the avenue approaching Seventy-second Street. A madman is screaming in the street. At Seventy-second, I look east and see a small group of people congregated in front of the Dakota. Uh-oh. We walk over. People are crying. Yellow police tape and squad cars. John's been shot. They've got the assassin, just a kid from Hawaii. A very strange vigil begins, as more and more mourners show up. It's incredibly sad.

TRIAL AND ERROR

January 18, 1981

I meet Anna Taylor in Club 57. She's dressed as Joan of Arc for some kind of performance. Like a school-play costume. So pretty. Beautiful skin, crooked teeth, blue hair. She smells good too. She's twenty-five and on the scene. Cool. Nutty. Nervous. Gamine. Smart. Has a creative way of talking, lots of wordplay.

I went home and watched a Horst Buchholz spy movie on the late show. Kuku lies on my stomach and watches me watching. She loves me. She reads my mind. It occurs to me that all this time I've been treating her as a cat. I don't even know what a cat is, really. I apologize to her.

February 6

I rendezvous with Anna at Café des Artistes. I learn she's from Ottawa, by way of Ann Arbor. Broken home. She plays bass in a band with tall drummer Jim Sclavunos called Madder Lake. Used to "go out" with Jean-Michel Basquiat (which you could say for legions of downtown girls). She's wearing checkered jodhpurs. She steals a hard-boiled egg. Kicks it down the street. We go to the Rock Lounge on Canal Street to see the Lounge Lizards. We like Arto Lindsay's skronk guitar. She lives in a storefront on East Tenth Street. Makes a living as a seamstress. Writes songs. I walk her home. Kiss her goodnight.

DH with My Funny Valentine

February 8. Anna and I are circling each other, unsure of the other, but intrigued by the connection that seems to be growing. This is the first time in my life I've courted someone sober. Very different enterprise. Sometimes awkward. I feel vulnerable as hell. No artificial shock absorbers to smooth out the road. No Irish courage. She's about to leave my apartment one night, and I ask her to stay, saying that we have to see where this goes. We undress. She is extremely beautiful. Breathtaking. All is revealed in bed. All the pent-up desire, the tenderness, the intensity, the excitement. A primeval union, a wordless articulation of how we feel towards another. Closer to the wonder of it all . . . I feel reborn.

Then we're just plain old falling in love. She asks me to sweep her away. She says, "I can rely on you, you're sensible, strong and constant, there are no holes in your will." Whereas she's more analytic,

struggles with doubt and confusion. Looks for the cracks. It's hard for her to let her guard down. But she says she likes me more than anything, so maybe love can triumph over adversity. She hopes I'll rub off on her, erase her trust issues. As for me, I feel high, heady, youthful, besotted. It's all so sweet. I feel grateful. Brimming over. What's better than love? Nuthin'.

New York/New Wave curated by Diego Cortez, at P.S. 1. February 15, 1981

Monolithic show in Long Island City featuring everybody. Mostly groovy outsiders from the last five years, marking their territories. Some stalwarts too, Andy Warhol, Larry Clark, etc. I showed draw-

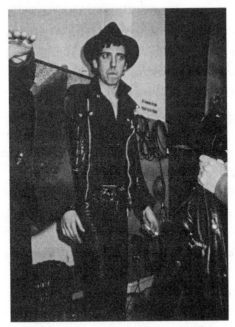

Mick Jones of the Clash at Glenn O'Brien's TV Party

ings, collages, and oil portraits of Ray Johnson and Victor Bockris, among others. Anna and I went to the afternoon opening, crawling with hipsters. A new generation is forming itself. I'm not down with it all, but I appreciate the energy. Afterwards eating cheeseburgers at the diner by the subway stop.

Glenn O'Brien writes it up for his column in April's *Interview*. He says that new art is better than old art, just like the new music is better than the old music. That's cute, but not necessarily true. I went to a taping of Glenn's TV show. Mick Jones from the Clash was there, Kate Simon, Chris Stein from Blondie. Everybody was pretty whacked out on strong marijuana. Even Amos, the cameraman. That's why the show's got that disconnected feel.

March

A week in Fort Lauderdale with the family, staying at a 1950s white-and-sea-green complex called Lago Mar. Near Port Everglades, where there is a rock jetty built out to the sea. Ships sail in, ships sail out. There's a big kidney-shaped pool, orange-and-green-striped cabanas. Mom, Dad, sister, brother-in-law, their two kids, Hannah and Sage, plus my old grandfather Bunny, who my dad calls "the General." A short, dapper man, who had to stretch himself on a rack to meet the height requirements for the Army, so he could do his duty in World War I. His buddies brought him to the physical in a flatbed truck so his vertebrae wouldn't settle back together, giving him that extra inch or two.

Anna is a big hit with the family, in spite of her blue hair. A relief to all after the three years they'd put up with the rather strange Terry. Dad's eyes twinkle when he looks at her, maybe seeing a little of the Audrey Hepburn of *Funny Face* in her. We are in the throes of new love, so keep sneaking back to our dark room at various times of the day for sex. It's so easy and mutually satisfying. Our appetites are

in sync. Unraveling together. We delight in each other. Then back out to the sun and sand and saltwater. I can't remember feeling so euphoric, now that I've found my happy soul mate. I feel as though my search is over.

We read books on the beach, Anna getting a pronounced tan line on her nymphet body from the thin cotton aquamarine one-piece she wears. Her cheeks dusted with freckles. She smiles with our shared secret. We play Scrabble. Take showers. Act foolish. Speak the same language. Her body language reminds me of Charlie Chaplin. Adrift in our bed of fantasy, we're on a Chinese junk that's floating away from it all. Narcotic kisses as the air-conditioner hums. "This is the best thing in the world," Anna says.

Books

Augustus John, Michael Holroyd

Je Suis Ein Americano, Tim Dlugos

In Between the Sheets, Ian McEwan

The Boy Who Followed Ripley, Patricia Highsmith

The Job: Interviews with William S. Burroughs

A Sport and a Pastime, James Salter

Four Days in a Lifetime, Georges Simenon

Endless Love, Scott Spencer

The Collected Poems of Theodore Roethke

POPism, Andy Warhol

Marry Me, John Updike

For Years, Tim Dlugos

Catcher in the Rye (again), J. D. Salinger

The Bell Jar, Sylvia Plath

Recovery, John Berryman

Crow, Ted Hughes

Show People, Kenneth Tynan

Art in Its Own Terms, Fairfield Porter

Letters to a Young Poet, Rainer Maria Rilke
The Immoralist, André Gide
With William Burroughs, Victor Bockris

Interview does a "Who's New" page on me. Written by young scribe Robert Becker. Shot of me on the West Side Highway in front of a shipwreck painting. It says, "The most accomplished of those young painters using the traditional format of oil painting—an innovator as reactionary."

May 12, 1981. The press release for my first real one-man show promises that these paintings "create an art evocative of the casual atmosphere and privileged intellectualism of a still-remembered café society. The paintings bridge the gap between our fondest memories of what art was and those most appealing innovations that make art as it is."

**One-Man Show at the Stefanotti Gallery,
30 West Fifty-seventh Street**
1. *Rites of Passage*
2. *Hide and Seek*
3. *The Dark Ages*
4. *The Wild Beasts*
5. *The Waiting*
6. *Limehouse*
7. *Arcadia*
8. *Pink Clouds*
9. *My Funny Valentine*
10. *19 rue de Lille*
11. *The Haunted Bookshop*
12. *Heaven*

Thirteen sold before it even opened. Going off into strangers' homes. Success! I am a professional painter at last! It's like a fairy tale with a happy ending. Looking at my room of paintings, I feel they pretty well represent my interior world. They're filled with love for people and places, filled with love for painting itself. They breathe. They're not nailed down. Allowing the viewer to provide their own narrative. This was a voyage to a beginning.

A colorful crowd showed up. Old pals, new pals, old girlfriends, and exquisite Anna, who is represented in the show by a canvas

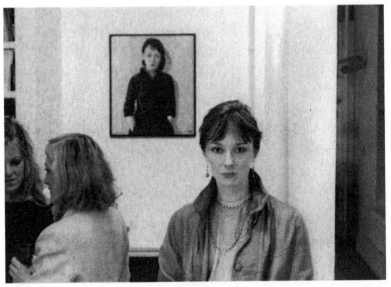

Anna Taylor at Stefanotti opening. Cookie Mueller and Johanna Heer in background. Photograph by David Forshtay

called *My Funny Valentine,* a very sensitive portrait that would have been beyond my capabilities even a few months ago. Knowing this show was approaching, the quality of my work leapt forward in great bounds. It's not a pipe dream anymore. This is real. Some students came up and thanked me, saying this show gave them "permission" to make pictures. Their teachers had told them they "weren't allowed." I told them, "You never need permission to be an artist. It's a calling, and if you feel the need to wave your tattered banner, then wave it you must. Look for what you love."

Acknowledgments

This book wouldn't exist without the generosity, talent, and understanding of many others. First off, thanks goes to John Leland for his article about me in *The New York Times*, which attracted the attention of Gerry Howard, who was instrumental in getting this project realized. He's a champ! Thanks to Gerry's assistant, Sarah Porter, for her mad skills. Thanks to the Knopf editorial department, especially Robin Desser, for their enthusiasm, and to Bill Adams for painstakingly poring over these unscrubbed accounts with a fine-tooth comb. Thanks to the Knopf design group, Cassandra Pappas for the interior, and the brilliant Megan Wilson for the cover.

Thanks to the photographers for lending their pictures: Dave Forshtay, Danny Fields, Regis Redin Scott, Roberta Bayley, Fernando Natalici, Michael Markos, Kate Simon, Alan Kleinberg, Dan von Behren, Bobby Miller, and the late Leee Black Childers, Eric Li, and Paul Hanson.

Special thanks to my friend and agent, Emma Sweeney, for guiding me through unknown waters.

Thanks to early readers for their encouraging words: Michael Friedman, Gillian McCain, Jonathan Rabinowitz, Andre Bernard, David Coggins, Rob duPrey, David Schwarz, Steve Brooks, Jim Mar-

shall, and Mark Rozzo. Thanks to Lorin Stein for picking up three excerpts for *The Paris Review,* and to Charlotte Strick for her inspired design.

For their continuous support I'd like to thank friends Adrian Dannatt, Richard Kern, Anna Sui, Walter Robinson, Michael Chaiken, J. C. Gabel, and the late Glenn O'Brien. Thanks to my sister for putting up with me patiently. And finally to all the characters who appear in these diaries, for all the fun we had . . . much appreciated!

—*Duncan Hannah*
Brooklyn, August 2017

Index

Page numbers in *italics* refer to illustrations.

PHOTOGRAPHIC CREDITS

Unless otherwise noted, all photos are from the collection of the author or in the public domain.